Ellen Emmet Rand

Contextualizing Art Markets

This series presents new, original research that reconceives the scope and function of art markets throughout history by examining them in the context of broader institutional practices, knowledge networks, social structures, collecting activities, and creative strategies. In many cases, art market activities have been studied in isolation from broader themes within art history, a trend that has tended to stifle exchange across disciplinary boundaries. Contextualizing Art Markets seeks to foster increased dialogue between art historians, artists, curators, economists, gallerists, and other market professionals by contextualizing art markets around the world within wider art historical discourses and institutional practices.

The series has been developed in the belief that the reciprocal relation between art and finance is undergoing a period of change: artists are adopting innovative strategies for the commercial promotion of their work, auction houses are expanding their educational programmes, art fairs are attracting unprecedented audience numbers, museums are becoming global brands, private galleries are showing increasingly "curated" exhibitions, and collectors are establishing new exhibition spaces. As the divide between public and private practices narrows, questions about the social and ethical impact of market activities on the production, collection, and reception of art have become newly pertinent. By combining trends within the broader discipline of art history with investigations of marketplace dynamics, Contextualizing Art Markets explores the imbrication of art and economics as a driving force behind the aesthetic and social development of the art world. We welcome proposals that debate these issues across a range of historical periods and geographies.

Volumes in the Series

Ellen Emmet Rand

Gender, Art, and Business

Edited by
Alexis L. Boylan

BLOOMSBURY VISUAL ARTS
LONDON · NEW YORK · OXFORD · NEW DELHI · SYDNEY

BLOOMSBURY VISUAL ARTS
Bloomsbury Publishing Plc
50 Bedford Square, London, WC1B 3DP, UK
1385 Broadway, New York, NY 10018, USA
29 Earlsfort Terrace, Dublin 2, Ireland

BLOOMSBURY, BLOOMSBURY VISUAL ARTS and the Diana logo
are trademarks of Bloomsbury Publishing Plc

First published in Great Britain 2020
This paperback edition first published 2022

Cover image: Ellen Emmet Rand (American, 1875–1941), *Mrs. John Potter*, 1940, Oil on canvas,
William Benton Museum of Art, University of Connecticut, Storrs, Connecticut.

A catalogue record for this book is available from the British Library.

Library of Congress Cataloging-in-Publication Data
Names: Boylan, Alexis L., editor.
Title: Ellen Emmet Rand : gender, art, and business / edited by Alexis L. Boylan.
Description: London ; New York : Bloomsbury Visual Arts, 2020. | Series: Contextualizing
art markets | Includes bibliographical references and index.
Identifiers: LCCN 2020033874 (print) | LCCN 2020033875 (ebook) | ISBN 9781350189935
(hardback) | ISBN 9781350189973 (paperback) | ISBN 9781350189942 (pdf) |
ISBN 9781350189959 (epub)
Subjects: LCSH: Rand, Ellen Emmet, 1875–1941–Criticism and interpretation. | Portrait painting,
American–20th century. | Painting–Economic aspects–United States–History–20th century. |
Women painters–United States–History–20th century.
Classification: LCC ND237.R129 .E46 2020 (print) | LCC ND237.R129 (ebook) | DDC 759.13–dc23
LC record available at https://lccn.loc.gov/2020033874
LC ebook record available at https://lccn.loc.gov/2020033875

ISBN:	HB:	978-1-3501-8993-5
	PB:	978-1-3501-8997-3
	ePDF:	978-1-3501-8994-2
	eBook:	978-1-3501-8995-9

Series: Contextualizing Art Markets

Typeset by Integra Software Services Pvt. Ltd.
Printed and bound in Great Britain

To find out more about our authors and books visit www.bloomsbury.com
and sign up for our newsletters.

Contents

List of Plates

List of Figures

Series Editor's Introduction

In their exploration of the social, financial, and creative frameworks in which art markets come into being and operate, books in the *Contextualizing Art Markets* series often debate macro-economic issues and large-scale historical trends. Much can, however, be discovered about the business of art when examined through the lens of an individual life. Such is the case in the present collection of essays. The contributors to this volume investigate the life and art of American portraitist Ellen Emmet Rand (1875–1941), an artist whose works and career have long been a neglected topic in scholarship.

This book unearths a range of new archival material about Rand's creative and professional life, including information found in diaries, studio files, sketchbooks, and accounts. Together the essays present a compelling image of Rand as an artist who operated in wealthy social circles, but also as an individual who had to concern herself with practical questions of how to make a living in a competitive art environment. Cultivating patrons and seeking out exhibition opportunities are obvious examples of the type of self-promotion needed to sustain a professional career. This book, however, delves more deeply into the business environments in which artists operate by examining subtler issues. These range from the mechanisms by which Rand determined the prices of her paintings to her negotiation of complex social networks, use of mentors, and interaction with power brokers in the museum world.

By locating Rand's career against changing examples of, and popular attitudes to, visual culture—and, in particular, portraiture—in the United States from the turn of the century to the end of the 1930s, contributors reveal the combination of patronage, class, and gender issues that shaped Rand's professional development and legacy. Rand did not enjoy many of the benefits that were available to her male counterparts. She could only access a restricted range of educational opportunities and needed to be mindful of the social expectations that determined her avenues for self-presentation as a professional artist. These were issues that also affected Rand's posthumous reputation. As this volume makes clear, in the absence of professional writers, family members, and dealers willing to promote an artist's legacy, the narrative of an individual's contribution to histories of art is liable to be erased.

As this book's editor, Alexis L. Boylan, makes clear in her Introduction, Rand's story also has a complicated relation to histories of feminism. As a society portraitist, Rand's art sits uneasily in narratives of aesthetic modernism. The fact that historians of twentieth-century art have privileged women's contribution to the development of the avant-garde reveals important aspects of the discipline of art history and of the lives that are, as Boylan puts it, "suited to feminist recovery." The example of Rand's personal and creative life exemplifies the point that narratives of "modernity" move at different paces and in variable ways within contrasting spheres of individual and

collective life. The recognizably modern aspects of Rand's business acumen and professional self-fashioning may, in some respects, be understood as a counterpoint to some of the more conventional aspects of her portraiture. Taken together, they offer a compelling account of the tensions and fissures that shape narratives of modern art in early twentieth-century America.

Boylan is also clear, however, that this book is not an attempt to "reclaim" an artist or to interpret Rand's career as a static piece of history. Instead, through an engaging use of the metaphor of "rewilding," the authors seek to set free Rand's life, creativity, and legacy in all of the latter's "unruliness." This gives the volume a welcome feeling of openness and sets the stage for other scholars to extend the conversation about the works of this fascinating and independent-minded artist.

Art markets do not exist independently of the people who make and inhabit them. For this reason, the following study of Ellen Emmet Rand's professional, personal, and creative life is an important contribution to our understanding of the history and business of art.

Kathryn Brown
Loughborough, Spring 2020

Acknowledgments

The first person who needs to be thanked for this volume—and indeed the exhibition that preceded it—is the late Ellen E. Rand (1941–2016). Granddaughter to the artist at the center of this book, it was Ellen's generosity, spirit, knowledge, and inspiration that pushed this project forward in its early days. After her death, her daughter Felicia Garcia-Rivera, her sister Rosina Rand, and her cousin Peter Rand gave time, energy, and endless support. It has been a great and unexpected joy to meet and work with the extended Rand family.

This book was made possible with the generous support of the Luce Foundation and the advice and steady hand of Dr. Terry Carbone. A transformative aspect of this book project was a writer's retreat that the Luce supported wherein all the authors could come to the University of Connecticut (UConn), talk about Rand, and work directly with her letters, photographs, sketches, and paintings. This time and space allowed this talented group of scholars to truly marinate with the archive and exchange ideas in a way that is seldom afforded in academia or the museum world, and is especially rare when working on the lives and careers of women artists. The Luce Foundation's support put this book in motion intellectually and then also supported its publication; they have been crucial to the rewilding of Rand.

At UConn, the Dean's Office of the College of Liberal Arts and Sciences, Dean's Office of the School of Fine Arts, the Humanities Institute, and the Office of the Vice President for Research and the William Benton Museum of Art, and Archives and Special Collections, Dodd Research Center all provided significant support. Former UConn President Susan Herbst, Dean of the School of Fine Arts Anne D'Alleva, UConn Humanities Institute Director Michael P. Lynch, and Director of the Benton Museum, Nancy Stula additionally encouraged, supported, and promoted this project at key junctures. Thank you.

The heart of this book are the nine clever, supportive, generous, and brilliant contributing authors. It has been an honor to work with these scholars and friends; their energy and enthusiasm are infectious. Another impossibly exciting result of this book has been to see these authors work together on other projects, reminding me that as scholars we are always better when we work within a feminist model of dialogue and collaboration. Many thanks to the authors for their million kindnesses and intellectual luminance.

There were so many scholars, collaborators, and friends that gave aid big and small to this multiyear project; this is an imperfect list. That said, much is owed to Nasya Al-Saidy, Lynne Bassett, the late Deirdre Bair, Thomas Bruhn, Sarah Burns, Kathleen A. Butler, Clarissa Ceglio, Scott Chapman, Evan Cowles, Kelly Dennis, Amanda Douberley, Mary Dougherty, Gary L. Dycus, Roberto C. Ferrari, Alain Frogley, Kerri Gonzalez, Amanda Gilvin, Robin Greeley, Barbara Gurr, Amy Kurtz Lansing,

Anne Moore, Jean Nihoul, Michael Orwicz, James Ouellette, Melina Pappademos, Jenny Parsons, Christine Pattee, Janet Pritchard, Brie Quinby, Emma Romano, Joel Salisbury, Tom Scheinfeldt, Kerry Smith, Karen Sommer, Reuter Turner, Jo-Ann Waide, Bruce Weber, Michael Young, and Sylvia Yount. April Peake at Bloomsbury Academic Press and her whole team, along with the outside reviewers, have made this book a joy to move to publication. Thanks for the support and patience.

Special thanks go to Benton Registrar Rachel Zilinski, collaborator, conspirator, and partner in this project, who always found creative solutions to the myriad problems thrown her way. Likewise, Kristin Eshelman, the superb archivist in Archives and Special, Dodd Research Center, UConn, gave her boundless creativity to making this multiyear, multistage project possible. You were my home team and I could not have done this without you both.

Finally, thanks to Micki McElya and the rest of my family, for everything and then some.

Introduction: The Rewilding of Ellen Emmet Rand

Alexis L. Boylan

How do we forget a life? How does a life get lost in the mass tumble of lives lived? It is easy, in fact, to find one's life historically disappeared and swept away. So much colludes to have most people and all their stories lost; all that remains on this planet from most of us are a few strands of DNA, which were borrowed to begin with. Add in the issues of race, class, gender, sexuality, and ability, and most lives just drift away. So much is forgotten, that the call to remember seems folly, almost an impossible arrogance.

Yet, we do so much to stem the tide of this loss, to stop the forgetting, and demand that a life be remembered. Ellen Emmet Rand, for example, was in the business of not forgetting, of making objects that would make people remember. As a portrait painter, her weekly work—her life's work—was to ensure that people would be seen in perpetuity. Portraits created with the intension of being proudly hung, passed down to children and grandchildren, or placed in offices of the government or businesses and meant to last for the ages. In this way, the patrons, if not fully remembered, would never be totally forgotten. The portrait was a talisman, bought likely with the wish that it would protect one from all the malice and indignities that threaten the remembrance of a person.

Odds were in Rand's and her patrons' favors. Rand understood and manipulated the power of race and class and she readily visually weaponized these signifiers of domination. All her patrons were white, and all had last names with connections and history behind them. Indeed, all those solid and entrenched American names—like Vanderbilt, Roosevelt, Astor, DuPont, Emmet, and James, just to note a few of Rand's patrons and familial relations—typically represented money and education. In other words, the deck was stacked in Rand's favor. She knew how history worked, as did her clients, as they had set many of the rules for making history. Rand also had an insurance policy, because even if *her* name and talent and money were not enough, she would be remembered through her clients. She would be ushered into the future and into memory by her signature, which she flamboyantly inserted with a contrasting color in the top corners of her canvas. Everyone should have remained visible; everyone should have been remembered.

How is it, then, that Ellen Emmet Rand was essentially forgotten? After making almost 800 portraits of the richest, whitest, most powerful Americans from 1900 to 1940, including several of a US president, how was her name lost to history like so many others with far less cultural capital? How can one play the game of being remembered so smartly, use all of her advantages, and still lose? And finally, to be frank, is the historical forgetting of yet another entitled white woman who did much to solidify dominant power dynamics such a tragedy?

Chances are that many readers of this introduction have never heard of Rand. I mean no judgment with this statement; before coming to this project, despite being a scholar of American art with an emphasis on gender and race, I had never heard of her either. Yet, chances are equally good that you have been near a university or college that has a Rand in the president's office, that at least one of the companies you purchase from have Rand's tucked away in their corporate headquarters, that you have toured a state or federal house of government with Rand's painted eyes staring down at you, or that you have visited a museum with Rand portraits in their collections. While working on this project, I saw Rand works in boardrooms, federal buildings in Washington DC, and hung at the Metropolitan Museum of Art. But I also saw several in disrepair or hanging above photocopy machines, in frat houses, and online for sale with "price negotiable" highlighted. How again is Rand at once precious and preserved but also disposable? Both everywhere and unseen?

A neutral, safe, and totally historically acceptable answer is that portraiture changed. Photography and celebrity culture, not to mention changing class structures and strategies for showing power and money, shifted. Yet not all portrait painters in the twentieth century have been so summarily dismissed from mention, recognition, and study. The near-total erasure of *this* woman's art and her career that spanned several crucial decades is remarkable.[1] Again, Rand's 800 portraits are by any measure an epic achievement of productivity and saturation. And her sitters—people such as Henry James, Augustus Saint-Gaudens, President Franklin Delano Roosevelt, almost all of the legal and political architects of the New Deal, dozens of academics, not to mention dozens and dozens of women on the social register—are not forgettable. The diminution of the prominence of painted portraiture does not adequately account for how Rand specifically has been so overlooked.

Perhaps the more obvious answer is gender. It can easily be argued, without engaging radical feminist theory or being steeped in women's and gender history, that Rand has been misplaced because she is a woman, making her views, opinions, labor, victories and failures, *her art*, disposable. The question, "why are there no great female artists" has been asked and answered for almost fifty years, so perhaps Rand's time just had not yet arrived.[2] Indeed, at the time of this writing, another book or exhibition appears monthly announcing the project of recovering the art and life of an underappreciated or unknown woman or woman-identified artist.[3] Maybe Rand's renaissance is right around the corner?

The problem is that Rand does not fit this story of feminist recovery or rehabilitation very well. As biographer Donna Seaman has noted, "for decades, there seemed to be room in the American pantheon for only one iconic woman artist, Georgia O'Keeffe."[4] While that pantheon has expanded, O'Keeffe remains a kind of standard-bearer for

recovering and reclaiming the lives and art of women artists. O'Keeffe's story has become the familiar origin story for the woman artist, one with a consistent narrative arc. Which women get "recovered" is often tied to how closely their stories hew to the script. First, they should be radical or at least recognizably progressive; their networks should be their moment's in-crowd of other artists known for pushing forward modern life and culture. The story demands that the woman artist's obvious social and artistic potential be thwarted by forces beyond her control, the central agent of which will inevitably be a male lover or husband whose own art making and career dominate her life. His legacy, built in part through her labor and support, swamps hers, making invisible her history and artistic contributions. If children enter this story it is typically as her personal tragedy; they are either desperately wanted but cannot be had, or they are had, by accident or misdirection, and family becomes another distraction from her work. Things get so bad, careers and talent so derailed, the reader is directed to ponder, as a recent critic of a book about artists Elaine De Kooning, Lee Krasner, Grace Hartigan, and other Ninth Street women phrased it: "So how did these artists—continually discouraged, derided, and attacked—do it? How did they keep working, in the face of so many obstacles, and keep believing in themselves?"[5] This is key to the script for subsequent feminist recovery and celebration, it sets up the inspirational third act in which the woman artist nonetheless perseveres through grit and fortitude, even though her husband is a lout and her children are needy. She keeps on making art, she defies the critics, she fights onward. Victory is seldom financial, but since capitalist systems of reward are beneath radical and progressive artists, that is no matter. Her victory is surviving, and then in being recovered. Thus, the actors in the drama, the writers of the drama, and the readers of the drama all get to be a part of the story. This uplifting narrative re-invests heavily in individualism, and the specific and personal ways women artists fought for recognition, but does little to indict the governing systems of power and knowledge.

This is not to discount or deride the very important and varied work done by countless feminist art historians and curators since the 1970s to bring more past women artists and their contributions to light and expanded the canon.[6] But this pattern to making women's lives visible is, in fact, partially what art historian Linda Nochlin warned against in her groundbreaking work about greatness and women artists.[7] There is always someone new to recover, but what of it? What is recovered in seeing these artists if we only see them the same way, flattening them out and disappearing others in the process? As art historian Wanda Corn so astutely noted about O'Keeffe, if scholars stick to well-worn patterns of containing women artists, "we risk not seeing the multiple and often different ways in which women performed their modernism."[8] More to the point, if scholars, readers, and viewers keep desiring narrow and repetitive versions of women's pasts, we risk a misremembering that is just as damaging as the initial forgetting.

Rand's story, as will become clear, is absolutely modern, but not in any of the conventional senses of how that word has been used in describing more familiar women artists. Her life and career do not bend to the arcs these narratives demand and hit no moment when a reader might ask: "how did she keep working?" Her diaries, her letters, her calculating choices, her decisions, all her machinations and strategies, in fact, deny

a "how," and instead offer action. What will become clear, in each of the chapters in this volume, irrespective of the very different interpretations their authors offer, is that Rand was in constant motion *forward*. Each setback was an opportunity, no path was too far gone to be retread, a patron's "no" today could be made a "yes" tomorrow. The reader is allowed no moment of catharsis about Rand's story because there is no moment of radical refusal or cruel personalized denial, no catalyzing instance of victimhood with a clear victimizer. Rand simply does not fit into the recovery and rehabilitation mold: her conservative politics do not fit, her traditional choices for having children and maintaining a difficult marriage do not fit, her class and explicit interest in money and maintaining status and appearances do not fit. Thus, on the one hand, Rand's story is a devastating one of systematic and pernicious misogyny, where her many privileges of class, money, and even whiteness could not keep her among the remembered. On the other hand, neither have her history and contributions vaulted her to necessary feminist recovery, to a place among the rediscovered, because she does not fit the script of the lost and found twentieth-century woman artist.

This volume should not be seen as a project of uncovering a static past, or reclaiming an artist disappeared by patriarchy. Instead, the aim is to "rewild" Ellen Emmett Rand. The term is borrowed from biologists and environmentalists who use it to name the process of relocating once-captive animals into the habitats where they had been eradicated (think grey wolves, bison, Siberian tigers).[9] While "rewilding" is at this point a familiar ecological practice, there is controversy about how to conceptualize the resulting ecosystems. While driven by the hope that these animals will be able to simply retake their former positions in the ecosystem, this is never the case. They are changed animals in a changed place. Naturalist George Monbiot suggests a new way to understand the word; he urges us to think of rewilding "not [as] an attempt to restore [ecosystems] to any prior state, but to permit ecological processes to resume." Monbiot continues,

> Rewilding recognizes that nature consists not just of a collection of species but also of their ever-shifting relationships with each other and with the physical environment. It understands that to keep an ecosystem in a state of arrested development, to preserve it as if it were a jar of pickles, is to protect something that bears little relationship to the natural worldRewilding, to me, is about resisting the urge to control nature and allowing it to find its own way.[10]

This is how we should approach Rand, her life, and her career, and once and for all leave aside the search for an origin story or authentic history that Rand belonged in or was cast out of.

The environment for women artists was, and continues to be, harsh and unrelenting. To paraphrase Frederick Douglass, power concedes nothing, so to strive for an authentic or peaceable return or integration is impossible.[11] Instead, this volume looks to rewild Rand into the art historical landscape. Carving out, in limber and changeable ways, why she matters in our moment, as well as in her own historical ecosystem. One advantage to this approach is the inclusion of the unruly and unconventional ways Rand crafted her career. It allows the authors and readers to think through her

strategies and choices not as a predetermined declension but to allow her words, her archives, and her art to speak for themselves in concert and contradiction. Most importantly rewilding "has no end points," as Monbiot argues, so the process is never completed.[12] Rewilding stays in the present tense demanding that this volume becomes but one piece of a new historical ecosystem that will add and shift with new scholarship. Rand is not refound, reimagined, rehabilitated, reconsidered, and not recovered. She is rewilded; in the here and now with all that is good and bad, righteous and malevolent.

<div align="center">***</div>

Who was this Ellen Emmet Rand of new memory? A short biographical sketch gives shape to the history and analysis that follows. Emmet was born in San Francisco in 1875, the third of four daughters born to Christopher Temple Emmet and Ellen James Temple. The Temples and Emmets had complex and intertwining family trees; both parents came from well-connected elite families. Emmet was called "Bay" and, according to family lore, was artistic from childhood, making Christmas cards at age four.[13] Tragedy hit when Emmet was nine and her father died. The family, while moving in elite social and extended family circles, had little money, and so the widow and her four daughters went to the East Coast to stay with various family members and friends. During this period, Emmet spent time with her older cousins—Rosina Emmet, Lydia Field Emmet, and Jane Erin Emmet—who were all established artists. Ellen Emmet followed in their footsteps and enrolled in classes at the Art Student League in New York City at age fourteen. Two years later, while taking summer art classes in famed painter William Merritt Chase's Shinnecock Hills program, Emmet's talent was noted by publisher Harry McVickar, who hired her to illustrate for *Vogue Magazine*. She was sixteen, and more than likely the money that she made from this work, which expanded to include regular illustration for *Harper's Weekly*, was crucial in supporting her three sisters and mother.

In 1896, inspired by her mother's re-marriage and move to England, as well as her cousins urging her to join them in Paris, Emmet made a bold decision and left the financial security she had established in the magazine business, and sailed to Europe. She first stayed with her mother, her mother's husband, and a new baby brother, Grenville, in England, but at the urging of her cousin, novelist Henry James, and armed with letters of support from such artists John Singer Sargent (arranged for by James), Emmet joined her cousins in Paris and began study with the great American sculptor Frederick William MacMonnies. As discussed by several authors in this collection, it was an electric time to study in Paris, and Emmet was immediately consumed with looking at art, meeting artists, and her studies with MacMonnies. This is when she began to gravitate toward portraiture as her signature subject. Her early portraits of friends, family, and her teacher, MacMonnies, reveal that even as she was learning a traditional model of portrait painting and style, her interest was in expressing personality and tone.

Ellen Emmet returned to the United States and settled in New York City in 1900. There is a bit of mystery surrounding her decision to leave France; letters are vague but suggest both a romance gone awry and money problems. Rand got an apartment near Washington Square Park, one floor below another notable female portrait painter,

Cecilia Beaux. Emmet set to work earning a living from her portraits. In early days, she painted family and friends taking advantage of her connections and social networks. Portraits from this foundational period included images of people as varied and famous as authors Henry James and William James; sculptor Saint-Gaudens; singer Susan Metcalfe; cellist Pablo Casals; socialite and sister to President Theodore Roosevelt, Anna Cowles Roosevelt; Progressive journalist Richard Harding Davis; Governor, environmentalist, and first Chief of the United States Forest Service, Gifford Pinchot; and matriarch and socialite Mary Pauline Foster du Pont.

Emmet worked hard and played hard in the first decade of the century; her name appears in newspapers for solo gallery shows and for prizes won at art shows. She is also noted in the *New York Times* for throwing a wild costume party in her Village apartment.[14] While it cannot be confirmed, it would not be unthinkable to imagine a young Franklin Delano Roosevelt and his then-cousin, soon-to-be fiancée, Eleanor Roosevelt enjoying the party. This period also saw Rand engaged to Robert Allerton, or, as *The Chicago Sunday Tribune* called him, the "richest bachelor in Chicago."[15] While Allerton would become noted later in life for his philanthropy and the various innovative legal strategies he used to pass money and land to his gay partner before such relationships were legal or legally recognized, his affair with Ellen Emmet was complex and tumultuous. It ended rather dramatically with Emmet's engagement announcement—to another man—in the *New York Times*.[16]

That man was William Blanchard Rand, who Emmet married in 1911. At that point Ellen was in her mid-thirties and William ten years her junior. By most standards of the period, this was a very late first marriage for Ellen, and to a man much less accomplished than she was professionally. That said, William came from a wealthy family with an overlapping social circle with the Emmet family, and both William and Ellen enjoyed horses and the outdoor life. The couple bought a farm in Salisbury, Connecticut, where they had three sons in three years (1912–1914). As discussed in several chapters to follow, this dramatic shift in living circumstances did little to slow down her artistic production but likely did ensure that Rand could continue to move easily through business and social circles as a married woman. Rand eventually established a pattern where she would work and live in New York City all week, and then take the train home to Salisbury on the weekends. This diligence with working and the commissions she received from it became crucial after the stock market crash of 1929. William lost not only all of the money he came into the marriage with, but Ellen's money as well. At that point Ellen essentially became the primary breadwinner for her husband and three children, as well as for her mother and sisters.

Rand's production of portraits intensified. It was also in the early 1930s that Rand secured her most prestigious commission, to create the official presidential portrait of her old friend, newly elected President Franklin Roosevelt. This would not be her last attempt to secure a presidential commission, as a letter regarding President Herbert Hoover attests; Rand was always working her angles.[17] By this time, she had numerous portraits of political figures under her belt and knew how to provide a compellingly modern look to power and authority in the post–Great Depression moment. As noted by the authors of this collection, Rand emerges as a crucial vector to changing visual cultures of wealth and power in the United States in the 1930s.

Yet Rand's foothold among the wealthy and powerful was always tenuous. She was constantly worried about, negotiating for, and in need of money. While her portrait prices remained high throughout her career, she often had to accept less than her typical fee, or barter her work to cover costs. Her three sons went to the exclusive and expensive Groton boarding school in Massachusetts and it would seem from diaries, and the collection of Rand portraits the school owns, that several tuition bills were covered through portraits. Rand hustled and leaned on the connections she had, and while money was often short, she was seldom without work.

While Rand strived to keep her name circulating in art circles, to keep her paintings shown in galleries, and machinated to place her portraits in museum collections of note, with her death in 1941, her name and reputation faded rapidly. According to her grandchildren, when William Rand became a widower, he put all of her things—paintings, sketches, diaries, letters—in a barn and moved away from Connecticut to create and follow hunts.[18] It was the occasion of cleaning out this barn that prompted Rand's son, John Rand, to find a more suitable home for her art. Only the William Benton Museum of Art at the University of Connecticut accepted the donation. Rand's letters and diaries stayed in the barn for several more decades until her granddaughter, also an artist named Ellen for her grandmother, moved them to her home and studio in New York City. Arguably, without a widow to maintain and continue promoting her name and reputation—the traditional advocate for artists after their deaths—Rand was forgotten in terms of her contributions to portraiture and indeed, to narratives about women artists and the business of art almost entirely in just a decade. Like so many women, her hold on legacy was tenuous and fragile. Paintings got lost, moved into storage, and just like that, she fell out of the story of art in the United States.

While rewilding Rand, this volume looks also to rewild interdisciplinary inquiry and the writing process. As Wanda Corn blithey notes, "customarily, art historians focus on the art and biographers focus on the life."[19] An enormous amount lies in the spaces between and around those two narrowly defined categories, which is where this book comes in. The project took shape first as an exhibition, and in early days it was suggested that a catalogue of the show would be the best way to carry on the conversation about Rand. But the artist's unconventional choices and complex relation to dominant narratives of American women artists in the early twentieth century demand more voices and disciplinary perspectives than a single-author book or catalogue could accommodate. This was also the first opportunity scholars had to read Rand's diaries (written daily from the 1920s until her death in 1941), consider her letters, study her bookkeeping and studio files, and view her sketchbooks. All of these materials had been in the Rand family's possession until 2016, when they were generously donated to the University of Connecticut.

The fullness of this artist's archive presented an opportunity to experiment with collaboration and invite scholars and specialists from business, American Studies, and the National Archives and Records Administration (NARA) to join art historians and curators. The authors came together in Connecticut to participate in a writing workshop with time to consider the documents, think through them together, and

exchange ideas. The process of creating this volume—the process of rewilding—yields a new kind of scholarship about the arts and artists. What follows is a set of fresh dialogues moving among the chapters and showing us a very different picture of an American artist and woman. The writers brought together here do not speak in a unified manner and offer complimentary and contradicting views of Rand and her legacy. They were let loose in the archives. This volume is what they returned with.

In the first section of the book, *Crafting a Career,* each author uses different methodological and archival tools to explore the craft of creating a space for oneself: in the art world, as an artist, and as a person who needed to make money. The collection begins with Betsy Fahlman's analysis of how Rand portrayed her body in self-portraits and photographs and also how she fit her body and career into the extant structures available to female, white artists in the late nineteenth and early twentieth centuries. It seemed important to start this collection with an author that argues that we miss Rand's ambition and skill if we miss the care and consideration with which she constructed herself, both on the canvas and off. Elizabeth Lee then focuses on two crucial relationships for Rand; her mentorship and romantic entanglement with MacMonnies and her emotional and familial relationship with her cousin, Henry James. Lee suggests that these relationships were complex and in moments taxing, and that we can read the various pushes and pulls the men made on Rand in her portraits of them. Lee also, however, highlights how Rand managed both men, personally and professionally, to enhance her career and aid her in artistic and financial self-reliance. The section ends with Marketing scholar Susan Spiggle's analysis of Rand's production, prices, and patrons. Using methods that will no doubt be new to many historians and art historians, Spiggle activates the archives with different kinds of metrics to pull out a version of Rand that is both more exacting and more abstract in regard to how much agency she had in regard to patrons and prices.

The next section pivots to consider Rand's laboring body and the bodies her artistic labor produced. *Working the Scene* begins with Thayer Tolles and her sharp consideration of Rand's portrait of sculptor Augustus Saint-Gaudens. If Rand had, through family name and connection opportunities, some advantages, what is quickly apparent is that if she did not take advantage of them, they would mean nothing. Rand's chance to paint Saint-Gaudens was an opportunity she pushed hard to make happen, and when Saint-Gaudens's widow tried to move the piece from its advantageous perch at the Metropolitan Museum of Art, Rand again pushed to not lose this opportunity. Archivist William Harris considers the complex interplay of opportunity, gender, and patronage in his comparative chapter about Rand and her contemporary (and competitor), painter Tade Styka. Harris begins his chapter with the day the stock market crashed in 1929 and uses the moment to explore how the two very different artists used what they had in terms of gender and sexuality to make it through the Great Depression as portrait painters. Curator Claudia Pfeiffer ends this section with an investigation into Rand and her sporting portraits. An understudied field in art history broadly, Pfeiffer gives context and gendered meaning to portraits of men and women in horsing attire and suggests the value, both personal and monetary, Rand found in this portraiture.

The final section, *Shifting Bodies*, theorizes more aggressively the meanings of and fissures in Rand's work and career. Emily C. Burns begins the section by analyzing a sketchbook a twenty-year-old Rand passed between herself and her younger stepbrother, Grenville Hunter, when he was a child. This sketchbook is the kind of material that typically gets thrown away over the course of travels and family life and so the very fact that it has survived is unique. In the rare moments when these kinds of materials do survive in the archive, they are typically ignored by scholars as the irrelevant detritus of a life—children's nonsense. Burns instead uses this sketchbook as a tool to unpack new theories about childhood at the end of the nineteenth century and also shifting ideas about innocence that circulated around and were manipulated by American artists working in France and Europe. Literature scholar Chris Vials similarly mines the archives for materials typically tossed or destroyed—letters of complaint to portrait painters by patrons. Vials cleverly takes these letters as deeply valuable and revealing documents that attest to the conflicted ways in which class, memory, and resistance were at work in Rand's portraits. The last chapter concerns an explicit act of disappearing Rand from the historical record, defined in the moment when President Truman had Rand's portrait of President Roosevelt removed and replaced in the White House presidential portrait collection. Mazzola argues that this would not have happened to just any painter, but was made easier by the fact she was a woman. Moreover, it was the depiction of President Roosevelt's body, and visualizations of ability and disability, that might have had a role also in Rand's removal from a place of national and historical prominence.

Taken together, all of these chapters begin the process of rewilding Rand. With clarity and cleverness, close looking and theoretical flare, the authors unpack what Rand meant in her own moment and what her life and art could mean to scholars and artists now. There is much work left to do. Rewilding is a continual, ever-shifting process. Rand is not forgotten, but she demands new attention, care, and diligence in showing the whole messiness of an ecosystem of art and memory, bodies and visibility, power and precarity.

Notes

1 It is crucial to note the important exceptions to this, especially Martha Hoppin, *The Emmets: A Family of Women Painters* (Pittsfield, MA: The Berkshire Museum, 1982) and Tara Leigh Tappert, *The Emmets: A Generation of Gifted Women* (New York: Borghi & Co., and Roanoke, VA: Olin Gallery, Roanoke College 1993). Likewise, there was significant advocacy for the legacy and importance of Ellen Emmet Rand from her family. Most notable was the continued exhibition of her grandmother's art by her granddaughter, Ellen E. Rand and her 2009 publication, *Dear Females*. This work hopefully honors their important early interventions and scholarly insights.

2 This is, of course, a reference to Linda Nochlin's field defining article originally published in 1971, "Why Have There Been No Great Women Artists?" in *Art and Sexual Politics*, eds. Thomas B. Hess and Elizabeth C. Baker (New York: Macmillan, 1973), 194–205.

3 There are too many shows to even begin creating a comprehensive list, but a
 few dialogues in popular journals and newspapers include Hilarie M. Sheets,
 "Through the Prism of Gender," *The New York Times*, April 3, 2016: AR1; Peter
 Schjeldahl, "The XX Factor," *The New Yorker*, April 24, 2017, 100–1; and Claudia
 Roth Pierpont, "The Canvas Ceiling: How New York's Postwar Female Painters
 Battled for Recognition," *The New Yorker*, October 8, 2018, https://www.newyorker.
 com/magazine/2018/10/08/how-new-yorks-postwar-female-painters-battled-for-
 recognition, accessed July 26, 2020.
4 Donna Seaman, *Identity Unknown: Rediscovering Seven American Women Artists*
 (New York and London: Bloomsbury Press, 2017), xi.
5 Pierpont, "The Canvas Ceiling."
6 Here it is worth mentioning just a few of works that have inspired this collection
 in thinking about gender, memory, and art: *American Women Artists: Gender,
 Culture and Politics*, eds. Helen Langa and Paula Wisotzki (London and New York:
 Routledge, 2016); Kirsten Pai Buick, *Child of Fire* (Durham and London: Duke
 University Press, 2010); Wanda Corn and Tirza True Latimer, *Seeing Gertrude Stein*
 (Berkeley and LA: University of California Press and the Contemporary Jewish
 Museum and Smithsonian Institution, 2016); Kirstin Ringelberg, *Redefining Gender
 in American Impressionist Studio Paintings* (Surry and Burlington, VT: Ashgate Press,
 2010); Kirsten Swinth, *Painting Professionals: Women Artists and the Development
 of Modern American Art* (Chapel Hill: University of North Carolina Press, 2001);
 Theresa Bernstein: A Century in Art, ed. Gail Levin (Lincoln and London: University
 of Nebraska Press, 2013); and Bailey Van Hook, *Violet Oakley: An Artist's Life*
 (Newark: University of Delaware Press, 2016). Finally, in regard to critical thinking
 about artists, gender, self-fashioning, and the marketplace, Sarah Burns, *Inventing
 the Modern Artist: Art and Culture in the Gilded Age* (New Haven and London: Yale
 University Press, 1996) shapes this study.
7 This is the "bait," according to Nochlin; the urge to "dig up examples" only falls into a
 losing dialogue. Nochlin, "Why Have There Been," 195
8 Wanda M. Corn *Georgia O'Keeffe: Living Modern* (New York: Brooklyn Museum of
 Art and Delmonico Books, Prestel, 2017), 17.
9 Books on rewilding include: Caroline Fraser, *Rewilding the World: Dispatches from
 the Conservation Revolution* (New York, NY: Metropolitan Books, 2009); Dave
 Foreman, *Rewilding North America: A Vision for Conservation in the 21st Century*
 (Washington: Island Press, 2004); Emma Marris, *Rambunctious Garden: Saving
 Nature in a Post-Wild World* (New York: Bloomsbury, 2013); Henrique M. Pereira
 and Laetitia M. Navarro. *Rewilding European Landscapes* (Cham, Switzerland:
 Springer Open, 2015). For examples of animals that have been rewilded, see https://
 www.theguardian.com/environment/2018/jun/03/rewilding-conservation-bison-
 wolves-beaver-giant-tortoise-tigers, accessed July 26, 2020.
10 George Monbiot, *Feral: Rewilding the Land, the Sea, and Human Life* (Chicago:
 University of Chicago Press, 2014), 8–9.
11 This is from Douglass's August 4, 1857 West India Emancipation speech. See
 Frederick Douglass: Selections from His Writings, ed. Philip S. Foner (New York:
 International Press, 1945), 61.
12 Monbiot, *Feral*, 10.
13 The most detailed and authoritative source for much of this early family information
 is in Rand, *Dear Females* (2009). This book, self-published by the author, references
 letters she had family access to and also stories from Ellen Emmet Rand's relatives.

14 "Costume Carnival in Artist's Studio: Gay Frolic in Bohemia," *The New York Times* (January 19, 1908): 11.

15 "The Richest Bachelor in Chicago," *Chicago Sunday Tribune* (February 18, 1906): D1. Quoted in Martha Burgin and Maureen Holtz, *Robert Allerton: The Private Man and the Public Gifts* (Champaign, IL: News Gazette, 2009), 1. For another reading on this affair and timeline, see too the brilliant blog *I Love Allerton Park,* http://www.iloveallertonpark.com/2019/01/27/allerton-portraits-a-missing-link-to-the-rand-exhibition/, accessed July 14, 2019.

16 On this relationship, see Michael Anesko, *Henry James and Queer Filiation* (London: Palgrave Pivot, 2018), esp. 29–33.

17 Letter to Rand from H.P. Caemerer, Secretary of The Commission of the Fine Arts, on September 26, 1939. Caemerer thanks her for her letter and application to thank Hoover. Ellen Emmet Rand Papers, Archives & Special Collections, University of Connecticut Library (EER Papers, ASC, UConn).

18 Conversation with author and Peter Rand, March 18, 2016 and also Ellen E. Rand, July 24, 2016.

19 Corn, *Georgia O'Keeffe: Living Modern*, 11.

Part One

Crafting a Career

Ellen Emmet Rand's *Self-Portrait:* Picturing the Professional Body

Betsy Fahlman

How did Ellen Emmet Rand view her professional body? Lacking letters, interviews, and other textual evidence, our best source of information is her full self-portrait from 1927 (Plate 1). A strong three-quarter view, this arresting image is in the collection of the National Academy of Design to which she had been elected an Associate member the previous year.[1] It was an honor she would have savored as it both confirmed her professional standing in the art world and represented a credential that would have embellished her stature among her elite and conservative clientele. Proudly signed with her name and date prominently in the upper-left-hand corner, Rand presents a serious image of an artist fully engaged in her work.

Rand's life was one of purpose, one that was focused on a career and on her family. She achieved considerable professional and financial success in a highly competitive field, and took great satisfaction in being able to support herself, her husband, and her children. Her financial independence was unusual for a woman in the first half of the twentieth century, and the clear-eyed assessment of herself in her self-portrait reveals an individual who knows her own measure. There is confidence and quiet pride in the image, and she had no need of anything extraneous to convey her status: her working clothes and tools were the only professional signifiers she needed. The image she submitted to represent her in the Academy's collection does not assert status, nor the comfortable living she made for herself and her extended family.

Wearing her trademark felt fedora that covers her unruly hair and shades her forehead and eyes, she looks directly at the viewer through her owlish round glasses. Her steady gaze is engaging but not revealing; her thoughts remain private. One senses that her pause from her painting will not last long, that she will return to her canvas as soon as the viewer turns away. Her expression is not unwelcoming, but clearly she has tasks to finish. She had obviously studied herself intently in a mirror, looking back and forth at her reflection and then at her canvas, a process that accounts for the fact that most self-portraits do not show the subject smiling. But Rand's serious expression of calm confidence also conveys her exceptional professionalism, her direct gaze and firm jaw both suggesting the discipline she maintained in her studio practice. Martha Hoppin characterized Rand as "strong, purposeful, and business-like."[2] Her blue smock,

palette, and brushes identify her as an artist, but Rand includes no attributes referencing her professional and financial success such as elegant clothing or an impressive studio. A viewer gets no clue that this is a busy and highly successful recorder of the visages of wealthy clients, some of them quite well known. Rand holds a large oval palette in her left hand, which she supports on her forearm and tilts toward her to better see the paints she has laid out on its surface (the palette is edged in bits of paint, adding subtle notes of bright color to an otherwise subdued chromatic range). From underneath, she firmly grips a handful of brushes of different sizes. Her right hand is out of view, but it must be holding another brush, as she pauses momentarily in the midst of her work, most likely a commissioned portrait. Both her hat and palette serve as a barrier between the artist and the viewer, an emotional distancing that would have been useful in maintaining a professional reserve with her clients. The financial pressures she faced in producing as many portraits as she did must have been exhausting, but none of this shows in her expression.

Rand's confidence in her abilities was the result of the rigorous training she had received that gave her a solid foundation on which to build the success she earned.[3] Her talents had been recognized while she was still young, and she began art study at the age of twelve, taking lessons in 1887 with Dennis Miller Bunker at the Cowles Art School in Boston.[4] Between 1889 and 1893, she studied at the Art Students League in New York, a progressive institution founded in 1875 that featured a broad range of instructors who represented many styles and aesthetic approaches. Rand took classes from three of them—William Merritt Chase, Kenyon Cox, and Robert Reid—and during the summer, she extended her city lessons at Chase's school in Shinnecock on Long Island, participating in critiques and other activities with her fellow-students.

Several years later, she decided to pursue further training in Europe, and in 1896 at the age of twenty-one Rand left America to study art in Paris, where the leading French artists offered the most thorough instruction to be had anywhere in the world. As the international center of the art world, students could work in private ateliers with the finest academic teachers, many of them also instructors at the École des Beaux-Arts, which did not admit women until 1897. They also experienced the exhilarating atmosphere of criticism and exhibition that was a hallmark of the French capital. Rand declared that she aimed to "swab myself with independence in the future," and would have shared her sister Leslie's views of being in Paris:

> I have never felt the free and delicious sensation that I've felt these last weeks since we came to Paris. A feeling of standing squarely on my own feet & of being ready for & almost capable of being able to tackle anything.[5]

Arriving in January 1897, she decided to work with an American painter and sculptor, rather than a French artist. Her studies with Frederic MacMonnies were an experience that proved personally and artistically transformative. In addition to her art classes, during this period she continued her commercial work, executing portrait commissions in England, where her mother and stepfather lived. She did not return to America until the fall of 1900, and soon achieved success when her first solo show was held in New York in January 1902 at the Durand-Ruel Gallery. Her career was thus well launched.

Mid-career, Rand was a woman whose mind and personality were described by a critic in 1928 as "quick, vigorous, searching and buoyant," and more importantly she was "an indefatigable worker."[6] Possessed of "a sturdy physique," it was a body fully capable of accomplishing the hard work necessary to sustain a career of nearly fifty years, during which she produced more than eight hundred portraits.[7] While she enjoyed being in the studio, the business of portraiture was also an economic necessity as she supported not only herself, but also several family members (including her mother and siblings after the failure of her mother's second marriage), and her husband and three children when the stock market crash in 1929 wiped out his investments.

Rand worked her entire life, and, while she relished painting, her portrait commissions were driven by economic necessity, and making her life one that was, according to scholar Tara Leigh Tappert, "determined and purposeful."[8] As Ellen wrote to her cousin Lydia Field Emmet in 1897, when she was just twenty-two years old and facing one of the many financial crunches that would pepper her life, "I have made money once and can do it again."[9] This declaration is reinforced by Tappert's observation that it was "a driving need to financially provide for her family" that motivated her.[10] Her years in Paris taught her the business of art, and made her understand clearly the value of shrewdly marketing her work. Rand was seldom free of financial anxieties, as her aunt Julia Colt Pierson Emmet wrote with concern about "Dear Bay" (her family nickname) in a letter: "she has too great a strain—the idea that she is to be the bread winner has been underlying her thoughts this winter."[11] But Ellen was a determined individual for whom personal independence was essential (there is some irony in the many people who were dependent on her to support them). And she was resolute in her desire for financial freedom, something she makes clear in a letter she wrote to her cousin Lydia: "We can get along as long as I have ten fingers."[12] Such determination may be seen in the purposeful set of her jaw and the strength with which she holds her brushes and palette. She will achieve her goals through diligent work.

As marketing scholar Susan Spiggle will demonstrate in a subsequent chapter, Rand was paid well for her work, from the earliest part of her career and well into the Great Depression. Her cousins Rosina and Lydia also worked to support their families at different times in their careers, but Ellen's many obligations overlaid most of her professional life. Her self-portrait speaks to her discipline and drive for economic security.

The Academy canvas was executed when Rand was fifty-two years old, well beyond the midpoint of her career. She had been a professional artist since 1893, when she began to earn a steady income for her illustrations that were published in *Vogue*, *Harper's Weekly*, and *Harper's Bazaar*. Her blue painter's smock was her working attire for most of her career, and it was, as a critic wrote in 1928, a year after this work was finished, something she wore "all the working hours of the day."[13] While it ostensibly protects her clothing, she is tidy and there are no splatters of paint visible on either her hands or the smock, avoiding a common visual trope of a professional artist so thoroughly absorbed in what she was doing that she is unaware of stray paint streaks on her person or her hair in disarray, an image favored by self-portraitists working in the late nineteenth and twentieth centuries.[14]

Her use of a smock dates from her years in France (and perhaps earlier), and may also be seen in a small sketch of Rand by Frederick MacMonnies that shows the artist, then in her twenties, in her Paris studio in the late 1890s (Figure 1.1). She stands in front of her easel, her mane of reddish hair untidy as she concentrates on her painting. Much later this "abundance of reddish hair" would be crammed into her felt hat.[15]

A pencil sketch and two photographs also record Rand in her typical painting attire. One photograph, part of a series made at the same time and nearly contemporary with her self-portrait, may be found in the Peter A. Juley & Son Collection. It shows her painting a portrait of her oldest son, Christopher Temple Emmet Rand (1912–1968) (Figure 1.2). Christopher is seated, holding a large black-and-white English Setter in his lap, and Ellen, who holds a rectangular palette, looks directly at the photographer. That her face is animated by a smile reveals her pleasure in painting her eldest son and his dog. More intriguing is Rand's pencil sketch, from the mid-1920s, that pictures

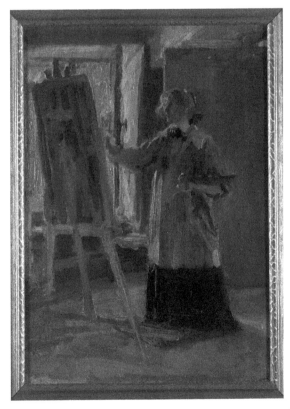

Figure 1.1 Frederick MacMonnies, *Sketch of Ellen Emmet in Her Paris Studio, c.* 1898, oil on canvas, 18 × 18 ¾", The William Benton Museum of Art, University of Connecticut, Storrs, Connecticut.

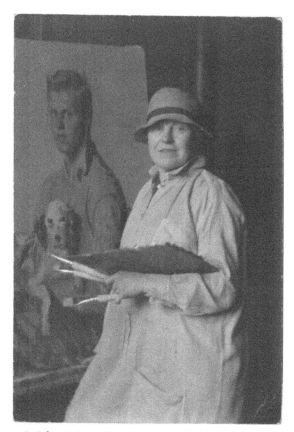

Figure 1.2 Peter A. Juley & Son, Ellen Emmet Rand in her studio, *c*. 1933, photograph, Ellen Emmet Rand Papers, Archives and Special Collections, University of Connecticut Library.

her standing, sketch book in hand, studying herself in the mirror (Figure 1.3). Her face is curiously birdlike in gaze, she stands and looks directly at the viewer, and her expression is alert. More informal than the painting she submitted to the Academy, her preliminary composition would have made an engaging canvas, albeit one less formal and more personally revealing.

There is one earlier self-portrait by Rand, though it is one in which the artist is visible only in the background. Painted in 1910, *In the Studio* portrays her niece Eleanor Peabody (the daughter of Ellen's elder sister Mary) wearing a white dress and black shoes; she holds a black cat in her lap (Plate 2).[16] The painting references a trio of models, including Diego Velázquez's Baroque masterpiece *Las Meninas* (1656, Museo Nacional del Prado), in which the artist stands proudly in front of his canvas, Whistler's chromatic musicalities, and Cecilia Beaux's *Sita and Sarita* (1893–94, Musée d'Orsay, Paris), the latter which also features a single female figure and a black cat. Eleanor is seated in front of a gold-framed mirror, through which Ellen's studio is reflected in the

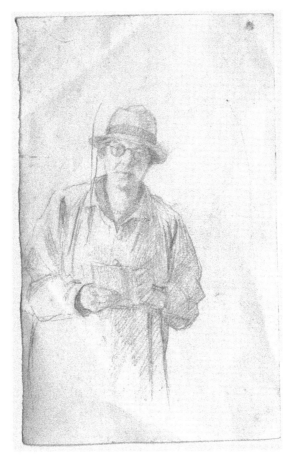

Figure 1.3 Ellen Emmet Rand, *Self-Portrait, c.* 1927, ink on paper, Ellen Emmet Rand Papers, Archives and Special Collections, University of Connecticut Library.

background. Rand stands in front of a large canvas, likely *In the Studio*. The viewer gets only a glimpse of her. Hatless as she was in MacMonnies's earlier sketch, she wears her smock as she works.

New York portrait photographer Clara Sipprell (1885–1975) was likely tasked to create a more formal image in the 1930s, presenting a profile view of the artist's head (Figure 1.4). This was not an image taken by a friend, but rather was commissioned and paid for, with the specific purpose of creating a market look for the artist. Grecian in its serious reserve, her hat firmly restrains her curls. Sipprell's image serves as a reminder that Rand wore her fedora both in the studio and in public. When she was engaged in her commission of the official White House portrait of Franklin Delano Roosevelt, an image published in *The Hartford Courant* in 1933 shows her with the president wearing heels and a dress, the latter covered by her painting smock.[17] Like her Academy self-portrait, she holds a large palette and brushes. The artist, who

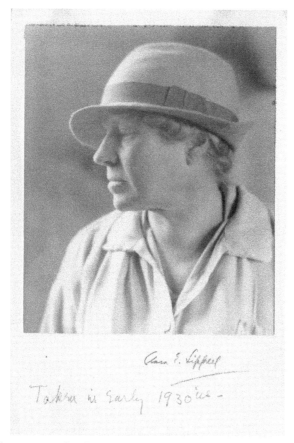

Figure 1.4 Clara E. Sipprell, Ellen Emmet Rand, early 1930s, photograph, Ellen Emmet Rand Papers, Archives and Special Collections, University of Connecticut Library.

liked to control how she presented herself to the public, was not happy with these publicity photographs that presented her in a more traditionally feminine way. The fedora was key to her image, but not the dress and heels. Rand's canvas participates in a long tradition of self-imaging by women, which can include displaying technical skill, demonstrating professional status and accomplishment, or simply doing something not possible in a commissioned work. As art historian Frances Borzello has noted, self-portraits by women tend to be more subdued than those of their male contemporaries as female artists were cautious about seeming to "boast of their abilities."[18] In an era suspicious of female ambition, Rand's austere image resists self-promotion. Scholar Nancy Mowll Mathews's observations regarding the early self-portraits of those artists about a generation ahead of Rand, such as Beaux and Mary Cassatt, could easily be applied to Rand: "In the modern era, it is fairly safe to assume that any person who establishes herself in the highly competitive profession of fine art painting has drive, savvy, and talent" as "the odds of succeeding to the extent of

supporting oneself financially" are "extremely low."[19] Women needed "ambition and ability" to "overcome the prejudices they will face at every stage of their careers."[20] Rand obviously beat these daunting odds.

While Rand's self-presentation in a fedora and shape-concealing smock is rather androgynous, it is notably distinct from the similarly garbed strikingly haunting self-portrait painted by Romaine Brooks (1923, Smithsonian American Art Museum). Brooks was a wealthy lesbian expatriate artist living in Paris who transgressed gender norms and boundaries. Like Rand, her hat shields her eyes, but the harrowing quality of Brooks's severe presentation contrasts with that of Rand, whose image projects calm rather than the searing emotional charge of Brooks. Rand worked in the era of the "New Woman," during which traditional gendered norms were contested by the first wave of feminism and the fights for voting and equality that dominated the 1910s and 1920s.[21] While Rand's challenges to convention were much more modest than those of Brooks, her 1911 marriage at the age of thirty-six to William Blanchard Rand, a twenty-five-year-old "gentleman farmer" eleven years her junior, was highly unusual.[22] The couple had three sons in quick succession: 1912, 1913, and 1914; women of Rand's generation did not wait to have children until their late thirties, nor did they continue to work while they were growing up. While how Rand approached her marriage and motherhood set her apart from many of the women who were her social peers, she did not engage in public affairs nor did her personal life attract the notoriety of Brooks, her partner Natalie Barney, and "the "Amazons" who were part of their circle in Paris.

In contrast, a self-portrait of 1914 by Margaret Lesley Bush-Brown (1857–1944) presents a more traditional gendered image (Figure 1.5). The two artists were similar ages when they produced their self-portraits: Rand was fifty-two and Bush-Brown fifty-seven. Laura Prieto rightly observes nothing in this self-portrait that identifies her "as a wife and mother" (they both had three children); it nevertheless conforms to contemporary social norms for women; it is decidedly a more gracious presentation than that of Rand.[23] Standing in her well-appointed Washington, DC, studio, she delicately holds a small brush in her left hand, and is clad in a bright red and green dress with a white bodice and lace collar. The shawl that has fallen from her shoulders over her arms would have actually restricted her ability to paint easily. Like Rand, she holds a palette and brush, and pauses at her work. A portraitist and a miniaturist—there was a revival of miniature painting at the turn of the twentieth century, particularly with women—she is at work on a small landscape.[24] The studio is an elegant one, and her small work is dwarfed by the elaborate fireplace, flanked by two female allegorical figures (one is reading a book) below the mantel by her husband, sculptor Henry Kirke Bush-Brown.

The presence of his work in her self-portrait suggests that Bush-Brown is using her husband's successful career as a public sculptor to encourage and validate her own (they would occasionally exhibit their work together). That she shows herself at work on a small landscape, rather than the portraits for which she was better known, alludes to a modest desire not to compete in her husband's sphere. The sexual politics of dual-career households was a vexed issue for women, but was not one that Rand had to negotiate, neither with her sisters nor her husband. Bush-Brown's use her husband's

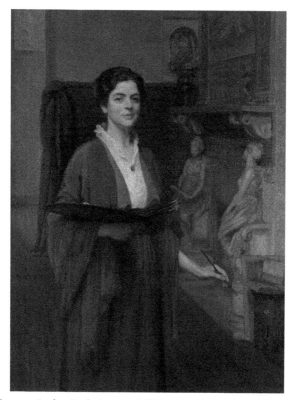

Figure 1.5 Margaret Lesley Bush-Brown, *Self-Portrait*, 1914, oil on canvas, 56 ½ x 42 ½", Pennsylvania Academy of the Fine Art.

career to encourage and validate her career was a strategy many women had to use, despite the fact that it ultimately served to mask their accomplishments. Rand was not married to an artist, nor would she have been happy deflecting the success she had worked so hard to earn.

Bush-Brown moved in some of the same circles as Ellen, her sisters, and her cousins, and all were acquainted with Beaux and fellow artist Ellen Day Hale, the latter who studied at the Académie Julian at the same time as Rosina Emmet and who also painted watercolor portrait of Beaux.[25]

Rand was in Paris at the same time as Mary Hubbard Foote (1872–1968) and the two became lifelong friends and correspondents. Foote had studied at the Yale School of the Fine Arts between 1890 and 1897, receiving several major prizes for her work, most notably the William Wirt Winchester Prize in 1897, which enabled her to go to Paris until 1901. In France, she was introduced to the Emmet sisters, with whom she shared a studio and attended classes. Like Ellen, she studied with MacMonnies, who advised her: "Mary you will be a fine and sterling painter if you will only get strong, vicious and self-reliant and chuck your wailing modesty and look at the charming flighty Emmets from a distance and give up acting the comet's tail."[26] Like Foote, the

Emmets were electrified by the magnetic personality of the handsome MacMonnies, who clearly did not scruple to play them off against one another. Foote would paint a portrait of Rand (Private Collection), who in turn made one of Foote (William Benton Museum of Art). Such a flurry of portrait making suggests the lively quality of these friendships and professional colleagues, relationships that were less grounded in professional rivalries, than the pleasure gained in establishing their careers.

Rand executed several portraits of notable male artists (her works of Augustus Saint-Gaudens will be considered in Thayer Tolles's chapter and her paintings of MacMonnies and her cousins Henry and William James will be puzzled by Elizabeth Lee), but the one she painted in 1938 of sculptor Eleanor Mary Mellon (1894–1980) is of particular interest for this chapter (Figure 1.6).[27] Mellon, who was then forty-four years old, had just been elected an Associate of the National Academy of Design, and

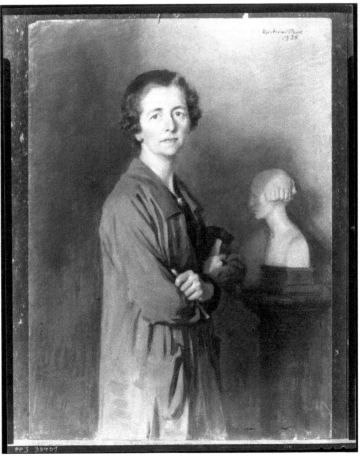

Figure 1.6 Ellen Emmet Rand, Eleanor Mary Mellon, photograph, Smithsonian American Art Museum, Washington, D.C., Peter A. Juley & Son Collection.

Rand's portrait was her diploma piece. She stands to the left of her 1921 marble bust *Helen* (National Academy of Design). Like Rand, she wears a blue smock, her arms are crossed, and she holds sculpting tools in each hand. Her expression is composed and serious. Mellon had studied with Edward McCartan who encouraged her to go to the Metropolitan Museum of Art, to study their collection of Italian Renaissance sculpture, and the influence of these traditional pieces may be seen in the delicate design on Helen's blouse. By the time of Rand's portrait, Mellon had begun to establish her reputation as an ecclesiastical sculptor.

Rand as a Connecticut Artist

For much of her professional life, Ellen Emmet Rand maintained a residence in Salisbury, Connecticut, a peaceful village located in the far northwest corner of the state near the Massachusetts and New York borders. Incorporated in 1741, Salisbury was a pleasant historic rural town that provided an attractive summer retreat for the artist and her family (she and the children spent the school year in New York). In the country, she could also pursue her passion for foxhunting and riding, which is how she met her husband. Rand had two country studios in Salisbury, where she executed many portrait commissions. The first was at Barack Matif Farm, which she had purchased in 1903, and the second at Hamlet Hill Farm, which she and her husband acquired after her marriage in 1911. Her painter cousins Rosina Emmet Sherwood and Lydia Field Emmet also summered in the Berkshires not far away in Stockbridge, Massachusetts.

Rand certainly deserves to be recognized as a Connecticut artist, but her professional identity was not geographically grounded. The state was the base for several groups of artists, though it is difficult to know how much contact any of them had, except within several specific communities.[28]

One of the most sizeable cohorts of female artists was to be found in New Haven at the Yale School of the Fine Arts. Founded in 1864, for the first forty years of its existence it was dominated by women, most of whom were residents of Connecticut.[29] While Yale's leaders were not pleased by the presence of such a large female contingent on the campus, the university had no choice but to accede to the wishes of the prominent wealthy New Haven citizens who founded the school—Augustus Russell Street and his wife Caroline Mary Leffingwell Street—and who specified that the new institution be open to female students. Because Yale provided no monies to support it, financially the art school depended on the tuition these women paid. Unlike many art schools that admitted women but otherwise ignored them, female students were well treated in the institution's early years: the first BFA degree Yale granted in 1891 went to a woman and, when traveling prizes were established to support further study abroad, these also were awarded to them as well (including Foote using the funding to bring her Paris and MacMonnies's studio).

Sizeable groups of women artists could also be found in the seasonal Impressionist colonies that flourished during the summer months along the Connecticut coast, particularly Old Lyme and Cos Cob (a Greenwich neighborhood). Research on the work by the men in these communities has dominated the scholarship on American

Impressionism in New England. These towns were readily accessible by train from the city, and male and female art students found these amiable places to spend the warmer months providing country living with easy proximity to both New York City and Boston. Some who had been studying at the Art Students League followed their instructors to Connecticut where they enrolled in the popular summer classes they offered. While women comprised "a significant percentage" of these students, their male counterparts regarded them as mere amateurs and often disdainfully dismissed them as "blotticellis," a nasty word play on the women's collective enthusiasm for *plein air* painting where bodies visually appear as interchangeable colorful painterly blots on the landscape.[30] These men, however, were perfectly happy to accept the tuition monies these women paid for summer study. The identities of many of these seasonal students are not known, but their presence is evident in local exhibitions. In 1903, it was reported that participant numbers in the annual summer show held in Old Lyme had noticeably increased "with the addition of work by eight women artists."[31] Women did not exhibit again with this group until 1911.

Old Lyme was an especially substantial art colony, though only Matilda Brown (1869–1947) was successful in cracking "the colony's exclusive ranks."[32] She was treated with respect by her male colleagues who took her seriously. Other summer rusticators included sculptor Bessie Potter Vonnoh (1872–1955), who with her husband Robert owned a house there. Brown and Ellen Axson Wilson (1860–1914), the latter the wife of future president Woodrow Wilson, were among the few women artists who stayed at the Florence Griswold House in Old Lyme. Most women found lodgings at local boarding houses, as Florence Griswold preferred her artistic guests to be male, seating their wives at separate tables for meals so as not to interrupt the men's professional activities and conversations that continued outside their studios. In Cos Cob, notable summer and resident female artists included Mary Roberts Ebert (1973–1956), Alice Judson (1876–1948), Mina Fonda Ochtman (1862–1924), and Dorothy Ochtman (1892–1971).[33] Beatrice Cuming (1903–1974) settled in New London in 1934.[34]

Salisbury had nothing on these art communities, yet the town sustained another woman artist of note in residence. Like Rand, Lillian Genth (1876–1953) split her time between her studio in New York and her Berkshire estate "Hermitcliff," declaring, "The things I have learned have come from the soil in the depths of my woods in Connecticut."[35] Her property was part of Lime Rock, a village within Salisbury. Both Genth and Rand showed at the Lime Rock Artists Association, which sponsored exhibitions between 1927 and 1935.[36] But Rand's portraits had little in common with Genth's pleasant nudes set in sun-dappled landscape settings. After 1931, Genth moved back to New York.

For Rand, Connecticut was less a community of artists, than it was a refuge from the many pressures and faster pace of New York. It was a place to enjoy rural pleasures and to paint with few interruptions in the studio she maintained there. But even if she did not identify with the many artists who worked in the state, she still deserves to be part of the chronicle of Connecticut's rich art history. Artists had many reasons to spend time in a particular place, and for Rand the state was a sanctuary and a place of work.

A Final Academy Honor (Attempted)

Rand died in 1941, fourteen years after executing her self-portrait, felled by a heart attack at the age of sixty-six. Although she had been elected a full Academician of the National Academy of Design in April 1934, she never completed the one final requirement necessary to confirm her membership.[37] Before academicians-elect could officially take their places on the roster of those who had been similarly honored, the Academy required that a "representative specimen" of their work be submitted. Secretary Charles Courtney Curran wrote her in January 1935 asking her to provide the necessary piece. It was not that the Academy ceased to be of interest to Rand, for in 1938 she had painted a portrait of Eleanor Mellon (1894–1979) that the sculptor submitted as her diploma piece when she was elected an associate member.[38] By February 1939, she had still not taken care of this, and Curran wrote her, "May we hear from you at your earliest convenience as to when you will send your Diploma picture?"[39] After her death, the Academy made a final attempt to secure this honor for her, contacting her sister Leslie in February 1945: "The Council of the Academy has instructed me to ask you if the lovely portrait of Jonas Lie which you presented to the Academy could be considered as Miss Emmet's contribution?"[40] There was no reply to this request, and it is impossible to speculate on why this final letter from the Academy went unanswered.

It was a curious professional lapse for an artist who had been so active in sustaining the business of her career. But perhaps it was not such unusual action after all, as Rand was less engaged in the formalities of the art world than many of her colleagues, being "totally unimpressed by pomp and circumstance."[41] Perhaps she was simply too busy to pay attention to non-remunerative world. She would have shared her cousin Lydia Field Emmet's view: "I love to paint and I hate to talk."[42] She may well have felt she could accomplish all she needed to without this final honor. For the public Rand, the work was primary, and she found the art world "pretentious and boring," declaring, "I really am not interested in Art. I love to paint, that's all."[43] At the end of her life, the honor the Academy sought to bestow on her meant less than the labor of art itself. Ultimately her 1927 *Self-Portrait* was sufficient evidence of her credentials and late in her career the Academy was not as important to her career. It was not the choice a male artist would make, even a self-assured one, who would have enjoyed the clubby nature of the venerable institution. As ever, Rand chose her own path in having that striking image represent her ambition and the seriousness with which she pursued her career.

Notes

1 I would like to acknowledge Amanda Burdan, Jenny Parsons, Tara Leigh Tappert, Diana Thompson, and Jonathan Walz for their contributions.
 Ellen Emmet Rand was made an Associate of the National Academy of Design on April 17, 1926.
2 Martha Hoppin, *The Emmets: A Family of Women Painters* (Pittsfield, MA: The Berkshire Museum, 1982), 37.

3 For more on art training for women, see Betsy Fahlman, "The Art Spirit in the Classroom: The 'New Women' Art Students of Robert Henri," in *American Women Modernists: The Legacy of Robert Henri, 1910–1945*, ed. Marian Wardle (Provo, UT: Brigham Young University Museum of Art and New Brunswick, NJ: Rutgers University Press, 2005), 93–115; Erica E. Hirshler, *A Studio of Her Own: Women Artists in Boston, 1870–1940* (Boston: MFA Publications, 2001); Kirsten Swinth, *Painting Professionals: Women Artists and the Development of Modern American Art, 1871–1930* (Chapel Hill: University of North Carolina Press, 2001); and Laura R. Prieto, *At Home in the Studio: The Professionalization of Women Artists in America* (Cambridge: Harvard University Press, 2001).

4 Frank Cowles and his brother founded the school that bore their name in 1882. Coeducational (women's classes were held in separate studios), it featured a curriculum based on that of the French academies. See Hirshler, *A Studio of Her Own*, 88–9.

5 EER to Lydia, September 1897, AAA, Box 5, Folder 19 and Edith Leslie Emmet to Lydia Field Emmet, September 1897, Emmet Family papers, Archives of American Art (Emmet Family, AAA) Box 1, Folder 34.

6 Grace Wickham Curran, "Ellen Emmet Rand, Portrait Painter," *The American Magazine of Art* 9 (September 1928): 473. Curran asserted that these words, used to describe her great-great-grandfather Thomas Emmett, could be equally applied to Ellen.

7 Ibid.

8 Tara Leigh Tappert, *The Emmets: A Generation of Gifted Women* (New York: Borghi & Co., and Roanoke, VA: Olin Gallery, Roanoke College, 1993), 37.

9 Emmet Family, AAA, Box 5, Folder 19.

10 Tappert, *The Emmets*, 44.

11 Julia Colt Pierson Emmet to unknown recipient, January 1898. Emmet Family, AAA, Box 1, Folder 43.

12 Ellen Emmet Rand to Lydia Field Emmet, September 1898. Emmet Family, AAA, Box 5, Folder 19.

13 Curran, "Ellen Emmet Rand, Portrait Painter," 478.

14 For more on self-portraits by women, see Frances Borzello, *Seeing Ourselves: Women's Self-Portraits* (New York: Harry N. Abrams, 2016 [1998]), Liz Rideal, *Mirror, Mirror: Self-Portraits by Women Artists* (New York: Watson-Guptill Publications, 2002), and Liana De Girolami Cheney, Alicia Craig Faxon, and Kathleen Russo, *Self-Portraits by Women Painters* (Brookfield, VT: Ashgate, 2000). See also James Hall, *The Self-Portrait: A Cultural History* (London: Thames and Hudson, 2014), and "Self-portraiture," in *Portraiture*, ed. Shearer West (New York: Oxford University Press, 2004), 163–85. For an excellent study of a single self-portrait by a woman artist, see Tracey Fitzpatrick, "Ellen Day Hale: Painting the Self. Fashioning Identity," *Woman's Art Journal* 31 (Spring/Summer 2010): 28–34.

15 Hoppin, *The Emmets*, 10.

16 Eleanor was the daughter of Ellen's elder sister Mary Temple Emmett Peabody, who was married to Archibald Russell Peabody (1873–1908), who died in 1908.

17 This is reproduced in Emily Mazzola, "Enabling Authority: Ellen Emmet Rand, President Franklin D. Roosevelt, and the Power of Portraiture," (MA Thesis, University of Connecticut, 2015): 72.

18 Borzello, *Seeing Ourselves: Women's Self-Portraits*, 20.

19 Nancy Mowll Mathews, "'The Greatest Woman Painter': Cecilia Beaux and Mary Cassatt, and Issues of Female Fame," *The Pennsylvania Magazine of History and Biography* 124 (July 2000): 293.

20 Ibid., 294.

21 See two books by Martha H. Patterson, *Beyond the Gibson Girl: Reimagining the American New Woman, 1895–1915* (Urbana: University of Illinois Press, 2005) and *The American New Woman Revisited: A Reader, 1894–1930* (New Brunswick: Rutgers University Press, 2008).

22 Gary L. Dycus, *The Connecticut Paintings of Ellen Emmet Rand* (Salisbury, CT: The Salisbury Association, 2008), 17.

23 Prieto, *At Home in the Studio*, 153.

24 See Maryann Sudnick Gunderson, "Dismissed Yet Disarming: The 20th Century Portrait Miniature Revival," MA Thesis, Ohio University, 2003.

25 This is reproduced in Sylvia Yount et al., *Cecilia Beaux: American Figure Painter* (Atlanta: High Museum of Art and Berkeley: University of California Press, 2007), 20.

26 Frederick MacMonnies to Mary Foote, August 20, 1904, Manuscripts and Archives, Yale University Library, John Ferguson Weir Papers, quoted in Fahlman "Women Art Students at Yale, 1869–1913: Never True Sons of the University," *Woman's Art Journal* 12, no. 1 (Spring/Summer 1991): 20.

27 In addition to Frederick MacMonnies and Augustus Saint-Gaudens, Rand also executed the portraits of painters Jonas Lie (1935) and William L. Carrigan (1933), and architect Charles Adams Platt (1929).

28 Although Connecticut has a distinguished art history, there surprisingly are very few scholarly on the state's women artists. In the Connecticut chapter in William H. Gerdts's massive *Art Across America: Two Centuries of Regional Painting in America* (New York: Abbeville Press, 1990), vol. 1, 100–33, the only female artist he mentioned by name was Lilian Genth, who merited only a few lines and no image. Publications on Connecticut's women artists include May Brawley Hill, *Fidelia Bridges, American Pre-Raphaelite* (New York: Berry Hill Galleries, 1981); Susan G. Larkin, *The Ochtmans of Cos Cob: Leonard Ochtman (1854–1934), Mina Fonda Ochtman (1862–1924), Dorothy Ochtman (1892–1971), Leonard Ochtman, Jr. (1894–1976)* (Greenwich, CT: Bruce Museum, 1989); Kevin Grogan, Cary Wilkins, Amy Kurtz Lansing, and Erick Montgomery, *First Lady Ellen Axson Wilson and Her Circle* (Augusta, GA: Morris Museum of Art, 2013); Eve Kahn, "Rediscovering Mary Rogers Williams," Fine Art Connoisseur 11, no. 5 (September/October 2014): 76–81; and Susan G. Larkin and Amy Kurtz Lansing, *Matilda Browne* (Old Lyme, CT: Florence Griswold Museum, 2017).

29 See Fahlman "Women Art Students at Yale," *Woman's Art Journal*, 15–23.

30 Amy Kurtz Lansing, "Art Colonies of the Connecticut Coast," in *Call of the Coast: Art Colonies of New England*, eds. Thomas Denenberg, Amy Kurtz Lansing, and Susan Danly (Portland, ME: Portland Museum of Art and Old Lyme, CT: Florence Griswold Museum, distributed by New Haven: Yale University Press, 2009), 16.

31 Gerdts, *Art Across America*, vol. 1, 124. Some of these women pursued art study with the intention of having a career, but their marriages to artists (sometimes their teachers) often derailed their youthful ambitions.

32 Lansing, "Art Colonies of the Connecticut Coast," in *Call of the Coast*, 16.

33 See Susan G. Larkin, *The Cos Cob Art Colony: Impressionists on the Connecticut Coast* (New York: National Academy of Design and New Haven: Yale University Press, 2001). In Appendix A (212–217), Larkin lists twenty-two women artists.

34 See *Beatrice Cuming, 1903–1974* (New London, CT: Lyman Allyn Art Museum, 1990).

35 Todd D. Smith, *Lillian Mathilde Genth: A Retrospective* (Hickory, NC: Hickory Museum of Art, 1990), 15.

36 Tappert, *The Emmets*, 57. Ellen showed at Lime Rock in August 1934.

37 Ibid.

38 See David Dearinger and Isabelle Derveaux, *Challenging Tradition: Women of the Academy, 1826–2003* (New York: National Academy of Design, 2003), 42.

39 Charles C. Curran to Ellen Emmet Rand, February 1, 1939, National Academy of Design Archives (NAD).

40 Georg Lober to Leslie Emmet, February 8, 1945, NAD. The Lie portrait dates from 1935. For an image see Peter Juley & Sons photographs numbers J0038474 and J0038389.

41 Hoppin, *The Emmets*, 10.

42 Ibid., 27.

43 Ibid., 11.

Among Women, between Men: Launching a Career, 1896–1900

Elizabeth Lee

Ellen Emmet Rand's success as a portraitist in America depended not only on her talent, the skillful management of her business, and the supportive presence of her family, but also on the influence of male mentors who actively shaped her education abroad and helped lay the groundwork for her painting career.[1] This chapter examines Rand's relationship with two specific figures: her teacher, Frederick MacMonnies; and her cousin, the writer Henry James. Both men played a formative role in her personal and professional development during her student days in Europe, providing Rand with opportunities that were rare for female art students at the time. However, their support was neither simple nor straightforward—and, at times, came at considerable personal expense—as Rand negotiated their sensitive personalities and positions of power as accomplished men in the arts.

Family First

In December, 1896, when Ellen Emmet (called "Bay" by her family) arrived in Paris to study art, she was in good company among ambitious American art students traveling abroad to receive their training, including members of her own family.[2] Two previous generations of Emmet women had studied painting and become portrait painters. First among them was Bay's cousin, Elizabeth Emmet Le Roy (1794–1878), an essentially self-taught artist, who learned by copying the work of colonial-era American painters.[3] A generation later, Bay's aunt, Julia Colt Pierson Emmet (1829–1908), studied with the artist Daniel Huntington and painted until she began a family of her own. Three of Julia's ten children—Rosina, Lydia, and Jane—studied with Bay and her sister, Leslie, in Paris.[4]

The "Emmetry" as their cousin, Henry James, referred to this third generation of Emmets, provided role models for one another as their personal and professional lives developed. Rosina studied in New York with William Merritt Chase at the Art Students League in 1879, successfully exhibiting as early as 1881 at the National Academy of Design and the Society of American Artists and becoming well known for

her portraits of children.[5] She and her younger sister, Lydia, became the first Emmets to study in Paris at the Académie Julian, setting the stage for Bay's subsequent arrival. Rosina painted portraits for the rest of her career, balancing professional demands with the care of her family and, much like Bay would, eventually became the family breadwinner, supporting her five children when her husband, Arthur Sherwood, suffered a major financial loss.[6] Lydia provided another and perhaps even more immediate career model for Bay. Following her trip to Paris in 1885, she continued her studies in New York with Rosina's former teacher, Chase, among other painters at the Art Students League. Lydia progressed from her role as Chase's prized pupil to become his colleague when she was hired as an instructor at his Shinnecock Summer School of Art on Long Island. Bay joined Lydia at the start of her training with Chase at the Art Students League when she was fourteen years old. Three years later, in 1892, she took her cousin's drawing class at Chase's Shinnecock School. Even more impressive, her work that summer earned Bay a position as an illustrator for the newly founded *Vogue* magazine. A year later, she picked up work illustrating for *Harper's Weekly* and *Harper's Bazaar*, demonstrating at an early age her capacity for professional work and earning money for her art. Lydia set an example in this respect by building a career upon a range of fine and decorative arts, including wallpaper, stained-glass window design, mural art, a medal, and a state seal, in addition to her portraits, landscapes, and figure studies. Lydia's connections and example guided Bay when she returned to New York from Paris in 1900 to start her career.

In addition to this professional influence, the Emmets provided one another with emotional and financial support as they made their way through the unfamiliar terrain of study abroad in Paris. For instance, Bay's earliest interactions were eased by the presence of her cousin, Rosina, who accompanied her to dinner with the celebrated sculptor and her future instructor, Frederick MacMonnies, shortly after she arrived in Paris. Managing the expense of what it cost to travel to Paris, pay tuition, and cover room and board made financing study abroad was another matter and became a major test of a young woman's career.[7] When it became clear that Rosina, Lydia, Leslie, and Bay could not all afford to continue studying in Paris in the fall of 1897, they came up with various plans, which included sending Rosina and Leslie home to work and cobbling together a living arrangement in which each might find a cheap place to live. However, Bay insisted that "as long as I have ten fingers" with which to work, she would find a way to support their study and keep them under one roof.[8] They managed to support themselves by creating ways to earn money (for Bay, this meant taking up portrait commissions in England), finding a place they could affordably live together (in the Latin Quarter at 96 Boulevard Montparnasse), and setting up their own informal study group in a borrowed studio with MacMonnies dropping in for weekly critiques.[9] Such creative arrangements sustained Bay's nearly four years in Europe.

Frederick MacMonnies

By the time Bay reached Paris in 1896, Frederick MacMonnies (1863–1937) was one of America's most celebrated sculptors, though he was no means destined to achieve

such fame. Born into a Brooklyn family whose import business was ruined by the Civil War, MacMonnies showed skill in sculpting at a young age, but left school to work several full-time jobs and help support his family. It was not until 1880, at the age of seventeen, that he was sent to work in the studio of Augustus Saint-Gaudens, who was then completing his first major public monument, *Admiral David Glasgow Farragut*, in Madison Square. For the next few years, MacMonnies observed Saint-Gaudens build his career, while taking on increased responsibility around the studio as the sculptor's apprentice and enrolling in classes at the National Academy of Design. By 1884, Saint-Gaudens began preparing MacMonnies for the next phase of his career: study at the École des Beaux-Arts. While his entrance was delayed due to an outbreak of cholera in Paris, MacMonnies passed his exams in 1886 and was accepted into the atelier of Alexandre Falguière. He quickly proved his talent and was hired as an assistant in Falguière's private studio; he also won the *prix d'atelier* in 1887 and 1888, considered a victory for the sculptor personally and for American sculpture more generally. MacMonnies's *Diana* (1889) received an honorable mention at the Salon of 1889 and was followed by four major commissions—*Nathan Hale, James S.T. Stranahan, Pan of Rohallion*, and *Young Faun with Heron*—that set his career in motion. His fame was secured with the success of his *Columbian Fountain* at the 1893 World's Columbian Exposition in Chicago. In 1900, the *Boston Journal* referred to MacMonnies as "perhaps the most famous sculptor in the world today," while the *Brooklyn Eagle* remarked on his productivity, concluding he had already completed a lifetime of work in his relatively short career.[10]

This career trajectory reflects the privilege enjoyed by male artists at the turn of the century, while for aspiring women artists abroad the reality was notably different. For one thing, women were not allowed entrance at the École des Beaux-Arts until 1897. Instead, they studied at the Académies Julian and Colarossi or enrolled in classes for women taught by independent artists. Photographs of the women's class at the Julian show a crowded room of students sketching a live model in a competitive environment. The teacher appeared once a week to publicly critique each student's work before the class, prompting much anticipation and anxiety. While women felt the demands of their training were rigorous, they typically received less feedback than their male counterparts, who received criticism not once but twice weekly; the critiques for female students were also typically less challenging, even patronizing.[11] Rosina and Lydia, who studied at the Académie Julian, complained that there were lower expectations for women's classes. Rosina quipped, "If they criticized conscientiously they would punch holes through some of the vile paintings and make them begin drawing from casts."[12] She clearly resented this double standard. By the late nineteenth century, women had overcome earlier perceptions that they were "lady amateurs," the cultural historian Laura Prieto observes, and were now recognized for their distinct presence as "women artists." However, they continued to inhabit a parallel professional world defined by "beneficent separatism," even as they fought for greater inclusivity.[13] Thus, while they began to be recognized for their work as artists, women were still assumed to exist in a separate realm from men.

Thanks to her cousins, Bay was aware of the limiting environment for women at the Académie Julian when she arrived in Paris in late 1896. Although she was

Figure 2.1 Ellen Emmet Rand in Frederick MacMonnies's Paris studio, *c.* 1899, Emmet family papers, 1792–1989, bulk, 1851–1989. Archives of American Art, Smithsonian Institution.

admitted to Mme. Vitti's Academy for Women, Bay's plans shifted quickly following a serendipitous encounter with the art critic Paul Bion, who saw her work while visiting Saint-Gaudens's niece, Rose Nichols, another resident at 96 Boulevard Montparnasse.[14] Bion immediately recommended Rand to MacMonnies and she went to work in his studio, leaving Mme Vitti's after only one day (Figure 2.1).[15]

MacMonnies had begun teaching as early as the mid-1880s in Brooklyn, but it was only a decade later, in Paris, that he made teaching a priority. Janet Scudder became his first sculpture student after seeing MacMonnies and his *Columbian Fountain* at the Chicago World's Fair, where the young star-struck artist realized "that he was the one—and the only one—that I must study with," she recalled in her autobiography.[16] Soon thereafter, she showed up at his Paris studio and convinced him to take her on as his first pupil. Scudder found that as soon as MacMonnies realized the extent of her commitment to sculpture, "he gave me the most enormous amount of time and attention," she explained, and was never too busy to offer criticism as well as "a practical demonstration of how to design and model."[17] It was a far cry from the feedback Scudder received in her drawing classes at Colarossi's, where the critiques

were breezy and insubstantial. MacMonnies' "interest in each individual pupil," she recalled, was "a revelation to the student who had learned to expect the indifferent glance and cutting remark of the usual instructors."[18]

By 1900, MacMonnies had shifted his focus from sculpture to painting.[19] As he later explained in an interview with Dewitt Lockman, "I was suffering so from indigestion of sculpture and hard work, and scale proportion, and compassing and casting that I had my belly full of it."[20] MacMonnies found painting to be a less taxing medium that left more time for "rest and recreation."[21] He also believed, as he explained to Lockman, "If I have any talent at all, it is for painting."[22] In addition, MacMonnies viewed painting—and portraiture, specifically—as a more lucrative career path, admitting to Lockman that if he had begun painting when he first arrived in Paris, he would "have plenty of money in the bank."[23] Finally, painting offered greater opportunities for teaching given the number of aspiring artists studying in Paris at the time.

This shift in medium proved amply rewarding. MacMonnies taught hundreds of students in Paris over the next decade and became known as "the merrymaker of the crowd" among American women at the Académie Julian in the mid-1880s.[24] The American painter Mary Foote wrote to John Ferguson Weir, Director of the Yale School of Fine Arts, where she was a student starting in 1890, that although she wanted to study with MacMonnies, it would not be easy since "so many girls over here are clamoring" to work with him.[25] According to an 1896 article from the *Chicago Post*, MacMonnies was even the envy of many male students in Paris: he took much longer analyzing the drawings of his female students than the five minutes male students had come to expect, an observation that speaks to MacMonnies's pedagogical approach and perhaps also his reputation among women.[26]

Bay was not simply invited to take one of MacMonnies's classes, but to work with him individually in his studio, where she joined three American male sculptors: Ernest Slade, Paul Conkling, and John Roudebush. Like Scudder, she found him to be a generous teacher. As she wrote to her mother,

> I did not know that it was possible to learn such yards of things about painting and drawing. I am a new person. MacMonnies has not spared himself one bit, as to teaching me. He has taken so much trouble and given so much time to it that I feel a tremendous gratitude to him if ever I can do anything, I should like to associate my success with him because he has taught me so much. He is so nice too.[27]

Working in MacMonnies's studio gave Bay advantages that most art students in Paris—male or female—could only imagine. In addition to the "yards of things about painting and drawing" she learned, she was able to observe firsthand how a successful artist operated his studio and ran a business. He also supported her career by hiring her as an assistant in his studio and by giving Bay and her family free regular critiques when they could not afford tuition at one of the academies.[28] Moreover, Rand became part of MacMonnies's inner circle of family and friends, gaining access to the social networks from which women were typically excluded.

As the art historian Kirsten Swinth explains, the educational and social lives of American women artists in late nineteenth-century Paris were typically segregated by

sex. Living and studying together, women developed a sense of independence from their families and built confidence and skills through their relationships with one another, but they were "excluded as a matter of course" from the "informal gatherings, suppers, and annual honorary dinners [that] brought men and their masters into a shared world of sociability."[29] Bay, however, enjoyed the best of both worlds, living with her cousins, while at the same time socializing with MacMonnies, his family, and his friends. In June 1898, Rosina describes in a letter to Lydia a Saturday evening at the house when "Mr. MacMonnies, Mr. Conkling, Mr. Pomeroy, and Bay and I had a perfect time—just one of our old talks—and I have never known the Patron [MacMonnies] so lovely and vital."[30] Gordon notes that when Stanford White asked MacMonnies to arrange a dinner in honor of Augustus Saint-Gaudens's arrival in Paris, Bay, Rosina, and Jane were all included.[31] In short, the Emmets were an integral part of the male-dominated expatriate community that surrounded MacMonnies in the late 1890s.

Why Bay and her cousins enjoyed this special status is not entirely clear. It certainly helped that they came from a prominent, well-connected family with a notable line of women artists. More importantly, it was apparent to MacMonnies from the start that Bay was a talented and serious artist worthy of his interest. As Janet Scudder observed in her autobiography, once MacMonnies recognized her commitment and "saw that I adored sculpture—as much as he himself did" there was no limit to the attention she enjoyed.

Yet MacMonnies's commitment to Bay was not only professional: he also took a deep personal interest in her and her family. Swinth points out that it was a challenge for turn-of-the-century women as emerging professionals to establish a good working relationship with a male teacher when the power differential often carried an underlying thread of sexual vulnerability.[32] In an effort to avoid the dynamic of seduction, women used the image of a father figure or a family friend as a reference point in their relationships. Ellen Day Hale, for instance, regarded William Morris Hunt as her "artistic father," while Emily Sartain emphasized friendship in her interactions with her teacher Evariste Luminais and his wife.[33]

At times, it seems that Bay and her cousins relied on MacMonnies as a surrogate father figure, as suggested by their nickname for him, "the Patron," and the fact that he stepped in to alleviate the worst of their financial fears as a father might. Yet, in terms of his age—twelve years older than Bay, nine years younger than Rosina—he was more like a brother. For Bay, there were moments in the studio when none of these familial models were particularly relevant, when she seemed to "overcome" her gendered presence and the perceived limitations of being a "woman artist." Working alongside MacMonnies and his male assistants, she was sometimes seen as "one of the boys." Jane wrote to her mother in 1897 that Bay could "pass" as a male artist from MacMonnies's point of view. As she put it, "MacMonnies told me today that he had never seen any man in any school do such good studies as (Bay) and he said ... if he had her another winter and she improved as she had this [winter] she would paint as well as anyone he knew."[34]

At the same time, surviving correspondence suggests that MacMonnies was often keenly aware of Bay's gender and that he was passionately attached to her. As previously

noted, MacMonnies was a charismatic figure who was magnetically drawn to young women artists. He met his first wife, the painter Mary Louise Fairchild, in 1887, while both were students in Paris. They married the following year and enjoyed enviable success in their careers, both exhibiting at the Salon, the Universal Exposition, and receiving commissions for major works at the 1893 World's Columbian Exposition.[35] Yet, as early as 1896, and especially after 1898, there were clear signs of strain in their marriage.[36] Mary spent most of her time at the couple's home in Giverny with their young children, Betty (b. 1896) and Marjorie (b. 1897), and a household staff that allowed her to continue her painting career, while Frederick mostly lived in an apartment in Paris. Shortly after he married, MacMonnies became involved with an American art student, Helen Glenn, after she began taking classes at the Académie Julian; they had a son together in 1897, a few days after MacMonnies's second daughter, Marjorie, was born. Frederick and Mary remained married, though lived essentially separate lives until they divorced in 1909. Soon thereafter, Frederick married a former student named Alice Jones.

Throughout his marriage to Mary, MacMonnies enjoyed intimate relationships with other female students, including Bay. While the details of such relationships are rarely documented in explicit detail, it is hard to imagine from the evidence which does exist that MacMonnies and Bay were not sexually involved. From letters, it is clear he was emotionally attached to Bay and had an almost child-like need to be cared for by her. While she was working in London in the summer of 1899, for example, MacMonnies described his feelings of abandonment, declaring, "when you come back I will be entirely happy and cheerful and good but when I know you are going away I feel so alone and stranded and exactly like an orphanage!"[37] Although MacMonnies had plenty of his own family nearby, including his mother and sister, his wife and two daughters as well as Glenn and their son—making him anything but orphaned—he apparently yearned for the Emmets as a surrogate family. As he wrote to Leslie while she was in England with Bay and Leslie's mother, "My eyes are choked with tears when I think of you. I have seen no lady since you left who can touch you in either carriage or profile ... I am longing to see you all."[38] In another letter to Leslie, MacMonnies writes, "I am simply dying of lonesomeness and homesickness for you and your family." But his most intense feelings were reserved for Bay. In the same letter, he writes, "Tell your Mama that she has no idea how much more rooted I am to her darling Bay I am and how absolutely unworthy of her I realize myself," suggesting that the family had reason to think MacMonnies did not deserve Bay's affection. Continuing in this apologetic vein, he insists, "I love her a million times more than ever, and all the beauties of 20 centuries."[39] Bay's friend, the painter Mary Foote, confirmed in a letter that with Bay's departure MacMonnies had "niched you on a pedestal as a Perfection lost and forever missed" and nothing would "let you pan out of his mind," as he was constantly occupied with her presence.[40]

Two pairs of portraits—one pair painted by Bay of MacMonnies, the other painted by MacMonnies of Bay—convey the sense of playful and flirtatious banter these artists shared at the height of their relationship. In 1898–1899, Bay painted MacMonnies in his studio, twice: the first shows him at an oblique angle from behind, painting his portrait

of Rand (Plate 3); in the second, he appears seated in the same wooden chair, adjacent to a dark pink upholstered chair visible in both portraits, and wearing the same tan jacket and crisp white shirt (Plate 4). MacMonnies's pose in the second example shows the artist in a three-quarter view at rest, perhaps admiring the recently completed portrait, though the object of his gaze cannot be seen. It is an unusual and elegant pose that captures the artist's fine features and lively disposition. The similarities between these portraits suggest an almost cinematic treatment of MacMonnies in his studio seen from different vantage points at roughly the same point in time.

This sense of a twinned pair of portraits is even stronger in MacMonnies's paintings of Bay, *Portrait of Bay Emmet at Her Easel* (Plate 5) and *Standing Artist at Her Easel* (1898–1899), which depict her in a half-length, three-quarter view, working on an unseen canvas from behind. In both, she wears the same clothing, the same hairstyle, and presumably paints the same canvas. She may be painting MacMonnies, although the subject is not clear.[41] In each of these pairs, we get a semi-frontal portrait of the artist and an accompanying similar posterior view of the painter at work.[42] MacMonnies introduces another dimension to this pair of paintings by depicting Rand in a third portrait, *Smiling Artist at Her Easel* (1898–1899), which is almost identical to *Portrait of Bay Emmet at Her Easel*, though it depicts a slightly older and heavier version of the artist. This third rendering thereby expands the element of time implicit in these paired portraits and perhaps suggests that a portrait can predict the future in addition to capturing complementary views of the present.

The exchange of portraits speaks to the sense of reciprocity in their dynamic, which from the start seems to have had more at stake than a traditional teacher–student relationship. Yet MacMonnies—as a popular instructor and an established artist—was the one with power over Bay and the capacity to significantly impact her career. (The same could not be said of Bay's ability to influence her teacher's reputation.) While MacMonnies was instrumental in launching her as a professional painter through one-on-one instruction and critique, by hiring her as his studio assistant, and by integrating her into his professional and personal networks, his life remained tethered to Mary, Helen, and three young children. It is not clear what exactly transpired between MacMonnies and Bay in the summer of 1900, but there was some sort of traumatic incident that forced her to abruptly leave Paris—and MacMonnies. As she explained to her mother, "Much as I worship and adore the entire atmosphere that encircles the life here, I am useless & only render someone else useless, whose time is very precious, & I have more moral sense than to prolong it any longer."[43] MacMonnies had played such an integral role in Bay's nearly four years of study that it was impossible to separate her experience in Paris from her relationship with him. Yet, even before her traumatic split with MacMonnies, Bay had already expressed a desire to come home and create a different kind of life. In 1898, she wrote to Lydia, "I would like to come back and make enough on portraits to purchase a remote and inexpensive small farm somewhere off in the country—where we could all live and in the winter we could go back to N.Y. and collect more ducats and go back again."[44] While Bay left Paris emotionally devastated, as further discussed below, she had worked hard throughout her training and was well poised to begin a professional career at home.

Henry James

Before setting sail for America, however, Bay had some unfinished business to address with her cousin, the author and critic Henry James (1843–1916), at his home in Rye, England. James had asked Bay to paint his portrait, but could not have anticipated the emotionally charged conditions in which the writer and painter found themselves—under different circumstances and for unrelated reasons—when she arrived to fulfill the commission.

James was one of Bay's strongest early supporters. In 1893, a few years before the two met, he saw the woodcuts she made as a teenager and pronounced them "full of promise," declaring, "she ought to have the best opportunities."[45] Their relationship developed through letters and regular visits during her four years in Europe, especially when she was painting portraits in England through commissions James helped her secure. He also promoted Bay's work to his friend, John Singer Sargent, who apparently told the writer that she had more talent than any other artist her age he had ever seen.[46] When Henry and Bay visited Sargent's London studio in April 1898, the celebrated painter regretted that she did not finish the portrait of her English cousin, Stanley Clarke, in time for the annual Royal Academy exhibition, since Sargent was on the selection committee and would have liked to support her work. More generally, Bay looked to James as a fellow artist who could empathize with the challenges of creative work. As Leslie once observed, a young artist could show him even the "worst" works in her studio, realizing that he "is so absolutely knowing and comprehensive and appreciates the difficulties attached."[47]

James also lovingly championed the rest of the "Emmetry" and was generous with his support. He once surprised Rosina by responding to one of her stories with twelve pages of "advice and admonitions," providing her with welcome, detailed feedback.[48] At other times, he treated the Emmets like characters in his fiction: unrefined Americans who were ill-prepared to navigate European culture. Jane wrote to her mother in 1897 that their cousin was "the nicest thing, but what a mental epicure." He was "horrified" by their accents and "I am afraid our voices and sentences hurt his eardrums," she explained.[49] It became a common refrain among the Emmets to wonder out loud, "What would Cousin Henry think?" as a test for gauging their behavior, though they found his habits peculiar and took his comments with a healthy dose of humor.

Rand completed not one but two portraits of James, though for decades only one of them was thought to exist (Plate 6 and Figure 2.2). The known portrait hung in James's dining room from the time it was completed until his death in 1916. He never considered it a strong likeness and referred to it jokingly as "the smooth and anxious clerical gentleman in the spotted necktie."[50] Yet he considered it a memento of Bay's time at Lamb House, his home in Rye, England, telling her it "reminds me of our so genial, roasting romantic summer-before-last here together, when we took grassy walks at even-tide, and in the sunset, after each afternoon's repainting."[51] The painting was given to James's biographer, Leon Edel, by his descendants sometime between 1953 and 1963.[52] When Edel took the portrait to be cleaned, restorers found a second, unfinished portrait of James on an identically sized canvas beneath the first. This more

Figure 2.2 Ellen Emmet Rand, *Henry James*, 1900, oil on canvas, 22 × 16 ⅜″, National Portrait Gallery, Smithsonian Institution. Gift of Marjorie Edel in memory of Leon Edel.

recently discovered rendering of James is often referred to as a sketch, since it is clearly the less finished of the two. It seems, however, that the concealed portrait is not so much a preparatory work for the portrait James ultimately displayed in his home as it is a "shadow portrait." This shadow portrait should be viewed as a different version of the writer, an unflattering alter ego, of sorts, layered beneath a self-image of the author that he displayed on the walls of his home.

The finished portrait presents James as a serious, if somber, writer with a pair of pince-nez casually suspended from his right hand. He is depicted as a confident, self-possessed man who commands the space he is in. The shadow portrait presents a far more raw and vulnerable image of James as a slump-shouldered, ruddy-faced figure with vacant, watery eyes. Edel observed that the color in this version, "especially of the nose, resembled that of James's alcoholic butler rather than the abstemious novelist."[53] However, this image of James may have corresponded with the version Bay knew during her stay at Lamb House. Just as he was about to begin posing for the portrait,

James was "laid low for a couple of days, with an attack I should say of the stomach," Bay explained in a letter to her family, while she watched and waited, doing what she could to aid in his recovery.[54] This was an ironic turn of events, given that the fifty-six-year-old author had invited Bay to paint his portrait at a transitional moment in his career when he was feeling years younger—as he put it, "*forty* and clear and light."[55] That spring, James shaved the beard that "had hidden his face since the days of the Civil War," Edel writes, and with it rid himself of an old identity.[56] When Bay arrived in Rye, she was not sure she liked James without his beard, but as she wrote to Leslie,

> He says he is a different person to himself. I can see that he is. He enjoys himself much more than before, enjoys his looks. I discern that he is as vain as anybody he is perhaps handsomer than before, and in his hat, he really looks much younger, but he is really in a way, like another sort of person.[57]

The summer of 1900 was also when James was writing *The Sacred Fount*, a novel Edel describes as a form of "self-therapy" in which the writer sorted through the issues of loneliness and age that had preoccupied him at Lamb House.[58] It examines how the psychological weight of relationships takes its toll, exacting consequences that may not be visible, but are no less damaging by not being seen. Through the narrator, James takes interest in the vagaries of perception, acknowledging that we arrive at meaning through an accumulation of impressions leading to one set of assumptions, though the same impressions might lead to an entirely different meaning, too. As Edel observes, *The Sacred Fount* questions what the narrator is able to see and how much he reads into what he thinks he sees.[59] We can read this as a foil for James's own investigations into the limits of the intellect and the role of the emotions and passions in interpreting experience. As Edel observes, writing this book aided James in stepping out of his egoic "palace of thought" and cleared a space from which to write his late novels with greater human warmth.[60] This openness comes through in his correspondences as well: "he is less distant, looser, less formal. He writes with more emotional freedom," Edel explains.[61] It was an occasion for a portrait as James established a new rhythm in new skin.

Long before he posed for Bay, James had found portraiture useful as a literary concept.[62] In *Portrait of a Lady* (1881, rev. 1908), the story develops through words around a single character, Isabel Archer, in much the same way a portraitist renders a sitter through the layering of paint.[63] Most relevant here is the way this process changes over time, between the author's original text and its revision over two decades later. Not unlike Bay's finished portrait of James, in which the writer appears more fully fleshed out as a complex psychological subject than in the view we get in the more recently unearthed version, Archer is a more layered three-dimensional figure in James's revised text. The literary critic Lyall H. Powers points out that James's language moves inward and becomes more probing in the later version, which was written near the end of his career. For instance, a passage from 1881 original *Portrait of a Lady* reads, rather vaguely, "But though she could conceive the impulse, she could not let it operate; her imagination was charmed, but it was not led captive." The same line in the 1908 revision becomes, "But though she was lost in admiration of her opportunity she

managed to move back into the deepest shade of it, even as some wild, caught creature in a vast cage. The 'splendid' security so offered her was *not* the greatest she could conceive."[64] These changes move the reader further into Isabel's consciousness, making the novel not simply about her, but about her relationship to herself.[65] Something similar happens with Rand's far more psychologically engaging, finished portrait of James as compared to its companion version in which the viewer looks upon—but not into—the writer. The latter keeps the viewer's gaze on the surface of the canvas by emphasizing the disparities between mottled patches of flesh on James's forehead, for instance, and the crimson coloring of his nose, left cheek, and ear. The same face in the finished portrait is less about eye-catching color contrasts than finely calibrated tones that subtly cohere into an integrated whole. At the same time, in the finished portrait, nearly half of James's face is cast in shadow, lending the painting an air of inscrutability that shifts the focus from the surface of the painting to the writer's interior world. Captured mid-thought, with his pince-nez in hand, James is thoroughly absorbed in a contemplative state, detached from the material realm.

The finished portrait perhaps corresponds to Rand's experience of her cousin on this visit, when she observed that the lifelong bachelor was "so accustomed to express his thoughts, unanswered, that it is rather unnatural to him to listen, so I assume the attitude of the typewriter after giving him a header and he talks and talks."[66] She approached her sitter in these terms: as the bachelor writer who lived in his own thoughts and from whom she remained emotionally detached, at least on this particular visit. Perhaps this is why the rougher—and presumably original—version suggests little connection between Rand and her cousin. Instead, she captures the atmosphere at Lamb House in summer 1900 while James was working through his own physical and psychological concerns and Bay waited patiently for him to recover. In the meantime, she passed the time by reading and otherwise "keep[ing] by myself as much as I can," as Bay put it, to avoid disturbing the writer's routine.[67]

This sense of separation between painter and sitter may also reflect Bay's own frame of mind on the heels of her sudden departure from Paris for Lamb House. She wrote to her mother that she would be coming home "the minute I finish Cousin Henry" and she was "even now crazy to go." "Nothing," she continued defiantly, "would induce me to stay here [in Europe] longer."[68] Compared to what she now described as the "asylum for seething passion" in Paris, it was a relief to be absorbed into the domestic rhythms of Lamb House, even as Bay found herself emotionally numb, lacking "any wants or desire, or particular ambitions," and feeling much "like a plaster cast."[69] Under the circumstances, her portrait of James began to feel like an obstacle, the thing she needed to complete in order to return home. Given her cousin's health, she had plenty of time to plan the painting and expected it to "drop off finished like ripened fruit" once she began; however, as we know, her initial effort was not her last.[70] At one point, she wrote to Leslie that she planned to finish "one of the two of H.J. before Wednesday" and, in an unusual boast of confidence, she described it as "the best thing I have painted."[71] Yet in a subsequent letter she called it a passably "jog trot portrait," which she completed only in 1902 on a return trip to England.[72] It seems the circumstances that summer made it difficult to paint the version of James that would appeal to the writer's renewed sense of self and to Rand's understanding of her accomplished, yet idiosyncratic, cousin. The

later portrait displaced the slump-shouldered, red-nosed version of James with one that more closely approximated the image of a self-possessed writer at the height of his powers, one that he displayed in his home until his death.

James remained one of Bay's biggest fans. In response to a letter from Leslie about Bay's latest accomplishments in New York, he replied, "I am delighted with everything you say about her, and I gloat over all her engagements and successes. May she drive all these sharply home and really clinch her reputation."[73] But unlike her cousin—or her teacher, MacMonnies—Bay had little interest in spending her career among American expatriates in Europe. Her vision for the future centered on a "remote and inexpensive small farm somewhere off in the country" but close enough to New York City to make a career in portrait painting. The modesty of her vision belies the fact that she became one of the most financially successful portrait painters in early twentieth-century America.[74] Persistent hard work, steely determination, and the support of the talented and prominent Emmet women of her generation created the ground for Bay's success. Yet in a male-dominated art world, women gained access to the inner circles of power through their contact with influential men. Bay realized this when she arrived in Paris and quickly found her footing. She lasted but a day in the women's academy before starting in MacMonnies' studio, where she found a supportive mentor and teacher, though he was emotionally damaging, too. From Bay's arrival, MacMonnies opened the way for her immersion into a rich artistic milieu that put her in touch with the "best opportunities" of the sort James imagined when he first viewed her work. Like MacMonnies, James also played a critical role in Bay's early career by bringing her into his network of artists and patrons and by encouraging her talent, even commissioning his own portrait. None of this would have mattered much if it were not for Bay's talent, which was immediately apparent to both of these men. Though neither acted in an entirely selfless manner, they recognized her strengths and threw their weight behind her career.

Notes

1 Thanks to Emily Burns for her help in tracking down Rand family letters and to Alexis Boylan for her tireless and extraordinary efforts in planning, organizing, and editing this volume. Ellen Emmet Rand would be proud.

2 On late nineteenth-century American artists in Paris, see Laurence Madeline, Bridget Alsdorf, Richard Kendall et al., *Women Artists in Paris: 1850–1900* (New York: American Federation of Arts; New Haven: Yale University Press, 2017); *Foreign Artists and Communities in Modern Paris, 1870–1914: Strangers in Paradise*, eds. Karen L. Carter and Susan Waller (Surrey, England: Ashgate, 2015); Kathleen Adler, Erica E. Hirschler, and H. Barbara Weinberg et al., *Americans in Paris, 1860–1900* (London: National Gallery Company Limited, 2006); Gabriel P. Weisberg and Jane R. Becker, *Overcoming all Obstacles: The Women of the Académie Julian* (New York: Dahesh Museum, 1999); H. Barbara Weinberg, *The Lure of Paris: Nineteenth-Century American Painters and Their French Teachers* (New York: Abbeville Press

Publishers, 1991); and Lois Marie Fink, *American Art at the Nineteenth-Century Paris Salons* (Washington, DC: National Museum of American Art, Smithsonian Institution, 1990).

3 Tara Leigh Tappert, *The Emmets: A Generation of Gifted Women* (New York: Borghi & Co., 1993), 4.

4 Ibid., 4–5.

5 Amelia Peck and Carol Irish, *Candace Wheeler: The Art and Enterprise of American Design, 1875–1900* (New York: The Metropolitan Museum of Art with Yale University Press, 2001), 178.

6 In addition to Tappert, for more on Rosina, see Martha J. Hoppin, *The Emmets: A Family of Women Painters* (Pittsfield, MA: Berkshire Museum, 1982) and Charlene G. Garfinkle, "Women at Work: The Design and Decoration of the Woman's Building at the 1893 World's Columbian Exposition: Architecture, Exterior Sculpture, Stained Glass, and Interior Murals" (PhD diss., University of Michigan, 1996).

7 For women, the cost of study in Paris was often higher than it was for men as the independent academies charged tuition—unlike the École, which was free. In addition, the more respectable neighborhoods in which women found housing were generally more expensive than the run-down and even dangerous places male students lived. Erica E. Hirshler, *A Studio of Her Own: Women Artists in Boston, 1870–1940* (Boston: Museum of Fine Arts, 2001), 76.

8 Letter dated October 1897, Emmet Family Papers, Archives of American Art, Smithsonian Institution (Emmet Family, AAA) Box 5, Folder 19.

9 MacMonnies's weekly critiques are mentioned in a letter from Ellen Emmet to Jane Emmet, "You must think that I am an indifferent chimp," Emmet-Rand Family Personal Papers, courtesy of Felicia Garcia-Rivera. Cited also in Ellen E. Rand, *Dear Females* (New York: Ellen E. Rand, 2009), 59.

10 The best single source on MacMonnies's life and career is Mary Smart, *A Flight with Fame: The Life and Art of Frederick MacMonnies* (Madison, CT: Sound View Press, 1996). For press clippings from the *Boston Journal*, the *Brooklyn Eagle*, and other publications, see MacMonnies's scrapbook, Frederick William MacMonnies papers, Archives of American Art, Smithsonian Institution, Reel D245, Frames 1–207.

11 Kirsten Swinth, *Painting Professionals: Women Artists and the Development of Modern American Art, 1870–1930* (Chapel Hill: University of North Carolina Press, 2001), 49.

12 Rosina Emmet Sherwood to Julia Emmet, Emmet Family, AAA, Undated, but circa late 1884, Box 5, Folder 36, Frame 39.

13 Laura R. Prieto, *At Home in the Studio: The Professionalization of Women Artists in America* (Cambridge, MA: Harvard University Press, 2001), 109.

14 Jane Emmet to Lydia Emmet, Undated, but circa February 1897, Emmet Family, AAA, Box 4, Folder 27, Frame 6.

15 Ibid.

16 Janet Scudder, *Modeling My Life* (New York: Harcourt, Brace and Co., 1925), 63.

17 Ibid., 83.

18 Quoted in Smart, *A Flight with Fame*, 157. Orig. Janet Scudder, "The Art Student in Paris," *Metropolitan* 5, no. 3 (April 1897), 242.

19 Art historian E. Adina Gordon believes the seeds of this change came earlier, between 1896 and 1897, when MacMonnies was at the height of his career, not later in response to the exhausting demands of sculpture. See her essay "The Expansion of a Career: Frederick MacMonnies as a Teacher and a Painter," in *An Interlude in Giverny,* eds. Joyce Henri Robinson and Derrick R. Cartwright (University Park,

PA: The Pennsylvania State University and Palmer Museum of Art; Musée d'Art Américain Giverny and Terra Foundation for the Arts, Giverny, France, 2000), 59.

20 Dewitt M. Lockman interview with Frederick MacMonnies, 1927, Box 3, folder 3, Mary Smart research files, Frederick William MacMonnies papers, Archives of American Art, Smithsonian Institution.

21 Robinson and Cartwright, *An Interlude in Giverny*, 10.

22 Lockman interview with MacMonnies, Archives of American Art, Box 3, Folder 3.

23 Ibid. In a 1901 letter to Stanford White, MacMonnies indicated that sculpture was something he would return to once he had made enough money as a painter. Cited in Robinson and Cartwright, *An Interlude in Giverny*, 10.

24 For "merrymaker of the crowd" quote, see Smart, *A Flight with Fame*, 62. Orig. Lorado Taft, "Fredk. MacMonnies," *Chicago Inter-Ocean* (September 1, 1895): 3. Scudder convinced MacMonnies to give a small group of students private weekly criticisms beginning in spring 1894. He also taught hundreds of women artists at the Académie Vitti, opened by the artist's model, Madame Vitti, in response to the number of women in Paris eager for art instruction. In 1898, MacMonnies opened a short-lived school with James McNeil Whistler—the Académie Whistler—under the direction of another model, Carmen Rossi. See Gordon, "Expansion of a Career," 62–4.

25 Gordon, "Expansion of a Career," 71.

26 Hildegard Cummings, *Good Company: Portraits by Ellen Emmet Rand* (Storrs, CT: William Benton Museum of Art, 1984), 5. There was a thin line dividing MacMonnies's pursuit of beauty in art and his more libidinal interests in women. In 1901, he created a minor scandal in Paris when he and another artist invited several American women to appear in states of undress as fairies and nymphs for a tableaux vivant to be performed for an American Art Association of Paris (AAUP) event. The women refused to cooperate and walked out of a rehearsal indignant in an episode that was widely reported in the American press. See MacMonnies papers, AAA, reel D245, frames 55–6.

27 Ellen Emmet to Ellen Temple Hunter, "I got your cable at about one o'clock," Emmet-Rand Family Personal Papers, courtesy of Felicia Garcia-Rivera. Cited also in Rand, *Dear Females*, 42.

28 The details of their dire financial situation come through in letters exchanged between Bay, Leslie, and Lydia in the fall of 1897 when an expected source of money—the Gourley money—did not materialize and Rosina, Leslie and Bay were all living in Paris. See Bay to Lydia, September 1897; Leslie to Lydia, September 1897; and Bay to Lydia(?), October 1897, all in Emmet-Rand Family Personal Papers, courtesy of Felicia Garcia-Rivera. Cited also in Rand, *Dear Females*, 56–7.

29 Swinth, *Painting Professionals*, 59.

30 Rosina Emmet to Lydia Emmet, June 1897, Emmet Family, AAA, Box 4, Folder 16.

31 Gordon, "Expansion of a Career," 67.

32 Swinth, *Painting Professionals*, 48.

33 Ibid.

34 Jane Emmet to Lydia Emmet, May 24, 1897, Emmet Family Papers, AAA, Box 4, Folder 30.

35 Mary Fairchild MacMonnies (later Low) is another example of a strong, professionally minded American artist who successfully negotiated the challenges of establishing her career as a woman artist in late nineteenth-century Paris. Unlike Bay, Mary enjoyed financial security during her studies thanks to a generous three-year scholarship from

Washington University, though she lacked access to the male-dominated networks Bay joined when she arrived in Paris. For both women, Frederick MacMonnies was a catalytic figure who helped propel their careers forward, though Mary maintained clear professional boundaries, keeping her career trajectory separate from her husband's by basing her practice at her studio and home outside Paris in Giverny. This undoubtedly helped her to create her own artistic identity. For recent scholarship on Mary's career, see Derek R. Cartwright, "Beyond the Nursery: The Public Careers and Private Spheres of Mary Fairchild MacMonnies Low," in *An Interlude in Giverny*, eds. Joyce Henri Robinson and Derrick R. Cartwright (University Park, PA: The Pennsylvania State University and Palmer Museum of Art; Musée d'Art Américain Giverny and Terra Foundation for the Arts, Giverny, France, 2000), 34–53 and Kirstin Ringelberg, "'The Painter Will Not Sink into the Mother': Mary Fairchild's Nursery/ Studio," in *Redefining Gender in American Impressionist Studio Paintings: Work Place/ Domestic Space* (Surrey, England: Ashgate, 2010), 73–115.

36 Bay wrote to Lydia in 1898, "I realize what an impossible marriage he [MacMonnies] has made. Don't let what I have said get about although it is an open secret for anyone who chooses to watch it all." Ellen Emmet to Lydia Field Emmet, September 18, 1898, Emmet Family Papers, AAA, Box 5, Folder 20, Frame 7.

37 MacMonnies to Ellen Emmet, "I have just dined with Scudder and your Mama and Leslie," Emmet-Rand Family Personal Papers, courtesy of Felicia Garcia-Rivera. Cited also in Rand, *Dear Females*, 93.

38 MacMonnies to Ellen Emmet, September 1899, Emmet-Rand Family Personal Papers, courtesy of Felicia Garcia-Rivera. Cited also in Rand, *Dear Females*, 94.

39 Emmet-Rand Family Personal Papers, courtesy of Felicia Garcia-Rivera. Cited also in Rand, *Dear Females*, 113.

40 Emmet-Rand Family Personal Papers, courtesy of Felicia Garcia-Rivera. Cited also in Rand, *Dear Females*, 113. Foote was another MacMonnies's students with whom he seems to have been romantically involved, though Smart believes that while he was "extremely fond" of her, his letters to Foote did not "contain the declarations of love that characterize his earlier correspondence with Helen Glenn and connote something more along the lines of 'happy intimacy'" Smart, *A Flight with Fame*, 204–5. However, in the same letter describing MacMonnies's pining for Bay, Foote writes that in Bay's absence he was now coming to see her several times a week, indicating his emotional and presumably physical needs had shifted to another of his talented American students.

41 Smart, *A Flight with Fame*, 319.

42 In this respect, MacMonnies's portrait of Bay is an exception. According to Bridget Alsdorf, on occasions when women artists were painted by men, they were rarely depicted as engaged in their craft. See her essay in Madeline et al., *Women Artists in Paris*, 30.

43 Ellen Emmet to Ellen Temple Hunter, undated letter, Emmet-Rand Family Personal Papers, courtesy of Felicia Garcia-Rivera. Cited also in Rand, *Dear Females*, 103.

44 Ellen Emmet to Lydia Field Emmet, September 18, 1898, Emmet Family Papers, AAA, Box 5, Folder 20, Frames 7–8.

45 Henry James to Rosina Emmet, 21 June 1893, Emmet Family, AAA, Box 6, Folder 29.

46 Cummings, *Good Company*, 4. Rand's initial meeting with Sargent took place late in 1896 through an introductory letter that she brought with her to London from the architect Charles McKim, a family friend.

47 Leslie Emmet to Ellen Emmet, "Cousin Henry has at last turned up," undated letter, Emmet-Rand Family Personal Papers, courtesy of Felicia Garcia-Rivera. Cited also in Rand, *Dear Females*, 91.

48 Leslie Emmet to Rosina Emmet, January 1897, Emmet-Rand Family Personal Papers, courtesy of Felicia Garcia-Rivera. Cited also in Rand, *Dear Females,* 39.

49 Jane Emmet to Lydia Emmet, August 6, 1897, Emmet Papers, AAA, Box 4, Folder 31.

50 Leon Edel, *Henry James, the Master, 1901–1916* (Philadelphia: Lippincott, 1972), 69.

51 Ibid.

52 Curatorial file on Rand's finished portrait of James, National Portrait Gallery, Smithsonian Institution.

53 Edel, *Henry James, the Master*, 69.

54 Rand, *Dear Females,* 107.

55 Leon Edel, *Henry James: A Life* (New York: Harper & Row, 1985), 513.

56 Ibid.

57 Leslie Emmet to Ellen Emmet, undated letter, Emmet-Rand Family Personal Papers, courtesy of Felicia Garcia-Rivera. Cited also in Rand, *Dear Females,* 104.

58 Edel, *Henry James: A Life*, 509.

59 Ibid., 508.

60 Ibid., 513, 509.

61 Ibid., 513.

62 On the relationship between James and American art, see Colm Tóibín, Marc Simpson and Declan Kiely, *Henry James and American Painting* (University Park: The Pennsylvania State University Press; New York: The Morgan Library and Museum, 2017).

63 Archer was modeled on Minny Temple, who was the first cousin of Bay's mother, Elly. James was close to her and when she died at twenty-three, it came as a major blow to the writer. She also inspired his character Milly Theale in *Wings of the Dove*.

64 Lyall H. Powers, *The Portrait of a Lady: Maiden, Woman, and Heroine* (Boston: G.K. Hall & Co., 1991), 21–2.

65 Ibid., 24.

66 Ellen Emmet to Leslie Emmet, "I got no letter today," undated letter, Emmet-Rand Family Personal Papers, courtesy of Felicia Garcia-Rivera. Cited also in Rand, *Dear Females,* 106.

67 Ibid.

68 Ellen Emmet to Ellen Temple Hunter, undated letter, Emmet-Rand Family Personal Papers, courtesy of Felicia Garcia-Rivera. Cited also in Rand, *Dear Females,* 102.

69 Emmet-Rand Family Personal Papers, courtesy of Felicia Garcia-Rivera. Cited also in Rand, *Dear Females,* 106.

70 Henry James to Mrs. Posie Sherwood, June 21, 1893, Emmet Papers, AAA, Box 6, Folder 29.

71 Ellen Emmet to Leslie Emmet, undated letter, "I am in bed so if written badly," Emmet-Rand Family Personal Papers, courtesy of Felicia Garcia-Rivera. Cited also in Rand, *Dear Females,* 109. Based on this letter, the finished version of the portrait should have a completion date of 1902.

72 Rand, *Dear Females*, 125.

73 Henry James to Ellen Emmet, January 1900, "I have delayed more days." Cited also in Rand, *Dear Females,* 120.

74 Cummings, *Good Company*, 9.

People, Places, Prizes, and Prices

Susan Spiggle

Periodically, Ellen Emmet Rand's financial manager, J.R. Swan, would reach out with grim updates, "your worldly wealth is $16,984.26 minus $2000 for a note you have signed" and then too with stern warnings, "It is important that you should have a nest egg and it has been growing smaller all the time."[1] Rand was, during her lifetime, one of America's most renowned and well-paid portrait artists. Yet, as the above missives from her financial advisor in the 1930s suggest, she was financially constrained. She was prolific in her output and painted many famous, wealthy, and well-connected people from a wide geographic area during her forty-one-year career in the United States. Well-connected socially and living in the Northeast megalopolis with a studio in New York City from 1900 to 1941, Rand painted many socially prominent subjects.

In this chapter, I will analyze Rand's career trajectory and its monetary outcome using a different analytical perspective than is usual in art history investigations. With quantitative data, I explore success, earnings, and marketing of Rand's career and employ analyses that economists and marketing scholars might use to consider value, success, earnings, and promotional activities. Specifically, I investigate (1) the social and geographic distribution of her portrait clients over time, (2) her validation by the art establishment (prizes, exhibitions, critical acclaim) and general renown, and (3) the prices she commanded for her portraits—her financial success. This analytical framework permits one to make comparisons across a single portrait artist over time. It could be useful in comparing multiple portrait artists over time and/or different geographic areas, allowing researchers to answer questions about individual versus collective forces shaping art prices.

The Social and Geographic Distribution of Rand's Portrait Clients

For portrait artists, two characteristics of their clients—their geographic locations and their social preeminence—both shape and reflect the artists' career trajectories. Geographic location represents a horizontal dimension that captures spatial and geographic distance. Social preeminence represents a vertical dimension, a hierarchy in which some clients enjoy higher status and regard than others, reflecting social distance. I use these two dimensions to analyze Rand's clients over time.

To explore the social and geographic distribution of Rand's portrait clients, I started with the more than 800 works compiled by Emily Mazzola in 2016 in the Ellen Emmet Rand catalogue raisonné and other archival material.[2] From these resources, I selected all of the paintings for which there is a non-duplicated, *identified* client, or sitter, versus a landscape, or generic label such as "Woman with Peonies." I collected data on this set of approximately 600 portraits, searching for the primary geographic location and the social prominence of the clients largely through Google searches, supplemented by letters and news clippings in the Ellen Emmet Rand Papers, Special Collections, University of Connecticut Library. Of the 600 identified portrait clients, I was able to find geographic and social information on 336 of them. Of these 336 clients, the catalogue raisonné provides dates of the painting for 213 portraits; another 123 portraits are listed as "date unknown," although there are labels such as before 1906. I used the 213 dated portraits to analyze the stability/change in Rand's clients over time and included the undated ones in the description of her clients in total. Over her career the number of portraits that Rand painted fluctuated considerably, declining during the years of her marriage to William Blanchard Rand in 1911 and following the birth of her three sons. An increase followed this 1915–1919 though, falling again before reaching her peak portrait production in 1935–1939 of sixty-two portraits. During the last two years of her career she painted twenty-five portraits that would have rivaled her most productive period (1935–1939) had she lived and continued painting at the same rate.

I divided the 213 dated portraits into five-year time blocks—1900–1904, 1905–1909, 1910–1914, 1915–1919, 1920–1924, 1925–1929, 1930–1934, 1935–1939, 1940–1941. The number of portraits and the social and geographic distribution of clients varied across time. Both macroenvironmental forces—for example, the stock market crash and Great Depression in the late 1920s and 1930s—and personal factors—marriage and child rearing in the 1910s—appear to have impacted the number of portraits and the consequent distribution of clients. This analysis, however, focuses on the extent to which the early social and geographic distribution of her clients shaped her access to clients in subsequent periods.

Geographic Distribution: The Horizontal Dimension

The geographic distribution of portrait clients represents the horizontal dimension. Broad spatial distribution may reflect two artist attributes, their reputation, and their access to sitters of greater social prominence. Artists' reputations, through word-of-mouth and media coverage, enable them to reach clients in further geographic locations; as their reputations grow beyond local, regional, and national boundaries, they have access to more distant clients, further increasing their reputation. This geographic diffusion may further propel their access to clients. In addition to the breadth of geographic distribution, acquiring clients in specific geographic locales—in metropolitan areas with business, political, academic, literary, and other elites—provides access to elite clients in other geographic locations. Elites circulate

geographically, rather than vertically. Thus, they are more likely to circulate with other elites in distant locales, than with local non-elites.

Determining the geographic location of the clients was relatively straightforward. Although some sitters moved, most were residentially stable, and information was readily available. For those who moved around, I designated their geographic location as that of the primary location where they lived and networked. If there were no identifiable primary location, I designated them in the category of "Other," which includes multiple locations and unknown. I assigned portrait clients into one of five categories—(1) New York City and environs (where Rand kept a studio from 1900 until her death in 1941); (2) Salisbury, Connecticut, and environs (where Rand's family lived and she spent much time, especially summers); (3) other Connecticut, Massachusetts, Rhode Island, and Vermont locations; (4) Chicago and Washington, DC; and (5) Other.

Chart 1 (Figure 3.1) displays the geographic distribution of all 336 identified Rand portrait clients. The largest number of her clients were located in New York City and environs (41 percent), followed by the approximately combined equal numbers in Other (22 percent) and Connecticut, Massachusetts, Rhode Island, and Vermont (21 percent), with Salisbury, Connecticut, and environs (8 percent), with Chicago and Washington, DC (5 percent) the smallest. With her studio in New York and a large number of potential clients, the dominance of New York is understandable. Proximity explains the Salisbury, Connecticut, and other southern New England and Vermont locations. The western Connecticut and New York City areas formed the primary portrait corridor for Rand.

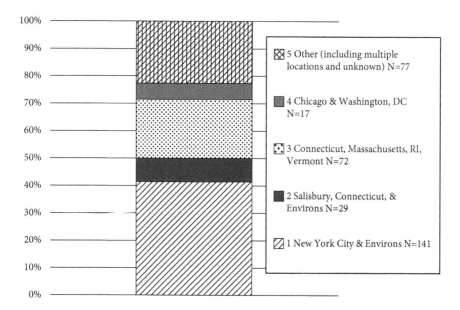

Figure 3.1 Chart 1, Geographic Distribution of Portrait Sitters.

Considering the geographic distribution of her clients over time, one might expect that portrait artists with a preeminent clientele (as Rand had) would continuously expand their geographic range of clients over time as their reputations grow and spread; prominent clients are networked with those of similar status in wider geographic areas. We do not, however, observe an ever-widening geographic distribution of Rand's portrait clients over time. Looking at the geographic distribution of Rand's portrait clientele across the nine time periods (see Figures 3.2 and 3.3), we observe considerable variation in the dominance of New York City and environs, as well as the proportions of other locations.

Over time the proportion of New York City clients exhibits a double-wave form, starting low, rising to a peak in the 1915–1919 period, then falling and remaining low for the last three time periods of her career (Figure 3.3). This pattern is especially interesting, as New York was the growing center of business, art, and finance in the United States during her career. Clientele in Salisbury, Connecticut, and surrounding towns also exhibits another notable pattern, starting as a small proportion early, then rising during her mid-career, to fall during the last three periods. She painted no one in her Connecticut locale during 1910–1914 and 1925–1929. Her marriage and raising of three children, who lived in Salisbury, likely accounts for the higher proportion in the 1915–1924 period; Salisbury clients likely filled in for the decline of New York clients during this period (some commissioned, and, as noted in Harris and Pfeiffer's chapters in this volume, some likely produced in exchange for goods and services). Also, Rand painted the fewest portraits in the 1910–1914 and 1915–1919 periods. She did exhibit widely during this period, however, and received her most prestigious award (the 1915 Panama Exposition Gold Medal, for example).

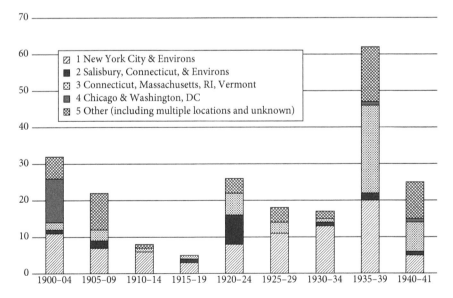

Figure 3.2 Chart 2, Geographic Distribution of Clients over Time in Numbers.

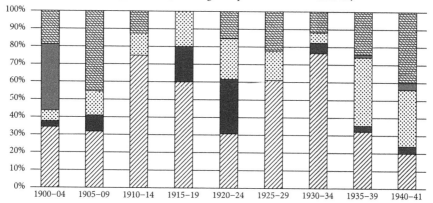

Figure 3.3 Chart 3, Geographic Distribution of Clients over Time in Percentages.

The proportion of portraits of other New England clients also vacillated in a wave-like fashion with two peaks. As Chart 3 (Figure 3.3) indicates, the proportion of clients in these areas rises until 1915-1924, remaining relatively constant before peaking during the last two time periods. Two urban areas in the United States to which wealth and power migrated during Rand's career were Chicago and Washington, DC. Rand painted a high proportion of portraits for clients in these two locations during the first period of her career—1900-1904. These two locations were insignificant in subsequent periods, however. Finally, the geographic distribution of clients in other locations, more distant from her New York, Salisbury, and other New England locales, peaks in 1905-1909, then declines, followed by another peak during the final time period—1940-1941.

What can we make of the pattern of Rand's geographic distribution over her career? The data in Figures 3.2 and 3.3 suggest that we cannot argue that continuous progression in Rand's career and reputation led to a steady geographic expansion. Over time the geographic distribution of her clients varied randomly in wave-like fluctuations lacking systematic repetition in form. This pattern suggests that macro social, political, and economic forces, along with individual life cycle events, and chance events likely produced these random patterns. Thus, the data on Rand's career over time do not support an expectation that Rand would paint more geographically diverse portraits over time.

Social Distribution: The Vertical Element

The social preeminence of portrait clients shapes the opportunities, prices, and the distinction of their portrait painters. Rand painted a wide swath of individuals from

local notables to those internationally known and widely recognized nationally. The social distribution of those she painted has a twofold significance. First, access to a portrait clientele flows significantly through social networks—the artist's own, and those of the clients. Some clients engage portrait painters through galleries exhibiting their work and charging a commission fee. For example, Rand's work was exhibited by the New York Durand-Ruel Gallery in 1902—the first one-woman show at the gallery, in 1917, 1921, and again in 1929.[3] Portrait artists also gain clients through their own personal networks, especially in the early stages of their careers when they have not yet developed a substantial clientele, or reputation. Thus, the initial social circles in which artists are embedded may provide conduits to others of similar prominence, driving their reputations (see Lee and Tolles for more on the gendered and personal connections that impacted Rand). Rand was a childhood friend of Eleanor Roosevelt, a cousin of William and Henry James, and family friend of the prominent New York architects Stanford White and Charles McKim. She studied with noted artists William Merritt Chase and Robert Reid, and maintained lifelong friendships with many socially preeminent people, often listed in the Social Register.

Secondly, the preeminence of artists' clients enhances the reputations of portrait artists. Psychologists have long contended that closely associated stimuli tend to evoke similar responses.[4] For portrait artists, or biographers, the public may transfer associations, such as the prominence, economic means, distinction, and fame of the client, to that of the artist. This process may result in a virtuous circle whereby the acquisition of prominent clients leads to a widening network of other prominent people. As their circle of prominent clients widens, portrait artists often receive knowledge of their work hanging in distinguished clients' homes, as well as recommendations and word-of-mouth affirmations from those whom they have painted. We might, then, expect that Rand would have access to a prominent clientele befitting her family and friendship connections and art circles during her early career; further, we might expect that an early prominent clientele would provide entrée to an increasingly preeminent pool of prospects and clients, as her career progressed.

Determining the social prominence of clients was more complicated than their geographic designation, especially for those who were less socially prominent and, thus, left many fewer traceable records. In fact, difficulty in finding information on some clients combined with a meager number of Google hits indicated that they were local notables—individuals with sufficient economic and social resources to afford a portrait, or be drawn into Rand's orb—but limited in social, political, and economic scope. Above them were clients designated as regionally prominent—well-known and connected politicians, businessmen, and other occupations, having state- or region-wide prominence. Further up were those designated as "Nationally Visible," "Known," and "Connected." At the top were clients who were "Internationally Known and/or Nationally Preeminent"—seventeen in total among the 336 identified portrait clients. I assigned portrait clients to one of the four social prominence designations based on the following criteria—occupation, location and address, memberships in clubs, news coverage, social networks, such unusual distinctions as being on the cover of *Time* magazine and number of Google hits, the latter as a general indicator of status

and celebrity. Following the conventional norms of the periods, I assigned wives and children the same designation as their husband's and father's.

Chart 4 (Figure 3.4) displays the social distribution of all 336 identified Rand portrait clients. By far the largest proportion of Rand's portrait "sitters" was drawn from those who were nationally visible, known, and connected, or regionally prominent (66 percent). Such individuals exhibited economic prosperity; were integrally embedded in national, or cross-regional, economic, political, educational, art, and social institutions; and tended to have wide social connections to others of similar status. They, or the organizations and institutions who commissioned their portraits, could readily afford the price of a portrait, and they traveled in social circles where portraits were common. This group comprised roughly two-thirds of Rand's clients. An early portrait (1905) that epitomizes this category was Mrs. Mark Hanna, wife of Mark Hanna, the notable American businessman and US Senator, Chair of the Republican National Committee, and friend of President McKinley.

Approximately 25 percent of Rand's clients were regionally prominent, often politicians, professionals, and businessmen, who lacked national visibility and significance, but were influential and known beyond their residential locales. Local notables, individuals of some means and locally prominent, made up a very small percentage of Rand's clients, 4 percent. Many were residents of Salisbury, Connecticut, and the surrounding towns and thus locally known to Rand as neighbors.

Finally, 5 percent of Rand's portrait "sitters" were internationally known and/ or nationally preeminent—roughly the same proportion as the local notables. Appendix 1 identifies these seventeen individuals and indicates the basis for their inclusion in this category—as politicians, academics, businessmen, artists, and

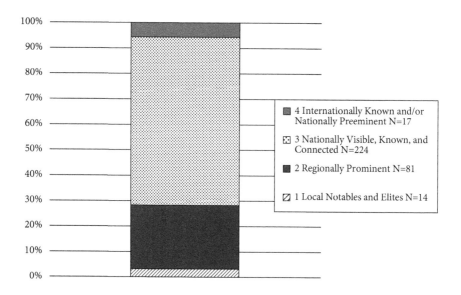

Figure 3.4 Chart 4, Social Distribution of Portrait Sitters.

notables in major institutions. Four were featured on *Time* magazine covers. Without data on portrait clients in general, we cannot know if the social distribution of Rand's clients mirrored that of distribution of other portraitists. Yet, Rand does seem to have a large proportion of prominent and socially visible clients.

Considering the social distribution of clients over time, we might expect that over time, as artists' reputations grow, they are increasingly able to parlay their reputations to engage more preeminent clients. Charts 5 and 6 (Figures 3.5 and 3.6) reveal the social distribution of Rand's clients over time. The proportions of clients in each preeminence category changed over time. In each period the "Nationally Visible," "Known," and "Connected," always the highest proportion, comprised 46 percent to 78 percent of clients. Local Notables, absent in five periods, were never more than 20 percent—and that highest proportion was in the (1915–1919) period, during which she painted the fewest portraits—her primary early childrearing years. The proportion of "Regionally Prominent" clients peaked in the 1920–1924 period (46 percent), but was substantial (18 percent or greater) in all but two time periods. If we were to note an overall pattern for "Regionally Prominent" clients, it is that she painted a lower portion of them in the early stages of her career. Finally, variations in the proportions over time of the seventeen Rand clients in the "Internationally Known and/or Nationally Preeminent" category and for whom we have portrait dates are a sufficiently small number that we cannot meaningfully interpret changes in proportions.

If we look at the proportion of the top two categories—Internationally Known and/or Nationally Preeminent and Nationally Visible, Known, and Connected, we see that clients in these two categories comprised the majority of her portraits (from 87 percent to 60 percent) in every period except 1920–1924 (46 percent). More interesting, the highest proportion occurred early, not later, in Rand's career in 1900–1904 (78 percent), 1905–1909 (78 percent), and 1910–1915 (87 percent). As with the geographic distribution of Rand's clients, fluctuations in the social distribution of clients display

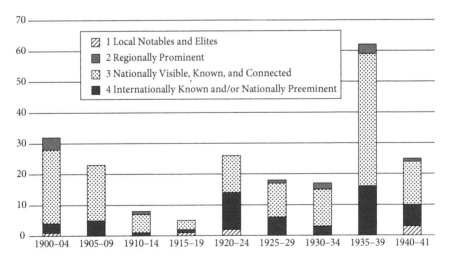

Figure 3.5 Chart 5, Social Distribution of Clients over Time in Numbers.

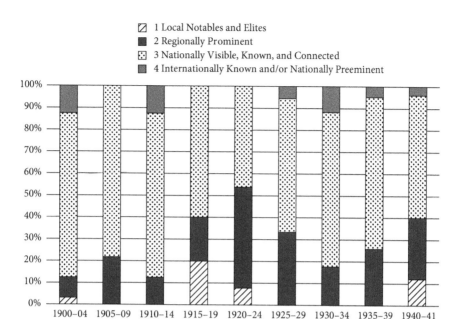

Figure 3.6 Chart 6, Social Distribution of Clients over Time in Percentages.

a largely random pattern over time with the exception of early predominance of the highest two categories mentioned above. This finding is contrary to the expectation that over time as artists acquire prestigious clients and their reputations grow, they are increasingly able to parlay their reputations and client connections to engage more preeminent clients. Rand's career again confounds expectations.

Summary

Rand painted clients from a wide geographic area and across a tall social hierarchy, although she concentrated in New York City, western Connecticut, and southern New England locations; her "sitters" spanned a hierarchy of large social distances with a majority drawn from the top two categories of social prominence (71 percent of the 336 total portraits). We observe fluctuations over time in the proportions of categories in both the geographic and social dimensions of Rand's portrait clients. In both cases, however, the findings do not support the expectations that over time the geographic distribution would result in a steady expansion of more distant geographic locales, and the social distribution would include higher proportions of more socially prominent clients. Had we found linear progressions toward greater spatial expansion and an upward social trajectory, we would assume a continual career dynamic whereby past locations and clients disproportionately affected the geographic and social distributions of future ones. Instead, we suspect that a variety of interacting macro and micro forces and chance factors shaped the geographic and social distribution of Rand's portrait

clients. In addition to the prominence of her clients and her own reputation, another factor shaping Rand's access to clients was her validation by the art establishment.

Validation by the Art Establishment and Portrait Prices

The art establishment validates artists through several agents and institutions, art competitions awarding prizes and medals, art museums acquiring their works and including their works in exhibits—even without acquisition—commercial galleries exhibiting their works and offering them for sale, and the art press and art reviews in the general press providing evaluations and endorsements. Additionally, general press coverage (primarily newspapers articles) of these events creates widespread public awareness and renown for artists. A hierarchy of prestige and esteem ranks the agents of the art establishment based on their resources, span of influence, and location. For example, the Metropolitan Museum of Art scores in the top of museums along these dimensions. The most venerable agents confer the strongest endorsements.

Rand received the art establishments' imprimatur from the most prestigious US art museum and from other prominent art organizations and agents throughout her career. Early in Rand's career, she received three highly significant confirmations of her artistic worth. The first was in 1902 when just shortly after Rand's return from Paris, the prestigious New York Durand-Ruel Gallery—credited with putting Impressionism on the map—held a single artist exhibit of Rand's portraits, the first in Manhattan devoted to a woman artist and one of a few single artist shows.[5] In a retrospective on Rand, *Time* magazine (1954) claimed that from this exhibit "the procession of the rich and famous to her studio began."[6] The exhibit then traveled to The Copley Gallery in Boston and Rand had subsequent exhibits at Durand-Ruel in 1917, 1921, and 1928. The second major early career event was in 1903 when Rand won the prestigious Temple Gold Medal at the Philadelphia Academy of the Arts.[7] Five years later, in 1908, the Metropolitan Museum of Art purchased Rand's portrait of the internationally recognized sculptor Augustus Saint-Gaudens. This purchase, as discussed in Thayer Tolles's subsequent chapter, was also a source of intrigue for Rand as Saint-Gaudens's widow sued Rand over the work. Rand not only won the case, but landed in the Met's collection with publicity. Thus, Rand gained three highly prestigious distinctions in the first decade of her career upon returning to the United States.

These validations were then followed by other nationally significant prizes, acquisitions, and exhibits. In 1914 the Metropolitan Museum of Art accepted the portrait of Benjamin Altman, noted art collector, for its permanent collection and exhibited it at the opening of the Museum's Altman[8] Collection. In 1915 Rand won the prestigious Panama Pacific Exposition Gold medal,[9] followed in 1922 by the Beck Gold Medal at The Pennsylvania Academy of Fine Arts, putting her in the company of other well-known artists, including fellow portraitist John Singer Sargent.[10] That same year she also exhibited at the Chicago Art Institute.[11] In 1930 Rand exhibited at the Corcoran Gallery in Washington, DC and at Anderson Galleries American Art Association Benefit Exhibition in New York in 1932, where her portraits were again in the company of John Singer Sargent's.[12] In 1934 the Metropolitan Museum

of Art commissioned Rand (from among a number of contenders) to paint a portrait of William Sloan Coffin.[13] Also in 1934 she was elected to be a full Member to the National Academy of Design.[14] Taken as a whole, Rand's reputation as a significant artist reflects her record of steady accomplishments and recognition by the art establishment.

Finally, Rand received considerable newspaper coverage around two events that contributed to her reputation and general renown. The first during the early period of her career was coverage of the 1914 Metropolitan Museum of Art's acceptance of the portrait of notable businessman and art collector Benjamin Altman. Thirteen New York papers reported on the gift.[15] Of greater significance was the completion of President Franklin Delano Roosevelt's official portrait in 1934. The story and a photo of Rand standing next to the portrait with Roosevelt's wife and mother was carried in at least forty-five newspapers throughout the United States[16] (for more on the commission, the paintings, and the press surrounding the paintings see Emily Mazzola's chapter in the last section of this collection). Significantly, the descriptions of the official presidential portrait describe the reaction of his wife and mother, but make no mention of the artistic merits of the painting. General press coverage of the Altman gift to the Metropolitan Museum and the presidential portrait contributed to Rand's reputation as a serious and accomplished artist along with other validations.

Rand developed the reputation as a first-rate artist in addition to a portraitist of a highly distinguished clientele during the first decade of her career. Prizes, museum acquisitions, gallery exhibits, other exhibitions, and press coverage from art and general sources throughout her career corroborated her early successes and reputation. Again, in thinking of a typical or traditional artist, one might expect that the prices that portrait artists charge reflect their validation by the art establishment and public renown, as well as the social status of their clients. Indeed, Rand's portraits won a number of prestigious prizes; she received the validation of the Metropolitan Museum's acquisition of four of her portraits, was the first women to have a single artist exhibition in New York, was sought after by galleries, and was widely covered by the press. Ninety percent of her portrait clients were nationally visible, known, and connected (65 percent), or regionally prominent (25 percent). Four percent were internationally known and/or nationally preeminent, the most notable being Franklin Delano Roosevelt. Thus, she had the benefit of an extraordinarily distinguished clientele.

The uneven availability of data on the prices that she charged across her career creates a problem in defining a complete picture; little archival evidence exists prior to the late 1920s. Rand wrote detailed diaries from 1918 to the end of her life, but we have very little on the years between 1900 and 1918. We are, however, able to assess her pricing strategy, her prices relative to other portrait artists, and the dynamics of her prices over time.

In a June 1940 letter to Ben and Isobel Dibble she wrote, "I am working very hard, but unfortunately not making an awful lot of money; prices are bad."[17] Shortly thereafter, an article in *Life* on portrait painters identified twenty-six artists and listed them by seven price categories—$50–$150, $150–$300, $300–$500, $500–$700, $700–$1000, $1000–$2000, and $2000 and up. Rand was identified in the next to highest

category–$1000–$2000 ($18,055–$36,010 in 2019 buying power) along with three other artists; only two were in the highest category of $2000 and higher.[18]

We may infer from these two pieces of information that during the latter part of Rand's career, she was one of the most highly paid portrait artists, and that she was struggling to make enough money. Rand continually experienced financial constraints, helping to support her mother and sisters prior to her marriage and being the primary support for Hamlet Hill Farm (Salisbury, Connecticut), where her husband and children lived and from which she commuted to her New York studio. The epigraphs at the beginning of this chapter from her financial advisor indicate that Rand was not building sufficient wealth in the 1930s. The *Life* article implies that she was faring well financially compared to most other portraitists; but the stock market crash of 1929 created financial difficulties for the Rand family and generally depressed portrait prices. Ironically, Rand had painted the official New York Stock Exchange portrait of E.H.H. Simmons, its president, in 1928.

Rand did not charge a single standard price for a portrait—even within a time period. Rather, she factored in a number of issues in setting prices. She offered quantity discounts to clients' purchasing multiple copies of the same portrait, or a family with purchases of multiple portraits of family members (again, chapters by Pfeiffer and Harris consider the different ways Rand managed these arrangements). In 1941 she painted five members of the Clement family, including Martin W. Clement who appeared on a 1936 *Time* cover, for a total of $7400 or $1480 average per portrait ($2,449, or total of $127,245) in 2019 buying power.[19] The same year she charged Mrs. Carlson $3500 ($60,184 in 2019 buying power) for two portraits of her daughters.[20] Rand also negotiated her price downward to get a commission, rather than lose a portrait opportunity. Within two months after the stock market crash, to secure the portraits of two distinguished Columbia University faculty in 1929, she wrote that her usual fee was $4000 ($59,128 in 2019 buying power), but she would be willing to do each of these for "the very low rate of $1000" ($14,782 in 2019 buying power).[21] In 1940 she quoted a price of $2000, but added, "if I can't get that, $1500" ($27,083 in 2019 buying power).[22] In 1941 she combined a quantity discount with a negotiation, quoting $2000, but $1700 if that was too much, or two for $1500, three for $4000 ($68,782 in 2019 buying power).[23] Rand also followed a long and storied tradition of pegging the price to the size of the portrait. In 1941 her proposed charge for two portraits for the Mariners Museum was "$2000 for 30"x40" or $1750 for 2, a little smaller $1650" ($28,373 in 2019 buying power).[24] Finally, she quoted higher prices when she traveled and for multiple "sitters" in a single portrait.[25]

We can infer from her pricing strategy described above and the substantial variation in her prices that Rand attempted to maximize her revenue by charging what she thought the market would bear; at the same time, she offered a variety of price concessions to acquire commissions. She further likely provided reduced prices in order to secure commissions to further her career. In 1939 John Francis Neylan (a 1936 *Time* cover sitter) writes, "I appreciate very much your attitude in reducing me of a part of the burden of the expense."[26] Yet, she had traveled to California to paint Neylan. Finally, she also gave special pricing to friends as indicated by Anna

Roosevelt Cowles's request that she paint her daughter, Bobbie, at the "full price," given the "nominal price" Rand charged for painting Cowles's son, Sheffield.[27]

One might also expect that the prices of renowned and successful portrait artists would increase over time as their reputations developed. If we look at prices over Rand's career, we see considerable variation and fluctuations. As her career unfolded with the acquisition of her studio in New York in 1900, she priced her early works between $500 and $1000 ($14,400 and $28,800 in 2019 buying power).[28] Consistent with the *Life* article, at the end of Rand's career in 1941, the highest price for which data is available that she charged for a single portrait was $2000 ($17,079 in 2019 buying power).[29] Between these two periods her prices ranged from $1000 (several dates) to $4500 in 1922 ($67,707 in 2019 buying power).[30] Looking at Appendix 2, where the available prices of her work appear along with their 2019 buying power equivalents, we see that her prices did rise from those in the early phase of her career. Further, the price data from 1929 (written in her hand before the stock market crash) suggest that the average price in that year for her portraits was $3974 ($66,520 in 2019 buying power). Considerable fluctuations, however, occurred across her career, and her prices in the last few years were largely below those of early 1929.[31] We do not, then, see a long-term increase in Rand's financial success, as we might expect. As can be seen in national inflation charts, in the final twenty-one years of Rand's career from 1920 to the end of 1941 general prices were largely depressed, especially in the early 1920s and late 1920s.[32] It is likely that macroeconomic forces were more important in shaping her financial success than her career dynamics.

Variations in Rand's prices in general and over time suggest two inferences. First, she actively priced her work to maximize her revenue, rather than having "a usual charge" as she claimed with the Columbia University faculty portraits. Second, the highest prices in her career appear to have been in the 1920s and early 1930s when general prices in the United States were the most depressed. Her prices declined after that, even as general prices in the United States rose. There is a sad twist that even as *Life* defined her in 1941 as in the penultimate price category for portraits painters, she struggled to earn sufficient income.

Conclusion

Rand had significant successes early in her career for which she received recognition and praise from the art establishment and the public. During the first decade after Rand returned from Europe, a distinguished portrait clientele rewarded her with their business (including four who were internationally known and/or nationally preeminent) and with recommendations to other well-placed individuals. From this advantaged beginning, Rand's reputation increased as her career progressed. She continued to paint a prominent clientele as her geographic reach expanded, although the proportions of sitters in the geographic and social categories varied over time. Contrary to expectations, neither the geographic boundaries, nor the social preeminence of her clients, increased over time.

Based on available price data, her financial success appears to have grown from the beginning of her career through the pre–stock market crash period in the late 1920s. Her prices remained strong throughout the 1930s, yet fell at the end of her career during the early 1940s when as she said, "prices are bad." As one of the highest-paid portrait artists at the time, however, she was not suffering alone. While she generally experienced her financial situation as stressful, her renown and reputation remained strong throughout her career.

This analysis of Rand's portrait clients and her portrait prices represents an investigative strategy that permits us to answer several interesting questions about art economics. First, how does an artist's career progress over time with respect to the prices of his or her artworks—an indicator of their value? We see in Rand's case fluctuations in prices over time, but not a steady linear increase as her renown grew. Second, how do the social networks in which artists are embedded both shape and reflect their opportunities and the subsequent value of their work? The prominence of Rand's social circle and her art world connections—education, gallery promoters, her portrait clients, and her social connections—served as resources that nurtured her career. Third, what is the role of such individual factors as aptitude, drive, life circumstances, versus larger social, economic, and cultural forces in shaping the dynamics of art careers? Rand clearly had talent and showed stamina and determination in her commuting between her dual residences and lives as wife and mother in Salisbury, Connecticut, and portrait painter in Manhattan. We see her career flowed in part in relation to her marital and maternal obligations. We also see that even when she was one of the highest-priced portrait painters in the early 1940s at the end of her life, her prices were lower than they had been earlier in her career, particularly the 1920s. These facts suggest the importance of individual factors as well as macroeconomic factors, particularly the impact of the Great Depression on portrait prices in general. It is also likely that painted portraits declined in their cultural significance during that period as well. *The New York Times* reported that portrait painting, once widespread, had almost disappeared by the second half of the twentieth century.[33]

While we can answer these questions about Rand, this type of analysis can also provide a broad perspective on the progression of artists' careers, how their artistic success and renown translates into value, and generally how micro and macro forces shape art careers across time and space.

Appendix 1

List of Seventeen Clients Identified as Internationally Known and/or Nationally Preeminent

Time Period	Name	Criteria for inclusion as	Google Hits
1900–04	Henry James	Internationally recognized writer	546,000
1900–04	Pablo Casals	Preeminent cellist of early 20th century	457,000
1900–04	Augustus Saint-Gaudens	Prominent, internationally recognized American sculptor	367,000
1900–04	William James	Internationally recognized philosopher	1,440,000
1925–29	E. H. H. Simmons	President of New York stock Exchange, widely published	141,000
1930–34	William H. Woodin	US Secretary of Treasury, *Time* magazine cover	897,000
1930–34	Franklin Delano Roosevelt	US president	1,550,000
1930–34	William Coffin Sloane, Sr.	President Board of Trustees, Metropolitan Museum of Art, highly successful businessman	173,000
1935–39	Harold W. Dodds	President Princeton University *Time* magazine cover	2,650,000
1935–39	Edward Dickinson Duffield	Acting President of Princeton, President of Prudential, *Time* magazine cover	141,000
1935–39	John Francis Neylan	William Randolf Hearst protégé, *Time* magazine cover	78,200
1940–41	Martin W. Clement	President The Pennsylvania Railroad, *Time* magazine cover	4690
Date Unknown	John Hay	US Secretary of State	617,000
Date Unknown	Seth Low	President of Columbia University, Mayor of New York City	194,000
Date Unknown	Daniel Willard	President of Baltimore and Ohio Railroad, *Time* magazine cover	59,3000
Date Unknown	Edwin D. Morgan	Prominent US businessman and Pioneer Fund Director	14,000
Date Unknown	Eilhu Root	US Secretary of State under McKinley & Roosevelt; Nobel Peace Prize Winner	376,000

Appendix 2

Rand's Prices: Ellen Emmet Rand Papers, Archives & Special Collections, University of Connecticut Library (EER Papers, ASC, UConn) Box 1, unless noted

Date	Citation Number	"Sitter"	Price	Price in 2019 Buying Power	Source*
1900	P1	Mrs Scott	$1000	$28,294	From letter to Leslie Emmet from EER, December 17, 1900 (New York to Paris) and cited in Rand, *Dear Females* (2009)
1900	P1	Mary Pell	$1000	$28,294	Same as above
1900	P1	Governor Morgan	$500	$14,147	Same as above
1900	P1	Robert Allerton	$500	$14,147	Same as above
1908	P2	Augustus Saint-Gaudens	$2000 purchased by Metropolitan Museum of Art	$52,222	Robert de Forest, MMA to EER, May 27, 1908 (copy), Archives, The Metropolitan Museum of Art, file P1660
1922	P3	Unknown	$4500	$67,707	3/10/1922 Invoice from Horace Ely & Company Folder 39
1927	P4	Sherard Billings	$1800 for balance	$25,149	11/16/1927 Invoice Folder 42
1928	P5	Newbury Frost Read	$300 (1/10 of $3000 price)	$4455 1/10 of $44,550	4/27/1928 Letter from NFR Folder 43
1928	P6	Henry Holt	$800 of $1500	$11,825 of $20,933	9/7/28 letter from Florence Holt Folder 43 and envelope of letter from Martha L. Wade 5/8/29 Folder 44
1929	P7	Professor Pupin and Dean Darrach	$4000 (my usual fee), then quoting "the very low rate of $1000"	$59.128 $14,782	10/26/29/and 12/29/29 EER to Dixon Ryan Fox Folder 44

Date	Citation Number	"Sitter"	Price	Price in 2019 Buying Power	Source*
1930	P8	John A. Hartwell	$500 partial		1/15/1930 Letter from John A. Hartwell Folder 45
1930	9	general	$4000 to $5000 including Gallery commission	$60,545 $75,681	3/15/1930 Letter from Frank Bayley of Copley Gallery requesting EER to set prices Folder 45
1930	P10	Sheffield Cowles	"nominal price"		7/15/1930 Letter from Anna Roosevelt Cowles Folder 45
1934	P11	Gherardi Davis	$2500	$47,159	5/3/1934 Letter from GD to W.E.S. Griswold, Esq. Folder 48
1934	P12	Reproduction of portrait by Sir William Orpen portrait	$3000	$56,591	5/22/1934 letter from illegible name with EER signature affirming price Folder 48
1934	P13	William Sloane Coffin, commissioned and purchased by the Metropolitan Museum of Art	$3000	$56,591	Metropolitan Museum of Art Committee on Purchases minutes, April 16, 1934, Metropolitan Museum of Art Archives
1935	P14	President and Vice president of Rhode Island Hospital Trust Company (proposed)	In Providence $2500 2 for $2000 each In NYC 1 for $2200 2 for 1800 each	$46,127 $36,901 $40,591 $33,211	4/19/1935 EER to Sharpe, Folder 49
1937	P15	Robert W. Huntington	$2800 if in New York City $2000 if in Hartford	$49,151 $35,108	April 1937 Letter from RWH confirming price Folder 51
1937	P16	general	$2000 to $2400 including gallery commission	$35,108 to $42,129	3/8/1937 letter from Argent Galleries Folder 51
1939	P17	William C. Corson	$1500	$27,278	3/3/1939 partial in letter from Hartford Steam Boiler Folder 53

Date	Citation Number	"Sitter"	Price	Price in 2019 Buying Power	Source*
1939	P18	John Frances Neylan	$2100	$38,189	6/3/1939 Letter from JFN "appreciate your attitude in relieving me of a part of the burden of the expense" Folder 53
1939	P19	general	$2025	$36,825	7/1939 EER to Mrs. Gertrude Rathbone stating price for California portraits, not including Rathbone commission Folder 53
1940	P20	Lowell M. Palmer	$1600	$27,592	4/21/1940 Letter from Carleton H. Palmer Folder 54
1940	P21	Judge Louis B. Harte	$1200 or 2 for $1000 each (quote)	$21,666 $18,055	5/13/1940 EER to Mrs. Harte Folder 54
1940	P22	Professor Joseph Warren	$1500 plus $50 for frame	$27,083 plus $903	5/24/1940 EER to Dean J.M. Landis Folder 54
1940	P23	Dr. Frank Pierrepont Graves	$1500	$27,083	6/10/1940 EER to J. Case Morrison Folder 54
1940	P24	K. Denworth	$2000	$36,110	6/10/1940 EER to Mrs. Henry Gilman Folder 54
1940	P25	Clarence M. Finche	$2000	$36,110	6/12/1940 EER to Greenwich Savings Bank Folder 54
1940	P26	Hulbert Taft and/or wife	$3000 for 2 portraits plus travel expenses	$54,166 for each	6/12/1940 EER to Hubert Taft proposing price Folder 54
1940	P27	Clarence M. Fincke	$2000 completes payment	$36,110	6/19/1940 EER to H.E. Browor Folder 54
1940	P28	Albert W. Hunt (proposed)	$2000, if I can't get that, $1500	$36,110 $27,083	6/25/1940 EER to My Dear Joe, Folder 54
1941	P29	Stanley Row	$2000	$34,391	1/4/1941 EER bill to SR Folder 55
1941	P30	Mr. & Mrs George F. Ryan (double portrait)	$3500 (portrait of two)	$60,184 $30,092 average	1/4/1941 EER bill to GFR Folder 55

Date	Citation Number	"Sitter"	Price	Price in 2019 Buying Power	Source*
1941	P31	Mrs. Charles Francis Clement Mr. C. F. Clement Laussat Clement Fianin Clement Martin W Clement Total	$2000 $1400 $1000 $1000 $2000 $7400	Average = $25,449 $124,247	2/4/1941 Letter from CFC Folder 56
1941	P32	F.G. McCloud Esq. (proposed)	$2000 plus travel expenses	$34,391	2/4/1941 EER to FGM Folder 56
1941	P33	Theodore Weicker (proposed)	$1600	$27,513	2/7/1941 EER to Lowell P. Weicker Folder 55
1941	P34	Stewart Carr	$1500	$25,793	3/6/1041 EER to Mrs. Stewart Hanna Folder 56
1941	P35	Lowell Palmer	$1600	$27,513	4/4/1941 EER bill to Carlton Palmer Folder 56
1941	P36	Laurie and Beda Carlson	$3500 for two portraits $1700 each	$60,184 Average = $29,232	4/4/1941 EER to Mrs. Carl Carlson Folder 56
1941	P37	Mr. Easton (proposed)	$2500, if daughter and child $1500 and $2000 for him	$42,989	4/29/1941 EER to Mrs. Easton Folder 56
1941	P38	Mr. Richardson William King	$1500	$25,793	4/29/1941 EER to Mr. Richardson Folder 56
1941	P39	Roger Williams and Edmund Heard (proposed)	$2000 for 30"x 40" or $1750 for 2, a little smaller $1650	$34,391	5/6/1941 EER to Mr. Ferguson Folder 56
1941	P40	Mr. Rowe (proposed)	$2000 if too much $1700, 2 for $1500 each, 3 for $4000	$34,391 $29,233 $25,793 $68,782	EER to Mrs. Farnsworth Folder 56

Prices written by Rand in several lists with totals on the back of an envelope of 5/18/29 letter from Martha L. Wade (Folder 44)

Name	Price	Price in 2019 Buying Power
Emmet	$3000	$44,347
Martin	$3500	$51,738
Lowell	$3600	$53,216
Read (Newbury Frost Read)	$2700	$39,912
McCain	$2700	$39,912
Reed	$4000	$59,129
Holt (Henry)	$1500	$22,173
Total	$21000	
Rindall Kindall	$3500	$51,738
Prach?	$2600	
Whaple?	$3000	$44,346
Total	$30,100	
McCullough	$1300	$19,217
Clark	$5000	$73,911
Total	$18000	
Blank (subtracted)	$3500	
	$14,500	
Muriel	$3000	$44,347
McHare	$4000	$56,983
Mckindall	$3600	$53,216
	$10,600	
Chapin (Charles Merrill)	$5000	$73,911
Reed	$4000	$56,983
Cannon (William Cornelius)	$1500	$22,173

Notes

1 Ellen Emmet Rand Papers, Archives & Special Collections, University of Connecticut Library (EER Papers, ASC, UConn) Box 1, letter from J.R. Swan to EER, May 18, 1934; letter from J.R. Swan to EER, November 21, 1938.

2 This catalogue raisonné was compiled by Emily Mazzola in 2016 as part of the Luce Foundation funding for the exhibition *The Business of Bodies: Ellen Emmet Rand and the Persuasion of Portraiture* and this volume. It will be available online as part of the EER Papers UConn information page. See https://archives.lib.uconn.edu/islandora/object/20002%3A860257637, accessed July 26, 2020.

3 Several catalogs from this period are in the EER Papers, ASC, UConn, Box 1, Folder 34.

4 Norman Guttman, and Harry L. Kalish, "Discriminability and Stimulus Generalization," *Journal of Experimental Psychology* 51 no. 1 (1956): 79–88.

5 *American Art News*, March 10, 1917; Clipping in EER Papers, ASC, UConn, Box 1 Folder 13.

6 *Time,* July 23, 1954 EER Papers; Clipping in EER Papers, ASC, UConn, Box 1, Folder 13.

7 Tremaine Gallery Program Timeline EER Papers, ASC, UConn, Box 1, Folder 34.

8 Various news articles October 1914, EER Papers, ASC, UConn, Box 1, Folder 12.

9 Rand obituary, *New York Herald Tribune*, December 19, 1941; Copy in EER Papers, ASC, UConn, Box 1, Folder 27.

10 Grace Wickham Curran, "Ellen Emmet Rand; Portrait Painter," *The American Magazine of Art* 19 (September 1928): 471–9.

11 Tremaine Gallery Program Timeline EER Papers, ASC, UConn, Box 1, Folder 34.

12 Letter from Director of Corcoran Gallery, September 30, 1930, EER Papers, ASC, UConn, Box 1, Folder 45. Copy of *Herald Tribune* article, March 1, 1931, EER Papers, ASC, UConn, Box 1, Folder 21.

13 See https://www.metmuseum.org/art/collection/search/19288, accessed January 25, 2019.

14 Article from a newspaper in Plainfield, NY, Undated, EER Papers, ASC, UConn, Box 1, Folder 23.

15 EER Papers, ASC, UConn, Box 1, Folder 12.

16 EER Papers, ASC, UConn, Box 1, Folder 23.

17 E EER Papers, ASC, UConn Letter to Ben and Isobel Dibble, June, 1940, Box 1, Folder 54.

18 "Portrait Painters," *Life*, February 3, 1941, 46–8.

19 EER Papers, ASC, UConn, Letter from Mrs. Charles Francis Clement, February 4, 1941, Box, Folder 56.

20 EER Papers, ASC, UConn, Letter from EER to Mrs. Carl Carlson, April 4, 1941, Box 1, Folder 56.

21 EER Papers, ASC, UConn, Letters from EER to Dixon Ryan Fox, October 26, 1929 and December 29, 1929 Box 1, Folder 44.

22 EER Papers, ASC, UConn, Letter from EER to My Dear Joe, June 19, 1940, Box 1, Folder 54.

23 EER Papers, ASC, UConn, Letter from EER to Mrs. Farnsworth, Box 1, Folder 56.

24 EER Papers, ASC, UConn, Letter from EER to Mr. Ferguson, Box 1, Folder 56.

25 EER Papers, ASC, UConn, Letters from EER to Sharpe April 19, 1935 Box 1, Folder 49; to Hulbert Taft, June 12, 1940 Box 1, Folder 54; Robert W. Huntington to EER, April 1939, Box 1, Folder 51; and Bill from EER to George F. Ryan, January 4, 1941, Box 1 Folder 54.

26 EER Papers, ASC, UConn, Letter from John Francis Neylan to EER, June 2, 1939, Box 1, Folder 53.

27 EER Papers, ASC, UConn, Letter from Anna Roosevelt Cowles to EER, July 15, 1930, Box 1, Folder 45.

28 Ellen Emmet Rand, *Dear Females* (New York: Ellen E. Rand, 2009), 119.

29 EER Papers, ASC, UConn, Bill from EER to Stanley Row, January 4, 1941, Box 1, Folder 55.

30 EER Papers, ASC, UConn, Invoice to Horace Ely & Company March 10, 1922, Box 1, Folder 39.

31 EER Papers, ASC, UConn Prices written by EER in several lists with totals on the back of an envelope of April 18, 1929 letter from Martha Wade, Box 1, Folder 44.

32 See http://www.in2013dollars.com/for inflation rates that are being used to make this assessment, accessed July 26, 2020.

33 Dusko Petrovich, "It Looks Like You," *The New York Times (T Magazine)*, February 28, 2018, 167.

Part Two

Working the Scene

The Power of Profile: Ellen Emmet Rand and Augustus Saint-Gaudens

Thayer Tolles

Quite by chance, in November or December 1904, Ellen Emmet Rand encountered the renowned sculptor Augustus Saint-Gaudens (1848–1907) on New York's Fifth Avenue. The possibility of painting his portrait was discussed and Saint-Gaudens consented to sit for Rand; as she recalled years later, he stated, "I will be tickled to death."[1] On the surface, the resulting likeness (Plate 7), which entered the Metropolitan Museum of Art's collection in 1908, was the product of a felicitous meeting. In reality, it came about through years of strategic planning on Rand's part to affiliate herself with high-achieving, high-profile artistic personalities. In this case, her strategy of career self-fashioning through the auspices of male influence and institutional imprimatur succeeded, but not without obstacles, maneuvering, and drama.

By the time Rand first settled in New York in 1889, Saint-Gaudens was the leading American sculptor, a new brand of cosmopolitan artist trained in Paris at the École des Beaux-Arts and celebrated for his monuments to Admiral David Glasgow Farragut (1877–1880; Madison Square Park, New York) and Abraham Lincoln (1884–1887; Lincoln Park, Chicago). During the 1880s Saint-Gaudens became the exemplar for a "new school" of American sculpture, assuming a prominent role in the city's artistic fabric, from serving as president of the upstart Society of American Artists to hosting informal Sunday afternoon concerts in his studio for New York's cultural elite (writers, artists, architects, and patrons alike).[2] Having succeeding in his own calculated campaign to circulate his name, or, as his brother put it, "curry favor with the rich like a flunkey,"[3] the sculptor possessed a firm belief in "paying it forward." He mentored numerous studio assistants who would themselves go on to have successful careers, and, beginning in 1888, taught sculpture modeling classes at the Art Students League (Figure 4.1).

At the League, Rand would likely have seen, if not met, Saint-Gaudens; though never studying with him, his near-celebrity status certainly would have made an impression on an aspiring young artist (extremely young; she was only fourteen when she first enrolled). Between autumn 1889 and spring 1893 Rand periodically registered for drawing classes, taught by, among others, Robert Reid as well as Saint-Gaudens's close affiliates Kenyon Cox and William Merritt Chase.[4] During this time Rand began

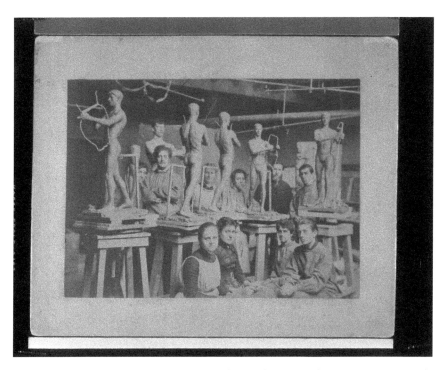

Figure 4.1 Saint-Gaudens with a modeling class at the Art Students League, New York, *c.* 1888, photograph, Department of the Interior, National Park Service, Saint-Gaudens National Historic Site, Cornish, New Hampshire.

to construct her network of well-placed contacts, not only the likes of Chase, but also the architects Charles McKim and Stanford White, principals in the leading firm McKim, Mead & White, and close friends and collaborators of Saint-Gaudens. Both men were family friends, and Rand's intermittent correspondence with each reveals a comfortable rapport.

After a brief stint in England where she enjoyed the encouragement of John Singer Sargent, in December 1896 Rand moved to Paris, the global training and proving ground for thousands of aspiring American artists. Eschewing the more common option for women students of enrolling in classes at one of the many private academies, and following the advice of McKim and White, Rand sought out Frederick William MacMonnies, who had collaborated with both architects on pedestals for his public sculptures.[5] Like his mentor Saint-Gaudens, MacMonnies taught, in his case drawing and painting, as well as clay modeling, in classes at his studio and also for the short-lived Académie Carmen with James McNeill Whistler. The Brooklyn-born artist rose from career beginnings in the early 1880s working in Saint-Gaudens's studio to a decade later commanding international status for monuments modeled in a facile and sophisticated Beaux-Arts style. More than any American sculptor, he epitomized the expatriate artist, exhibiting and selling fluidly between the United States and France.

He was a shrewd marketer of his work, the first American to capitalize on issuing his small bronze statuettes in commercially successful editions. Rand would learn not only valuable artistic lessons, but also business management ones, during her three years in his studio (see too Elizabeth Lee's chapter).

Rand was also steered toward MacMonnies by Paul Bion (1844/45–1897), a French artist and critic who was a close friend of Saint-Gaudens from their student days at the École des Beaux-Arts, and later of MacMonnies. During a visit to the Emmet's quarters at 96 Boulevard Montparnasse with Saint-Gaudens's niece Rose Nichols, Bion was suitably enough impressed by Rand's paintings to recommend to MacMonnies that he take her on as a student.[6] Rand wrote to White shortly after arriving in Paris, "I am getting along at a great rate with MacMonnies. I did not believe it was possible that I could learn so much in a few months."[7] MacMonnies's impact on Rand was arguably the most significant artistic, and male, presence she would experience during her lifetime.

While in Paris, Rand completed two extant paintings in which MacMonnies was the subject. One is an unusually posed study, a three-quarter view from the rear, with the artist at an easel at work on a canvas (Plate 3); in the other more formal portrait, he is jauntily seated in near-profile, the palette a tonal study in beige and brown (Plate 4). Jane Emmet's (Rand's cousin) observation to her sister Lydia within months of arriving in Paris is telling of Rand's savvy ambition: "Bay is wild to be known by a portrait of him."[8] This deliberate strategy of recognition by association would extend to her first few years back in New York, for instance, by publicly exhibiting MacMonnies' portrait and, even more frequently, the one of Saint-Gaudens. Although both men were from less pedigreed social backgrounds than Rand, their global reputations, indeed even their very associations with the young artist, had the potential to serve as invaluable currency for her.

Saint-Gaudens relocated from New York to Paris in late 1897, living there for a third extended period, ostensibly to complete work on his monument to General William Tecumseh Sherman (1892–1903; Grand Army Plaza, New York), but also to prove his mettle as an artist of international reputation. Beginning shortly after Saint-Gaudens's arrival, Rand, her sisters, and cousins intersected with him socially on several occasions. In November 1897 cousin Lydia Field Emmet reported to her mother that Rand attended a most American event with MacMonnies and Saint-Gaudens—a Thanksgiving morning football game played by American art students; several months later Lydia raved about sitting next to her "mash St. Gaudens" at a dinner party.[9] Saint-Gaudens was also a frequent visitor to MacMonnies's studio, as was MacMonnies to his.

Shortly after Saint-Gaudens's arrival, the Emmets intended to visit his studio; however, the sculptor wrote to one of the sisters: "I must also beg off from your proposed visit to this totally uninteresting barn in which I live … May I ask you wait until various things which are on the water arrive from America?"[10] Although Rand was in England in April 1898 attending to family matters, an extended Emmet circle of female admirers, at least five, paid Saint-Gaudens the delayed visit to his studio at 3 bis rue de Bagneaux. Armed with cameras, they took a number of photos of the artist standing confidently in front of his works (Figure 4.2).[11] Lydia Field Emmet's

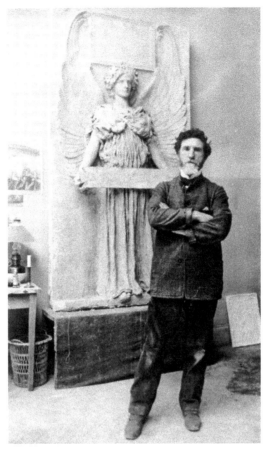

Figure 4.2 Augustus Saint-Gaudens in his Paris studio with a plaster model for the John Judson Hall tomb at Sleepy Hollow Cemetery in Tarrytown, New York, 1898, photograph, Department of the Interior, National Park Service, Saint-Gaudens National Historic Site, Cornish, New Hampshire.

description of Saint-Gaudens the man is complex in its implication of a diminished persona quite undetectable in the photos of Saint-Gaudens the self-possessed artist:

> St. G can't have too many girls at a time and was a mixture of pleased to death and embarrassed vacillation. He has the most helpless, childish humorously meek note about him and seems less like a celebrity than any I ever saw. Bay says in a letter "He loves the darling ladies from Mexico and Cardiz." He gave us all reproductions of the Adams tomb [photographs of the Adams Memorial, 1886–91; Rock Creek Cemetery, Washington, D.C.]. It was the most wholesale ridiculous expedition.[12]

It was "ridiculous," probably in the sense that they perceived the visit to the eminent artist as something of a lark. The Emmets were among a number of young American

female students who are recorded as having visited Saint-Gaudens's Paris studio, and Saint-Gaudens, like MacMonnies, also taught some privately.

Like her sisters and cousins, Rand was privy to—and participated in—a web of opinion-forming about the artistic personalities they met in Paris. Through MacMonnies, if not others, she would also have learned of the complicated nature of the Saint-Gaudens–MacMonnies relationship, which ranged from heartfelt professions of mutual admiration and respect to stormy bouts of spite and jealousy.[13] For instance, in March 1898, MacMonnies wrote to Lydia Field Emmet asking her to carry out damage control over dinner party conversation in New York in which it was said he "was taking [him]self to great airs, and considered St. Gaudens as a very inferior sort of person in art" and that he deemed Saint-Gaudens's Farragut Monument "stuffed with straw" and his memorial to Robert Gould Shaw and the Fifty-fourth Massachusetts Regiment (1884–1897; Boston Common) "beneath consideration." In his belief that Lydia Emmet had the power to set gossip straight in circles in both New York and Paris, he "beg[ged her] to implore [her] correspondents to correct with infinite pains this absurdity ... Altho' we are not of the same persuasion and our processes differ, I have a profound respect for St. Gaudens as the first of American sculptors doubled with the strongest possible affection."[14] While Rand had her own opportunities to form opinions of Saint-Gaudens and his work, she certainly was impacted by MacMonnies's views, both directly from him and filtered through the Emmet-family gossip mill.

Both Rand and Saint-Gaudens left Paris and returned to the United States in 1900; in both cases the timing was not of their own volition. Rand proclaimed Paris off-limits due to a culminating incident with MacMonnies that it is reasonable to speculate capped off several years of romantic entanglements between the married teacher and the young artist. That aside, she had made a conscious decision that it was time to launch her career as a painter of commissioned portraits. For his part, Saint-Gaudens had been diagnosed with an intestinal tumor and required immediate surgery, opting for treatment in Boston and then relocating year-round to his home and studios in Cornish, New Hampshire. Departing Paris in haste, he left behind a group of works on view at the Exposition Universelle that collectively earned him a Grand Prix, including the recently completed plaster version of the Sherman Monument. Other awards and honors followed, including the prestigious decoration as Officier de l'Ordre de la Légion d'Honneur, validating his status as an artist of international reputation.

Back in New York, Rand purposefully began establishing herself as a professional artist, not to mention a socially connected presence. She reached out to such old contacts as Stanford White to help her get her work before the public eye and to generate new commissions. He made suggestions for potential exhibition venues, in 1901 affirming, "you may be sure you can count on my aid as far as I can give it to you," and writing in a letter of introduction to Durand-Ruel Galleries: "I think she has the greatest talent."[15] In January 1902 Rand held her first one-artist show at Durand-Ruel, renting the space for two weeks to display forty portraits as well as figure and landscape studies.[16] Criticism of her work was largely positive, establishing career-long patterns of comparison to such artists as Cecilia Beaux, John Singer Sargent, and Anders Zorn.

White also recruited Rand's work for a benefit exhibition for the Orthopaedic Dispensary and Hospital in autumn 1903, making it clear that only portraits of

well-known (MacMonnies) and society figures such as Susan Metcalfe (1900; William Benton Museum of Art), a singer and cousin of the Emmets, were appropriate, or, as White put it, wanted "for the power of attraction."[17] Rand herself understood this idea implicitly, and the portraits of White and his son Lawrence, the latter painted in 1904 (White Family Collection, St. James, NY), were no doubt executed on that premise. Stanford White's portrait (Figure 4.3), painted before his murder in 1906 and partially retouched posthumously, follows her early tendency to seat her figures in profile at half-length, spot-lit against a dark background with loosely worked brushstrokes and little sense of depth.

By the time Rand encountered Saint-Gaudens in late 1904, circumstances had changed significantly for both artists. Rand's clientele base in New York had expanded rapidly. Her mother recalled that Rand had first appealed to the sculptor while in Paris to paint his likeness, apparently more than once: "Saint-Gaudens used to say: 'Bay, some day I am going to have you paint my portrait and will sit for you; some day I am going to sit for you.'"[18] Saint-Gaudens's willingness to accommodate Rand in New York was likely colored by several factors. He clearly considered her an artist of talent, at one point in Paris even mistaking one of her paintings as by Sargent.[19] Perhaps

Figure 4.3 Ellen Emmet Rand, *Stanford White*, c. 1904, retouched 1906 or after, oil on canvas, 48 × 38″, White Family Collection.

most significant was his keen awareness of his own mortality. Ensnared in a routine of doctors' visits in New York, cancer treatments, and dietary regimens, sittings for Rand might have offered a pleasant diversion. More than that, a new portrait represented an opportunity to enshrine his likeness for posterity, or rather re-enshrine it, for Saint-Gaudens had suffered a disastrous fire in his Cornish studio just weeks earlier in October 1904, losing not only many clay sketches and plaster models, but also such personal effects as furnishings, correspondence, drawings, and gifts of art from the likes of Sargent, Chase, Winslow Homer, and Kenyon Cox.

When Cox's portrait of Saint-Gaudens of 1887 (Figure 4.4) was destroyed, gone was a painting of a sculptor in his robust prime, an intimate likeness with narrative elements that summarized Saint-Gaudens as a forceful artistic presence.[20] In his Thirty-sixth Street studio, he stands in half-length profile amid several works of his own making, modeling in clay a bas-relief portrait of Chase (1888; American Academy of Arts and Letters, New York), who likewise reaches out to paint. Cox later described Saint-Gaudens:

> No one who ever came in contact with him, no one who ever saw his portrait, can have missed one of his dominating characteristics, a fiery and compelling energy. That extraordinary head, with its heavy brow beetling above the small but piercing eyes, its crisp and wiry hair, its projecting jaw and great, strongly modelled nose, was alive with power.[21]

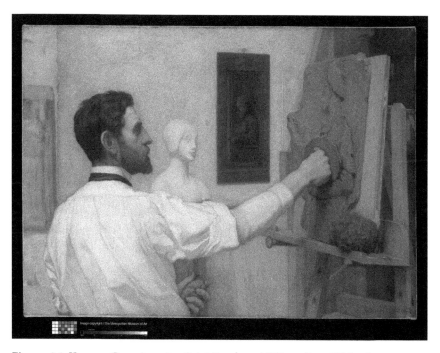

Figure 4.4 Kenyon Cox, *Augustus Saint-Gaudens*, 1887; replica, 1908, oil on canvas, 33 ½ × 47 ⅛″, The Metropolitan Museum of Art, Gift of the friends of the artist, through August F. Jaccaci, 1908 (08.130).

Cox's painting stood as a visual representative for Saint-Gaudens, and, without this reference point for the sculptor and his family, a portrait by Rand had the potential to become a surrogate of sorts.

Saint-Gaudens sat for Rand at least twice in January 1905, shortly after encountering her at a dinner party. The first sitting took place on the 17th, and as the sculptor noted to his niece Rose Nichols, herself a confidante of the Emmet sisters, Rand began "a very good profile." Evidently he enjoyed the experience for he wrote to Nichols again three days later: "the ½ hour posing with frequent rests is very reposeful to me … besides it pleases my vanity to have any one fussing about my personality and that contributes to my happiness and consequently to my health."[22] Saint-Gaudens's remarks suggest a rapport between Rand and himself, evidence that he was easy in his role as sitter, rather than as celebrated sculptor. Rand's mother remembered that Saint-Gaudens's adult son Homer even joined him at Rand's Washington Square studio on one occasion. She worked expeditiously, since by mid-February the painting was in the possession of her framer of choice, D. B. Butler & Co.[23]

While Cox's painting celebrated an artist in his creative sanctum, Rand's followed the conventions of traditional formal portraiture. Saint-Gaudens is seated at half-length in right-facing profile. His right hand, with prominent veins and splayed fingers, rests on the arm of a Louis XVI-style chair, a studio prop that appears in several paintings by Rand. His left arm is raised at the elbow, his hand grasping the chain for his eyeglasses that is attached to the buttonhole of his lapel. The fashionable pince-nez glasses, suspended vertically from Saint-Gaudens's hand, and the white cuff of his shirt are the secondary visual players in the painting's narrative. The principal one, of course, is the ruddy, pensive face, with lowered eyelids, prominent nose, and white beard and mustache. The full head of hair is the darkest element in a unified palette of browns and grays. Unlike Rand's earlier male portraits that feature slashing brushwork in the background, here it is rendered smoothly, forming a monochromatic scrim. In contrast, bravura dabs of pigment embellish the nearer chair arm to suggest gilded elements. Thin sweeping brushstrokes denote the other arm, the entire lower right corner sketchily rendered in order to refute any sense of depth.

Rand's decisions regarding format and pose for her sitters are infrequently documented, and none is recorded for Saint-Gaudens. It is reasonable to assume, however, that her selection of the profile format was entirely calculated. Saint-Gaudens was broadly known for his distinctive profile, and by adopting that pose Rand inserted herself into a lineage of image-making. Saint-Gaudens's own self-identity revolved around his profile; beginning in the 1870s he frequently closed letters to intimate friends such as White and McKim with sketches of his sharply drawn facial features. His medallion from 1878 (Figure 4.5) celebrating this three-way friendship of redheads encapsulates the power of profile as a shorthand assertion of identity; his appears at lower left facing McKim's. While Saint-Gaudens's use of his own profile approached self-caricature, Cox appropriated and dignified it, inserting it in collective memory. That painting, of commanding scale, was prominently published and exhibited soon after it was completed, including at the Exposition Universelle in Paris in 1889 and the World's Columbian Exposition in Chicago in 1893.

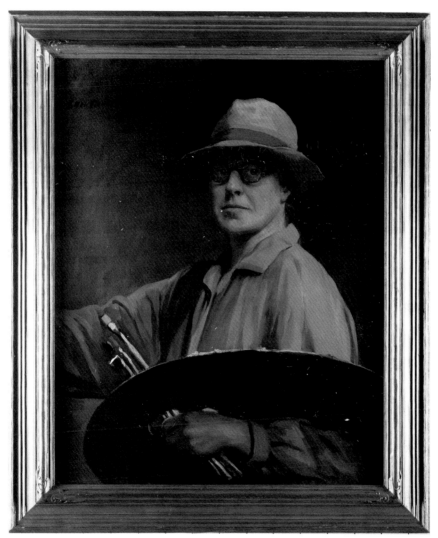

Plate 1 Ellen Emmet Rand, *Self-Portrait*, 1927, oil on composition board, 30 × 24″, National Academy of Design, New York, USA/Bridgeman Images.

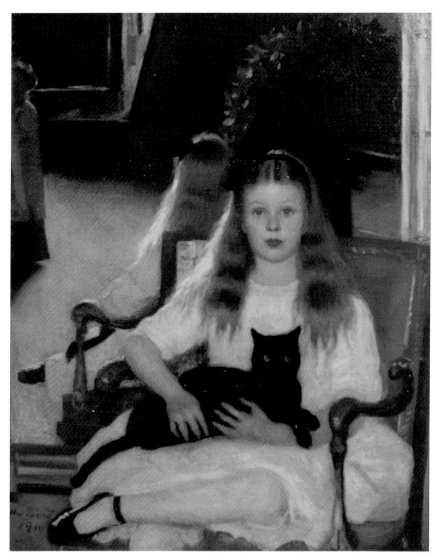

Plate 2 Ellen Emmet Rand, *In the Studio*, 1910, oil on canvas, 44 ⅓ × 36 ¼″, The William Benton Museum of Art, University of Connecticut, Storrs, Connecticut.

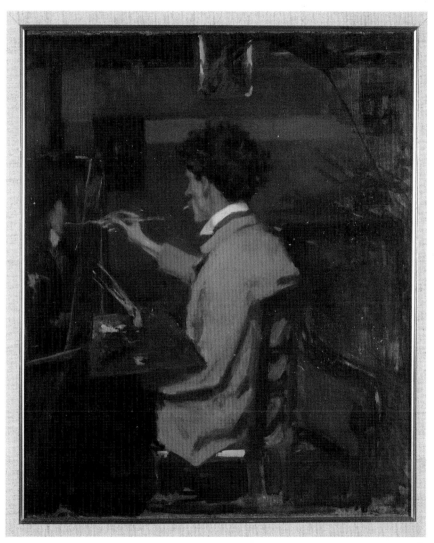

Plate 3 Ellen Emmet Rand, *Frederick MacMonnies in His Studio*, 1898, oil on canvas, 21 ⅜ × 17 ½″, The William Benton Museum of Art, University of Connecticut, Storrs.

Plate 4 Ellen Emmet Rand, *Frederick MacMonnies*, 1898–1899, oil on canvas, 39 ¾ × 32 ¼″, The William Benton Museum of Art, University of Connecticut, Storrs.

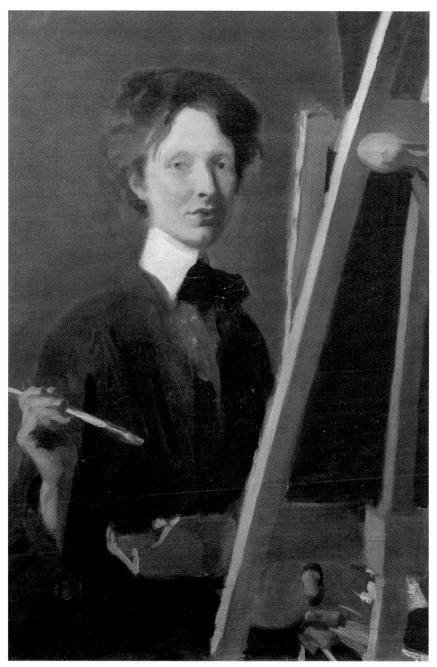

Plate 5 Frederick MacMonnies, *Portrait of Bay Emmet at Her Easel (Red-Haired Student at Easel)*, 1898–1899, oil on canvas, image courtesy of Taylor Graham, New York City.

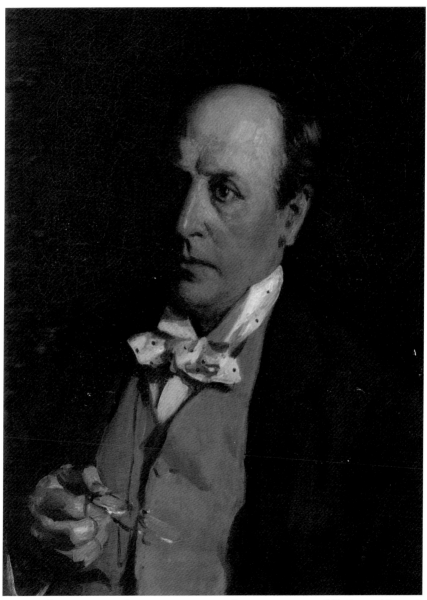

Plate 6 Ellen Emmet Rand, *Henry James*, 1900, oil on canvas, 22 × 16 ⅜″, National Portrait Gallery, Smithsonian Institution, Gift of Marjorie Edel in memory of Leon Edel.

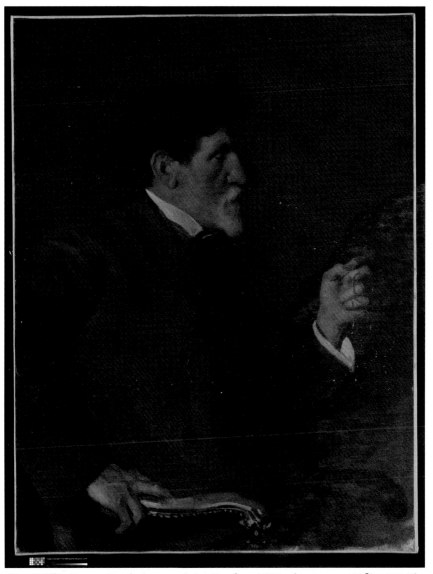

Plate 7 Ellen Emmet Rand, *Augustus Saint-Gaudens*, 1905, oil on canvas, 38 ⅞ × 30″, The Metropolitan Museum of Art, New York, Rogers Fund, 1908 (08.129).

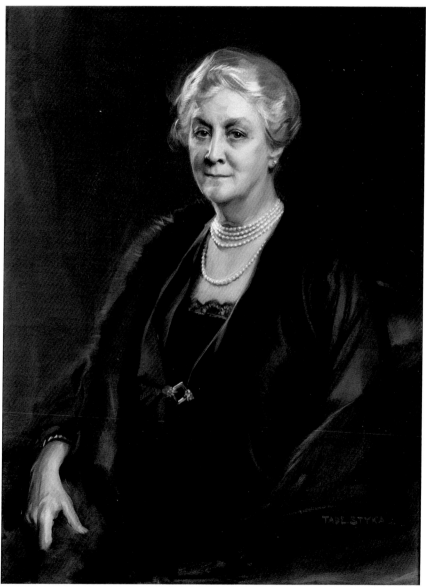

Plate 8 Tade Styka, *Painting of Sara Delano Roosevelt*, 1936, oil on canvas, 40 ¼ × 30″, courtesy of the Franklin D. Roosevelt Presidential Library, Hyde Park, NY.

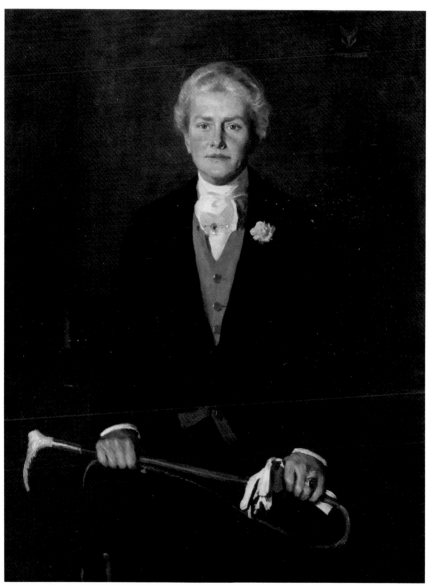

Plate 9 Ellen Emmet Rand, *Miss Charlotte Noland, Joint M.F.H., The Middleburg Hunt,* 1929, oil on canvas, 40 × 30″, Foxcroft School, Middleburg, Virginia, photograph by Claudia Pfeiffer.

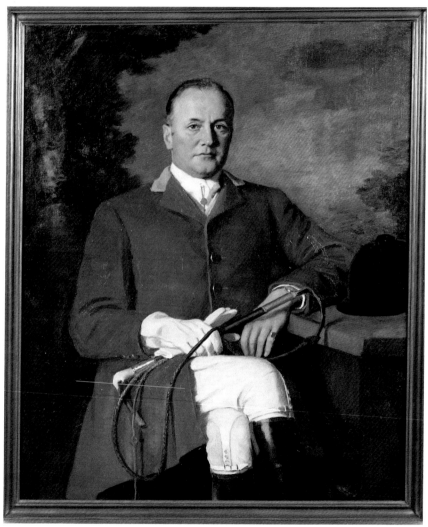

Plate 10 Ellen Emmet Rand, *William Blanchard Rand, MFH of the Old Chatham Hunt*, 1936, oil on canvas, 46 ¼ × 36″, The William Benton Museum of Art, University of Connecticut, Storrs, Connecticut.

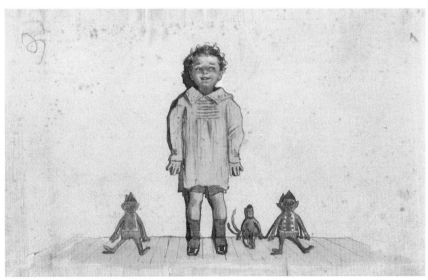

Plate 11 Ellen Emmet Rand, inside cover of Grenville's Picture Book, 1896–1900, Ellen Emmet Rand Papers, Archives & Special Collections, University of Connecticut Library.

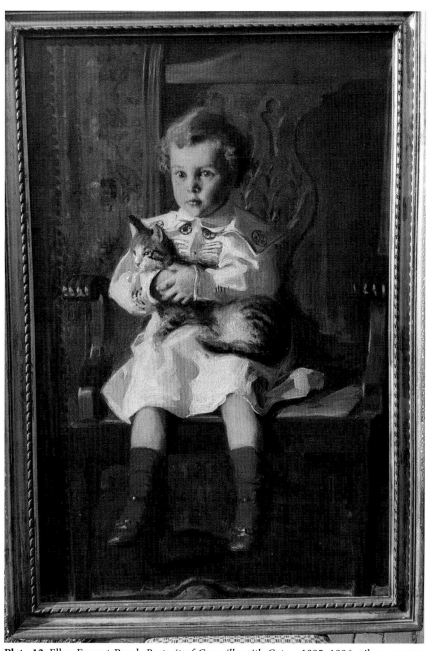

Plate 12 Ellen Emmet Rand, *Portrait of Grenville with Cat*, *c.* 1895–1896, oil on canvas, collection of Christopher Emmet.

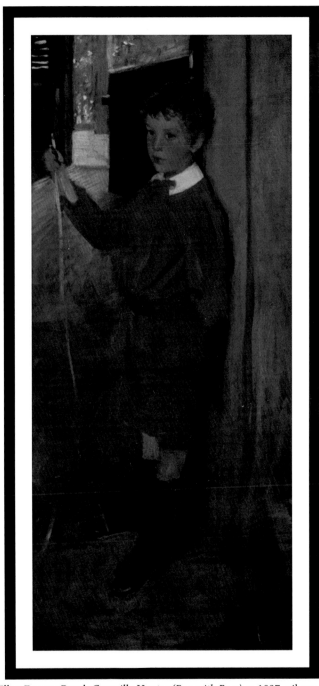

Plate 13 Ellen Emmet Rand, *Grenville Hunter (Boy with Bow)*, *c.* 1897, oil on canvas, 26 ×
16″, The William Benton Museum of Art, University of Connecticut, Storrs, Connecticut.

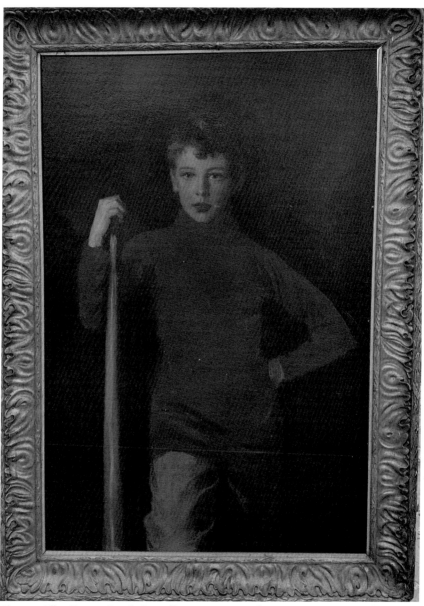

Plate 14 Ellen Emmet Rand, *Grenville Hunter*, 1909, oil on canvas, 49 × 31″, collection of Christopher Emmet.

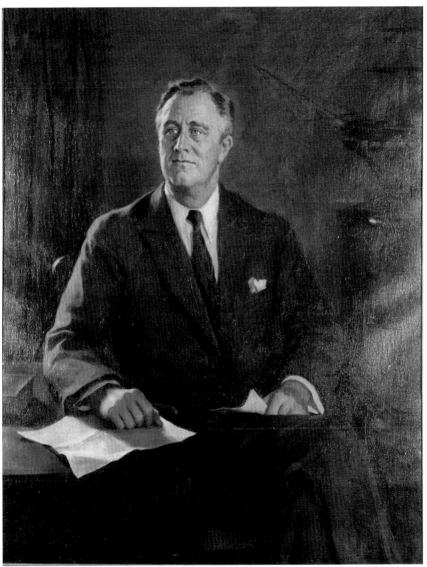

Plate 15 Ellen Emmet Rand, *President Franklin D. Roosevelt*, 1934, oil on canvas, 53 ½ × 42 ½″, courtesy of the Franklin D. Roosevelt Presidential Library, Hyde Park, NY.

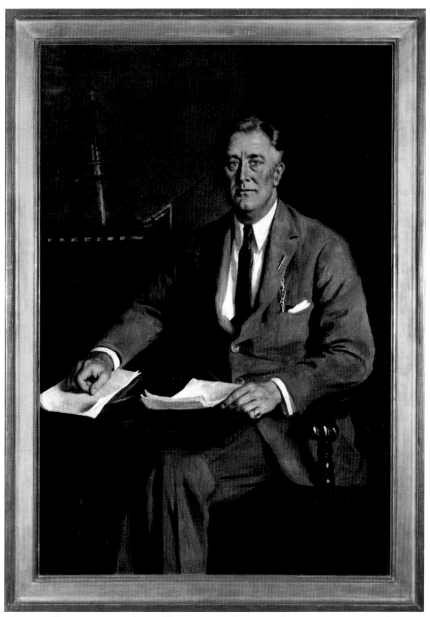

Plate 16 Ellen Emmet Rand, *Franklin D. Roosevelt*, 1932, oil on canvas, 58 ¼ × 39″, Home of Franklin D. Roosevelt National Historic Site, National Park Service.

Figure 4.5 Augustus Saint-Gaudens, *Charles F. McKim, Stanford White, and Augustus Saint-Gaudens*, 1878, bronze, Diam. 6″, The Metropolitan Museum of Art, New York, Morris K. Jesup Fund, 1992 (1992.306).

Saint-Gaudens was a willing portrait subject for painters, sculptors, and photographers throughout his career. While not one to seek out the spotlight, he possessed a healthy element of vanity. As a portraitist himself, he understood the potential benefits of image circulation, even as many were produced as expressions of friendship, such as those sketches also gone in the fire by Sargent and French artists Jules Bastien-Lepage and Carolus-Duran. While the Cox portrait of 1887 was by far the best-known, others were issued in multiples, and intended for public dissemination. For instance, among those completed before the Rand portrait were a drawing of a profile medallion of the sculptor or the "Saint," as he was known to friends and studio assistants, published in *The Book of the Tile Club* the same year. Likewise, Swedish artist Anders Zorn completed two etchings of Saint-Gaudens in his studio, with his model Hettie Anderson (1897) in New York, and a second in Paris (1898; both Metropolitan Museum of Art) in which Zorn experimented compositionally by dramatically cropping a plaster cast of *The Puritan*, with the sculptor seated in the foreground. Moreover, longtime studio assistant James Earle Fraser completed a medal of honor (Figure 4.6) celebrating Saint-Gaudens's works for the Pan-American Exposition in Buffalo in 1901; on the obverse his features are naturalistically rendered in profile, the bare-chested herm bust and lettering a nod to the Quattrocento predecessors that both men admired.

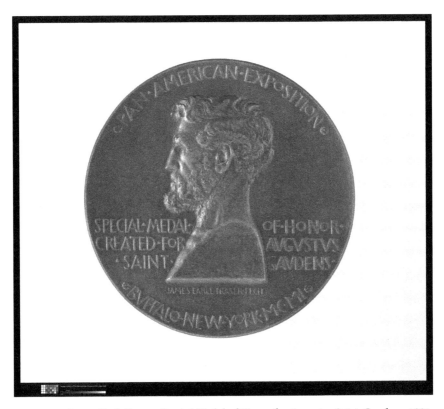

Figure 4.6 James Earle Fraser, *Special Medal of Honor for Augustus Saint-Gaudens*, 1901, bronze, Diam. 3-9/16″, The Metropolitan Museum of Art, New York, Gift of Mr. and Mrs. Frederick S. Wait, 1909 (09.114a).

Photography was another expedient means of image circulation, even in the days before its mass reproduction in newspapers and journals. Saint-Gaudens began sitting for formal photographs by at least the late 1880s, a practice he continued throughout the remainder of his life, in both the United States and France. For many years, his photographer of record was De Witt Ward, who shot record images of his sculptures. In 1904, Ward traveled to Cornish, presumably for that purpose, as well as to photograph Saint-Gaudens in his studio. The group of resulting photographs depicts the sculptor in a herringbone tweed suit with vest, dark necktie, and high-collared white shirt. He appears in all manner of poses, standing and seated, frontal and profile, from close-up headshots to full-length in his surroundings, holding a hat, his pince-nez glasses with chain, or a cigarette. Copyrighted in 1905, several of these photographs (Figure 4.7) were published in the years immediately preceding and following Saint-Gaudens's death. It is certainly possible that Rand may have had access to one or more of these photographs as references points as she completed her portrait of Saint-Gaudens following the sittings from life in January 1905.

Figure 4.7 De Witt Ward, *Saint-Gaudens in His Studio*, 1904, photograph, Smithsonian American Art Museum, Washington, D.C., Peter A. Juley & Son Collection.

As a comparison to Ward's photographs suggests, in addition to depicting Saint-Gaudens in identical attire, Rand likewise opted to portray him in a sedate, contemplative mien. In her work, there is no hint of the physical frailty that is evident in some contemporaneous photographs. Constructing a more vital presence would have satisfied both the sitter and his family, as well as Rand's own ends. Saint Gaudens presents not only as a recognizable individual, but also as one with professional status. Interestingly, by removing the sculptor from his studio surroundings, as he was depicted in many previous paintings and photographs, Rand depersonalizes him as an artist, rather granting him the generalized status that she infused in her male portraits, whether lawyers, statesmen, bankers, or artists. Without the distraction of supporting narrative, the focus is on the insightful projection of male identity, with strength, distinction, and dignity its foremost traits.

Rand used the portrait of Saint-Gaudens as reputation-building currency, including it in her second one-artist exhibition of some seventy portraits and additional black-and-white sketches, held at Copley Hall in Boston in January 1906. This prestigious venue previously held solo shows of works by Sargent, Whistler, and Monet, and now, for the first time, one of a woman artist. The exhibition marked the starting point of Rand's critical recognition for the success of her portraits of men, or "modern men of the somewhat worldly order," as one reviewer observed. The writer noted Saint-Gaudens's portrait "though not lacking in quality, is very quiet … the face is calm and reflective" a studied, and rather ironic contrast to the portrait of MacMonnies also on view, "nervous, impulsive and rather eccentric perhaps."[24] The following year, in March 1907 Rand had another solo exhibition in New York, with the Saint-Gaudens portrait among the twenty on view at Macbeth Gallery.[25]

While the painting was attracting critical favor in the press, it also earned notice from Saint-Gaudens's inner circle, foremost Charles McKim. He too had his portrait painted by Rand, destined for the American Institute of Architects, a requirement for its past presidents. McKim's portrait (1906; private collection, New York) did not ultimately end up there. Perhaps, as he wryly noted to Saint-Gaudens in an April 1906 letter, "I am uncertain just now whether her work is really intended for the Institute or the Rogue's Gallery, and admire her persistent determination to carry it to completion."[26] In spite of his reservations about his own likeness, he was "deeply impressed" by Saint-Gaudens's, and proposed to him "to have it placed, with the approval of the trustees, in the Metropolitan Museum, where it could be seen, not only by all your personal friends, but by the general public who know you only by reputation."[27] McKim, who served as a trustee of the museum from 1904 until his death in 1909, further reasoned:

> The more I think of it, the more I feel sure that a portrait of you, more worthy in every way, cannot be painted, and that, if this is so, it should be hung in the Museum of the Metropolis. It not only would become a precious possession for the Museum but an acknowledgement of Bay Emmet's standing as an artist,–of the utmost importance and value to her.[28]

McKim's motives were thus dual and entirely transparent—he acknowledged the boon to Rand's young career in having a painting in the collection of the Metropolitan Museum, and the implicit power of its placement. Likewise, he was participating in a larger movement to enshrine Saint-Gaudens's reputation at the museum, one that trustees, led by sculptor Daniel Chester French, belatedly acknowledged once the gravity of Saint-Gaudens's illness was well known. With only two minor works by Saint-Gaudens in the collection before 1905, the museum commissioned three marble relief portraits of his choosing as well as the bronze *Head of Victory* (1897–1903; cast 1907) from the Sherman Monument. While the reliefs were not completed until after Saint-Gaudens's death, *Head of Victory* entered the collection in spring 1907, just months before he died. Rand's painted portrait thus had the potential to act, among other things, to enhance the narrative of Saint-Gaudens's legacy at the Metropolitan Museum.

In spite of McKim's exertions, the acquisition of the painting hit its first of several roadblocks in its path to entering the collection. While Saint-Gaudens was honored at the prospect of a portrait "so good" at the museum, his wife Augusta and son Homer did not share his view, reminding him, "we have nothing of you that is good, everything was destroyed in the fire." Saint-Gaudens then proposed that Rand paint a copy for the Metropolitan, and that the original remain in his family.[29] At this point, it becomes clear that Rand and Saint-Gaudens never discussed the most basic of business transactions—who would own the painting—artist or sitter? Was it a commission, a gift, or a labor of love to remain in her possession? Or was it never specified? Correspondence over the next several years bears out the latter.

For the time being, at the Metropolitan at least, the matter was irrelevant. Assistant director Edward Robinson reported to McKim that although he found the portrait to be an excellent likeness, assistant curator of paintings, Bryson Burroughs, himself an artist, strongly disagreed. Burroughs, who would steward the acquisition of many major American paintings, was "doubtful whether as of a work of art it was of sufficient merit to find a place on the Museum walls ... he wondered whether [Rand] would be satisfied after a few years to be represented here by this portrait."[30] Robinson made it clear that the decision, whether made qualitatively or subjectively, was more about prominence of the sitter than the talent of the artist. He laid stress "upon the question whether the personality of Saint-Gaudens and the desirability of having a portrait of him here, even though not of the highest merit, should not outweigh the qualities of the picture as a work of art."[31] The matter rested in abeyance, Burroughs's judgment in acquisition matters for the time respected.

Several months later, Saint-Gaudens's suggestion of having his portrait copied rematerialized, though for an alternative purpose. Along with other international accolades, in 1905 he was named an academician of the Accademia di San Luca in Rome. To fulfill a requirement that he present a portrait of himself, he inquired whether Rand would be willing to paint a copy, finding "nothing of me that would be so acceptable as your painting."[32] Rand ultimately asked her close friend Mary Foote, who had also studied with MacMonnies in Paris, to carry out the work, charging the sculptor $250.[33] In May 1907 Rand wrote to Saint-Gaudens that she herself could not tell the difference between the original and the "excellent" copy and that McKim was to pass judgment on it, an act she hoped would serve as Saint-Gaudens's tacit approval. Why she chose not to do the copy herself is grounds for speculation—perhaps she felt it was not career-enhancing given the distant intended destination, or perhaps she liked the idea of commissioning another artist to copy her work even in spite of being an early career artist herself. Having dispatched the matter of the copy, Rand then boldly returned to the topic of McKim's "great desire" (her words) to have her portrait of the sculptor in the Metropolitan Museum. Proposing she make a copy for the Saint-Gaudens family and the original go to the Metropolitan, she quipped, "It is not a weakness to want to see your portrait in the Museum of Art, is it?"[34]

Homer Saint-Gaudens, who wrote to Rand on behalf of his father who was too ill to respond, saw the matter differently. His letter in response makes clear that Saint-Gaudens sat for Rand "in the belief that the portrait should become a precious heirloom

to the family." Foote's copy was not going to Rome after all, and he suggested it go to the Metropolitan. Of Rand's version, he was emphatic: "under no consideration could we give consent to have it hung permanently in the Metropolitan Museum ... There is a sentimental attachment to the original."[35] Rand ignored his request that the painting be shipped to Saint-Gaudens in New Hampshire, and in fact, she never responded to the letter.[36] By this point she certainly had full understanding the family's position; standing her ground, it would be another four years before the matter of ownership was definitively resolved.

Saint-Gaudens died on August 3, 1907. His death occasioned lengthy, front-page obituaries that unilaterally proclaimed him the leading American sculptor to date, no less than an artistic genius. Rand's painting became an important player in an immediate and well-orchestrated campaign by the sculptor's friends and family to martyrize "The Saint." Within the year, two monographs and many articles were published, several of them illustrating Rand's portrait, including in October 1907 the prestigious and widely circulated *Century Magazine*, edited by Saint-Gaudens's longtime friend and critical trumpeter Richard Watson Gilder.[37]

The most ambitious commemorative effort was an exhibition of 154 works of art held between March 3 and May 31, 1908, in the Hall of Sculpture (now the Great Hall) at the Metropolitan Museum. The show was organized by sculptor Daniel Chester French, a museum trustee and head of its committee on sculpture, with the cooperation of Augusta and Homer Saint-Gaudens and an exhibition committee of artists and worthies, including Kenyon Cox and Charles McKim. At French's behest, Cox painted an enlarged replica of his well-known 1887 portrait of Saint-Gaudens, which upon its completion was installed in the southwest corner of the exhibition space (Figure 4.8). Rand lent her portrait of Saint-Gaudens for the corresponding southeast spot.[38] A bronze bust of Saint-Gaudens by his assistant Henry Hering (1908; Saint-Gaudens National Historical Park, Cornish, NH) was installed on a wreath-adorned plinth in front of a plaster model of the Sherman Monument, completing a trinity of portraits.

The memorial exhibition to Saint-Gaudens afforded McKim the perfect platform to renew his quest to acquire Rand's painting for the Metropolitan, but it was done covertly. Shortly after the committee was formed and the exhibition announced in October 1907, the *New-York Tribune* issued a call for the Metropolitan to acquire a portrait of Saint-Gaudens; the writer knowledgeably cited specific examples destroyed in the Cornish fire and observed that Rand's would be a "valuable addition" to the collection, puffing it as "a wonderfully true likeness and a skilful [*sic*] piece of painting."[39] In December McKim wrote Rand a lengthy and illuminating letter that makes clear that his behind-the-scenes efforts to mollify her growing concerns over the issue of ownership. During a visit to Washington, DC, McKim had conferred about the matter with lawyer and former Secretary of War Elihu Root (who was then sitting for Rand and was a trustee of the Metropolitan) and transmitted counsel to Rand. Conceding it was a delicate situation, McKim advised Rand to settle the matter with Augusta Saint-Gaudens even as it was apparent Rand had clear title to the painting. Recusing himself from the negotiations as a member of the museum's Saint-Gaudens Memorial Committee (though clearly siding with Rand), McKim suggested once the

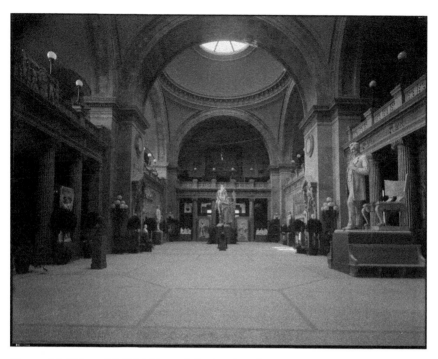

Figure 4.8 "Memorial Exhibition of the Works of Augustus Saint-Gaudens," Hall of Sculpture, The Metropolitan Museum of Art, view looking south, 1908, photograph, photo credit: The Metropolitan Museum of Art, New York.

matter of ownership was resolved that an offer to acquire it for the Metropolitan come from the museum itself, not from a group of Saint-Gaudens's friends, to avoid an appearance of taking sides as they themselves had longtime relationships with his widow and son.[40]

In April 1908, the acquisition of Rand's painting proceeded on those grounds. The movement to commemorate Saint-Gaudens by securing Rand's portrait was thus more powerful than curator Bryson Burroughs's objections. Rand was paid $2000, her first sale to a public institution, at what was considered "a special price."[41] At the same time the Metropolitan also received Cox's new replica, a gift through a subscription fund from friends of the artist. The dual acquisitions were celebrated by the museum and in the press, with Rand arguably benefiting from the fortuitous pairing of her work with the senior artist's celebrated picture.[42] Following the close of the Metropolitan's installation of the memorial exhibition, the paintings hung together in a gallery with other recent acquisitions before traveling to the Corcoran Gallery of Art for the second venue (December 7, 1908–January 17, 1909) of the five-stop tour.

There is no extant correspondence to confirm whether, as McKim had advised, Rand approached Augusta Saint-Gaudens directly about the matter of the portrait's ownership. Instead, it seems she contented herself with the knowledge that the

painting was in her possession and she had clear title, regardless of having failed to clarify circumstances with Saint-Gaudens at the outset. Rand's transactional moxie, whether cavalier or naïve, met its match in Augusta Saint-Gaudens, however. A shrewd negotiator, for many years Saint-Gaudens managed her husband's business affairs, as well as the production of his small bronzes, with acumen. After his death, she oversaw the production of an expanded repertoire of twenty-five small bronze sculptures in unlimited commercial editions into the early 1920s. She sold casts to American museums such as the Metropolitan, in order to generate income for herself as well as to protect and assure her husband's legacy.

Born in 1848, Augusta Homer Saint-Gaudens was twenty-seven years Rand's senior and when younger had herself trained as a painter. It is plausible that Rand's gender and relatively young age worked against her in what otherwise might have been seen as a watertight case in her favor, as the older and more seasoned Augusta Saint-Gaudens may have felt emboldened to pursue her junior female adversary. Among Saint-Gaudens's studio assistants and his friends, she was disliked, even feared, while at the same time earning their admiration for her steadfast loyalty to her husband through his marital infidelities and long illness. That the legal wrangling between Augusta Saint-Gaudens, executrix of the sculptor's estate, and Rand went many rounds is not surprising. Adjudicating this involved attorneys, testimony, court decisions, and press, yet may be readily distilled into two chapters of she said—she said.

The first chapter involves the Metropolitan Museum. When questioned by Augusta and Homer Saint-Gaudens in the months following the acquisition, officials at the museum denied any knowledge of the contentious issue of ownership, believing they innocently had purchased the painting in perfect good faith. For her part, Rand disregarded what was intended to be a guilt-inducing entreaty from Homer Saint-Gaudens "that since my father was a sick man he did not pose for this painting simply so that you might sell it elsewhere."[43] Museum trustees, frustrated by the recalcitrance of the opposing Rand-Saint-Gaudens camps to settle the matter of title, adopted a resolution in December 1908 asking Rand whether she would accept cancellation of the purchase and return of the portrait after the close of the Corcoran Gallery venue in January 1909, thus exiting the institution from the matter.[44] In early February 1909, with the painting physically back at the Metropolitan, Rand finally responded tersely to the museum's request: "I state in reply that I have no intention of taking any steps whatsoever, tending in any form to affect the title to the picture purchased."[45] That she boldly took on the leading American museum and its powerful male trustees is remarkable, and ironically perhaps she may have been driven such perseverance by the example of Augusta Saint-Gaudens herself.

Months of stalemate led to escalating tensions between the three parties. Augusta Saint-Gaudens and Rand were dug in to the extent that Metropolitan trustee Robert de Forest expressed frustration: "I have done my level best in my relations with both ladies concerned to settle it and so has Mr. [Joseph] Choate and so has [John] Cadwalader. There is nothing any of us can do."[46] Days later, in early December 1909, Augusta Saint-Gaudens brought suit against the Metropolitan to recover the portrait, attracting notice in the New York press. The case against the museum was quickly resolved, however. An order of discontinuance was issued by the court in January 1910, as

Augusta Saint-Gaudens dropped her claim against the museum, presumably because the referee for the court found insufficient evidence of the museum's liability.[47] She soon normalized relations with the Metropolitan, giving one and selling six sculptures to the museum over the next few years to form the core of its impressive holdings of Saint-Gaudens's work, even as the matter of the painting's ownership remained unresolved. That the Metropolitan was an important player in her campaign to burnish her late husband's lasting image also may have impacted her decision to end the suit promptly.

Instead Augusta Saint-Gaudens focused her litigation regarding the matter of ownership solely on Rand, filing suit against her in early 1911, contending that the painting was the property of the sculptor's estate. The case proceeded not only through in-courtroom examination of Rand as defendant, but also through a careful review of existing correspondence and witness interviews by the referee Charles H. Brown.[48] The judgment was reached and case dismissed on its merits with costs in June, with Brown making official what Rand had contended all along: she was the rightful owner of the portrait and that no evidence existed that the title had never been vested in Saint-Gaudens. In the end, the second lawsuit cost Augusta Saint-Gaudens well over $600 in legal fees.[49]

The lengths that Rand was motivated to go over several years to ensure that Saint-Gaudens's portrait remains at the Metropolitan is revealing. One facet concerns the power of personal relationships, allegiances between the painter and her social and artistic circles that she, and often they, felt were immutable. Correspondence surrounding the two successive lawsuits also indicates that a number of those involved with the Metropolitan felt a personal obligation to Rand to honor the circumstances of the purchase.[50] Trustees Charles McKim; Elihu Root (1907; unlocated); Joseph Hodges Choate (1908; Naumkeag, Stockbridge, Mass.), and perhaps others all sat for her before and during the unfolding saga. Another aspect revolves around Rand's perceptions of career development and life stages. Her first ten years in New York (1900–1910) may be characterized as a period of reputation establishment in which she found her way through trial, error, and the power of association. A successful solo exhibition at Macbeth Gallery in January 1911, her marriage in May amid the ongoing legal wrangling, and the suit's culmination in June corresponded to a transition to the next, mature phase of her career. Her business individuated beyond reliance on others to facilitate commissions and name recognition to become a successful and efficient operation for the next three decades. The incident with the Metropolitan, the lawsuit with Augusta Saint-Gaudens, and Rand's unyielding position did not damage her career. In fact, her gamble likely propelled it forward.

Thus, in 1905 Saint-Gaudens gave Rand the privilege of painting his portrait, and for the cost of paint, canvas, framing, and labor, the resulting image garnered her incalculable reputation collateral. Twenty years after its acquisition, a feature article for the *American Magazine of Art* cited the presence of Rand's portraits of Saint-Gaudens and merchant and art collector Benjamin Altman (1914) at the Metropolitan as evidence of her ability to perceive and convey individual personality.[51] It is hardly surprising that Rand continued to promote her association with the Saint-Gaudens portrait—and its placement at the Metropolitan Museum—throughout her career; indeed it remains one of her several best known to this day of some 800 that she painted.

Notes

1 Opinion of Charles H. Brown, Referee, in *Augusta H. Saint-Gaudens v. Ellen Emmet*, United States Circuit Court, Southern District of New York, May 26, 1911, copy in Ellen Emmet Rand Papers, Archives & Special Collections, University of Connecticut Library (EER Papers, ASC, UConn), Box 1, Folder 2. In Rand's testimony, she incorrectly remembered the date she and Saint-Gaudens met and that she had painted the portrait in February or March 1904. Her mother, who was also present in 1904, remembered the encounter taking place in November or December.

2 On Saint-Gaudens, see John H. Dryfhout, *The Work of Augustus Saint-Gaudens*, rev. ed. (Hanover, NH: University of New England Press, 2008; first published, 1982); Henry Duffy and John H. Dryfhout, *Augustus Saint-Gaudens: American Sculptor of the Gilded Age* (Washington, DC, 2003); and Thayer Tolles, *Augustus Saint-Gaudens in The Metropolitan Museum of Art* (New York, 2009).

3 Louis St. Gaudens to Annetta Johnson St. Gaudens, October 23, [1902], Augustus Saint-Gaudens Papers, Rauner Special Collections Library, Dartmouth College, Box 32, Folder 45 (Saint-Gaudens Papers).

4 Thanks to Stephanie Cassidy, Archivist, The Art Students League of New York, for providing documentation for Saint-Gaudens's teaching history and Rand's student enrollment status (recorded as Miss E[llen] G. Emmet). Saint-Gaudens taught at the League until 1897 when he moved to Paris.

5 On MacMonnies, see Mary Smart, *A Flight with Fame: The Life and Art of Frederick William MacMonnies (1863–1937)*. Catalogue raisonné of sculpture and checklist of paintings by E. Adina Gordon (Madison, CT, 1996).

6 Jane Emmet to Lydia Field Emmet, February 1896 or 1897. Emmet family papers, Archives of American Art (Emmet Family, AAA), Box 4, Folder 27.

7 Rand to White [undated, *c.* 1897], Stanford White Papers, New-York Historical Society.

8 Jane Emmet to Lydia Field Emmet, May 24, [1897], Emmet Family, AAA, Box 4, Folder 30.

9 Lydia Field Emmet to her mother Julia Emmet, November 24, 1897, Emmet Family, AAA Box 2, Folder 37. Lydia Field Emmet to Julia Emmet, February 18, 1898, Emmet Family, AAA Box 2, Folder 38.

10 Saint-Gaudens to [unidentified Emmet sister], Emmet-Rand Personal Papers, courtesy of Felicia Garcia-Rivera. Cited also in Rand, *Dear Females*, 117. The letter dates to late 1897 or early 1898 as Saint-Gaudens had his studio contents shipped to Paris when he left New York.

11 Three photograph proofs are in Emmet Family, AAA, Box 9, including ones of Saint-Gaudens standing full-length in front of plaster casts of the John Hudson Hall tomb and *The Puritan*, and a half-length view with his head turned three-quarters to the right. Leslie Emmet, Rand's sister, also wrote of the visit in an undated fragment of a letter reproduced in Rand, *Dear Females*, 68.

12 Lydia Field Emmet to Jane Emmet, postmarked April 12, 1898, Emmet Family, AAA, Box 2, Folder 39.

13 Saint-Gaudens and Paul Bion engaged in a voluminous correspondence for more than two decades, Bion keeping Saint-Gaudens informed about the artistic scene in Paris as well as MacMonnies's progress. The extant letters from Bion to Saint-Gaudens (housed in the Saint-Gaudens Papers) contain frequent allusions to the tension of the Saint-Gaudens-MacMonnies relationship. See also E. Adina Gordon,

"The Lure of Paris," in *Augustus Saint-Gaudens, 1848–1907: A Master of American Sculpture* (Paris, 1999), 91–8.

14 MacMonnies to Miss [Lydia Field] Emmet, March 13, 1898, Emmet Family, AAA Box 7, Folder 29.

15 White to Rand, March 27, 1901 (copy), and White to Durand-Ruel, March 27, 1901 (copy), Stanford White Correspondence and Architectural Drawings, Avery Architectural and Fine Arts Library, Columbia University, outgoing correspondence, vol. 25, 255, 257 (White Correspondence).

16 That Rand would have paid to use the space is suggested in an earlier letter (*c.* April 2, 1901) to White about negotiations with Durand-Ruel: "They told me the price for renting the gallery is $500 per week, but that they would reduce it on account of you." White Correspondence, incoming correspondence, Box 13, Folder 12.

17 White to Rand, October 12, 1903 (copy), White Correspondence, outgoing correspondence, vol. 29, 342. See American Art Galleries, *Loan Exhibition of Portraits for the Benefit of the Orthopaedic Dispensary and Hospital* (New York, [1903]), nos. 77–79. In addition to the portraits of MacMonnies and Metcalfe, Rand's likeness of J. Kennedy Tod, a banker and railroad executive, was also included.

18 Opinion of Charles H. Brown, Referee, in *Augusta H. Saint-Gaudens v. Ellen Emmet*, United States Circuit Court, Southern District of New York, May 26, 1911, copy in EER Papers, ASC, UConn), Box 1, Folder 2.

19 Apparently, upon seeing a photograph of Rand's portrait of Mrs. [Florence] Cross in July 1899, Saint-Gaudens said, "Why, that is one of the best Sargent's [*sic*] I've seen." Mary Foote to Lydia Field Emmet, July 2, 1899, Emmet Family, AAA, Box 7, Folder 12. Florence Cross sat for Rand in London in early 1899.

20 On the Cox portrait, see T[hayer] T[olles], *Augustus Saint-Gaudens, 1848–1907: A Master of American Sculpture*, 100–1. Cox also completed a shoulder-length frontal portrait of Saint-Gaudens (1888; National Academy of Design, New York).

21 Kenyon Cox, "In Memory of Saint-Gaudens," *Architectural Record* 22 (October 1907): 249.

22 Saint-Gaudens to Rose Nichols, January 17, 1905, Rose Standish Nichols Papers, Houghton Library, Harvard College Library (MS Am 2656), Box 1, Folder 7; and Saint-Gaudens to Nichols, January 20, [1905] (typescript copy), Nichols Papers, Box 2, Folder 6.

23 Opinion of Charles H. Brown, Referee, in *Augusta H. Saint-Gaudens v. Ellen Emmet*, United States Circuit Court, Southern District of New York, May 26, 1911, EER Papers, ASC, UConn, Box 1, Folder 2.

24 "In Copley Hall. Miss Ellen Emmet Exhibits Some Exceptional Work. Unique Study in Modern Men," unidentified clipping, [January 1906], EER Papers, ASC, UConn, Box 1, Folder 11.

25 Macbeth Gallery, *Exhibition of Portraits by Ellen Emmet from March Eleventh to Twenty-third 1907* (New York, 1907), no. 5.

26 McKim to Saint-Gaudens, April 13, 1906, Charles Follen McKim Papers, Library of Congress, Box 5, Letterbook, vol. 15 (hereafter McKim Papers). Copy in Archives, The Metropolitan Museum of Art, Paintings Purchased—Emmet—Saint-Gaudens (P1660).

27 Ibid.

28 Ibid.

29 Saint-Gaudens to McKim, April 16, 1906 (copy), MMA Archives.

30 Edward Robinson, Assistant director, MMA, to McKim, May 26, 1906 (copy), MMA Archives.

31 Ibid.

32 Saint-Gaudens to Rand, August 21, 1906 (copy), Saint-Gaudens Papers, Box 6, Folder 24.

33 The Foote copy never was given to the Accademia di San Luca; somehow it passed to the architect Thomas Hastings. In 1955 it was donated to the National Academy of Design by Jessie Mann, who had received as a bequest from Hastings. David Dearinger, ed., *Paintings and Sculpture in the Collection of the National Academy of Design, Volume 1, 1826–1925* (New York and Manchester, 2004), 99.

34 Rand to Saint-Gaudens, May 28, 1907 (copy), Saint-Gaudens Papers, Box 6, Folder 24.

35 Homer Saint-Gaudens to Rand, June 6, 1907 (copy), Saint-Gaudens Papers, Box 6, Folder 24.

36 As noted in Opinion of Charles H. Brown, Referee, in *Augusta H. Saint-Gaudens v. Ellen Emmet*, United States Circuit Court, Southern District of New York, May 26, 1911, copy in EER Papers, ASC, UConn, Box 1, Folder 2.

37 The portrait was reproduced as a half-tone plate engraved by H. Davidson. See *Century Magazine* 74, no. 6 (October 1907): 910.

38 Metropolitan Museum of Art, *Catalogue of a Memorial Exhibition of the Works of Augustus Saint-Gaudens* (New York, 1908), 66, no. 129. For an overview of the exhibition, see Tolles, *Augustus Saint-Gaudens in The Metropolitan Museum of Art*, 50, 54–5.

39 "Art Exhibitions," *New-York Tribune*, November 6, 1907, 7.

40 McKim to Rand, December 3, 1907, McKim Papers, Box 6, Letterbook, vol. 17.

41 That Rand lowered her usual price for a portrait is suggested by a letter from Metropolitan trustee Robert de Forest to Macfarlane & Monroe, counsel for Augusta Saint-Gaudens, January 12, 1910, MMA Archives: "The difficulty is that we have bought the picture from Miss Emmet at a special price, based upon the understanding that we should retain it permanently."

42 See, for instance, an extended comparison of the two paintings in "Art at Home and Abroad. Some Recent Pictures Acquired by the Metropolitan Museum of Rare Interest," *The New York Times*, July 12, 1908: X6.

43 Homer Saint-Gaudens to Rand, July 23, 1908 (copy), MMA Archives. Much of the correspondence concerning the dispute, both in original and copy, is held in the MMA Archives.

44 Resolution of Executive Committee, MMA Board of Trustees, December 21, 1908, MMA Archives.

45 Rand to Dear Sirs, MMA, February 12, 1909, MMA Archives.

46 De Forest to Frederick S. Wait, December 6, 1909, MMA Archives.

47 See, for instance, "Discontinues St. Gaudens Suit," *New York Tribune*, January 30, 1910, 9.

48 Opinion of Charles H. Brown, Referee, in *Augusta H. Saint-Gaudens v. Ellen Emmet*, United States Circuit Court, Southern District of New York, May 26, 1911, copy in EER Papers, ASC, UConn, Box 1, Folder 2. For representative press coverage, see "Mrs. Saint-Gaudens Loses. Ellen Emmet's Portrait of the Sculptor Found to be the Painter's Property," *The New York Times*, June 23, 1911, 11.

49 See entries in the plaintiff's expense account book during 1911, notably July 10
 ($306.97 to Bowers & Sands) and July 17 ($310.85 to Mcfarlane & Monroe), pp. 97–8,
 Saint-Gaudens Papers, Box 53.

50 See, for instance, Robert de Forest to Macfarlane & Monroe, January 12, 1910 (copy),
 MMA Archives.

51 Grace Wickham Curran, "Ellen Emmet Rand, Portrait Painter," *American Magazine
 of Art* 19, no. 9 (September 1928): 478. Rand painted the portrait of Altman (1840–
 1913) posthumously from a photograph and it was presented to the museum by his
 estate along with the most valuable bequest of art that it had received to date.

Work What You've Got: The Contrasting Careers of Tade Styka and Rand

William Ashley Harris

Tuesday, October 29, 1929, dawned fair and mild in New York City. After lunch, with "bags and baggage," in hand, Ellen Emmet Rand left a Manhattan hospital. She had been under a doctor's care since the previous Friday, having fallen from her horse and broken a wrist. Alone in the hospital over the weekend, her husband having decided to hunt, she noted in her diary that "I am to be orphaned. It is a bad morning for anything." Yet, in spite of the fall and the boredom of a hospital stay, Rand was enjoying a prolonged period of professional success. She was finishing a portrait of a Vermont governor and looking forward to several new commissions.[1]

Across the Atlantic in Paris, France, Polish portraitist Tadeusz "Tade" Styka (Figure 5.1) was preparing for his voyage to the United States. That same Tuesday, he obtained his traveling papers in the French capital.[2] Styka was returning to America with a commission from the Polish government to paint a portrait of President Herbert Hoover.[3] He also planned to visit wealthy friends and fellow Poles in the Midwest and exhibit works in Chicago.[4] The New York social scene also offered an artist with Styka's talent and European charm opportunities to mingle with potential clients, discuss exhibition opportunities with dealers, and make long-term contacts that might result in new commissions.

Yet all was about to change for both artists: not dramatically at first, but slowly, over time. By the end of the day, the New York Stock Exchange lost 25 percent of its value.[5] Rand recorded matter-of-factly in her diary that "the stock market went completely to the limit yesterday and tonight is worse. It has never reached such a low in its history." That day would soon be known as Black Tuesday, the beginning of the worst depression in American history. By the following evening, Rand's financial position evidenced market losses. "I had to sit at the telephone while in bed … dealing with money matters, finally providing $3,500 to hold certain securities."[6]

A week later, Styka embarked from Cherbourg on the luxury liner RMS *Berengeria*.[7] Market conditions were almost certainly a topic of conversation among his fellow first-class passengers. He was traveling among a set of wealthy Americans and Europeans, including fashion designer Elsa Schiaparelli, the Princess Lieven, and Milwaukee businessman F. G. Comstock.[8] As the ship sailed out of the English Channel past Land's

Figure 5.1 Photography of Tade Styka, *c.* 1930, https://commons.wikimedia.org/wiki/Category:Tadeusz_Styka.

End, the mood in US business sectors was dark, and *The New York Times* offered a front-page story on the suicide of a noted, local banker who was rumored to have suffered heavy, personal losses.[9]

Portraitists like Rand and Styka and a host of other artists had always competed for commissions, relying on talent, reputation, and contacts to remain in business. Their art was their commerce, their product. As the Great Depression worsened from 1930 through 1933, the magnitude of the economic calamity became steadily apparent to artists in terms of reduced commissions and sales prices and customers unwilling or unable to pay. Money grew tight. The future seemed bleak indeed. Yet Rand and Styka survived—no lost homes, no lost families, and no lost futures.

How did two very different artists like Rand and Styka adapt to and navigate those times? How did gender and social position influence their choices and their

opportunities? The answers are revealing and offer a unique opportunity to explore how two very different artists exploited their strengths in pursuit of their art. Though they had shared certain similar experiences as emerging artists, they took decidedly different courses as their careers progressed, adopting personalized business models that reflected their individual preferences and unique styles. Some of these choices were influenced, if not governed, by both gender and social position, others by choice and opportunity. In the end, they both succeeded in spite of historical events and social constructs far beyond their control.

In terms of education, Rand undertook more formal education than Styka, but both studied privately with noted artists from a young age.[10] In Styka's case, his primary teacher was his father, Jan, a Polish artist noted for his epic paintings of classical and biblical subjects, as well as an eclectic array of artists, models, and writers who frequented his father's Paris atelier.[11] This was not unlike the milieu in the studio of Rand's mentor, Frederick MacMonnies. Both artists also relied on family connections to advance their careers. Rand could call upon her cousin Henry James or architect Stanford White for career advice and letters of introduction, and Styka had access to a host of his father's Parisian contemporaries, such as Jean-Jacques Henner, and a close-knit community of Polish emigres.[12]

In one key area of professional development, however, their careers diverged markedly. In the United States, Styka seemingly sought out and certainly encouraged press attention.[13] A childhood prodigy of enormous talent, he first visited the United States with his father in 1904, and numerous news stories noted his "nascent celebrity."[14] Photographs of him nattily clad standing alongside his widely publicized portrait and portrait bust of Leo Tolstoy announced the arrival of a new star.[15] Press coverage continued unabated into young adulthood.[16] He was notable enough that psychologist Alfred Binet, inventor of the IQ test, conducted a study of him. Binet acknowledged Styka's natural talent, but he also commented on the young man's stated intention of becoming not just a good artist, but a famous one.[17]

For women artists like Rand, the social and artistic worlds, especially in relation to the popular press, were often in direct conflict and had to be navigated delicately. No flippant, forgettable news columnist reported Rand's relationship with her instructor, MacMonnies, a liaison ripe for scandal and ruin, and one that ended badly for Rand, who left France for an extended stay with her cousin, Henry James (see previous chapters by Elizabeth Lee and Thayer Tolles for more insight on this relationship). Scandals from the period inevitably cast the woman as either the injured party forever ruined or a woman in need of social sanction; there was little room for error if a woman wanted to earn a living as an artist.[18]

Of course, a woman artist's need to maintain a scrupulous outward appearance of respectability did not preclude private choices regarding sexual activity and sexual partners. In fact, Rand may have had a relationship with the wealthy art collector Robert Allerton for several years after her return to New York City in 1901.[19] She certainly entertained and led an active social life with friends, fellow artists, and family.[20] But in 1911, at thirty-six, Rand made a key decision that would inform and perhaps secure her career. She wed the much younger William Blanchard Rand.[21] What would ultimately become a troubled, disappointing marriage produced three sons in quick succession. Yet the marriage and motherhood came with benefits to her career

that she no doubt carefully considered. The union signaled, lest any doubt existed, that she was one among those in classed terms whose commissions she sought.[22] Propriety, too, may have influenced her decision. Painting married men alone in the atmosphere of an artist's studio could lead to gossip about her reputation which would not have been good for business.

By the end of the 1920s, Rand divided her time between a Connecticut farm and her New York studio, her career a success, her clientele one of debutantes and dowagers, business leaders and elected officials, family members and friends at $3000 to $5000 per canvas (see Susan Spiggle's chapter for more details on her marketing acumen).[23] Though adept at rendering women and children, she was most noted as a painter of men.[24] Her talent was respected by her peers, and she exhibited regularly, her portraits capturing the likenesses of her subjects as well as their personalities, their positions, and their times.[25] She worked hard at her profession, at her art, and provided primary, ongoing support for her family, including her mother and sister, Leslie, an expensive undertaking with three children in private school, a New York studio, and a horse farm in Connecticut.[26] Her life throughout the 1920s was lived tastefully well in a world of hunt clubs and country houses, art galleries and dinner dances. She made her choices, lived with them, and succeeded.

In Europe, Styka parlayed his early notoriety into a successful career. His easy, natural style seemed casual and unforced, though perhaps too florid and rushed for some reviewers, or too derivative of Giovanni Boldini, the Italian portraitist with whom he was sometimes compared.[27] Styka was a young man who wanted to be not just a good artist, but a famous one, and only the tumult of the First World War slowed his progress.[28] As the world changed rapidly throughout and after the war, he adapted his art to the times, painting portraits of contemporary luminaries and a generous sample of beautiful young women, notably for postcards and publications, which supplemented his income when commissions ran low.[29]

Yet by the 1920s, he was no longer a boy genius, and in what seems like a move as calculated as Rand's marriage, he carefully developed and tended the image of a continental gentleman with an air of old European style that played well in the America of the Roaring Twenties.[30] He could have stepped out of an Elinor Glyn novel with his head of wavy brown hair; sturdy, athletic build; aristocratic bearing; and whiff of romanticism.[31] Acknowledged as a painter of great talent, Styka also highlighted his masculinity, heading off any notion that he was an effete, effeminate aesthete. His was a carefully modulated public image that made the most of his manhood yet at the same time played down any risk he might pose to a proper woman's respectability.[32] Starlets and artist's models were another story.

After the First World War, Styka came to the United States for the first time since childhood. The plentiful clientele and easy money of the period were no doubt irresistible attractions.[33] So too unquestionably was the lure of fame. He had already gained credibility as a serious artist through the Paris salons and his paintings of great men, but his works of women, especially motion picture and stage stars, brought him popular attention outside the arts sections of newspapers, as did his images of nude or nearly nude women for postcards.[34] Of course, he continued to paint men, such as Senator William A. Clark, but Clark's wife and daughter Huguette proved more lucrative clients in the long run, especially after the senator's death.

By the early 1920s, Styka had firmly established his public persona as a well-dressed, impeccably mannered, yet manly, painter of women and acknowledged expert of them, too.[35] His public persona came along with any commission. To be painted by Styka garnered attention for him and his subjects. He made plenty of money, charging twice Rand's going rate, reflecting not only his fame, but likely his gender as well.[36] Indeed, keeping up appearances and maintaining a lifestyle essential for well-heeled circles in both Europe and the United States required a great deal of money. He needed the best of everything from clothes to first class accommodations.[37]

To appreciate his public persona, one need only examine a 1923 scandal that involved movie stars and romance. The controversy caused no harm to Styka's reputation, but would have undoubtedly ruined the credibility and standing of a woman artist like Rand. The business began with his daring portrait of Polish screen siren Pola Negri (National Museum in Warsaw, 1922)—a naked back, a string of pearls, furs sensuously screening eager eyes from moral disaster. According to the press, after the sitting came a torrid affair.[38] It ended when Negri jilted Styka in favor of movie star Charlie Chaplin.[39] She soon decamped for Hollywood. The painter followed, though his primary reason for traveling to California was likely to exhibit in Los Angeles.[40] The melodrama played out in headlines across two continents.[41] Though Styka lost Negri's heart, he won something else—copious news coverage, not bad for business.[42] Thus, Rand and Styka, two successful portraitists with two very different lives and approaches to their careers, continued on with business as usual in their own respective manners as the tumultuous month of October 1929 passed into November. During the first two weeks of that autumn month, Rand worked on several commissions, visited her sons at boarding school, taking in a polo match, and attended a family friend's funeral.[43] She nursed her broken wrist and regularly saw a specialist in the city. As for Styka, upon landing in New York, he was greeted by an eager press. Photographed hat in hand, posing elegantly for the cameras and "drawing sighs from the smartly dressed young men of Manhattan," he took questions on deck while showing off a tailored top coat and dandy cane.[44] Sartorial splendor was part of his persona.[45] He had arrived.

The initial shock of the stock market crash quieted as the notion of widespread depression and economic collapse seemed offset by a sense that the market would rebound. As *The New York Times* reported, "the period of financial hysteria has passed, and with it is rapidly blowing away the feeling of uneasiness which has permeated the country during the last month, due to the slump."[46] Certainly Rand's diary and Styka's public insouciance at the time support the notion that after the first jolt, the dramatic market collapse and stockbroker suicides, a degree of cautious normalcy was returning to Wall Street. No less a sage than Walter Winchell, whose gossipy, often mean-spirited column appeared in papers nationwide, reported that Styka, "who charges them 10 Gs for their portraits, is here [in New York] from Paree looking for chumps."[47] It would be business as usual—everyone hoped.

Yet, the economy ultimately slowed. In March, Rand paid her income tax, over $8000, an enormous sum that evidences her healthy 1929 income.[48] She noted in her diary that she would need to be "unextravagant [*sic*] this year," but then proceeded to buy a cottage in Old Chatham, Connecticut. By November, she was forced to provide $2500 to hold an account, but did so on the same day she bought an evening dress with sable trim. Even Rand appreciated the contradiction emerging in terms of her

financial position and spending. "I found I had very little money in the bank and I need a lot, but this is largely my fault. I am too d—-d [*sic*] extravagant," she observed knowingly.

In search of commissions, Styka traveled to the Midwest with its large communities of Polish immigrants. In Chicago, he exhibited at the Knoedler Galleries. A local newspaper gushed that the Pole "demands either absolute quiet or a rush of all the hyperbolic adjectives in the dictionary. If there is genius in the world today, Styka is possessed of it," the author lauded. He went on to Milwaukee and Detroit where the mayor of neighboring Hamtramck, with its large Polish population, presented him with a palette.[49] He returned to Europe in late summer 1930, and, for the next few years, split his time between New York and Paris. On transatlantic voyages, he was noteworthy enough to be mentioned by the press along with an array of famous passengers.[50] On both sides of the Atlantic, he continued to garner newspaper attention for his artistic prowess and personal life.[51]

Shortly into 1931, Rand's need for ready funds became acute. She made plans to speak with her financial manager about borrowing against her life insurance. "I must raise $3000 to pay every bill right away," she proclaimed in her diary. Yet, out of hope, stubbornness, or sheer denial, she promptly went shopping for dresses and a hat. Two days later, she worked with her husband to figure "out ways to pay bills," as they had overdrawn their bank account. She hustled for even modest sums of cash and scrounged for work. Painting a portrait on speculation in hopes a subject would pay for the finished canvas proved a fruitless effort, but she tried.[52] She even undertook a drawing for a customer who could not afford a painting and charged only $400. Having demanded upward of $5000 for a canvas in 1929, she now worked for $1500 to $2500 (see Susan Spiggle's chapter for the details of her year-to-year prices). Customers failed to remit final balances due as well. "What worries me," she jotted in her diary, "is how to get more money–it is hard to make people pay."[53]

Rand entered 1932 in a dark mood tempered by the knowledge that she had spent her life scrambling for funds; nevertheless, she expressed a sense of hope that all would be well no matter what. The unseasonably warm weather made her want to hunt, but she acknowledged that it cost too much "to keep the horses up" and worried about the fall hunting season. The cost of her three sons' education came to mind, and she was torn about the need for college, wondering whether a training course might be more beneficial. Money woes were "the absorbing problem for everyone," she observed, but tried to find some good in the dire situation and noted that her family was happy and healthy and "that's all that matters."[54]

Yet in stark honesty after the new year in 1932, she wrote in her diary, "the reason why I dwell on financial matters is because all my life, or since I was 15 years old, I have had to produce cash." Hustling for money was a habit, she recorded, that she "would gladly give up, but I probably never shall." She went on to add that she "could live on a dollar as I lived on ten years ago," and then somewhat disingenuously offered that "it is fun to economize. I wish I had been doing it in the past 3 years. I'd have a lot now. Well that can't be and couldn't be." Her frustration and concern are understandable as she did not want to lose everything. Ultimately, also, it was not simply her but several people whose lives depended on her career.

The reduced number of commissions led to stark choices. She wrote to a client, asking for only $1000 of the $2400 owed. Any money was better than none. She passed on hunting, fearing any injury that would keep her from working. "Goodness," she worried, "everyone is trying to withdraw from paying." She decided to let a groom go and sign a note on her Ford. She wrote attraction letters to drum up business. February brought trouble letting an investment property even with rent reduced to a "depression price." Scarce funds and trouble with one of her sons made her reflect that "the whole value in life is making use of natural resources ... I did not seem to realize that until a little while ago I just wasted my talents. Now, I know it is all I have."[55]

The grim financial situation worsened. She tried to mortgage the Connecticut farm. "We are in a momentary financial deadlock," she recorded in mid-March, "and I hope and believe we will get out of it all right in the long run." Borrowing against securities offered some money and momentary peace of mind, but then in June, her financially and emotionally troubled half-brother Grenville Hunter committed suicide. And the bills kept coming. Her second son was accepted to Yale adding yet another expense. Few could afford even her "very lowered prices," but she hoped "portraits will come around." By October 1932, she was owed $6000 toward executed commissions, roughly $100,000 today.[56]

It was the presidential election of Franklin D. Roosevelt that would ultimately and radically impact both Rand's and Styka's careers, breaking for them, as the president did for many Americans, the impact of the Depression. Rand had long associations with the Roosevelts especially through the Delano family, but regardless of any personal connections, the strongly Republican Rand was not enthusiastic about his election. She wrote: "Well, I suppose we must bow to the inevitable and accept with all possible graciousness the election of Franklin Roosevelt." Grudgingly, she added, "I suppose he got it by fair political means. At any rate, he's President for 4 years."[57]

With the Depression worsening, Styka began 1933 with a new, unconventional business opportunity for selling his paintings. Having charged as much as $10,000 for a portrait in 1929, by 1933 he was asking between $1500 and $5000 per painting.[58] Ever hustling for funds, he entered into an arrangement with designer and decorator James Mont, described as "the George Raft of American design, with a carnation in his button hole and brass knuckles in his pocket."[59] Born Demetrios Pecintoglu in Istanbul, Mont was violent-tempered and unpredictable, and, though talented, he was known for doing business with organized crime.[60]

Styka and Mont became friendly, if not friends, and Mont promoted Styka to his varied clientele. In mid-1933 Mont established a gallery in Atlantic City and attempted to sell Styka's work. Short of funds, Styka agreed to give Mont a 25–30 percent commission on any sales. Styka consigned $100,000 worth of art to Mont; however, the venture proved unsuccessful. Mont lost his entire investment. Styka lost nothing out of pocket, but the lack of sales must have been disappointing. In fact, still in need of money, Styka offered to sell Mont two canvases originally priced at $2500 each for $1000 total, but Mont demurred, having lost money on the Atlantic City project.[61] The artist soon after returned to Europe.[62]

Styka's arrangements with Mont evidence not only the artist's obvious need for money, but also his freedom—gendered and classed—to explore unconventional

methods for promoting his work and earning income without necessarily sacrificing his position in respectable society.[63] His choices of associates and methods of conducting business, however, did place him at risk, both personally and professionally. Even he acknowledged that it was not common for an artist of his caliber to work in conjunction with an interior decorator, especially one with Mont's questionable reputation.[64] Yet, considering the difficult times, the immediate risk to Styka's career was relatively negligible considering the alternative was potential financial insolvency.

Though Rand was facing similar, difficult financial circumstances, she never substantively varied from her business model, courting clients within her social circle and accepting commissions referred to her by former customers, friends, and family. She had no other tenable options if she wanted to remain a credible, professional portraitist. There can be little doubt that had she entered into any arrangement with a man like Mont that she would not only have lost standing within her social circle, but also suffered severe repercussions as a "respectable" woman and serious artist. Dire times required dire actions, but actions and options had to be weighed against gendered and classed repercussions.

Rand confronted 1933 no differently than 1932, even as her financial situation grew worse. First, she borrowed $700 from her financial manager. Then, to Wall Street she went seeking money to defray the cost of her sons' college tuition only to be rebuffed by the bank.[65] As financial institutions failed daily, unable to withstand runs by nervous depositors, the new president ordered a bank holiday.[66] With tellers idle and cash running low, Rand pleaded with a banker friend to cash a check. Fortunately, Roosevelt's actions proved successful in stabilizing the immediate financial crisis and signaled some respite for Rand. She obtained a commission to paint Henry L. Stimson (former Secretary of State and future Secretary of War) in Washington and learned that the president might be inclined to commission her to do his portrait. She was hopeful enough to leave her card at the White House on April 18, 1933.[67] Then came good news in a letter from Eleanor Roosevelt. "Today was mostly notable for the fact that I did get a real honest to God order to paint President Franklin D. Roosevelt for the White House," she recorded with amazement in her diary.[68] "I had a letter from Eleanor Roosevelt," she continued, "in which she said that he wanted me to paint him at any time at Hyde Park." The long, lean years of crisis seemed at an end.

Styka returned from Europe on December 20, 1933.[69] His prospects were likewise improving. In early February, the Wildenstein and Company Gallery at 17 East 64th Street in Manhattan hosted an exhibit of his work. Included were his recent portraits of the crown prince and princess of Italy. A *New York Times* review was generally favorable, though somewhat tongue in cheek: "Tade Styka could become famous as a painter just of dogs, had he a mind … There is a beautiful collie in one of the canvases and several other breeds are to be remarked here and there, tucked away as engaging accessories." The review went on to note in extraordinary language that "this fashionably resourceful artist does not paint all of his subjects with a brush that has been dipped into the heart of a gilded marshmallow and that has plundered the orchid of her beauty."[70]

Little could Styka have realized whom he would soon be painting, for two commissions that February and March would take him into vastly disparate worlds.

Just around the corner from the Wildenstein Gallery, at 47–49 East 65th Street, lived a matron of the highest repute whose far reaching connections would be beneficial to any artist seeking work.[71] Her name—Sarah Delano Roosevelt—the president's mother. She was not new money like the Vanderbilts and Rockefellers, but instead she represented old New York aristocracy.[72] The details of how Mrs. Roosevelt came to select Styka as her portraitist are unknown. Regardless, the estimable Mrs. James Roosevelt commissioned Styka to paint her portrait (Plate 8). It would be a gift to her only child for Mother's Day.[73]

Also that winter, Mont, who had been seeking subjects for Styka, introduced him to his richest, most powerful client—none other than Joe Adonis, one of the most notorious mobsters in the country.[74] An intensely vain man, hence his self-chosen name, Adonis was purportedly a rapist and murderer and controlled the rackets, from prostitution to gambling, throughout Manhattan and Brooklyn.[75] That Styka knew of Adonis' reputation must be assumed, and Mont lobbied Adonis to commission a Styka portrait.[76] Adonis demurred at first, likely at the price, but eventually relented. The painting would be of Mrs. Adonis and their young son, not the mobster himself. To seal the deal, Adonis invited Mont and Styka to a spaghetti dinner at his Brooklyn home. When asked later if he had enjoyed the meal, Styka responded without hesitation, "yes, indeed."[77]

In a curious twist, the Adonis meeting occurred on the same day that Styka began painting Mrs. Roosevelt at her Upper East Side townhouse.[78] The contrast must have been jarring. He would alternate sittings between the president's proper mother and Adonis' wife and infant son.[79] One can easily imagine Styka gossiping in French with the worldly Sarah Delano Roosevelt, who had lived in Asia and Europe, about current events and common acquaintances in New York and abroad. One can just as easily picture him perhaps self-consciously, and nervously, dabbing at his palette with not only Mrs. Adonis and junior looking on, but also the mob boss himself along with his coterie of protectors and loyalists.[80]

Rand's FDR likeness first appeared publicly at the Museum of the City of New York in April 1934 and received widespread notice and much praise in the press. The *New York Times* reported that Eleanor Roosevelt approved the final canvas after a visit to Rand's studio (see Emily Mazzola's subsequent chapter in this collection for more on the FDR commissions and portraits).[81] The paper made mention of the fact that Rand had removed a smile from the president's face at his request, and she praised the president as "a very good subject, a very willing sitter."[82]

Styka's portrait of Mrs. Roosevelt draped in sables appeared in the press in early May. Like Rand's work, his painting was covered extensively by the media.[83] On Sunday, May 6, 1934, Mrs. James Roosevelt surprised her son with the work.[84] He had spent the day on the presidential yacht, *Sequoia*, and returned to the White House to find his wife and her guests, along with his mother and Styka, at tea on the south portico. Mrs. Roosevelt allowed Styka to make the presentation, and the pleased president had the work hung in a prominent place in the White House.[85]

The pair of Roosevelt portraits are striking for a number of reasons beyond their aesthetic qualities. Rand, the woman artist of great men, painted the great man himself, FDR, the man of the people, the Democrat and democrat, the betrayer of his class, a class

to which Rand belonged, but betrayal was relative when a commission was involved. The fashionable European portraitist, the man who cultivated an elegant and exotic persona, noted for his appreciation of the female form and showy, dramatic technique, rendered that conservative scion of old New York society, Sarah Delano Roosevelt. Each painting is serving a purpose, but the president's portrait serves a grander one indeed. Rand's painting is "official," the formal White House portrait. Through her painting, FDR represents not only the presidency, but American democracy, the ideals of the American people.

In spite of 1934's successes, all was not well in Styka's world. Joe Adonis was refusing to pay the balance due on the portrait of his wife and son, and Styka needed the money. He was scheduled to depart for Europe in June.[86] Mont gave him five hundred dollars on account.[87] While abroad, Styka traveled from France to Poland, continuing throughout the trip to seek final payment for his work.[88] When the artist returned to New York in March 1935, he threatened to sue both Mont and Adonis, a bold move indeed. Mont was horrified, and in a chance encounter on Manhattan's 6th Avenue menacingly warned Styka, "you try, and you will see what you get."[89] Yet the artist did the unthinkable. He sued Joe Adonis, and, shockingly, he won.[90] As discussed in Thayer Tolles's previous chapter, this brazen lawsuit would not have been surprising to Rand. She too had battled a formidable (if less violent) adversary and won. Artists who depended on money for their works could not always appeal to the goodwill of clients, whether ruthless mobsters or grieving widows, to honor commitments.

For Rand, the Roosevelt commission seemed to revive her spirits, and she began obtaining commissions again.[91] She was also nominated to full membership in the National Academy of Design and worked steadily until the end of her life, her reputation only growing.[92] Styka's career continued, too, especially in Europe, and he was promoted to the rank of officer in the French Legion of Honor.[93] The Polish portraitist also remained active on the New York social scene, and he even became an American citizen.[94] In a nod to his connections in the Polish community, in the election year 1948, he was commissioned to paint a portrait of President Harry S. Truman.[95]

Rand, fourteen years Styka's senior, died in late 1941. She was memorialized at the time as a painter of great men, a mother, and a wife.[96] Subsequent exhibits featuring her work lauded her talent and achievements. Styka died in 1954, following a long decline brought about by a stroke in 1952.[97] An exhibit of his work in 1956 received mention in the *New York Times*.[98] The review acknowledged Styka's talent and past popularity, but concluded on a sour note: "With such powers of appeal … it hardly matters that his work sails straight onto the rocks of vulgarity."[99] Changing tastes in a world dramatically altered by the cataclysm of the Second World War impacted Styka's reputation in a way Rand would not live to see.

Rand and Styka were two very different painters who shared a common goal—to succeed as professional artists. Though sometimes overlapping, their clienteles generally represented two different segments of the wealthy and classed elites. Rand's customers may easily be described as old guard establishment—social register regulars, business leaders, mainstream politicians, diplomats, and philanthropists.

Styka certainly traveled in elite circles, but of a different variety. Old world aristocracy, long on titles and rich with faded glory, were a major source of his commissions—countesses, baronesses, titled nobles of every rank. He also flourished with the emerging, international café society set with its revolving cast of characters ranging from heiresses and opera singers to movie stars and mobsters. His subjects were often of the faddish or faded variety, passing fancies or relics from another era. Rand's clients, however, were bound up with institutions, organizations, and social sets seemingly solid and settled. Her work may have quietly receded into the hushed history of board rooms, university halls, and elaborate mansions, but there they remain today in environments seemingly solid and settled.

What is surprising about the careers of Rand and Styka is how they defy the way in which we often contextualize gender as a prevailing force, one that must be overcome in order for a woman to succeed. In the case of these two artists, gender roles are not easily placed into comfortable categories that allow for tidy conclusions. Though Rand obviously followed a generally proscribed course in her education and early career, and even made conventional decisions about marriage and children, she never gave up her career. Would she have rather dispensed with the domestic roles of wife and mother for a life singly focused on art? We have no way of knowing. Even in her diary, she never addressed her life in these terms. She played by the rules, sure, but perhaps she did so in a complex, calculated move to open up opportunities among her class and advance her career.

The Depression clearly and dramatically highlighted the difficulties of an art career, especially one focused on portraiture—the luxury of a portrait, its discretionary nature, the cost. It threw into relief the hustling and struggling and worrying that went along with making art a life's work. Rand succeeded because of talent, but also in large part because she knew how to capitalize on her position in the world, on her connections, in addition to her abilities. She used the unwritten rules and constraints of gender to her benefit. She largely did as she pleased within a personal context that she herself had constructed. Just as with her art career, she built a life with eyes wide open and worked assiduously to make it a success even in calamitous economic times.

For Styka, the course proved perhaps more difficult. He possessed a freedom to do as he pleased, to be sure, but he exercised this freedom to craft a persona inextricably bound up with his gender and ever-evolving tastes and styles. Yes, he could move back and forth from one continent to another among a disparate set of people who possessed the means to commission portraits. But he needed to satisfy both a flashy American clientele and a hidebound European nobility. His public persona required a fluid and adaptable approach to his art. He was fashionable both in his personal style and his work. Crafted during the 1910s and 1920s, in periods of high living and easy money, his persona and concomitantly his art did not suit the Depression era particularly well, but he found work, nonetheless, through sometimes unconventional methods.

Rand tirelessly pursued clients, but she did so within a conservative, establishment milieu, of which she was an unquestioned member by birth and marriage. Her quiet world of horses and hunts and old acquaintances did not make for an ostentatious life. Unlike Styka, she did not live large and publicly on two continents; make rounds of nightclubs and parties; travel first class to and from Europe; and casually

adapt her art to ever-shifting trends. Styka's work sometimes seems commercial and dated, and, while his gender gave him many more freedoms, he used those freedoms in a manner that chained him and his art to gender and popular fashion in a way that Rand never experienced.

In March 1929, months before their respective worlds would shift, Styka and Rand crossed paths for what was most likely the only time—not in person, but through their work. Connecticut artist Ann Crane ran a small gallery in tony Bronxville, New York, and advertised a selection of Styka and Rand paintings.[100] Bronxville was the perfect locale for their one joint appearance. Here was an upscale, suburban community straddling the worlds of the cosmopolitan, raucous city of New York and the comfortable, pastoral countryside of Connecticut. Styka brought the little gallery headlines and attention. Rand brought clients.

"Works of Tade Styka and Others," The Bronxville Press heralded. Styka, "the internationally known Polish portrait painter," was "alone worth a trip to the little gallery in The Towers." He is the "artist of the beau monde" who paints the "great personages of the haute couture … and commands the admiration of the cream of society." Rand conversely gets no such build up in the article other than "also shown in this exhibit." She receives a brief reference to her painting of a woman in hunt dress with a wire-haired terrier.[101] The dog gets more attention than the hunter, but the most important fact relating to the portrait is that it was previously on the cover of *Town and Country*, a magazine that provided appropriately reverential coverage of the social register set.

This is where the complexities of gender come into focus with class adding an extra dimension. Styka's art and appeal make sense mainly in the popular context of his gender and self-styled persona. He is a personality, as well as a portraitist, and he used both his own gender, as well as that of his subjects, to define himself and his art. Yet, with all that press and all that name recognition, it is hard to imagine a Styka's painting making *Town and Country*'s cover or even its pages. Rand is known to readers of *Town and Country*, and, even more to the point, Bronxville was probably already the home to Rand portraits.[102] She was one of the *Town and Country* set. Gender impacted her career, of course, but class defined it more. Conversely, Styka defined himself and his work by gender. Class had a fluid impact on him, the construct varying wildly by continent, convenience, and changing times. He would never be a part of Rand's world; likewise, Rand would have never sought out the company of café society gadabouts and European nobility. Theirs were different spheres altogether.

The show lasted for two weeks. In those last, fleeting days of the 1920s, the money was easy and times were good. Yet, in their own ways, using their own approaches to obtaining clients and painting them, Rand and Styka made it through the next difficult ten years without giving up their art. That gender and class both informed and impacted their decisions and careers comes as no surprise. That it informed Styka's career more than Rand's perhaps does. His exploitation of gender as an essential component of his fame and art undermined his artistic credibility in the long run. Rand was certainly known as a painter of great men, but *she* did not define herself as an artist by her or her subjects' gender. His approach proved to be a reputational and creative trap. He commanded attention which proved fleeting.[103] She commanded respect which proved enduring. Perhaps that is Rand's best commission.

Notes

1 Ellen Emmet Rand Diary, October 29, 1929, Ellen Emmet Rand Papers, Archives & Special Collections, University of Connecticut Library (EER Papers, ASC, UConn). Rand does not record the name of the Vermont governor.

2 List or Manifest of Alien Passengers for the United States, New York, Passenger Lists, 1820–1957, Roll T715, 1897–1957, 4001–5000, Roll 4628, Line 7, p. 50.

3 "Polish Artist 'To Do' Hoover," *The Tribune-Coshoctin* (OH), April 27, 1930, 5. The story datelined Baltimore, Maryland, notes that Styka will commence the painting with Hoover in May. It is unknown whether he completed the portrait. The Hoover Presidential Library has no record of Hoover sitting for Styka, conversation with Hoover Library staff, March 25, 2017. See also "Will Paint Hoover Portrait for Poland," *Wilmington* (DE) *Evening Journal*, April 26, 1930, 6. The article notes that the artist will complete the portrait in three or four sittings, as well as "World News Told in Pictures," *Chester* (PA) *Times*, November 20, 1929, 18. The Associated Press also released a short news item. See "Artist to Make Hoover Portrait," *The Burlington* (VT) *Hawk-Eye*, November 17, 1929, 6. For information about his transatlantic voyage, see List or Manifest of Alien Passengers for the United States, New York, Passenger Lists, 1820–1957, Roll T715, 1897–1957, 4001–5000, Roll 4628, Line 7, p. 50.

4 "Noted Painter Here," *Milwaukee Sentinel*, February 28, 1930, 8.

5 "Closing Rally Vigorous," *The New York Times*, October 30, 1929, 1. For historical context concerning the Great Depression and the initial 1929 market collapse and aftereffects, see John Kenneth Galbraith, *The Great Crash 1929* (New York: Houghton Mifflin Harcourt, 1954 and 2009).

6 EER Papers, ASC, UConn, Rand Diary, October 30, 1929.

7 List or Manifest of Alien Passengers for the United States, New York, Passenger Lists, 1820–1957, Roll T715, 1897–1957, 4001–5000, Roll 4628, Line 7, p. 50.

8 "Four Liners to Sail, Three Are Due Today," *The New York Times*, November, 15, 1929, 27.

9 "J.J. Riordan Ends Life with Pistol in His Home; His Bank Declared Sound," *The New York Times*, November 10, 1929, 1.

10 Martha J. Hopping, *The Emmets: A Family of Women Painters* (Pittsfield: The Berkshire Museum, 1982), 30; "Un Petit Prodige," *La Presse* (Paris), March 11, 1904, 3. See also Czeslaw Czaplinski, *The Styka Family Saga* (New York: Bicentennial Publishing Company, 1988).

11 Anabel Parker McCann, "Jan Styka and His Work," *The World Today* VII, no. 3 (March 1905): 282.

12 Tara Leigh Tappert, *The Emmets: A Generation of Gifted Women* (New York and Olin Gallery, Roanoke College, Roanoke, Virginia, 1993), 39; Czeslaw, *The Styka Family Saga*.

13 Even a quick search in newspaper and magazine archives in Europe and North America reveals a remarkable number of stories. In an era during which the social activities of the very rich and later the exploits of motion picture stars were reported breathlessly in national and international publications, Styka frequently found his name in print. Everything from his comments about women to his clothes to his romances received notice.

14 *Tatler* (London), Number 145 (April 6, 1904): 9.

15 "Tade Styka, Famous Prodigy Artist of Poland, Will Exhibit with His Famous Father
 at St. Louis," *San Francisco Call*, June 26, 1904, 17. Another photo of Styka in a
 velvet suit admiring the Tolstoy bust surrounded by his works can be found in *Tatler*
 (London), Number 145 (April 6, 1904): 9.

16 "Pictures at the Second Salon," *Pall Mall Gazette* (London), May 1, 1907, 6; "The Paris
 Salon," *The Morning Post* (London), May 2, 1907, 8; "A Page of Truth and Fiction,"
 Islington Daily Gazette and North London Tribune, May 22, 1908, 3.

17 Alfred Binet, "La Psychologie Artistique de Tade Styka," *L'année Psychologique* 15
 (1908): 316–56.

18 A good example of a woman presented as both wronged and wicked depending on
 the source is Evelyn Nesbit. She played a central role in the sensational murder of
 Emmet family friend, Stanford White, by wealthy socialite Harry K. Thaw in 1906.
 Nesbit, an actress and model, became a national sensation after marrying Thaw, who
 then murdered White over her "honor." A representative period account may be
 found in "Public Demands That Every Vestige of Mystery in Thaw-White Case Be
 Cleared at Coming Trial of Pittsburgh Millionaire-Murderer," *Philadelphia Inquirer*,
 July 1, 1906, 29.

19 Martha Burgan and Maureen Holtz, *Robert Allerton: The Private Man and the Public
 Gifts* (Champaign: The News-Gazette, 2009), 46 and 52. For more on this relationship
 see Michael Anesko, *Henry James and Queer Filiation: Hardening Bachelors of the
 Edwardian Period* (New York and London: Palgrave, 2018), 29–37.

20 "Costume Carnival in Artist's Studio," *The New York Times*, January 19, 1908, 11;
 "Elizabeth Emmet's Debut," *The New York Times*, March 27, 1904, 7; "What Is Doing
 in Society," *The New York Times*, February 14, 1904, 7.

21 "Miss Ellen Emmet a Bride," *The New York Times*, May 7, 1911, 11.

22 Kirsten Swinth, *Painting Professionals* (Chapel Hill: The University of North Carolina
 Press, 2001), 94. Considering the number of women who ceased or substantially
 reduced their careers upon marriage, Rand's decision to continue painting
 professionally and maintain a separate studio in Manhattan is noteworthy.

23 "Seen in New York Galleries," *The New York Times*, January 9, 1927, X10.

24 "The World of Art and Artists," *The New York Times*, April 1, 1906, X8; "Portrait
 Exhibit of Hartford Men," *The Hartford* (CT) *Daily Courant*, January 24, 1926, 42;
 "Solon's Wife Illustrious Painter," *The Hartford* (CT) *Daily Courant*, January 30, 1927,
 D5.

25 "The Exhibition of Portrait Painters," *The New York Times*, February 9, 1913,
 SM15; "Art Notes," *The New York Times*, March 11, 1917, E2; Willard Metcalf, "Art
 Exhibitions of Paintings," *The New York Times,* April 24, 1921, X8; "Seen in the New
 York Galleries," *The New York Times*, January 9, 1927), X10; Grace Wickham Curran,
 "Ellen Emmet Rand, Portrait Painter," *The American Magazine of Art* XIX, no. 9
 (September 1928): 473.

26 "Portrait Exhibit of Hartford Men," *The Hartford* (CT) *Daily Courant*, January 24,
 1926, 42.

27 For a Boldini comparison, see *Bulletin Polonais Littéraire, Scientifique et Artistique*,
 Association des Anciens Elèves de L'école Polonaise (Paris), June 15, 1914, 177.

28 "Le Monde & La Ville," *Le Figaro* (Paris), May 26, 1917, 3. Styka virtually disappears
 from European press coverage after the commencement of the war. An Austro-
 Hungarian subject living in France, he may have wanted to maintain a low profile,
 though his father actively sought support for Polish relief efforts. By 1918, he appears

to be in Lemberg, now Lviv, then in Austria-Hungary, but later in independent Poland. See *Lviv Kuryer Lwowski* (Poland), Number 269, June 14, 1918, 2.

29 "Millicent's Diary," *The Washington Post*, March 20, 1923, 10 and "Debutante's Diary," *San Francisco Chronicle*, April 9, 1923, 8.

30 Meryl Gordon, *The Phantom of Fifth Avenue* (New York: Grand Central Publishing, 2014), 156.

31 Ibid., 124. Photos of Styka from the 1920s, as well as his self-portraits, show an impeccably dressed young man with a headful of wavy hair. Glyn was a celebrated, though not critically acclaimed, author who churned out popular novels of the romantic variety often set in a make-believe Europe of exotic personages and wild passions. Several were made into highly successful silent films. See Anthony Glyn, *Eleanor Glyn: A Biography* (London: Hutchinson, 1955).

32 Two good examples of Styka the personality may be found in "Of Art and Artists," *Los Angeles Times*, November 16, 1924, 75, and "Tade Styka Thinks Wet France Dryer Than Arid United States," *Baltimore Sun*, March 26, 1923, 18. See also Chapter 5, "Wielding the Big Stick in Art" in Kirsten Swinth's *Painting Professionals* for a discussion of masculinity and virility in relation to artists and art criticism.

33 For an entertaining overview of America in the 1920s, see Lucy Moore, *Anything Goes: A Biography of the Roaring Twenties* (New York: The Overlook Press, 2010).

34 A good example of his commercial art is a 1923 painting, "Doley with Her Cat," which pictures one of "Styka's blonds" aptly holding a kitten. See the *Detroit Free Press*, March 3, 1923, 14 and a quarter-page advertisement for a "coloured presentation plate" in the Christmas issue of *The Sphere: An Illustrated Newspaper for the Home* (London), December 19, 1925, n.p. One reviewer in 1925 even likened his serious portraits to "chic magazine covers." See Edward Alden Jewell, "Parnassian Suppers," *The New York Times*, January 13, 1929, 120. For another representative example, see *The Sketch*, Number 1848, vol. CXLII (June 27, 1928): front cover. Additional reproductions of Styka's paintings that would encourage a comparison to period magazine covers include "The Petting Party," *The Sketch* (September 24, 1924) and "Good-Night," *The Sketch Christmas Number* (1927).

35 By 1931, Styka was unequivocally identified by newspapers as "the best known American painter of women," in a wire story about who might be the most beautiful American wife. See "Europe Picks US Beauty," *The Provo* (UT) *Herald*, September 29, 1931, 1. Also, "The Most Beautiful Woman in the World," *Los Angeles Times Sunday Magazine*, December 6, 1931, 3. For an interesting combination of Styka commenting on painting a great man, in this case French Prime Minister Raymond Poincare, and American women, see "Styka Gives His Impressions of Poincare and Ideal Woman," *Baltimore Sun*, March 28, 1934, 11. He also became noteworthy as a painter of blond-haired women, the "Styka blond." See, for example, "Styka, Tade," Name Card Index to AP Stories, 1905–1990, 11–29-31, NLA33-34; "Through the Exhibitions," *Le Gaulois: Litteraire et Politique*, May 17, 1925, 3; and a passing reference to a "Styka blond," *Le Petit Journal*, May 18, 1932, 1. His expertise on women culminated in a patent for ornamental women's stockings, United States Patent Office, 121.856, Design for a Stocking, Tade Styka, New York, New York, August 6, 1940.

36 Walter Winchell, "On Broadway," *Wisconsin State Journal*, December 18, 1929, 3. Winchell's influential column was nationally syndicated by the *New York Daily Mirror*.

37 List or Manifest of Alien Passengers for the United States, New York, Passenger Lists, 1820–1957, Roll T715, 1897–1957, 4001–5000, Rolls 4628, 3239, 3410, and 4383.

He travelled in high-end comfort on the chic liners *Paris, Ile de France, Majestic, Olympic, Berengaria*, and *Aquitania* among others.

38	"Chaplin Blighted Artist's Romance," *New York Daily News*, February 4, 1923, 3. This overheated account of their romance has Negri taking out a million-dollar insurance policy against her heart lest she fall in love with the artist.

39	"Pola to Give Her Portrait Rival Painted to Charlie," *Minneapolis Star*, April 5, 1923, 1; "Chaplin May Have Contest for Heart of Polish Actress," *Minneapolis Star*, February 26, 1923, 1.

40	"Pola's Ex-Beau Coming West?" *Los Angeles Times*, February 26, 1923, 21; "Pola Negri Jilts Charlie Chaplin and Gives Only a Woman's Reason," *Baltimore Sun*, March 2, 1923, 1; "Ruffo Hits Report of Purchase," *Los Angeles Times*, March 8, 1923, 28.

41	"Chaplin's Love Comedy," *Pall Mall Gazette* (London), March 2, 1923, 4; "Gilded Poverty," *Sheffield Daily Telegraph* (England), March 3, 1923, 10; "Charlie's Love Affair," *The Leeds Mercury* (England), March 3, 1923, 9; *Moderne Welt*, Vienna (April 1923): 8.

42	Styka claimed merely friendship with Negri when she broke her engagement with Chaplin. See a United Press datelined item, "Just Friends," *Lebanon* (OH) *Daily News*, March 3, 1923, 6. He continued to be linked to her on occasion into the 1930s. See Grace Kingsley, "Pola's Newest Heartbreak," *New York Daily News*, January 18, 1925, 88; "Pola Thinks Again," *Aberdeen Press and Journal* (Scotland), December 23, 1929, 8; Ed Sullivan, "Broadway," *New York Daily News*, February 26, 1934, 29.

43	Rand's diaries between the end of October and through the first of 1930 continue on as they had since the early 1920s, describing the mundane details of life as well as more substantive topics such as her subjects and family relationships.

44	"Late News from All Parts of the World Reported by the Camera," *Asbury Park* (NJ) *Press*, November 30, 1929, 11.

45	Later Styka would be a serious contender for the "10 Best Dressed Men" in New York City. See "Steward Is Voted Nattiest Man Here," *The New York Times*, February 13, 1937, 15.

46	"Stock Market Quiet, with Prices Sagging," *The New York Times*, November 19, 1929, 1.

47	Walter Winchell, "On Broadway," *Wisconsin State Journal*, December 18, 1929, 3.

48	Again, see Spiggle's chapter for detail on annual earnings by Rand.

49	"Mayor Honors Polish Painter," *Detroit Free Press*, March 26, 1930, 26.

50	*The Gazette* (Montreal), May 22, 1931, 24. Among the passengers on a 1931 voyage were the Polish composer Ignace Jan Paderewski, whom he would paint soon thereafter; the Countess de Chambrun, sister of the late speaker of the US House of Representatives; and the French playwright Henri Bataille.

51	"Opera Singer Coming Here for Banquet," *Wilkes-Barre* (PA) *Times Leader*, April 21, 1931, 15; "Funeral Notes," *Wilkes-Barre* (PA) *Times Leader*, September 6, 1932, 21; "Folk You Know," *Wilkes-Barre* (PA) *Times Leader*, January 3, 1933, 11; *The Newark* (NJ) *Advocate*, November 30, 1931, 7; and "Europe Picks US Beauty," *The Provo* (UT) *Herald*, September 29, 1931, 1.

52	EER Papers, ASC, UConn, Rand Diary, January 8, January 10, and January 12, 1931. She agreed to paint a Mrs. Walker who had to pay only if she liked the portrait. Rand was convinced that she could satisfy her and took the chance.

53	EER Papers, ASC, UConn, Rand Diary, December 6, 1931 and February 15, 1931.

54	EER Papers, ASC, UConn, Rand Diary, January 15, 1931. Note, this appears to be a misdated diary entry and should be January 1, 1932. The entry appears at the

beginning of the diary and is immediately followed by January 2, 1932. The tone of the entry suggests introspection at the beginning of a year that she knows will be a challenging one considering economic conditions.

55 EER Papers, ASC, UConn, Rand Diary, January 9, 13, 15 and 29 and February 3 and 5, 1932.

56 EER Papers, ASC, UConn, Rand Diary, February 28, 1932, March 9, 1932, March 11, 1932, June 4, 1932, July 6, 1932, July 8, 1932, and October 12, 1932. Her financial affairs had continued to worsen, and she noted on October 6th that "I am very low in cash—I must try to accumulate some tomorrow. How? I don't know." By October 17th, she was hurrying "around trying to get my foot on something." She needed to "collect ready cash and when I get it is the question. It is owing me, but I can't collect." For the rate of inflation calculated to 2018 dollars, see the United States Bureau of Labor Statistics calculator at https://www.bls.gov/data/inflation_calculator. htm, accessed July 26, 2020.

57 EER Papers, ASC, UConn, Rand Diary, November 8, 1932.

58 State of New York, Supreme Court, Appellate Division—First Department, Tade Styka against Joseph Adonis (438), Record of Appeal, 1936, 54.

59 Mitchell Owens, "Godfather of Exotic Modernism," *The New York Times*, October 6, 1995, 6006028; Todd Merrill, *James Mont: The King Cole Penthouse* (New York: Todd Merrill and Associates, 2007), 12–17; State of New York, Supreme Court, Appellate Division—First Department, Tade Styka against Joseph Adonis (438), Record of Appeal, 1936, 13.

60 Wendy Goodman, "The Gangster's Favorite," *New York Magazine* (November 23, 2008): n.p. See also Stephanie Murg, "Remembering James Mont: 'Singular Scoundrel-Aesthete,'" digital *AdWeek*, July 8, 2008, https://www.adweek.com/digital/ remembering-james-mont-singular-scoundrel-aesthete, accessed July 26, 2020.

61 State of New York, Supreme Court, Appellate Division—First Department, Tade Styka against Joseph Adonis (438), Record of Appeal, 1936, 14–15, 24, 52, and 54.

62 List or Manifest of Alien Passengers for the United States, New York, Passenger Lists, 1820–1957, Roll T715, 1897–1957, 5001–6000, Roll 5429.

63 Styka even offered to let Mont design a bar for one of his clients in Connecticut as a means of making up for some of the funds Mont lost in the Atlantic City venture. See State of New York, Supreme Court, Appellate Division—First Department, Tade Styka against Joseph Adonis (438), Record of Appeal, 1936, 60.

64 Ibid., 31.

65 EER Papers, ASC, UConn, Rand Diary, January 31 and February 21, 1933.

66 Conrad Black, *Franklin Delano Roosevelt: Champion of Freedom* (New York: Public Affairs, 2003), 276–7.

67 EER Papers, ASC, UConn, Rand Diary, March 4, 9, 14, 1933 and April 10, 12, 18, 1933.

68 EER Papers, ASC, UConn, Rand Diary, August 9, 1933. See also Eleanor Roosevelt to Mrs. William B. Rand, August 8, 1933, President's Personal File (PPF) 1630, Franklin D. Roosevelt Presidential Library, Hyde Park, New York.

69 List or Manifest of Alien Passengers for the United States, New York, Passenger Lists, 1820–1957, Roll T715, Roll 5429.

70 Edward Alden Jewell, "Art of Tade Styka of Boldini Flavor," *The New York Times*, February 9, 1934, 17.

71 H.W. Brands, *Traitor to His Class: The Privileged Life and Radical Presidency of Franklin Delano Roosevelt* (New York: Anchor Books, 2008), 47.

72 Black, *Franklin Delano Roosevelt*, 3–6.

73 "A Mother Has Her Day," *The Washington Post*, May 14, 1934, 1; Evelyn Peyton
 Gordon, "Roosevelt Gets Picture of Mother," *The Washington Post*, May 8, 1934, 10.

74 State of New York, Supreme Court, Appellate Division—First Department, Tade
 Styka against Joseph Adonis (438), Record of Appeal, 1936, 1X

75 For an overview of the Mafia in New York City and elsewhere, as well as Joe Adonis'
 reputation and role, see Joe Reppetto, *American Mafia: A History of Its Rise to Power*
 (New York: Henry Holt and Company, 2004).

76 State of New York, Supreme Court, Appellate Division—First Department, Tade
 Styka against Joseph Adonis (438), Record of Appeal, 1936, 1 and 38.

77 Ibid., 40, 61, and 19.

78 Ibid., 22, 30.

79 Ibid., 22, 62.

80 Ibid., 22.

81 "Roosevelt Canvas Approved by Wife," *The New York Times*, March 2, 1934, 17.

82 Ibid.

83 "Gift to Roosevelt," *Cincinnati Enquirer*, May 18, 1934, 10; "A Gift to the President,"
 Miami Daily News-Record, May 20, 1934, 5; "A Gift to the President," *Wausau* (WI)
 Daily Herald, May 23, 1934, 7.

84 "President Gets Picture of Mother," *The Washington Post*, May 8, 1934, 10.

85 White House Usher's Log, May 6, 1934, Franklin D. Roosevelt Presidential Library,
 Hyde Park, New York. See Photograph of White House Oval Sitting Room, Franklin
 D. Roosevelt Presidential Library, ca. 1935.

86 State of New York, Supreme Court, Appellate Division—First Department, Tade
 Styka against Joseph Adonis (438), Record of Appeal, 1936. Styka arrived in LeHavre,
 France, on the liner *Paris* in June 1934. See *Neues Wiener Journal* (Vienna), June 16,
 1934, 9.

87 State of New York, Supreme Court, Appellate Division—First Department, Tade
 Styka against Joseph Adonis (438), Record of Appeal, 1936, 17, 19.

88 Ibid.

89 Ibid., 76.

90 Ibid., 2. The trial transcript is almost comical as English was the second language
 for Styka and Mont. It is easy to see how a misunderstanding may have arisen
 over representation and payment between the men. The judge is equally comical,
 sounding harried and frustrated. He clearly does not want attention drawn to
 president's mother in court. Adonis is all bemusement and innocence. His words as
 captured by the court stenographer read like a script to a gangster movie.

91 The number of entries in the account pages of her diary increases dramatically by the
 end of the decade. See Rand Diaries, 1936–1940, EER Papers, ASC, UConn.

92 "Jonas Lie Gets Highest Honor in Art World," *Bridgewater* (CT) *Courier-News*,
 April 26, 1934, 5.

93 "Demarches et Echanges," *L'Intransigent* (Paris), August 12, 1935, 3; "New French
 Honor for Styka," *The New York Times*, September 4, 1935, 47.

94 U.S. Naturalization Records, Original Documents, 1790–1974, Tade Styka, 389951–
 370000; New York, Naturalization Records, 1882–1944, Certificate of Arrival; New
 York, Index to Petitions for Naturalization filed in New York City, 1792–1989, No.
 5143459, 1942; U.S., World War II Draft Registration Cards, 1942, Tade Styka, 1642.

95 "Portrait Given to Truman," *The New York Times*, October 3, 1948, 38. In accepting
 the painting a month before Election Day, President Truman noted US sympathies

for the Polish and support of an independent Poland. Styka also painted a portrait of Theodore Roosevelt as a Rough Rider. This hangs in the eponymous Roosevelt Room in the West Wing of the White House.

96 "Mrs. Ellen Rand, Noted Artist, Dies," *The New York Times*, December 19, 1941, 25.

97 Morgan, *Phantom of Fifth Avenue*, 195–6.

98 "Varied Exhibitions at 5 Local Galleries," *The New York Times*, April 21, 1956, 20.

99 Ibid.

100 "Famous Polish Artist Exhibits at Ann Crane Gallery," *Bronxville* (NY) *Review*, March 9, 1929, 9.

101 "Crane Gallery Opens Exhibit," *Bronxville* (NY) *Press*, March 12, 1929, 1. At least, the *Bronxville Review* gives her full second billing in the advertisement. The *Bronxville Press* did not even initially mention her name in ads. See advertisement, *Bronxville* (NY) *Review*, March 16, 1929, 7, and advertisement, *Bronxville* (NY) *Press*, February 22, 1929, 5.

102 For insight into Bronxville, see Harry Gersh, "Gentlemen's Agreement in Bronxville: The 'Holy Square Mile,'" *Commentary* (February 1, 1959). Gersh specifically focuses on anti-Semitism in this rarefied, restricted bedroom community, but in doing so, he describes the village, its history, and its residents.

103 Styka was "rediscovered" in 2011 when his student and friend, the eccentric heiress Huguette Clark, died just shy of age 105, naming the artist's daughter as a beneficiary of her $300,000,000 estate. See Julia Marsh, "Fight for Heiress' $300M Fortune Finally Over," *New York Post*, September 24, 2013, https://nypost.com/2013/09/21/deal-in-300m-copper-heiress-fortune/, accessed July 26, 2020.

6

Artist and Amazon: The Sporting Paintings of Ellen Emmet Rand

Claudia P. Pfeiffer

In 1936, the same year that Ellen Emmet Rand held her solo exhibition, *Sporting Portraits by Ellen Emmet Rand, N.A.*, her friend Elizabeth Chapman, wrote to her:

> My Dear Bay, I've simply got to tell you of how proud I was to be connected to the Rand Family yesterday. It was the handsomest exhibit ever put on at the horse show … I wish that you might have been an observer as well as a performer.[1]

Chapman was not referring to Rand's art exhibition, as one might assume, but to the First Place showing that the Rand family had at the Dutchess County Fair Horse Show on September 2, 1936. In a photograph taken during the awards presentation, the family is captured side-by-side in a line on their respective mounts (Figure 6.1). Rand is seen talking to a show judge. Her husband Blanchard is to her right, and to her left are their son Christopher, Christopher's wife Margaret, and their other two sons, William and John. The family is dressed in matching white riding jackets, yet Rand stands out. Wearing her ever-present fedora, the "Amazon" is at ease in her sidesaddle, beaming with pride.

Ever since women began to ride aside (both legs to one side, as opposed to astride) for sport, the "Amazon," the formidable female warrior of Greek mythology, became synonymous with the "equestrienne," the feminine derivative of the word "equestrian." In the contemporary horse world, most women ride astride; today the term Amazon evokes the skill and arete of the generations of hard-riding females, who, from their first pioneering efforts, excelled in the sidesaddle wearing skirts—galloping and jumping alongside men in sporting pursuits.

Rand was an Amazon, who as an artist fearlessly launched herself into becoming a successful portrait painter as well as an accomplished equestrienne, forging relationships and gaining commissions from some of the most recognized sporting figures of the day. While others in this collection have focused on her broader patron base and career trajectory, an aspect of Rand's artistic production that was crucial to her both personally and professionally has been largely under-examined: her sporting oeuvre.

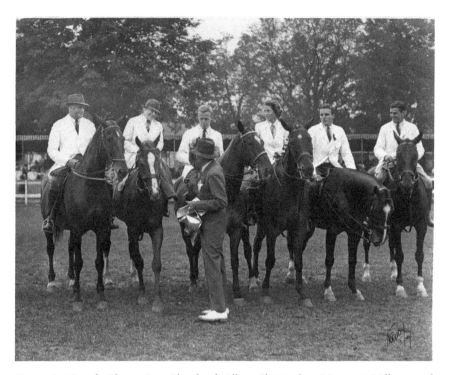

Figure 6.1 Freudy Photos Inc.; Blanchard, Ellen, Christopher, Margaret, William, and John Rand win First Place in the Family Class at the Dutchess County Fair Horse Show, September 2, 1936. Ellen Emmet Rand Papers, Archives & Special Collections, University of Connecticut Library.

The most revered sporting artists have historically been sporting enthusiasts themselves; an intimate understanding of their subjects lends an authenticity to their artwork. Many historians and art historians dismiss sporting art, marginalizing it for its niche subject matter. This centuries-long artistic tradition, however, is represented in numerous international museum collections, and is solidly grounded in academic painting. Worthy of examination, the genre that focuses on turf and field sports such as hunting, horse racing, wingshooting, and fly fishing is valued for its realism, much in the same way traditional figurative portraiture has historically been recognized. It follows that Rand's body of work should equally be explored and acknowledged for her successful sporting portrait compositions in the context of her personal life as a horsewoman and an active member of sporting circles in the interwar period, a time that is acknowledged by historians as a "Golden Age" of sport.

The Exhibition

Rand, at the age of sixty-one years and a decades-long established artist, held her four-week solo exhibition of sporting compositions at the Sporting Gallery & Bookshop

on 52nd Street in New York City in April 1936. The double-sided, folded 8 ½ x 11 sheet of paper that served as the exhibition catalog bears the title *Sporting Portraits by Ellen Emmet Rand, N.A.*; the twenty paintings listed within were a who's-who of the 1930s foxhunting world. The exhibit was a testimony to the rich sporting culture that existed in the United States in first half of the twentieth century as well as Rand's stature within it. On the cover, the black-and-white reproduction of the portrait of Dr. Howard D. Collins clarified the focus of the exhibit. The silver-haired, mustachioed ex-Joint Master of Foxhounds of the prestigious Millbrook Hunt sat for the painting wearing his livery with a whip across his lap.[2]

The Sporting Gallery was the perfect venue for the works that were a departure from the portraits of politicians, captains of industry, urban socialites, artists, scholars, and children for which Rand had become known. Gallery owner Melville "Ned" Stone, II opened the business in 1935, advertising as "agents for leading sporting artists."[3] Although the gallery was a new venture, Rand had known the Chicago art dealer for several years, as they were related by marriage. In 1929, she described her cousin Katherine Temple Lapsley's wedding: "Ned Stone is short + blonde, with a strong rather sad face. I know he will make a steadfast good husband."[4]

Rand visited the gallery in midtown Manhattan for the first time to view the space in January 1936. She noted, "It is very attractive and quite roomy. The gallery proper has a blazing fire going all the time + a sofa in front of it. There are two rooms both excellent."[5] In the weeks preceding the exhibition, Rand gathered paintings from lenders, touched up some of them, and completed new ones. On April 13, the day of the opening, she installed the canvases with assistants in the galleries. It was a difficult lead-up for her. She wrote, "This has been one terrible day for me except that I wasn't painting for a change. I had to hang my Exhibition … The show is too colorful, conspicuous, etc. It hits you in the face + is embarrassing."[6] The self-effacing artist was critical of the visual impact of the variety of portraits of Masters of Foxhounds, a huntsman, whips, and other sportsmen and—women in an array of bold scarlet hunt coats, sidesaddle habits with brightly colored waistcoats, and gunning attire. In addition, two unexpected compositions that were not portraits were on view—*Meet of the Old Chatham Hounds* and *The Hound Show at Riding Club,* both completed in the months preceding the show.

Perhaps Rand was nervous about the content and financial potential of the exhibition. She had historically commanded strong prices for her portraits, yet as discussed in previous chapters by Susan Spiggle and William Harris, by February 1933 Rand was under significant financial strain. She took a loan to pay the college tuitions for her three sons who were three years apart and attending Yale University at the same time, a sum that, until then, she had been able to afford. She noted, "Today I may say was among the bad ones of my recent years. I started off fairly early having no sitter to see what could be done in the great Wall St. section to land enough money to pay the most important bill. The boys' college."[7] Rand's loose monthly accounting at the end of her 1933 annual diary listed fewer patrons and lower prices.[8]

In other words, Rand needed to make the most of the exhibition opportunity at the Sporting Gallery. The exhibit featured well-heeled sitters for paintings she had completed between 1928 and 1936—Mr. and Mrs. Fletcher Harper, Miss Emily Davie,

Miss Helen Bedford, Frederic Bontecou, and Dr. Howard Collins—and was meant to develop new patrons in the sporting world. "While we haven't got any definite commissions I believe the exhibition stirred up more than just interest for we have had quite a few inquiries," wrote Ned Stone in a letter to Rand following the show.[9]

The reviews of the exhibition were mixed. *The New York Times* gave a nod to Rand's professionalism, "The artist's long experience tells in her characterizations of these red coated huntsmen and huntswomen," but noted, "though they seem perhaps a little self-conscious, definitely posed."[10] *The Brooklyn Daily Eagle* delved into the characteristics of horse people, labeled Rand as a "sporting portraitist," and reiterated the sentiment that some of the portraits were a bit stiff:

> One of the better known sporting portraitists is Ellen Emmet Rand, and one can understand her popularity after seeing her current exhibition of paintings at the Sporting Gallery. Mrs. Rand does not indulge in the flashy bravura style of society portraiture, but paints soundly and solidly, with a sincere directness of method. Her sitters have character and life, though some of them hold themselves stiffly.[11]

The characterization of Rand's *Sporting Portrait* sitters as "self-conscious," "posed," and "stiff" may be attributed to a bias against or misreading of the formality of the compositions and the sporting culture they echoed. During her career, Rand solidified her reputation through her ability to capture not only her sitters' likenesses, but their individual essences. Grace Wickham Curran wrote in her 1928 article about Rand featured in *American Magazine of Art*, "It is her own intellectual ability to see and understand the personalities of others, and the sure hand to express what she sees, that have won for her so much well-deserved recognition."[12] This broader analysis of Rand's abilities correlates to her success in capturing all of her sitters, whether they were lounging debutantes, stolid judges, caring mothers, children with beloved pets, academic professors, or sporting personalities.

The paintings in the Sporting Gallery show were of recognized sporting figures in formal attire: most represented the upper echelons of foxhunting. The titles of the paintings listed the various roles that some of the sitters held within the sport, "M.F.H.," "Huntsman," and "Whipper-In." An inherently esoteric tradition, foxhunting was brought to the United States by British settlers in the mid-seventeenth century who enjoyed the sport as a leisure pursuit but, perhaps paradoxically, consciously preserved its formality and gravitas to the present day. The Master, huntsman, and whip wear a uniform historically adopted from military livery, specific to each hunt. The title "MFH" following a name stands for "Master of Foxhounds" or "Master," an appointed leader of a hunt with proven, years-long experience, who is charged with the responsibility of fostering sport for the hunt's members. He/she oversees the hunt staff and, during the chase, follows the huntsman and leads the hunt field comprising members of the hunt and guests. The huntsman, usually a paid employee ("hunt servant"), is an expert charged with the care of the kennels, development of the breeding program, raising of the hounds, and hunting of the pack. The whip, also a hunt servant, reports to the huntsman, assists in the daily activities of the hound kennels (feeding, exercising, and upkeep), and flanks the hound pack during a day afield under the huntsman's direction.[13]

The genuineness and bearing of Rand's sitters wearing traditional hunt attire were intended to convey a timeless, poised carriage and demeanor, but may not have resonated with some critics unfamiliar with the subjects and sporting pursuits. Rand's consistent and observant treatment, however, would have been evident to peers in the sporting community. A positive *New York Sun* review more sensitively suggested these qualities in vibrant detail:

> The red hunting coats liven up the rooms decidedly, and the individuals inside the coats have the air of being entirely reconciled with the fact of life; the satisfaction, one opines, that comes with hunting. Mrs. Rand's portraiture is excellently designed to please hardy, healthy, outdoor people. It is earnest, confident, direct, and quite free from offensive subtleties. There is no trace of psychoanalysis in the work … It is also free from fashionable flimsinesses in the painting. It is almost Timeless in the way it concentrates on hunting toggery and ignores the passing changes in ordinary garmentry. Hunters are true classicists; they do not change much outwardly from year to year.[14]

The Amazon

Rand's personal perspective as an equestrienne and kinship with the subject informed her portraits. A middle-aged sidesaddle rider in the 1920s and 1930s, her formative years were spent living on a farm. Her father, Christopher Temple Emmet, a lawyer from New York, had established himself in California maintaining his profession in the city of San Francisco and supporting his family's sixty-acre San Rafael valley farm and vineyard until he unexpectedly died when Rand was nine years old. Her father was described as,

> fond of fresh air, he was an athlete in physical exercises. In person, he was large and finely built with blue eyes, light complexion, light hair, iron-gray whiskers, and English appearance and style and dress, as well as in tastes. He had more domestic animals and servants about his house than almost any other man in the State. Fidelity to his profession and friends, gentleness to his dependents, and devotion to his family, marked his life.[15]

With her family background, it is not surprising that Rand learned to ride in a sidesaddle, a mark of the upper-middle-class equestrian culture and the town and country lifestyle to which she aspired as an adult. When she was twenty-three years old, during the time when she was studying in Paris with the artist MacMonnies in 1898, Rand wrote, "I would like to make enough on portraits to purchase a remote and inexpensive small farm somewhere off in the country – where we could all live and in the winter we could move to New York and collect more ducets [*sic*] and go back again."[16]

In 1903 Rand realized her dream. With her earnings as a professional artist, she purchased Barack-Matif Farm in Salisbury, Connecticut, for herself, her mother Elly, half-brother Grenville, and two of her sisters, Rosina and Leslie. Owning horses

for leisure was then, as it remains today, a financial investment, and by 1906 the enterprising horsewoman had also started a breeding program at the farm. "My gray mares are each going to have colts not to be out of fashion," she noted.[17]

In 1911 Rand married Blanchard, a dashing gentleman farmer and polo player for the Rockaway Hunting Club, Long Island, New York. She and her husband shared a sometimes-tumultuous relationship and a lifelong love of horses and the countryside.[18] They spent their honeymoon on an extended trip, first carriage driving two horses fifty miles from Salisbury to Hartford, Connecticut, and then riding the horses an additional fifty miles to Pomfret, where they spent two weeks riding every day.[19] They then reversed the trip back to Salisbury, where Blanchard purchased Butterly Farm with the intent to start a training stable of 100 polo ponies.[20] The couple renamed the farm Hamlet Hill. Within short order they had Christopher Temple (1912), William Blanchard, Jr. (1913), and John Alsop (1914), all while Rand continued to paint portraits.

The farm became the center of the Rand family's country life and the focus of much of Rand's personal writings. The Rands were an active part of the equestrian community—horseback riding, jumping, hunting, and watching flat races and steeplechases together. Rand attended hunter trials and horse shows where her husband and boys often competed. John and Bill played polo on school teams that Rand followed closely and supported financially. Hamlet Hill was not only a source of leisure but also Rand's country studio, a working dairy farm, and, for a short time, a riding school. The latter two businesses were managed by Blanchard, but Rand was involved in decisions.

Rand's motivation to make a living as a self-sufficient artist to support her personal interests seemed unchanged throughout her life. Her simple, straightforward, first-person dialogue in her diary evokes an image of solid dependability. She liked being successful, but she did not seek the limelight. In 1928, she wrote while at the farm when her children were away at school:

> I wish I could just stay here, + work + ride + not have to go away – it rises above me like a Banshee to have to go away. I also don't like Blanchard to go, I just like to stick around Hamlet Hill with him, and the boys, when I can have them. We will soon have them. I wonder if I could stay here alone day in day out, if I were painting + riding all day + playing bridge most of the night I should never be bored or lonely![21]

The artist worked tirelessly and consistently, continuing a pattern of travel between her New York studio and the farm for most of her life, reveling in every opportunity to horseback ride or live vicariously through her family and friends.

Prior to 1927, Rand and Blanchard began taking annual trips to Middleburg, the heart of Virginia's hunt country, for the Thanksgiving holiday. There they sought invitations to ride, attended the Warrenton Point-to-Point, and visited with friends and acquaintances.[22] Sometimes their plans fell through. "B telephoned to Jim Skinner but he did not sound encouraging about horses to ride down here + Walter has nothing. I entertained Blanchard with nothing but rage + despair + regrets that I had come down here," wrote Rand in a rare flare of hostility when denied any opportunities to ride on their vacation.[23]

In 1928 Rand received a query to paint Miss Charlotte Noland, the famed founder of the prestigious Foxcroft School in Middleburg. Known as "Miss Charlotte," Noland was regarded as one of the most competent equestrians in the country. A graduate of the Sargent School of Physical Education at Harvard, she founded Foxcroft School in 1914 and created a curriculum at the all-girls boarding school incorporating exercise and a riding program that fostered horsemanship as a character-building discipline.[24]

Noland rode with Middleburg Hunt and encouraged her students to participate as well. She was a force of nature that inspired two generations of equestrians. Former students recounted memories of the headmistress "riding sidesaddle on her beautiful white horse and sailing over the fences leading all of us on the hunt," "going 'hell-for-leather,' " and "looking all dressed up in her sidesaddle habit, black boots and top silk hat, sitting in Study Hall calling the roll before our morning class."[25]

Mrs. G. Gordon "DeeDee" Massey noted in a letter inquiring about the commissioned painting of Miss Charlotte Noland, "The alumnae of Foxcroft have a little money set aside to have Charlotte's portrait painted + asked me to find out what you charged." [26] Noticeably missing from Rand's payment ledger, however, is remuneration for the completed portrait.[27] Rand looked at two horses with a discerning eye toward a purchase while in Middleburg, but they were not to her liking or budget. Instead, she received what would become one of her favorite hunters, the mare Gandora, in lieu of payment for Miss Charlotte's painting.

Rand made the long trip to paint the portrait of Noland, traveling alone from Connecticut to New York to Washington, DC by train and taking a car to the Red Fox Inn in Middleburg, where she stayed. She wrote,

> Miss Noland telephoned for me to come out at 2.30. I had a late lunch + went in the same hired car … + then drew her, in her habit + looking very lovely, + so this portrait for which I am going through so much burden to accomplish is actually started - tomorrow I shall get on fast with it.

Although Noland was not yet Joint-Master of the Middleburg Hunt when she sat for her portrait in 1929 (Plate 9), she attained the honor in 1932 and served until 1946 with Daniel Sands, MFH, who was the first president of the Masters of Foxhounds Association. The 1936 *Sporting Portraits* exhibition catalog listed Noland as a Joint-MFH, even though she did not wear the hunt coat of a Master in the portrait. She is instead depicted in formal sidesaddle attire, a dark-single button coat with a flower on her lapel, side saddle apron, and an apple green waistcoat which signifies that she was a member of the hunt's Board of Directors. She is holding a horn-handled whip, and a silk hat rests atop a table in the dark-toned background.

Rand noted in her usual humble tone, "Whether it is well done or not I can't be so sure, I know that one or two things about it are fairly good, but I have never done a portrait yet that has brought down such a wave of enthusiasm, not one dissenting voice."[28] The well-executed likeness mirrors the photos of Miss Charlotte during that time. Her direct gaze and upright-posture invite respect and admiration, and the hunt attire and accoutrements are accurate depictions expressed with a painterly balance.

When Rand finished the painting she wrote,

The deal for this portrait is a very good mare of Miss Charlotte's thoroughly broken + a fine jumper + a good size + a good horse quite nice looking. That is Miss Charlotte's return for the portrait + I am well satisfied … Altogether so enjoyed Middleburg more than ever before. I'm sorry Blanchard wasn't here—I am delighted about the mare, "Gandora".[29]

Noland and Rand were both from the same generation of Amazons, and Rand would have been hard-pressed to find a more qualified equestrienne from whom to receive a prime sidesaddle hunter. The trade for the portrait and the mare was the equivalent of $40,000–60,000 today and speaks to the reputations of Rand as an artist, Noland as a horse person, and, importantly, the seriousness of Rand's commitment as a horsewoman.[30] Prior to the stock market crash, she was still able to afford the luxury of this barter instead of receiving payment. By 1933, however, when her financial situation had turned, the lure of a horse trade for her portrait of Frederic Bontecou, Joint-Master of the Millbrook Hunt, another painting that would be in the 1936 Sporting Gallery exhibition, was no longer a realistic consideration:

The boys + I went to Millbrook this morning to see F. Bonticou [*sic*] + look at the horse offered with $1000 for the portrait I never meant to accept this offer but of course if the horse had been what they call a "hum dinger" I might have pondered on it but he wasn't, he was a half bred 3 yr old bad in the hind leg + looking somewhat of a dog.[31]

For several years after acquiring Gandora, Rand's diary entries were peppered with the exploits of the horse being ridden by Rand, her family, and friends on the farm, at horse shows, and in hunts. Although Rand was a longtime, confident, and fearless rider who took great satisfaction in going fast and launching herself over jumps, she had herself never truly taken part in a foxhunt, having only hill-topped, following the Middleburg Hunt until this point.[32]

Started off riding at Foxcroft - big field about 200 … I did not hunt altho [*sic*] I longed to. I rode on Jim Skinner's chestnut with DeeDee Massey + "hill topped" I jumped a stone wall + we jumped well. I pulled out after about an hour and a half + rode home. They got a fox … The hunt breakfast was very nice + I saw many people whom I know.[33]

Rand enjoyed the camaraderie that the foxhunting community provided and remained determined to experience a bona fide hunt riding "straight to hounds" (following the direct path the hounds take). It is worthy of note that endeavoring to start this as a middle-aged sidesaddle rider was unusual, and it underlines Rand's mettle. Only the most skilled and seasoned Amazons have the physical stamina to succeed in safely navigating the demands of jumping fences, chicken coops, streams, and ditches over open country. Falls are inevitable in a foxhunter's experience but are made even more dangerous for sidesaddle riders; they have the disadvantage of both legs being to one side with two pommels between their legs, additional obstacles to clear safely in the event of an accident.

In 1929, Blanchard actively discouraged Rand, who was fifty-four years old and ten years his senior, from trying to hunt, even though she rode and jumped almost daily as part of their routine at Hamlet Hill farm. On September 21 she wrote, "Blanchard + John + Charlotte went off early to hunt at Lebanon. I made myself most disagreeable before they went because B. did not seem to want me to go + the whole thing appealed to me greatly. He said he thought I'd better not hunt."[34]

Rand, however, remained undeterred, and she noted on October 6, 1929, after joining The Old Lebanon led by Blanchard who was Joint-Master, "This is the first time I have ever really gone hunting. We had a beautiful run through ranching country … we jumped about 12 fences."[35]

The Rands had again found companionship in riding. That autumn Blanchard prepared two drag hunt courses at Hamlet Hill for a Lebanon Valley Hunt meet to be held there.[36] Rand was involved in planning and riding the property looking for appropriate places to jump and lay the drag. She noted on October 11, "I put on my riding habit + rode with Charlotte + William, trying the new chicken coops, they are a bit too high to be popular."[37] They continued to practice the challenging course of approximately fifteen jumps in the following days.

The first day of the meet went well. Rand was elated, writing,

> And then the hunt oh what fun, I rode Gandora + she took every fence beautifully - She got bogged in a swamp + fell, I with her, William + Blanchard were right there + I got right up + wasn't even scratched. We rode about 2 hours + the hounds worked well over a good course + it must have been a very good scent.[38]

Rand was keeping pace at the head of the hunt field riding aside when she and her mare went down. As previously noted, falls from a sidesaddle are more likely to cause injury, but as a true equestrienne, Rand was undeterred and got back up on the horse, both proverbially and literally. Mounting a sidesaddle requires assistance, and Blanchard or her son William was there to help her re-mount.

A few days later, Rand went for a ride over the course with her husband and three others. Her previous note that the chicken coops were a bit too high became an ominous prediction:

> We went over three chicken coops quite well + over the fourth I lost my balance + fell from Gandora, breaking my left wrist. In the instinctive gesture to save my right hand, I instantly knew it was broken. It had such a strange bad look. I walked home leading Gandora (She had a beautiful jump.)[39]

Ever the hardy equestrienne, she held her horse blameless; and ever the artist she saved her painting hand.

The fall did not diminish Rand's passion for being in the saddle. She returned to riding within three months and hunted behind her husband in the successful 1930 season. She was supportive of Blanchard's hunting endeavors and took pride in his successes. In 1929, he was first elected Joint-Master of the Lebanon Valley Hunt that became Old Chatham, along with W. Gordon Cox (another prominent foxhunter who

was represented in the 1936 sporting exhibition). Rand wrote, on November 3, "B here full of Lebanon news has been made Joint Master of hounds. I am delighted."[40]

The renamed Old Chatham Hunt was first recognized by the Masters of Foxhounds Association in 1931. Rand again marked the accolade in her diary, "Blanchard got a letter from Harry Vaughn [sic] today settling the question of his being in the Master of Foxhounds Association so now he is established."[41] This was an important honor that elevated the hunt—and those who were associated with it—in the sporting community. Founded in 1907, the Master of the Foxhounds Association of America (MFHA) was the national governing body that unified and regulated the sport of fox, other legal quarry, and drag hunting, and the highest officials in the organization were among the Rands' inner sporting circle and her portrait sitters.

Sporting Circle—Sporting Legacy

Of the men featured in the *Sporting Portraits* exhibitions, Fletcher Harper, William Bell Watkins, Frederic H. Bontecou, Dr. Howard D. Collins, George H. Timmins, and Blanchard Rand were Masters; W. Gordon Cox was a former Joint-Master and honorary secretary; and Thomas Thornton a huntsman. Additionally, Harper, Watkins, and Collins had served on the Board of Directors of the MFHA for various lengths of time by 1936.[42] They represented several of the old-guard esteemed hunts in the United States: the Orange County, Blue Ridge, and Middleburg in Virginia; the Millbrook in New York; and the Norfolk in Massachusetts. Many of the sitters were successful businessmen but chose to have their formal portraits painted in hunt attire, reflecting the perceived status the sport held for them within their circles.

Of the eighteen portraits in the 1936 exhibition, seven were of female equestrians. The catalog listed Miss Helen Bedford, Mrs. I. Tucker Burr, Jr. (Evelyn Thayer), and Miss Charlotte Noland as Masters of their various hunts as well as Mrs. Holger Bidstrup (Frances Whitfield) in two paintings and Miss Emily Davie, both Ex-Honorary Whips. Although Mrs. Fletcher Harper (Harriet Wadsworth), also included, did not have an official role, she was a nationally recognized equestrienne and was instrumental in assisting her husband, Fletcher Harper, Master of Orange County Hunt Club (now the Orange County Hounds), to make it one of the leading hunts in the United States.[43]

Like Harper and Noland, Evelyn Thayer Burr (Figure 6.2) was a strong female figure in the hunt world. Burr was credited with maintaining the Norfolk Hunt's stability during her eight-year tenure as Master beginning in 1933 at the height of the Depression through to 1940, the onset of the Second World War.[44] Prior to that, she was Master of the Dedham Hunt beginning in 1923. "One of the earliest lady Masters in the country hunting hounds, Mrs. Burr, always in side-saddle habit, brought a great deal of panache to the hunt field," noted Norfolk Hunt historian Norman M. Fine.[45] In Burr's portrait, she is depicted wearing a black hunt coat with the white collar and yellow waistcoat, colors of the Dedham, and a hunt cap. She is holding a whip and resting a hand on the neck of a competently painted foxhound. This painting is a classic sporting composition, incorporating a human figure, an animal bred and raised for sport, and a landscape. While Rand often contrasted her sitters against an interior

Figure 6.2 Ellen Emmet Rand, *Mrs. I. Tucker (Evelyn Thayer) Burr, Jr., MFH the Norfolk*, Private Collection, Photograph from Ellen Emmet Rand Papers, Archives & Special Collections, University of Connecticut Library.

backdrop created from a carefully selected piece of fabric, Burr is juxtaposed against the terrain over which she provided sport. The artist also chose landscape backgrounds for two other Masters, Fletcher Harper and Blanchard.

It was an exciting time for women realizing more equal footing with men in equestrian pursuits. For centuries hunt roles had been solely fulfilled by men. It was not until 1908 that the first pioneering woman, Mrs. Gertrude Rives Potts of the Castle Hill Hunt in Albermarle County, VA, was acknowledged as a Master of a recognized American hunt by the MFHA.[46] Within three decades, by 1935, 22% of the Masters of the 135 hunts recognized by MFHA were women.[47] The growing role of women likely appealed to Rand as a female equestrian and as someone accustomed to pushing gender boundaries in her career but also, in more practical terms, as providing additional clientele in need of paintings. Indeed, while it is undeniable that Rand gained broader introductions in the foxhunting world through her husband, she developed and

fostered business relationships and acquaintances independently of Blanchard's rise as Master of the Old Chatham Hunt. Her correspondences and diary entries reveal that many of the members of the hunting community she knew and painted were as a result of the friendships she made, direct solicitations on her part, or inquiries by prospective patrons.

Until the 1936 exhibition, Rand did not promote herself as a sporting artist and did not strive to compete with contemporaries working in the genre, yet she remained a contender within discerning sporting circles. Her patrons looked to her for her ability to capture sporting tack and faithful figurative likenesses. In 1941, a longtime friend, John Bowditch, ex-MFH of the Millwood Hunt, sent Rand photographs of James Butler riding in the Bayard Taylor Memorial Hunt to review for a possible commission.[48] He wrote, "Would doing the horse bother you? If you think it would, let me know and I will ask Frank Voss about it."[49] Bowditch respected Rand's talents enough to contact her before Franklin Brooke Voss, who was also a foxhunter and premier sporting portraitist in the first half of the twentieth century, known for foxhunting, racing, and coaching subjects. Some of Voss's other sporting portrait contemporaries were American artist Richard Newton, Jr. and British painters who also worked in the United States. such as Sir Alfred Munnings, an icon of the genre, James Lynwood Palmer, and William Smithson Broadhead.[50] Bowditch's question drove home his concerns about Rand's potential weakness—equine portraiture. The ability to capture not just an accurate likeness of a human but of an animal is a prerequisite for most sporting paintings. With the exception of one portrait, *Mrs. Holger Bistrup on "Dr. Little,"* in the *Sporting Portraits* exhibition, Rand never publicly showed another portrait that included a horse.

Interestingly, she made a distinction between what she called the "Equestrian portrait" of Mrs. Bidstrup and a second painting she began spontaneously, a "real portrait" as she called it, of the same sitter: "Today I started painting Peter Whitfield [nickname 'Peter' and maiden name] not on the horse but a real portrait I got on well with it. Tomorrow I will go at the Equestrian portrait. She was so paintable in her black coat + black velvet cap that I could not resist a portrait."[51] Rand seems to have elevated figurative art over animal subjects, although her early illustration art, sketches, portraits with pets, and personal family works reveal that she often competently portrayed animals including horses, dogs, birds, and cattle.

Rand only on occasion offered that a portrait was an enjoyable experience. A striking insight is her husband Blanchard's painting (Plate 10), also completed for inclusion in the *Sporting Portraits* exhibition using a recycled background landscape from another unfinished painting:

> Today has been exclusively given over to a portrait I am actually painting of Blanchard. I started it this morning on an old canvas on which I had a start of Harry DuPont. It had a rather good out of door background + all that made it easier – + quicker – I got on quite well + was surprised at the amount of likeness as I never believed I could paint him, he is all rigged up as M.F.H. Which makes it a lot more fun to paint.[52]

She found her husband most challenging, but what made it enjoyable was his sporting attire. Blanchard's portrait follows the same formula as some of the others. He is seated in a chair, leaning one arm on a table, legs crossed, making direct eye contact with the viewer with piercing gray/blue eyes. His expression is neutral. Rand spent several sittings making adjustments to the hands and legs and fleshing out the details of her husband's immaculate turned out (ensemble). He cut a striking figure in his well-fitted hunt coat with shiny brass hunt buttons and canary yellow colors (collar of Old Chatham) and vest, a perfectly tied stock with stock pin, and riding britches with boot straps at the top of his boots. He has one white glove removed and wears a pinky ring and wristwatch. Blanchard holds his whip across his lap, and his hunting hat is next to him. It is a portrait of which any sportsman would be proud, but Rand did not provide insight as to whether her husband approved of it or not.

<p style="text-align:center">***</p>

After the 1929 stock market crash, Rand had to work even harder than before and was often understandably less motivated to paint people whom she did not find interesting. Even before then, she was unsparing in voicing this in her diary entries. In April 1928, she noted: "I've had no fun lately from good painting. I shall have to start in + get going. I shall get lots of canvasses the right size etc. + simply paint and paint. Meantime the money must be made."[53] The portraits of the Harpers, Noland, and others she included in the *Sporting Portraits* exhibition, however, were clearly not rote exercises churned out for financial gain.

Even though Rand is not remembered as a sporting portraitist, the 1936 *Brooklyn Eagle Review* described her as such in the article about the *Sporting Portraits* exhibit because of her output.[54] The paintings are a silent testimony to Rand's personal interests as a horsewoman, sporting enthusiast, and a countrywoman, and her unparalleled ability to translate her passions into refined paintings for a discerning patron base. She was acutely aware that the details of tack and attire were defining characteristics of critical importance to her sitters and as an artist enjoyed the variety the compositional elements offered. She conducted herself in her life as a force of nature, projecting herself into her professional and private experiences with equal determination as both an Amazon and an artist. Rand's sporting works are significant contributions to art, not only as documents of important sporting figures, but as a reminder that the art that depicts sport remains a rich and varied genre to be considered within the context of contemporaneous art movements and the broader narrative of history and art history.

Notes

1 Rand Family wins first place in the Family Class at the Dutchess County Fair Horse Show on September 2, photograph, Ellen Emmet Rand Papers, Archives & Special Collections, University of Connecticut Library (EER Papers, ASC, UConn), Box 1, Folder 1.

2 *Sporting Portraits by Ellen Emmet Rand, N.A.* (New York: Sporting Gallery & Bookshop, 1936): cover.

3 "Obituary: Melville E. Stone 2d, Bookseller, 84." *The New York Times*, March 29, 1989, D24.

4 Ellen Emmet Rand, Diary, April 27, 1929, EER Papers, ASC, UConn.

5 Rand Diary, January 29, 1936, EER Papers, ASC, UConn.

6 Ibid.

7 Rand Diary, February 21, 1936, EER Papers, ASC, UConn.

8 Rand Diary, Financial End Pages, 1933, EER Papers, ASC, UConn.

9 Melville Stone, Letter, October 7, 1936, EER Papers, ASC, UConn. Box 1, Folder 50.

10 "In Local Galleries," *The New York Times*, 19 April 1936, 8.

11 "Art Auctions," *The Brooklyn Eagle*, 27 April 1936, 9.

12 Grace Wickham Curran, "Ellen Emmet Rand, Portrait Painter," *The American Magazine of Art* (September 1928), 478.

13 For an overview of the history, rules, attire, etiquette, and terminology relating to foxhunting, see Lt. Col. Dennis J. Foster, *Introduction to Foxhunting* (Millwood, VA: MFHA Foundation, 2012).

14 "Attractions in the Galleries," *New York Sun*, April 18, 1936, 12.

15 Oscar Tully Shuck, ed., *History of the Bench and Bar of California* (Los Angeles: The Commercial Printing House, 1901), 439

16 Letter from Ellen Emmet to Lydia Field Emmet, September 18, 1898, Emmet family papers, Archives of American Art, Smithsonian Institution (Emmet Family, AAA), Box 5, Folder 20.

17 Letter from Ellen Emmet to Jane Erin Emmet, November 7, 1906, Emmet Family, AAA, Box 5, Folder 21.

18 "Polo Handicaps for 1906," *The Brooklyn Eagle*, February 7, 1906, 13.

19 Lydia Sherwood McLean, preface to *The Emmets: A Family of Women Painters*, ed. Martha J. Hoppin (Pittsfield, MA: The Berkshire Museum, 1982), 11.

20 "Miss Ellen Emmet A Bride. Portrait Artist Married to William B. Rand. In Salisbury, Conn," *The New York Times*, May 7, 1911, 11.

21 Rand Diary, June 4, 1928, EER Papers, ASC, UConn.

22 Rand Diary, November 23, 1926, EER Papers, ASC, UConn.

23 Rand Diary, November 27, 1928, EER Papers, ASC, UConn.

24 Elizabeth Letts, *The Eighty-dollar Champion: Snowman, The Horse that Inspired a Nation* (New York: Ballantine Books, 2012), 41.

25 Mary Custis Lee deButts and Rosalie Noland Woodland, *Charlotte Haxell Noland, 1883–1969* (Middleberg, VA: Foxcroft School, 1971), 85, 69, and 68.

26 G. Gordon Massey, May 29, 1928, EER Papers, UConn, Box 1, Folder 43.

27 Rand Diary, January–December Cash Rec'd Paid, 1929, EER Papers, ASC, UConn.

28 Rand Diary, March 8, 1929 EER Papers, ASC, UConn.

29 Ibid.

30 1929 $3000–4500 commission price inflated to 2017 values using calculator from: Dollar Times. dollartimes.com, March 28, 1929. http://www.dollartimes.com/inflation/inflation.php?amount=1&year=1929, accessed July 26, 2020.

31 Rand Diary, July 31, 1933, EER Papers, ASC, UConn.

32 To "hill-top" means to follow a hunt from hill-top to hill-top, usually to avoid jumping.

33 Rand Diary, November 29, 1928, EER Papers, ASC, UConn.

34 Rand Diary, September 21, 1929, EER Papers, ASC, UConn.

35 Rand Diary, October 6, 1929, EER Papers, ASC, UConn.
36 A drag hunt is created by "laying" (dragging) a scent along a planned hunt route that simulates the natural movements of quarry for a pack of hounds to follow a few hours before a hunt moves off.
37 Rand Diary, October 11, 1929, EER Papers, ASC, UConn.
38 Rand Diary, October 19, 1929, EER Papers, ASC, UConn.
39 Rand Diary, October 24, 1929, EER Papers, ASC, UConn.
40 Rand Diary, November 3, 1929, EER Papers, ASC, UConn.
41 Rand Diary, January 10, 1931, EER Papers, ASC, UConn. Henry Vaughan was then the Master of the Foxhounds Association of America's secretary and Master of the Norfolk Hunt and later became President of MFHA.
42 Ibid., 8–14.
43 Peter Winants, *Foxhunting with Melvin Poe* (Lanham, MD: Derrydale Press, 2002), 38.
44 Norman Fine, *The Norfolk Hunt: One-Hundred Years of Sport* (Boyce, VA: Millwood House, 1995), 123.
45 Ibid., 125.
46 A. Henry Higginson, *The Hunts of the United States and Canada, their Masters, Hounds and Stories* (Boston: Frank W. Giles, 1908), 15.
47 Data extrapolated from Henry Vaughan, *Master of Foxhounds Association of America: 1935* (Master of Foxhounds Association of America, 1936), 57–82.
48 The Bayard Taylor Memorial Hunt was a commemorative hunt run in Kennett Square, PA, and in 1940 recorded approximately 550 participants in the hunt field.
49 John Bowditch, Letter, 1941, EER Papers, ASC, UConn, Box 1, Folder 56.
50 For more information on Voss and American sporting portraits, see *Animal and Sporting Artists in America*, ed. F. Turner, Reuter, Jr (Middleburg, VA: National Sporting Library & Museum, 2011).
51 Rand Diary, June 24, 1929, EER Papers, ASC, UConn.
52 Rand Diary, January 10, 1936, EER Papers, ASC, UConn.
53 Rand Diary, April 10, 1928, EER Papers, ASC, UConn.
54 *The Brooklyn Eagle*, 9.

Part Three

Shifting Bodies

Hide and Seek: Ellen Emmet Rand, Childhood, and US Art Study in France, *c.* 1898

Emily C. Burns

With a sneaky expression of playful fear in a sidelong glance, a child presses up against a wall (Plate 11).[1] As though trying to flatten to make his body meld into it for a successful game of hide and seek, his arms and back are straight and flush with the surface. His proximity to the wall is enhanced with a thick shadow on his right side, but his body remains relentlessly three-dimensional. He is not alone in this game; two human-like dolls and a stuffed monkey toy join in the hiding. The seeker remains invisible, implied only by the expression on the boy's face and by the strokes that built the image.

With a single ground line, painter Ellen Emmet Rand transforms the blank page on the inside of a sketchbook cover into a wall. Parallel lines jut out to create the impression of floorboards. The dolls are flat and schematic, but the boy's head is jarringly lifelike with his wiry hair and vibrant face, on which Rand used the widest color palette in the image. The distinction creates a tension between naturalism and insistent fabrication as the artist reveals and hides her hand, as though playing hide and seek alongside her sitter. As much as the child in the image, Rand makes visual play with her pairing of two- and three-dimensionality and both experiment with the imagined limits of visibility.

The painting initiates a twenty-five-page sketchbook, which served as a visual game between Rand and her half-brother George Grenville Hunter (1892–1932), who is figured as the hiding child.[2] With some drawings side by side, poems, and games of tic-tac-toe, the book can be understood as a collaborative project between artist and child. The blank book was purchased at art supplier A. Moreaux at 106 Boulevard Montparnasse, in the neighborhood favored by US art students studying in Paris in the late nineteenth century.[3] At age twenty-one, in late 1896, Rand moved to this Montparnasse neighborhood to study painting—in what her cousin later described as the "uninterrupted unbroken atmosphere of paint"—and so the sketchbook probably dates from the last few years of the nineteenth century.[4] Her mother, Ellen James Temple Hunter, stepfather George Hunter, and Grenville were then based in England, and it is probable that Rand and Grenville embarked on this project while Rand was visiting with them in the spring of 1898, January 1899, or in the summer of 1900 before

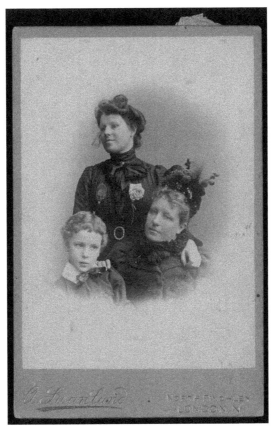

Figure 7.1 Ellen Emmet Rand, Ellen James Temple Hunter and Grenville Hunter, *c.* 1900, photograph, Mary Foote Papers, Yale University Special Collections, Beinecke Library.

her return to the United States. It may also have been made in Giverny, the popular artists' colony where Rand, her sisters, and Grenville spent the summer of 1898 during Ellen Hunter's marital troubles.[5] A photograph from around this time depicts Rand with her mother and half-brother (Figure 7.1). All three of them strike bohemian poses; Grenville and Rand look coyly off to the side, and their mother gives the camera a side-long glance.

On the surface, the sketchbook might be dismissed as merely a private family game. Yet this chapter takes this piece of material culture more seriously as a point of entry both into Rand's early career in France and into the larger cultural conversations about childhood and artmaking in this period. The sketchbook testifies to the closely interwoven relationship between Rand's personal life and professional career, a dynamic enhanced by the pressure she absorbed by supporting not only herself but also her family. The project of the sketchbook also highlights what many contemporaries in the field of psychology were beginning to understand of childhood as a unique

developmental phase in human life. Observers in this period began to challenge presumptions of pure childhood innocence with the possibility that children possess more self-awareness than previously imagined. In her representations of Grenville and other children, Rand engages with this more complex construction of childhood. Furthermore, her adoption of this motif in her art practice skirted details of her world of art study that belied innocence, thus placing Rand's early career into a wider current of US and French artists' appropriating the iconography of the child as an artistic metaphor for unencumbered vision. While much of the critical discussion on adopting a child's perspective presumed a male subject, Rand's engagement with this discourse expanded the space of naïve art practice to women artists. Her construction of childhood frames her modernist intervention into the psychology of portraiture.

"We Have Left Paris Way Behind": Fresh Vision, Giverny, and US Art Study in Paris

As with several other women artists of her generation, including Cecilia Beaux and Mary Cassatt, Rand's initiation into the Paris art world came through paintings of children.[6] The paintings she carried with her to Paris to gain entry into the private ateliers included a loosely painted portrait of her cousin Rosina "Posie" Emmet Sherwood holding her son Robert (private collection) and a horizontal oil painting of Grenville sleeping (private collection), his fingers still grazing the legs of a doll.[7]

But the child was not merely a domestic subject often relegated to women painters; it also took on metaphorical significance in the context of US art study in France during the late nineteenth century. While thousands of US art students sought training in Paris, reviewers on both sides of the Atlantic began to criticize US artists' demonstrable stylistic dependence. Many declared these students the children of French art and as mere "embryo artists."[8] When US artists displayed paintings of children in France, they tapped into this discourse, and drew on narratives in modernist circles about the child as a direct signal of the rejection of academic traditions. By playing the child, they reframed a liability of cultural youth into an artistic asset. In these international artistic circles, Rand's representation of her sleeping brother participated in an ongoing narrative of the artist's adoption of a similar posture of naïve, fresh vision. In this context, Grenville became more than an iconographic subject in line with other women painters of her generation, but also served as an ideological model.

Within a generation anxious about artistic influence and the repetition of formulae, the child offered an escape and a statement of individuality. Charles Baudelaire wrote in the mid-nineteenth century, "Genius is nothing more than nor less than childhood recovered at will." But as appropriated by an adult, according to Baudelaire, the genius's posture of childhood needed a level of self-awareness: "a childhood now equipped for self-expression with manhood's capacities and a power of analysis which enables it to order the mass of raw material which it has involuntarily accumulated."[9] Baudelaire pinpointed the paradox of a knowing naïveté in adopting the child's perspective when he claimed that childhood could be

harnessed by adulthood. Gustave Courbet took up this call in his inclusion of two child muses in his artistic manifesto *The Artist's Studio, A Real Allegory of a Seven Year Phase in my Artistic and Moral Life* (1855; Musée d'Orsay), one positioned at center and another sprawled across a large sheet of paper, drawing, at the right of the painting.[10] The depiction of the child in the act of creation underscores artists' wistful attempts to attain a similar approach to their work. In the international fin de siècle, many artists adopted the figure of the child as a flexible metaphor to celebrate these characteristics of freshness and renewal.[11] One cartoonist joked about the lengths to which artists went to attain a child's perspective (Figure 7.2). In "An Enthusiastic Impressionist," P. Nexxeil figures a painter before his canvas musing, "Let me see, what do I need with which to produce that effect?" as he reaches toward his table of materials, where a child stands idly watching him paint. In the second image, the painter has scooped up the child, toppled the table, and rubs the boy's head against the canvas while looking up to the sky, as though channeling the child's energy. The image mocks the absurdity of the impressionist goal of naïve vision.

Already a site of escape from the staid academic structure of Parisian study, Giverny invited particular attention to the metaphor of the child. Aside from the draw of Giverny as a quaint artists' colony since the early 1880s, the Emmets were encouraged to base themselves in Giverny by Frederick MacMonnies, who had been visiting Giverny since 1890.[12] In 1898, Frederick and Mary MacMonnies purchased the old monastery, which became known as Le MacMonastery or Le Prieuré. The house and gardens became center of the countryside colony for US artists working

Figure 7.2 P. Nexxeil, "An Enthusiastic Impressionist," *Harper's Bazaar*, July 25, 1885, scan by Avery Agostinelli.

in France.[13] The move from city to country enacted more than escapist leisure; many artists suggested that Giverny and other rural artists' colonies enabled them to move away from academic conventions trained in the Ecole des Beaux-Arts and private ateliers in Paris, where Rand and her relatives were training.[14] When Rand and her sisters first visited in the summer of 1897, Jane wrote to their mother, "We have left Paris way behind."[15]

In the countryside, artists frequently claimed to forget their academic knowledge in favor of an innocent eye. The child became a key icon to signal this investment in artistic naïveté. Artists drew not only from French romantic narratives of the child such as Courbet's, but also from US critics, such as Harrison Morris, who instructed painters of children to "put on the badge of the nursery and live its life [...] he must be fresh in wonder and inventive in whim, and he must be very pure of art."[16] In 1901 critic Maria Taylor Blauvelt reinforced these ideas arguing that the artist might find originality by mimicking the child and being "the impressionable man – the man whose soul lies open to all impressions, as the child's soul does." She continued, "The artist is the child who becomes more and more of a child as the years go on," and concluded, "to be an artist at all, it is absolutely necessary that the child be there."[17] William Merritt Chase, with whom Rand briefly trained at his Shinnecock plein-air painting class before her travels to France, expressed a similar idea when he declared, "Absolute originality in art can only be found in a man who has been locked in a dark room from babyhood."[18] This circulating discourse around the artist as child informed impressionist experiments with a loosely painted surface that implied a more haphazard and quick perspective on a dynamic subject. In all of these claims, as well as Baudelaire's, Courbet's, and Nexxeil's uses of the child, the artist is figured as a man. Yet Rand reclaims this gendered discourse by applying it to her own art practice.

A drawing in Jane's sketchbook that is likely by Rand suggests the newfound playful perspective (Figure 7.3) invited by the countryside. Four women sit close to the ground at easels making plein-air paintings. The artist implies her own bodily presence on a nearby bench and acknowledges this view with her feet splayed to either side and the edge of her skirt visible. Her informal pose highlights Giverny as a site for challenging artistic formula and social propriety. As Leslie wrote to cousin Lydia Field Emmet in June 1898, "Bay has done a few awfully good out of door things & is getting really crazy about the landscapes."[19] In addition to drawing attention to her own unconventional angle, the women in Rand's drawing also look in subtly distinct directions; she draws attention to how each artist finds her own slightly unique viewpoint. In this, she aligns with the consistent practice in art colonies of seeking new artistic perspectives.[20]

In the summer of 1898, Rand spent the summer in Giverny, renting a cottage nearby in Bois Jerome that she shared with her mother, Grenville, and her sisters.[21] Rand's younger sister wrote about their mother and half-brother serving as models in June 1898: "We are all painting Mama & Gren too. Bay is doing a lovely thing of them. Mamma sitting down with a book in her lap & Gren leaning up against her sort of looking over her shoulder."[22] Grenville appears in several photographs in the papers of Mary Foote, another US artist working in Giverny who worked closely with the Emmets and with Frederick MacMonnies.[23] These photographs recount Grenville's summer adventures alongside Rand in the act of picking berries, reading while leaned

Figure 7.3 Ellen Emmet Rand, *Sketch of Women in an Outdoor Art Class*, Giverny, c. 1898, sketch on paper, Emmet family papers, 1792–1989, bulk, 1851–1989. Archives of American Art, Smithsonian Institution.

up against hay bales (Figure 7.4), and wearing costumes. In Giverny, Grenville was not only Rand's side-kick, but also served as a model for impressionistic portraits by MacMonnies, Foote, and Rand. All three painters take on a child-level perspective in their representations of him, as though adjusting their point of view to his.[24]

Several pairings in "Grenville's Picture … Book" suggest that Rand and Grenville were making drawings simultaneously on opposite leaves of the sketchbook.[25] These pairs reinforce the idea that adult artists could appropriate a child's perspective. In one pairing (Figure 7.5), at right Rand draws a part of a storybook narrative, in which two children attempt to save a fairy captured by an ogre who glares down at them. On the adjacent page, Grenville draws a landscape with a diagonal denoting the ground line, a stick figure walking toward a tree with a round sun, punctuated with lines to signify its rays. The pencil drawing has a haphazard effect, with the sun's rays not always connecting with the center circle and lines to indicate grass and circles to dot a few flowers. Rand and Grenville's drawings both construct a landscape setting, but differ in Rand's emphasis on illustrated characters for the audience of a child, and Grenville's drawing reveals his childish perspective with a long diagonal groundline and schematic pencil markings. In another drawing, Rand and Grenville share a single page (Figure 7.6). Grenville draws an imaginary beast, while Rand draws a portrait of

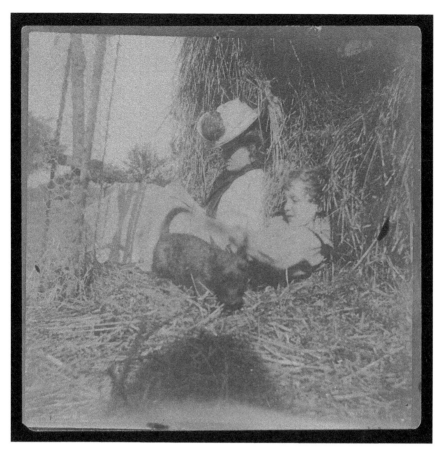

Figure 7.4 Ellen Emmet Rand and Grenville Hunter in Giverny. *c.* 1898, photograph, Mary Foote Papers, Beinecke Rare Book and Manuscript Library, Yale University.

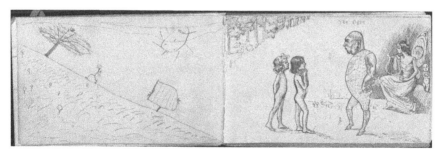

Figure 7.5 Ellen Emmet Rand and Grenville Hunter, pages from Grenville's Picture Book, 1896–1900. Ellen Emmet Rand Papers, Archives & Special Collections, University of Connecticut Library.

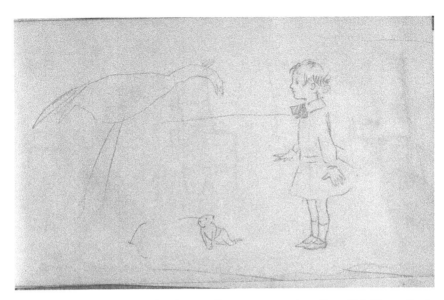

Figure 7.6 Ellen Emmet Rand and Grenville Hunter, page from Grenville's Picture Book, 1896–1900. Ellen Emmet Rand Papers, Archives & Special Collections, University of Connecticut Library.

Grenville looking surprised and frozen at the creature. On the ground, she draws an anthropomorphized mouse, which turns back to observe the child's expression. In this sketch, she mimics Grenville's style in which almost none of the lines she uses to depict his body and clothing actually connect. She leaves the eye to finish the image. These images frame other sketches in the book, which include Rand's detailed self-portrait in profile at a desk, tendrils of her curls falling forward into her face while she is at work on a letter, sketch, or perhaps even this book itself next to a light (Figure 7.7). Through spatial proximity to the paired drawings, the labor and gravity of her subtly modeled self-portrait interweave her art with the discourse around child's art.

The line between painting the child and playing the child was porous among the US artists in Giverny. Some evidence suggests that—in addition to relentless flirting and likely romantic entanglements with his students—MacMonnies performed a childlike persona.[26] The Emmets frequently commented on MacMonnies's boyishness. Jane wrote, "He is so young, really almost a boy and yet so distinguished … He is very funny and you never have any idea of what he is going to say or do next."[27] Rosina concurred, "The complexity of his nature is marvelous […] at times he is nothing but a thin little boy with curly hair and locks of scraggly behind the ears – and this side of him is the most appealing of all."[28] Rand's cousin Lydia reinforced this claim,

MacM with his shock of blond curls, like a stage child, and thin throat in the middle of a collar six sizes too loose and a tomato little nervous twitching face on top of it and his long bony sensitive hands and big feet is without precedent

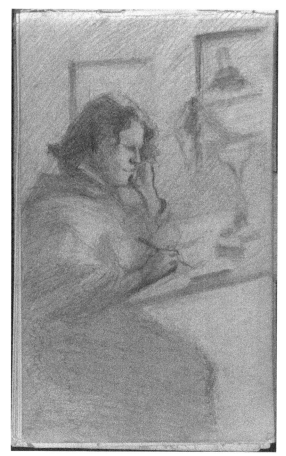

Figure 7.7 Ellen Emmet Rand, *Self-Portrait*, inside Grenville's Picture Book, 1896–1900. Ellen Emmet Rand Papers, Archives & Special Collections, University of Connecticut Library.

> [...] He is the youngest and most ungreat seeming thing to have attained so much
> [...] you have to pinch yourself to remember it, he is so childish and in some ways
> inexperienced. [29]

Significantly, however, in calling him a "stage child," Lydia seems to see through this persona as performance. This persona reinforced MacMonnies's art, especially given his turn to painting in 1897 as a way to renew his artistic identity. [30] MacMonnies's childish performance also deflected attention from his extramarital exploits and displays of virility. It marks his gender privilege as he instructs a coterie of women art students. In the process of defining his artistic success through the metaphor of the child, he subtly undercuts the professionalism of his female students. The child as a motif of creativity is fraught in this structure, but Rand's explorations with Grenville

mark her attempt to re-shape that discourse to frame her own art practice, creativity, intellectual, and visual engagements through her constructions of childhood.

"Under the Influence of Curious Intuitions and Knowledges"

The idea of childhood was increasingly complicated in the psychological and philosophical discourses of the period. In the late nineteenth century, constructions of childhood shifted from imagining the child as a dutiful mirror of parents and a miniature adult, to the notion of the child as a unique individual with an independent imaginative life and interior self.[31] Scientific and popular journals began to discuss the autonomy, creative potential, and individuality of the child. American psychologist G. Stanley Hall and others studied the development of personality and individuality in childhood as separate from their parental relationships.[32] Hall spearheaded an effort to better understand children's innate self-awareness. Psychologists argued that parents should allow their children greater opportunities for self-assertion to develop their imaginative capacities.

As the nineteenth century progressed, popular notions of childhood evolved to the belief expressed by historian Horace Scudder that children "possessed ... consciousness, as isolated, as disclosing a nature capable of independent action, thought and feeling." According to Scudder, in the United States in particular, the child came to be viewed, by the mid-1880s, as "a very free and independent person indeed."[33] Writers applied this association with self-awareness and individuality both to the child and to new ideas of the adolescent.[34] As these categories were becoming re-defined, critics used them with increasing specificity.

Concurrent literature began to imagine the deep self-awareness and consciousness of the child. As with artists, writers, including Rand's cousin Henry James, appropriated presumptions of children's subjectivity and interiority.[35] Turn-of-the-century US writers branded childhood less by notions of innocence, and more by developmental self-awareness, insightful perception, and even uncanny interiority. Henry James's short story "The Pupil" (1891) foregrounded a child who seemed too young to understand the conversations around him, but his face was "at one moment ... infantine; yet it appeared also to be under the influence of curious intuitions and knowledges."[36] James extended this construction in his novel *What Maisie Knew* (1897), which traces the perspective of a young girl being shuttled between her divorcing parents as they consistently assume her oblivion; James proves her depth of awareness of the manipulations and betrayals around her. The characters' presumptions of Maisie's childhood innocence are unraveled through her self-awareness and her active involvement in the complex social transactions around her.[37] Throughout the novel, James offers "a register of impressions" to explore Maisie's interiorized self, her "small expanding consciousness" in which she comprehends more than she can articulate in the convoluted sexual relationships of her parents.[38] Maisie's self-awareness belies her age, and, in order to protect herself from the world around her, develops "the idea of an inner self" and a "sharper sense of spectatorship."[39] Midway through the

novel, James announced Maisie's ironic possession of "an innocence so saturated with knowledge."[40] This phrase resonates with performances of childlike perspectives in the artist community in Giverny.

In her depictions of children, Rand seems aware of these narratives of children's subjectivity, and participates in them, even in her earliest magazine illustrations in the early 1890s. Sometimes she emphasized children's manipulation of the adult world. For example, in an image of a family riding in a carriage, the poem suggests that while the father is driving the horses, the child holding the reins is actually the one controlling the motion.[41] In another early sketch, a child sitting on a bench beside a man offers a knowing glance.[42] Comments in the Emmet family letters also imply the interiority of children, as well as their ability to manipulate adults. When Jane first met the child of Frederick and Mary MacMonnies, Bertha, who was born in 1895, she described her as "too lovely and cunning."[43] In a letter to her mother, Jane also described the children walking along the Champs Élysée in Paris: "I've never seen such cunning children."[44] Likewise, a few years later, Grenville had a "heat attack," but then used the attention to have an extended reading session in bed: "Gren is too cunning, like a little pallid gold thread in bed, & Mamma is reading him 'Treasure Island' while I paint him in the morning."[45] These comments suggest children's manipulation of adults, challenging notions of inherent innocence. In some of her poems and sketches in "Grenville's Picture ... Book" Rand also makes adult-targeted humor. In a sketch imagining a dog's knowing resistance to a woman's orders, "Sporty Sam/does not give a damn/when the word of command is given/He says ... /you can't boss me/I declare I won't be driven/says he/by any young woman liven."[46] This humorous image and poem for Grenville in his sketchbook plays on the private family life of the Emmets, in which Grenville was surrounded by women. Furthermore, this joke only thinly veils critique of gender roles in the period. Rand suggests that even a dog would not obey a woman's wishes. In the context of hundreds of US women artists struggling to attain professionalism in foreign art study in France, this image suggests the frustrations of that endeavor.[47]

Like the troubled adult relationships in Maisie's life, Grenville's home life was similarly complicated (a situation James would have observed when the Emmets were in England). Lydia wrote to her mother in March 1898, describing Ellen's "fluctuating and unreasoning feelings about Mr. H ... She is by turns threatening to leave him and then wildly jealous of him and then she says she doesn't care for him and is going to run away to America with Gren and then loves England and is perfectly contented with Mr. H."[48] With the fluctuations of Ellen's feelings for the "insurmountable object" of her husband,[49] Rosina observed, "we ... have finally realized that no decision come to on that subject is inevitable," creating an "uncertain background to our lives." She concluded, "Mama has made a failure of marriage as far as everything but Gren is concerned."[50] Rosina, Rand, and her sisters were old enough to observe, comment on and distance themselves from this volatile relationship, which Rosina called "her most unmanageable life."[51] Rosina stated, "we have decided to put Mama's orders & plans out of the question & live our own lives in blessed independence."[52] At age six, Grenville must have experienced such turmoil even more directly, and, as in Maisie's character, with an expectation (or a hope) of his oblivion.

Rand described Grenville in a letter to her cousin Lydia after spending the Christmas holiday with him in 1899, "In some ways he is just as old as a grown up person, in other ways very young."[53] Over time, Rand ramped up the intensity of the psychology of her many portraits of Grenville. An early portrait features Grenville with red socks and shoes and a red-trimmed dress seated in an oversized chair with rounded arms like claws (Plate 12). He clenches a cat on his lap. His wide blue eyes gazing intently off into space and the right shadow on the left side of his face highlight an interiority in his act of perception. The scale distinction between child and chair underscores the distinction between adult and child perspectives. In another portrait, perhaps made in Giverny, Rand depicts Grenville leaning up against a wall, his brown clothing absorbing him into the surface behind him (Plate 13). He holds a bow, perhaps a playful pun on his name "Hunter." Yet, he is not a lighthearted or smiling child. Isolated and placed at an oblique angle, he looks off into the distance, his face a stone in silent reflection. In the background, a window and shutters are open, but little light touches the boy. He leans on a doorframe with one arm tucked behind his back, as though in between two spaces. This open but un-illuminating window plays with the idea of Grenville's interiority; his thinking is both revealed to and obscured from the viewer who looks down upon him.

This complexity dominates Rand's later portraits of Grenville. In one painting from about 1909, he leans on bow, a larger and thicker than the previous as though it has aged with him. He looks directly at the viewer with one hand on his hip. His pursed lips echo the color of his maroon turtleneck and his eyes are a piercing blue (Plate 14). Light rains on his thigh that projects forward toward the viewer, but the rest of his body leans back toward the darkness behind him that threatens to absorb him. Again, the gravity of expression on his face implies his interiority, and he exudes no joy.

Twice in *What Maisie Knew*, James used the metaphor of being flattened against a pane of glass to register the meeting between Maisie's consciousness and the world. He described:

> the sharpened sense of spectatorship was the child's main support, the long habit, from the first, of seeing herself in discussion and finding in the fury of it [...] a sort of compensation for the doom of a peculiar passivity. It gave her often an odd air of being present at her history in as separate a manner as if she could only get at experience by flattening her nose against a pane of glass.[54]

Maisie peers out at the world from a subjective position, feeling "henceforth as if she were flattening her nose upon the hard window-pane of the sweet-shop of knowledge."[55]

Rand's depictions of her half-brother present him with a knowing and brooding expression. In their shared sketchbook (Plate 11), his attempt to be absorbed by the wall implies his exploration of the boundaries between himself and the world around him. In the oil compositions (Plates 12–14), he seems pressed and flattened at the edge between interiority and exteriority and between the viewer and the space of the painting. In the earlier painting, the dramatic diagonal and sitter's gaze push the viewer away. In the later painting, even as Grenville looks directly out of the picture plane and

is drawn right up to the edge of it, his vacant expression insists on his inner thoughts and refuses the viewer's attempt to seek them. He seems knowing, to peer into what James described as "the sweet-shop of knowledge."

In these paintings, Rand rivals the interiority presented in portraits of children by John Singer Sargent, such as the *Daughters of Edward Darley Boit* (1882, Museum of Fine Arts, Boston) and the *Children of Edouard and Louise Pailleron* (1880, Des Moines Art Center, Iowa).[56] In reviewing the former painting, James described the "slightly 'uncanny' spectacle" of Sargent's talent exhibited by the painting, arguing that the composition foregrounded "the freshness of youth combined with the artistic experience, really felt and assimilated, of generations."[57] James's commentary noted the irony within the painting. The iconography of the child signaled "the freshness of youth," but the apparent consciousness of the children coupled with Sargent's adept brushwork and awareness of art history, such as the painting styles of Diego Velázquez and Sargent's teacher Carolus-Duran, revealed it to be a shrewd synthesis of past and present art. Rand plays with a similar tension, belying expectations of childhood innocence with Grenville's uncanny interiority; she also employs open brushwork that situates her in an international art network while claiming her artistic independence. Rand's paintings of Grenville are more than experiments in psychological interiority and served as well as marketing devices to show the versatility of the artist's painting styles. Upon her return to New York City in 1900, these works were likely shown to potential clients visiting her studio to observe Rand's abilities to capture personality with a range of visual effects.

In Rand's 1910 large-scale portrait of *In the Studio*, Rand also depicts a knowing, self-aware child (Plate 2).[58] The sitter, her niece Eleanor Peabody, gazes directly toward the viewer, fondling a black cat in her arms (see too Betsy Fahlman's analysis of the painting in her chapter). Her eyebrows are slightly raised in an expression of small surprise, and Rand captures the effect of her mind processing of whatever has caught her attention. Furthermore, the artist constructs a reflection in the large mirror behind her sitter, reflecting her wavy blonde hair and also in the shadowy left-hand corner, a self-portrait of the artist before a canvas of the same dimensions as *In the Studio*. This construction has obvious resonances with Diego Velázquez's *Las Meninas*, in which the intensity of the sitter's gazed it matched by that of the artist. The spatial distortion created by that mirror leaves the viewer unsteady in receiving the child's gaze. Rand's adaptation of Velázquez's self-portrait, and indeed Sargent's riff on Velázquez, mark her attempts to engage with the narrative of the child to professionalize her artistic career. Her submission of this painting to major exhibitions, such as the Panama-Pacific exhibition in 1915, where it won an award, underscores her use of a complex notion of childhood to design her career.

Rand both reflects and intervenes in the discourses of the child and adolescent in the late nineteenth and early twentieth centuries. While easily dismissed under a veil of innocence, "Grenville's Picture … Book" and Rand's paintings of children demarcate a more anxious terrain about building art and understanding human psychology. Grenville's sketchbook can be overlooked as a private family affair, but this closer look reveals Rand's shrewd and calculating use of the artistic, intellectual, and psychological discourses of the turn of the century to deftly build an artistic career in a

male-dominated art world. Furthermore, Rand's appropriations of childhood expand art historical understanding of modernism. Her portraiture might be initially sidelined as a traditional medium and her practice as centered around the profits of representing high society that enabled her to support her family. Yet thinking about the ways in which she actively engages with contemporaneous ideas of psychology and childhood not only as an icon, but also as inflected by her very approach to painting, insists upon her portraits as part of an emerging and non-gender bound modernist project.

Epilogue: Blank Spaces

Grenville committed suicide on June 4, 1932. In a letter to her sister reporting the news while awaiting details of the incident, Posie commented, "The thought of suicide is apparent in my mind. He had often fits of nervous exhaustion and depression."[59] In her diary, Rand wrote, "everything is made insignificant today in comparison to the outstanding fact that Grenville Hunter, my half-brother, has taken his life." She described a personality apparent in her array of childhood portraits: "his nature was divided in two, he had a very loveable and attractive and good side, then again a strange lonely side, tuned in a minor key."[60] At the funeral parlor, Rand made a pencil

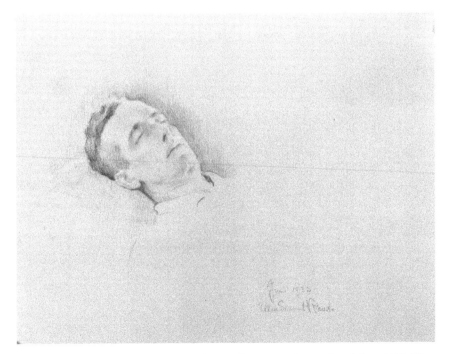

Figure 7.8 Ellen Emmet Rand, *Sketch of Grenville Hunter after His Death*, June 1932. Ellen Emmet Rand Papers, Archives and Special Collections, University of Connecticut Library.

sketch of his head and neck in her diary which she expanded on a single sheet of paper for his widow (Figure 7.8). While her sketch of him as a playful child (see Plate 11) had transformed the paper into a wall to support his body, in this drawing, the blank space of the paper absorbs his body altogether. She takes on a similar view peering down as Claude Monet's death portrait of his wife Camille (1879, Musée d'Orsay). Only Grenville's head emerges with the same thick cast shadow outlining his form. The placement of his head on the support recalls the composition of her oil painting of him sleeping as a child, yet any innocence of a temporary state of sleep is here frozen in lifeless permanence, merely saturated with knowledge. Rand again takes on the role of the unseen seeker, though her art of portraiture was no mere child's play.

Notes

1 I am grateful to the other contributors for a wonderful collaborative experience and to Alexis Boylan for her incisive edits. My thanks as well for Dianne Kim for help finding relevant digitized letters in the Archives of American Art database, and to Avery Agostinelli for copy edits.

2 "Grenville Picture … Book," Ellen Emmet Rand Papers, Archives & Special Collections, University of Connecticut Library (EER Papers, ASC, UConn), Box 8. Some drawings and poems clipped from the book are in Box 7, folder 93. Since the book is not fully intact, the number of 25 is approximate and the original order of the pages is difficult to discern.

3 On US art study in France, see Lois Marie Fink, *American Art at the Nineteenth-Century Paris Salons* (Washington, DC: National Museum of American Art, Smithsonian Institution, 1990); H. Barbara Weinberg, *The Lure of Paris: Nineteenth-Century American Painters and Their French Teachers* (New York: Abbeville Press Publishers, 1991); Kathleen Adler, Erica E. Hirshler, H. Barbara Weinberg, *Americans in Paris, 1860–1900* (London: National Gallery, 2006).

4 Lydia Field Emmet to Ellen Hunter, March 4, 1898, p. 5, Emmet family papers, 1792–1989, bulk, 1851–1989. Archives of American Art, Smithsonian Institution. (Emmet Family, AAA), Box 2, Folder 38.

5 E. Adina Gordon, "The Expansion of a Career: Frederick MacMonnies as a Teacher and Painter," in *An Interlude in Giverny*, eds. Joyce Henri Robinson, Derrick R. Cartwright, and E. Adina Gordon (University Park: The Pennsylvania State University, 2001), 72. On US artists in Giverny, see also Katherine M. Bourguignon, ed., *Impressionist Giverny: A Colony of Artists, 1885–1915* (Giverny: Musée d'art américain, 2007); William H. Gerdts, *Monet's Giverny: An Impressionist Colony* (New York: Abbeville Press Publishers, 1993); and William H. Gerdts, "American Art and the French Experience," in *Lasting Impressions: American Painters in France, 1865–1915* (Chicago: Terra Foundation for the Arts, 1992), 45–65.

6 Beaux sent *Les derniers jours d'enfance* (1884; Pennsylvania Academy of the Fine Arts) to the Paris Salon before visiting. See Cecilia Beaux, *Background with Figures: Autobiography* (Boston: Houghton Mifflin, 1930), 92–4; 98–9.

7 This painting and a similar pastel of Grenville (*c.* 1893; private collection) are reproduced in Ellen E. Rand, *Dear Females* (United States: Ellen E. Rand, 2009), 25 and in Tara Leigh Tappert, *The Emmets: A Generation of Gifted Women* (New York:

Borghi & Co., 1993), 49. A pair of undated sketches also probably depict a sleeping Grenville (EER Papers, ASC, UConn).

8 Helen Cole, "American Artists in Paris," *Brush and Pencil* 4, no. 4 (July 1899): 201.

9 Charles Baudelaire, "The Painter of Modern Life," (1863), repr. in *The Painter of Modern Life, and Other Essays*, trans. and ed. Jonathan Mayne (London: Phaidon, 1964), 8. See also Marilyn R. Brown, "Introduction," in *Picturing Children: Constructions of Childhood between Rousseau and Freud*, ed. Marilyn R. Brown (Aldershot: Ashgate, 2002), 7–11; Anna Green, *French Paintings of Childhood and Adolescence, 1848–1886* (Aldershot: Ashgate, 2007), 4–5, 27–30; and Jonathan Fineberg, *The Innocent Eye: Children's Art and the Modern Artist* (Princeton, NJ: Princeton University Press, 1997), 5.

10 Daniel R. Gurnsey, "Childhood and Aesthetic Education: The Role of *Emile* in the Formation of Gustave Courbet's *The Painter's Studio*," in *Picturing Children*, ed. Brown, 71–88; and Fineberg, *Innocent Eye*, 8–9. Some artists justified de-skilling in their art production in the name of adopting the child's perspective as a stylistic strategy.

11 Greg M. Thomas, *Impressionist Children: Childhood, Family, and Modern Identity in French Art* (New Haven: Yale University Press, 2011).

12 Bourguignon, *Impressionist Giverny*, 132–3; Gerdts, *Monet's Giverny*, 132–40; and Cartwright, "Beyond the Nursery: The Public Careers and Private Spheres of Mary Fairchild MacMonnies Low," in *Interlude in Giverny*, eds. Robinson, Cartwright, and Gordon, 44–53.

13 C.I.B. "Monet and Giverny," *New York Tribune*, September 8, 1901, pt 2, p. 1.

14 Nina Lübbren, *Rural Artists' Colonies in Europe, 1870–1910* (Manchester: Manchester University Press, 2001); Laura Meixner, *An International Episode: Millet, Monet and their North American Counterparts* (Memphis, TN: Dixon Gallery and Gardens, 1982); and David Sellin, *Americans in Brittany and Normandy, 1860–1910* (Phoenix: Phoenix Art Museum, 1982).

15 Jane Emmet to Ellen Hunter, May 20, 1897, Emmet Family, AAA, Box 4, Folder 30 (image 9 of 39).

16 Harrison S. Morris, "American Portraiture of Children," *Scribner's Magazine* 30 (December 1901): 645, 647. On the role of nationalist discourses in the appropriation of the child, see Emily C. Burns, "Nationality, Modern Art, and the Child in Late-Nineteenth Century Painting," in *Children and Childhood: Practices and Perspectives*, eds. Chandni Basu and Vicky Anderson-Patton (Oxford: Inter-Disciplinary Press, 2013), 45–59; and Caroline F. Levander, *Cradle of Liberty: Race, the Child, and National Belonging from Thomas Jefferson to W.E.B. DuBois* (Durham: Duke University Press, 2006).

17 Maria Taylor Blauvelt, "The Artistic Temperament," *Book Buyer* 21 (January 1901): 545, 548.

18 "From a Talk by William Merritt Chase with Mr. Benjamin Northrop, of the Mail and Express," *Art Amateur* 30, no. 3 (February 1894): 77.

19 Edith Leslie Emmet to Lydia Field Emmet, June 2, 1898, Emmet Family, AAA, Box 1, Folder 34.

20 A cartoon printed in *Le Journal amusant* in 1875 mocked this desperation for new perspectives by showing Anglo-US painters painting from waist deep inside a pond (Bourguignon, *Impressionist Giverny*, 18). On impressionism and the innocent eye, see Joel Isaacson, "Constable, Duranty, Mallarmé, Impressionism, Plein Air, and Forgetting," *Art Bulletin* 76, no. 3 (1994): 427–50.

21 Lydia noted, "They are so delighted at its being possible again this summer to be with her and Gren," Lydia Field Emmet to Julia Colt Pierson, March 1898, Emmet Family, AAA, Box 2, Folder 38. Gerdts suggests that it was 1899 when they rented in Bois Jerome (*Monet's Giverny*, 142–3; 147–8).

22 Edith Leslie Emmet to Lydia Field Emmet, June 2, 1898, Emmet Family, AAA, Box 1, Folder 34. The current location of this painting is unknown.

23 Mary Foote Papers, Beinecke Rare Book and Manuscript Library, Yale University, MS 607, Box 35, 36 and 44.

24 Paintings of Grenville in costume by MacMonnies and Foote are reproduced in Gordon, "Expansion of a Career," 73. MacMonnies's Young Chevalier is now in the collection of the Virginia Museum of Fine Arts in Richmond.

25 On children's drawings, which were of increasing artistic interest in the late nineteenth century, see Fineberg, *Innocent Eye*; Jonathan Fineberg, *When We Were Young: New Perspectives on the Art of the Child* (Berkeley: University of California Press, 2006); and Jonathan Fineberg, ed., *Discovering Child Art: Essays on Childhood, Primitivism, and Modernism* (Princeton, NJ: Princeton University Press, 1998).

26 As Jane described, "Mr. MacM is too funny about American girl art students," Jane Erin Emmet de Glehn to Lydia Field Emmet, April 16, 1897, Emmet Family, AAA Box 4, Folder 29.

27 Jane Erin Emmet de Glehn to Ellen Hunter, April 1897, Emmet Family, AAA, Box 4, Folder 29.

28 Rosina Hubley Emmet to Lydia Field Emmet, May 28, 1897, Emmet Family, AAA, Box 4, Folder 15.

29 Lydia Emmet to Ellen Hunter, January 18, 1898, np/L58–L59, Emmet Family, AAA, Box 2, Folder 38, Emmet, Lydia Field, circa 1898, January–March (Images 7–8, typescript images 14–15 of 127).

30 On MacMonnies's turn to painting, see Smart, *Flight with Fame,* 199–213; Frederick William MacMonnies Papers, 1874–1997, Archives of American Art, Smithsonian Institution, Reel D-245, frames 46–51, such as, "MacMonnies Has New Love: He Will Desert Sculpture and Become a Painter," *New York World*, October 15, 1900; and "MacMonnies Abandons Sculpture for Painting," *New York Evening Journal,* October 15, 1900.

31 On the cultural construction of childhood, see Philippe Ariès, *Centuries of Childhood: A Social History of Family Life*, trans. by Robert Baldick (New York: Alfred A. Knopf, 1962); Colin Heywood, ed., *A Cultural History of Childhood and Family in the Age of Empire* (Oxford: Berg, 2010); Chris Jenks, ed., *The Sociology of Childhood: Essential Readings* (Aldershot: Gregg Revivals, 1992); and Chris Jenks, *Childhood* (London: Routledge, 2005).

32 G. Stanley Hall, The Contents of Children's Minds (New York: E.L. Kellogg, 1893); and Hall, *Adolescence: Its Psychology and Its Relations to Physiology, Anthropology, Sociology, Sex, Crime, Religion and Education* (New York: D. Appleton, 1904). Other relevant child-study texts of the period include Mrs. Theodore W. Birney, *Childhood* (New York: Frederick A. Stokes Company Publishers, 1905); and Nora Archibald Smith, *The Children of the Future* (New York: Houghton, Mifflin and Company, 1898).On ideas of childhood and adolescence as independent categories at the turn of the century, see Kent Baxter, *The Modern Age: Turn-of-the-Century American Culture and the Invention of Adolescence* (Tuscaloosa: The University of Alabama Press, 2008), 3–5; Steven Mintz, *Huck's Raft: A Cultural History of Childhood in America* (Cambridge: Belknap Press of Harvard University Press, 2004), 186, 196–7;

Glenn Davis, *Childhood and History in America* (New York: The Psychohistory Press, 1976), 91–114; David Macleod, *The Age of the Child: Children in America, 1890–1920* (New York: Twain, 1988); Amy Green, "Savage Childhood: The Scientific Construction of Girlhood and Boyhood in the Progressive Era" (PhD diss., Yale University, 1995), 19–23, 45–57; Gretchen Sinnett, "Envisioning Female Adolescence: Rites of Passage in late nineteenth- and early twentieth-century American Painting," (PhD diss., University of Pennsylvania, 2006); Harvey Green, "Scientific Thought and the Nature of Children in America, 1820–1920," in *A Century of Childhood, 1820–1920*, eds. Mary Lynn Stevens Heininger, Barbara Finkelstein, Kathy Vandell, and Green (Rochester, NY: The Margaret Woodbury Strong Museum, 1984), 134–5.

33 Horace E. Scudder, "Childhood in Modern Literature and Art," *Atlantic Monthly* 56, no. 338 (December 1885): 764.

34 John Neubauer, *The Fin-de-Siècle Culture of Adolescence* (New Haven: Yale University Press, 1992); and Michelle A. Massé "Constructing the Psychoanalytic Child: Freud's *From the History of an Infantile Neurosis*," in *The American Child: A Cultural Studies Reader*, eds. Caroline F. Levander and Carol J. Singley (New Brunswick, NJ and London: Rutgers University Press, 2003), 149–53.

35 Neubauer, *Fin-de-siècle culture*, 10; and Sylvia Yount, "'The Delicious Character of Youth': Harold and Mildred Colton," *Pennsylvania Magazine of History and Biography* 124, no. 3 (July 2000): 376–8.

36 James, "The Pupil," (1891), repr. in *Henry James: Complete Stories, 1884–1891* (New York: The Library of America, 1999), 716.

37 Peter Brooks, *Henry James Goes to Paris* (Princeton and Oxford: Princeton University Press, 2007), 142; Susan Honeyman, "*What Maisie Knew* and the Impossible Representation of Childhood," *Henry James Review* 22, no. 1 (Winter 2001): 67–80; Kevin Ohi, "Children," in *Henry James in Context*, ed. David McWhirter (Cambridge: Cambridge University Press, 2010), 115–25; and Robert B. Pippin, "On Maisie's Knowing Her Own Mind," in *A Companion to Henry James*, ed. Greg W. Zacharias (Malden, MA and Oxford: Wiley-Blackwell Publishing, 2008), 121–37.

38 Henry James, *What Maisie Knew* (1897; repr. London: Penguin Books, 1985), 24. James does not mention her age, which scholars estimate between eight and twelve; however, he applies characteristics associated with child's interiority and experimenting adolescents from psychological circles.

39 Ibid., 43, 101.

40 Ibid., 150.

41 No date. "Driving with Papa. Daddy drives the horses/to our dog-cart trim/and I hold the reins ends/Coz I'm drivin' him." Rand illustration clippings, EER Papers, ASC, UConn, Box 2, folder 59.

42 Rand illustration clippings, EER Papers, ASC, UConn, Box 2, folder 59.

43 Jane Emmet de Glehn to Ellen James Temple Emmet, May 20, 1897, Emmet Family, AAA, Box 4, Folder 30.

44 Jane Emmet de Glehn to Ellen James Temple Emmet, February 1897, Emmet Family, AAA, Box 4, Folder 27.

45 Ellen Emmet Rand to Edith Leslie Emmet, Monday, July 9, 1900, in Rand, *Dear Females*, 112.

46 EER Papers, ASC, UConn, Box 7, folder 93.

47 On women artists in Paris, see Tamar Garb, *Sisters of the Brush: Women's Artistic Culture in Late Nineteenth-Century Paris* (New Haven: Yale University Press, 1994); Kirsten Swinth, *Painting Professionals: Women Artists and the Development of Modern*

American Art, 1870–1930 (Chapel Hill: University of North Carolina Press, 2001); and Laurence Madeline, *Women Artists in Paris, 1850–1900* (New York: American Federation of Arts, 2017).

48 Lydia Field Emmet to Julia Colt Pierson, March 1898, Emmet Family, AAA Box 2, Folder 38, pp. 6–7.

49 Letter from Ellen Hunter to Ellen Emmet Rand, May 25, 1900, Emmet-Rand Family Personal Papers, courtesy of Felicia Garcia-Rivera. Cited also in Rand, *Dear Females*, 101.

50 Rosina Hubley Emmet to Ellen Emmet Rand, Summer 1898 or October 1898, Emmet-Rand Family Personal Papers, courtesy of Felicia Garcia-Rivera. Cited also in Rand, *Dear Females*, 73–4.

51 Rosina Hubley Emmet to Lydia Field Emmet, January 17, 1900, Emmet Family, AAA, Box 4, Folder 16.

52 Rosina Hubley Emmet to Ellen Emmet Rand, Summer 1898 or October 1898, Emmet-Rand Family Personal Papers, courtesy of Felicia Garcia-Rivera. Cited also in Rand, *Dear Females*, 74.

53 Ellen Emmet Rand to Lydia Field Emmet, December 25, 1899, Emmet Family, AAA, Box 5, Folder 20.

54 James, *What Maisie Knew*, 101.

55 Ibid., 120.

56 Erica Hirshler, *Sargent's Daughters: The Biography of a Painting* (Boston: MFA Publications, 2009); Richard Ormond and Elaine Kilmurray, *John Singer Sargent: Complete Paintings* (New Haven: Published for the Paul Mellon Centre for Studies in British Art by Yale University Press, 1998–2012), vol. 1, 66; and Barbara Dayer Gallati, "From Souvenir to High Art: Childhood on Display," in *Great Expectations: John Singer Sargent Painting Children*, ed. Gallati (New York: Brooklyn Museum, 2004), 79–84. The psychological intensity of Sargent's *Daughters* is analyzed in David Lubin, *Act of Portrayal: Eakins, Sargent and James* (New Haven and London: Yale University Press, 1985), 83–122; and Susan Sidlauskas, *Body, Place and Self in Nineteenth-Century Painting* (Cambridge: Cambridge University Press, 2000), 61–90.

57 Henry James, "John S. Sargent," *Harper's New Monthly Magazine* 75, no. 449 (October 1887): 684.

58 I am indebted to Emily Mazzola's talk on this painting, "In a Studio of One's Own," at SECAC 2015, Pittsburgh. See also Martha Hoppin, *The Emmets: A Family of Women Painters* (Pittsfield: The Berkshire Museum, 1982), 33.

59 Rosina "Posie" Emmet Sherwood to Jane Emmet de Glehn, June 3, 1932, Emmet Family, AAA, Box 6, Folder 5 (image 52 of 56). In the same letter which spanned several days, Posie reported that Grenville shot himself.

60 Rand, diary entry, June 4, 1932, EER Papers, ASC, UConn. Thanks to Alexis Boylan for sharing this reference.

Ellen Emmet Rand, Bourgeois Portraiture, and the Disruption of Ideological Fantasy

Chris Vials

In March 1939, Ellen Emmet Rand received a letter from William R.C. Corson, president of the Hartford Steam Boiler Inspection and Insurance Company.[1] The insurance executive had recently commissioned Rand to paint his portrait, which was now hanging in the director's room of the company, a space for the firm's leadership meetings. Corson approved of his portrait overall, but issued one complaint:

> As I told you over the phone yesterday, my portrait is very well liked and admired by my associates in the office and by several of the directors who have seen it. Only one criticism has been made and that is that the picture does not show the sparkle that some of my friends see in my eyes. This may be due to the lack or quality of the light in our directors' room, although I think it largely lies in the imagination of the critic.[2]

Corson ended his letter with a reference to an enclosed check, and an assurance that he was not asking for another sitting. Yet other clients of Rand were not so forgiving. One year earlier, Rand got a similar complaint from a Mrs. James L. Thompson in Hartford, who was disappointed with Rand's recent portrait of her daughter, which the family hung in their spacious home on Prospect Avenue. Thompson wrote, "The portrait has come and we are a little disappointed but it may be the light. Her skin looks very gray, especially at night, but I shall hold decision until I get the light on the piano which I have ordered." Unlike Corson, Thompson did ask for Rand to return for a re-touching, not only because of the gray skin, but because the "face looks drawn and pinched, instead of fat and [writing illegible], as it really is."[3]

At this late stage of her career, Ellen Emmet Rand was an internationally known portrait artist known for her likenesses of the wealthy and the famous. Her abilities as a painter should have been beyond question, and one is struck by the comfort with which these very local bourgeois in Hartford questioned her work. Without a doubt, Rand's gender played a key role in the ease with which her authority was questioned, a fact of which she was well aware (as early as 1898, she privately protested the double-standards set for women painters).[4] Moreover, there should be little doubt that the

complaints of her clients were driven in part by vanity and were no doubt a part of all portraitist's work life. The verisimilitude a patron demanded—to see a spark of vitality in their own eye, or the vibrancy in a daughter's face—was grounded in wish-image and an idealized projection of self and other.

Yet, buried in these complaints is also something deeper about the ideological reproduction of class position, as well as Rand's muted critique of the very class she made a career out of representing. That is to say, identity, which holds a material relation to one's social position, is not something that is forged once, in a single instance—rather, it is something that needs to be ritually reproduced. Sitting for one's own portrait is a singular event in this process, arguably an attempt to permanently capture and freeze the ennobled "I." Moreover, it is an expensive service accessible only to a privileged few, with the finished product providing material evidence of one's class position. The completed portrait, though a frozen image, offers dynamic, ritual reaffirmation, to self and others, through its everyday viewing and display in quotidian spaces both public and private—amid the business of the director's room or the intimacy of the hearth. Most of Rand's bourgeois clients were quite satisfied with the images they commissioned, which suggests that her portraits generally performed the ideological work demanded by their patrons. Yet the complaints, which appear with increasing frequency in the 1930s (a crucial period as noted in detail by both Spiggle and Harris), suggest that something was gradually interfering with what should have been an otherwise smooth process of ritual reaffirmation. This chapter sets out to probe the nature of this interruption, and argues that Ellen Emmet Rand's later portrait work unevenly functioned as intended by its affluent patrons due to a number of factors. First and most fundamentally are the ideological crises intrinsic to performance, which I will outline using Slavoj Žižek's notions of "the kernel" and "the stain." Added to this deep structure, however, is historical factor of the 1930s and its attendant class upheavals, which made bourgeois identity particularly fragile, and helped lead to the decline of the painted portrait as an honorific form. Finally, there are qualities inherent in Rand's work, in which the artist, at times, allowed herself a complex and ambiguous form of realism that could only be read by her clients as muted critique.

I reconstruct these dynamics less through close readings of the paintings themselves and more from the reactions of those who beheld them—and paid for them—as found in letters and business transactions between Rand and her wealthy clients. I concentrate most on private correspondence surrounding the work she produced in the last two decades of her life (the 1920s and 1930s), a body of work that has received even less attention from scholars. In so doing, it is not my intention to claim Rand as a forgotten class warrior of the 1930s left, which surely she was not. Rather, this chapter uses the reception of Rand's work to probe the ideological function of bourgeois portraiture, and to suggest that serious artists like Rand could not help but to run afoul of its dictates, if ever so slightly. Moreover, it suggests that a closer attention to other archival artifacts apart from the visual—that is, written requests from clients to the artist, correspondence giving clues as to the context of a painting's display, business transactions, and so on—are sometimes better positioned to tell us about the ideological function of portraiture as it is historically performed and lived than our twenty-first-century close readings of the work itself.

Other chapters in this volume have no doubt covered the nuances of Rand's biography, but a brief reprise of her career with attention to the ambiguities of her class position is necessary here in order to set the stage for a full reading of her work and its reception. Ellen Gertrude Emmet was born in California in 1875 to economically secure Irish immigrant parents. Her father died early, causing financial chaos for the family. They moved back East and seemed to move from relative to relative for over a decade. Her mother was able to pull together the funds, or beg for free access to artistic training at an early age, allowing her to receive an excellent arts education in Boston and New York in her teenage years. By age sixteen, she was an illustrator for the newly formed *Vogue* magazine and had become the primary breadwinner for her mother and four siblings (it should be noted that a teen auteur supporting an entire family through her art is an extremely unusual way of preserving middle-class status). But it was her extended and economically precarious apprenticeship in France under the famed sculptor Frederick MacMonnies that helped catapult her career to the next level. She left for Europe in 1896, and with the training she received in MacMonnies's atelier as well as the commissions in England she secured, she was able to return to New York in 1900 and open her own studio there. Once back in the United States, she rapidly built a reputation as a leading portrait artist of the American bourgeoisie, which included industrial and finance capitalists, society women, college presidents, headmasters at elite academies, and intellectuals (the latter category included her cousins William and Henry James). She married William Blanchard Rand in 1911, subsequently splitting her time between their spacious horse farm in Salisbury, Connecticut, and her New York studio. She lost most of her money in 1929, however, which returned her to the lean years of her youth. This scarcity was relieved, somewhat, in 1932, when she received her first commission to paint her first of three portraits of Franklin D. Roosevelt. Despite her contempt for the New Deal, she retained a warm correspondence with the Roosevelt family throughout the decade.[5]

Despite this impressive visibility in her lifetime, there has been precious little scholarship on Rand, and what little that exists has not closely scrutinized the class politics of her work. As noted above, she spent her life in and around the elite, and ultimately scrambled to make a living by valorizing their images. Her papers contain records of negotiations to paint the visages of presidents and professors at Ivy League colleges, the chief executives of companies, the wives and children of prominent capitalists, the president of the New York Stock Exchange, members of Franklin Roosevelt's extended family, prominent lawyers, and headmasters at preparatory schools. With Rand's reputation preceding her by the early 1920s, potential clients would write to her and ask about her availability and fees; then, if the terms were acceptable, Rand would typically travel to them for a number of sittings after accepting a down payment (though sometimes they would come to her). Once the portrait was completed—generally after further treatment in her studio after the sitting—she would then frame it and send it to the client, who would then pay the remaining balance. From the latter half of the 1920s until the end of her life in 1941, a Rand portrait would cost her clients a figure typically in the $1000–$2000 range, but in one case $3000 (see Spiggle for more details on her prices).[6] To

put these numbers in perspective, the average family income in the period from 1919 to 1936 was approximately $1500 per year.[7] Rand would sometimes offer to meet with her clients again and alter their portraits if all was not to their liking. Unsurprising given her profession as an artist who represented the elite, she was a devout Republican who had little patience for radicals or even the New Deal.[8]

The placement of Rand's portraits within the overall aesthetic of her patrons' homes, offices, clubs, and schools reveals the ways in which the artist's work entered a long but now largely displaced culture of portrait collecting among the transnational bourgeoisie. In their letters to Rand, her clients would often describe where they had hung their portraits, and would sometimes ask for her advice on where to place them for optimal effect. In so doing, they divulged how the commissioned portrait rarely hung on its own, but, rather, appeared alongside the framed faces of other notables in the same room or, frequently, the same wall. For instance, her painting of E.H.H. Simmons, president of the New York Stock Exchange, was hung in the "Governor's Room" with those of former presidents; her portrait of a Professor Pupin at Columbia University hung in the school's East Library among fifty others; Anna Roosevelt Cowles (older sister of Theodore Roosevelt) hung Rand's portrait of her husband Sheffield opposite that of her father and "the Admiral" in their truly spacious dining room.[9] As these examples indicate, portraits commissioned for the home were generally placed in the dining room or hall; those commissioned for a company leader were typically placed in the board room or "director's room"; and those of a school master or university notable in some highly visible public place like a dining hall, central administration building, or library.

Such uses of portraiture are as old as the bourgeoisie itself, which adopted them from the landed aristocracy. From seventeenth-century Dutch burgers, this emergent class, like the aristocrats living before and among them, used portraiture to aggrandize its subjects, to elevate them as examples to viewers. The bourgeois portrait collection, in turn, generally served to bestow cultural capital on an institutional space or family home.[10] Art historian Karl Kusserow has written that such portrait collections reveal "a pervasive desire among the rich to sacralize gains won in the profane marketplace through the ennobling properties of art."[11] If the portrait and portrait collection lent prestige to a space, it was also through a temporal operation: the juxtaposed images suggested *lineage*, that is, a dignified continuity between past and present, one seemingly more fitted to an aristocratic order than a bourgeois one.[12] In his work on the portrait collections of the New York Chamber of Commerce, Kusserow writes further:

> American institutions like the Chamber signaled [through their collections] that they, along with select others, had attained sufficient age and significance to present themselves as historical entities on their own terms, in the process conferring prestige and an aura of authority and sanction on their varying enterprises ... Arrayed along the group's walls for the contemplation of members and visitors alike, they fallaciously but persuasively constructed its past as linear, stable, even dynastic, when in fact it had been punctuated by years-long periods of inactivity and decline.[13]

Insofar as identity is constituted by memory, such collections, in conferring a prestigious past on a dynamic present, helped greatly to give present-day bourgeois a historical sense of themselves and their mission *as a class*, or, as Karl Marx might say, as a class not only in-themselves but for-themselves. Hanging within the boardroom alongside others, the company executive's portrait served to forge not only organizational coherence in terms of values and purpose, but also, by extension, a broader class identity as well. Likewise, the portrait of the patriarch or matriarch, hung within the home, signaled the family's notable and rightful place within this class and its aspirations, ultimately connecting the supposedly private world of the home to the ostensibly public world of class formation and accumulation. In the realm of elite private education, the portraits of presidents and faculty conferred legitimacy on the institution as a training ground for entrance into the class, and through a similar aesthetic operation. For instance, a client from the elite Hotchkiss School in Lakeville, Connecticut, wrote to Rand about the effect of her portrait of the school's head master when hung in the school library: "we agree that it is a real work of art with splendid beauty and dignity ... We have hung it over one of the fire-places where it tends to dominate the room and it has produced an attractive, charming stateliness which is altogether new there."[14] Here, the ideological work of the portrait is signaled in the phrase "attractive, charming stateliness," a wedding of authoritative lineage and aesthetic pleasure that works to interpellate visitors into classed space. Whether in the home, school, or office, the portrait's power of interpellation lay precisely in its placement within everyday confines, rather than in the rarified air of the gallery (although, as Tolles notes, museums such as the Metropolitan effectively recreated such intimate settings). Such placement not only brought the cultural authority of fine arts into the quotidian realms of bourgeois life, but, in so doing, reproduced that authority in a daily, repetitive, ritual, one all the more powerful because dimly perceived.

For the portrait to fully perform its function, however, it could not simply represent its subject as a stock figure or generic icon, one just like any other member of their ennobled class. Rather, the portrait also needed to show its subject as an individualization of a social type, thereby bridging the personal and the immediate to the social and the universal. In portraiture, a long-established means of enacting this individualization was through "the trait," a distinguishing feature of the individual "brought out" by the artist. Kusserow describes it as a "salient detail of the sitter – a physical feature connoting a particular personality trait," that is to say, an external feature that reveals inner character.[15] The *trait* was not a physical object or a choice of clothing included in the frame: for example, the silver teapot and engraving tools in John Singleton Copley's *Paul Revere* (1768) that indexed Revere's trade of silversmith. Rather, it was an anatomical feature that purported revealed the subject's essence. It could be a trace of humor around the eyes, a piercing glance indicating warmth or foresight, a slight curvature in the mouth suggesting hidden wisdom, etc.

As with other portraitists, Rand was deemed a great artist because of her ability to "capture" this elusive element, an element known only to those closest to the subject. One admirer from Schenectady, New York, for instance, wrote to the artist to praise her portrait of William Le Roy Emmet, a senior engineer at General Electric, remarking,

"I am sure it is the best portrait paining I have ever seen. I have worked with Mr. Emmet for over thirty years and the expression on his face, which you painted, is exactly what I have seen a great many thousand times, and am so glad we now have a permanent record of our grand man."[16] This aesthetically untrained correspondent names the trait rather broadly as "the expression on his face," which the employees recognize as real and undeniable, as they have seen it "a great many thousand times." The trait thereby serves as a "record" of essence, frozen in time, that can offer daily inspiration. It works precisely because it does not simply put forth the boss as an abstract member of the bourgeoisie, but as Mr. Emmet, a concrete, recognizable individual of his class whose "expression" metonymically draws the employees of the firm into his class's managerial and leadership role. In a different instance, a client who had commissioned a portrait for a member of her social club wrote to Rand to praise the "the glint of humor" captured in the face of the subject, a feature that the admirer deemed "so appropriate for a club picture."[17] In this particular case, the trait is named more precisely, and the correspondent praises it not only for flagging the sitter's essence, but also because it is skillfully matched to the context of his portrait's display—the club house. As such, the trait helped to define and delimit the function of that space for those who passed through it.

In these instances, ideology and object are working together as they should: Rand's portraits are functioning precisely as intended by those paying the bills. But to fully articulate this process, and to identify and explain how it begins to go awry, it is helpful to think through the mechanism of ideology more broadly. Here, Žižek's definition of ideology is productive:

> Ideology is not a dreamlike illusion that we build to escape insupportable reality; in its basic dimension it is a fantasy-construction which serves as a support for our "reality" itself: an "illusion" which structures our effective, real social relations and thereby masks some insupportable, real, impossible kernel (conceptualized by Ernesto Laclau and Chantal Mouffe as "antagonism": a traumatic social division which cannot be symbolized). The function of ideology is not to offer us a point of escape from our reality but to offer us the social reality itself as an escape from some traumatic, real kernel.[18]

Ideology, in other words, is not the opposite of "reality," but, rather, is something materially grounded in real and everyday social relations. While it may be a fantasy in its totality, it generally contains an element of truth because it works to construct our reality, which then becomes reflected again in ideology. In this sense, ideology is a "fantasy," but one that materially reproduces real social structures, and vice versa. Be that as it may, while ideology cannot simply be opposed to reality because of its basis in truth, it is also not the *whole* truth: its fantasy quality works to bury and banish another aspect of the real—the kernel—which cannot be admitted into the subject's field of vision because it is too painful or destabilizing. If the kernel is seen, or even glimpsed, the subject is unsettled, and ideology stops working as it should.

Žižek's notion of ideology, much like the Lacanian and Althusserian strands of theory it draws upon, does not take us very far when trying to theorize resistance and most intentionally oppositional gestures, but it is handy for apprehending the

operations of the dominant culture and its subtler and more intricate fault lines. One could apply it to bourgeois portraiture in the following way: Rand's portrait of Mr. Emmet works, first and foremost, by feeding Emmet and the viewers of the painting with his own self-image as an elevated and important person, which no doubt he is— his class standing is a material reality, based on holdings of wealth and his prominent position within the company, for which he receives an esteem and a special treatment not afforded to most other citizens. This materially grounded esteem is internalized by Emmet, and captured and reproduced in the portrait, for which it serves (or tries to serve) as quotidian totem of bourgeois leadership for other employees. The portrait as a whole interpellates its subject, who recognizes himself in its lines and textures ("that image is me"), as well as the viewers, who learn their status as subordinates through its formal properties.

The trait—"the expression on his face"—is perhaps the central formal property here, a key vehicle in this ideological reproduction. The trait might have an element of the real—Mr. Emmet might in fact have carried a warm expression, just as the sitter for the club portrait might indeed have had a "glint of humor" in his everyday dealings. But the element of pure fantasy comes in seeing these traits as metonymically related to the virtues of the institutions that their visages adorn, and to the wider class structures these institutions constitute (i.e., that the employing class is essentially warm, or humorous). This takes us to the kernel. Emmet's importance is real, yet there is traumatic element here that could not be admitted by the man or his faithful devotees, nor be easily symbolized into the portrait. That is, what's equally real is the fact that his income, and perhaps the wealth of his ancestors, was fueled by the alienated, surplus labor time of working people, hooked into supply chains which likely extended into the colonies, who worked away their days so that their labor could be valorized to create, among other things, Emmet's $2000 portrait. Moreover, when Eskil Berg wrote to Rand to praise Emmet's image, the date was July 3, 1929, just three months before the infamous stock market crash that plunged this system into crisis, wiping out whatever meager savings families could accrue through their (hopefully) $1500 annual budget, and putting to rest any notion of general, incremental progress through a regime of capital accumulation.

Crucially though, the kernel is not just what is excluded (the broken bodies and stunted lives of the workers and the colonized). It also resides in what is included: in the trait, "the expression" on the face. That is, what cannot be acknowledged is that the dignified mien in the expensive frame is *only* important because of this exploitative social order, not because of any intrinsic worth in the sitter. If Emmet had been raised in a genuinely democratic society, with a full level playing field, he, like Rand's other affluent subjects, might have been regarded as a fool or a genius, a skillful tactician or a talentless buffoon. We'll never know, as the social order that produced the image never allowed an equality of opportunity or of outcome where individual ability, let alone human worth, could honestly express itself. More to the point, it is highly unlikely, given a social order truly based around equality, that Emmet would have been in a position to sit for a portrait, or that we would even have artistic forms dedicated to elevating individual economic elites. For Emmet and his admirers, this is "the traumatic real kernel" that cannot be admitted into the frame, never mind the clubhouse.

Such ideological reproduction did not always proceed so smoothly among Rand's clients, however, who sometimes clearly felt the presence of the kernel. Indeed, they sometimes reacted to her work with unease or outright dismay, and this is particularly in evidence as the 1920s came to a close and a new era born of economic catastrophe began. Though Rand saved correspondence with her clients dating back to the early 1920s and even before, the first critique of her work by a client appears in the Ellen Emmet Rand Papers in 1927, with such complaints reappearing in the archive with increasing frequency in the late 1930s.[19] An early example comes from 1929, when a woman living in Manhattan wrote to Rand and begged her to come alter the portrait she had painted a year earlier of her husband Reddy. The distraught correspondent, named Anne, wrote:

> Will you plan to come again to us in June (before both our boys return from school if possible) and try to make some changes in Reddy's portrait? I am very sorry to say that it has not worn well as I thought it would. Reddy and his sister never liked it, and the children and I have all grown less and less happy about it as the year has passed. There is something very "stary" about the eyes which takes away all his kindliness of expression and makes us all unhappy … I am wondering somewhat whether you will think it better to paint the portrait all over again and if so what you would charge? Or whether if the expression of the eyes changed the present portrait can be made to seem more like the Reddy we know.[20]

What is interesting here is the failure of the trait. The eyes are supposed to reveal a "kindliness of expression" that Anne holds as key to his essence and central to the broader ideological fantasy it serves. Instead, they are "stary"; in other words, they are eyes that uncannily index an alienation that is felt but cannot be fully symbolized, other than through the banal phrase, "[it] makes us all unhappy." With the failure of the trait to perform its function, Anne can no longer recognize Reddy within the terms of the ideological fantasy, and thus demands from Rand a new creation that would restore him once again to the status of dignified patriarch, "the Reddy we know."

So what happened here? Did Rand deliberately, or unconsciously, paint Reddy's eyes to evoke the uncanny? Or did she perform her services faithfully, in which case the reaction of the family derived from an intense level of insecurity that was unusual for their class? The painting is not accessible for public viewing so we lack the ability to see for ourselves. But even that piece of evidence would not resolve the issue, which, to modify an old cliché, is not really in the eyes of painting but in those of its historical beholders. Our own viewing could never reproduce the ideological moment of 1929, much less the relations of intimacy expected in the Reddy household; that is to say, in gauging the painting's historical function as an ideology that was performed and lived, other forms of artifacts that allow us to piece together the context of its reception are far more important. The most salient matter is not our twenty-first-century impressions of the painting itself or even the early twentieth-century intention of the artist, but rather a letter revealing that for Anne Reddy in 1929, those eyes, which should signal kindness, have instead become "stary."

To put the matter in Zizekian and Lacanian terms, when loving eyes become dead ones, the trait has become the "stain." Žižek describes the stain as a "remainder of the real that 'sticks out.'"[21] To explain by analogy, the stain is much like a blot or tear on a movie screen that distracts us from the fantasy intended by the film, and that reminds us instead that we are in fact sitting in a theater trying our best to escape our everyday routine and enter a fantasy. Likewise, the stain disrupts from the regular workings of ideology. It is a visible element that reminds us of the kernel, that part of the traumatic real outside of ideology, and at the same time makes us conscious of the fact that we are trying to escape that kernel. It need not be intentional or intrinsic to the work itself. Whatever the artist's intent, for example, the eyes in Rand's portrait of Reddy became the stain: instead of reproducing bourgeois ideological fantasy, they defamiliarized him to his family, making him into an uncanny figure who was ordinary, perhaps even sinister. In so doing, the eyes reminded them, every day, that were avoiding something as they sought the idea of Reddy, something that would unsettle their view of the patriarchal authority he represented.

This consideration of the stain returns us to the complaints recorded at the beginning of this chapter, those from William R.C. Corson and Mrs. James L. Thompson in the late 1930s. Here too, eyes, facial colorations, and necklines that should have functioned as external traits to index virtuous inner character instead became stains. Consistent in the complaints is a recurrent theme indicative of ideological disruption, and the attempt to suture it. That is, the unhappy clients persistently express uncertainty as to whether they are even seeing the portraits properly, which causes them to take action to restore their images of self and other that have been compromised in their encounters with Rand's work. When Corson suggests that Rand didn't capture the "sparkle in his eyes," he introduces doubt by adding, "This may be due to the lack or quality of the light in our directors' room, although I think it largely lies in the imagination of the critic." Likewise, when Mrs. Thompson complains that her daughter's skin appears grey and her face looks sallow, she uncertainly avers, "it may be the light … I shall hold decision until I get the light on the piano which I have ordered." In both cases, the clients don't fully recognize their own self-images—or those of their family members—in the portraits they have paid so dearly for, thus shaking their confidence in their powers of vision, or, perhaps more to the point, making them conscious of vision to begin with. One additional point that Žižek makes about the kernel is germane here: our desire to suppress the kernel is formative. We persistently encounter phenomena that cause us to fleetingly glance the kernel, and our efforts to keep it in check are what persistently drive our behavior. Thus, Corson and Thompson suggest that they will try to remove the stain and restore their ideological vision by simply altering the light in the room; Thompson takes the additional steps of demanding more artistic labor from Rand and purchasing more commodities (a light near the piano). These were small quotidian actions, like so many others, that they likely took in order to remain in ideological fantasy, and that, to Žižek, are constitutive of the subject.

The question remains as to whether such complaints were triggered by aesthetics intrinsic to Rand's intent, or whether they were driven by the insecurities of their clients. I would argue that both factors were at play. First, it is telling that these

complaints appear in the archive from 1929 onward, through a time when the power of affluence was challenged as never before in US politics, and when bourgeois selfhood was consequently embrittled. The 1930s were not only the decade of the Great Depression, but also an era of major class upheavals that dramatically reshaped the US socioeconomic structure. As a number of scholars have argued, the 1930s and 1940s were a time when the political left was at its peak in power and influence in American politics, an era when redistributive programs were rapidly becoming common sense among the public as they were implemented in policy. A broad social movement, sometimes labeled "the Popular Front," emerged by the second half of the decade, united around the issues of labor, antilynching, antifascism, and the idea of a "moral economy" to temper the ravages of laissez-faire capitalism.[22] This movement was the force from below which enabled Roosevelt and Congress to enact the more radical reforms of the "Second New Deal" and set the terms of the social democratic, Keynesian state that would emerge from the war.[23] The legalization of unions, federal mandates of basic labor standards, the creation of progressive taxation, and the expansion of inheritance taxes in this decade set in motion quite real redistributions of wealth that the American working class, including working-class people of color, began to fully experience during the war.[24]

Inversely, this political environment was one in which the American elite felt embattled and ostracized as never before. Media mogul Henry Luce, for example, criticized President Roosevelt and his allies for making it seem that businessmen "were not part of America."[25] Indeed, from 1935 on the president was widely seen by his affluent peers to have turned on his own class in favor of a distinctly anti-business rhetoric; during the war his Vice President Henry Wallace publicly stated that there were inherent fascist tendencies in America's business classes, a theme taken up even by Harry Truman in his campaign against Dewey.[26] The 1930s and 1940s were a time, in other words, when elites were not only losing a share of social wealth, but were feeling dishonored in the eyes of elected officials and the public. They were an elite whose self-image needed to be ritually re-affirmed as perhaps never before—or since—in US history. It should come as little surprise that the affluent increasingly wrote to Rand to register discomfort with their own images, and to wonder aloud, "Is it the light, or is it just me?" Such fidgety reactions mark the unravelling of an era, the unsettling of an identity.

The 1930s were also a time when so many American writers and artists turned to the political left. They formed what Denning called the "cultural front," a generation of cultural producers devoted to realigning cultural values toward the vision of the new society imagined by the left-wing and labor movements of the era.[27] To be sure Rand did not join them. She had a warm correspondence with President Roosevelt and his family around the time she was hired to paint his portrait, but she was attracted more to the possibilities a presidential commission offered her career than to his politics. As Emily Mazzola has written, Rand was "a staunch Republican [who] abhorred FDR's liberal politics and her diaries from 1932 are filled with frustrated exclamations of the public's approval of him."[28] Such an early rejection of Roosevelt placed her on the arch-conservative end of her contemporary political spectrum (the president-elect still enjoyed the support of much of the business elite in the early years of his presidency, a

time before the more radical Second New Deal of 1935–1936 earned him the reputation as a traitor to his class). Indeed, in 1939 Rand also offered to paint the portrait of Herbert Hoover, by then the very symbol of discredited, laissez-faire economics.[29] Other chapters in this collection have detailed the artist's struggle to make a living, her perennial cycles of boom and bust, and I have alluded to this facet of her biography above as well. Suffice to say here that like so many other middle strata whites who were in the orbit of the bourgeoisie, and yet who did not enjoy their true economic security, she made the choice to ally with them politically, though existentially this alliance was never a perfect fit.

Evidence of this existential gap can be seen in her periodically expressed yearnings for artistic independence, particularly in her younger days. For example, in a sojourn to England in 1899, at the age of twenty-four, she wrote with disdain about one of her wealthy English sitters, and in a manner suggestive of realist inclinations:

> It is not a pretty picture ... But Mr. Ashley is not pretty and I only ask that it will give the impression of a thickset middle-aged man with an ugly face sitting in a chair. I think it is solid and I do think the values are about right though in places I'm afraid it is rather stodgy. But they like it very much, which really makes it very pleasant for us all.[30]

Her missive expresses a desire for a realist verisimilitude in which "the ugly delights as well as the beautiful," as William Dean Howells famously wrote, and it suggests that she pulled no punches in trying to achieve that aesthetic.[31] Happily for everyone, her clients did not seem to notice, and thus she was able to retain her artistic integrity and her client's money at the same time. How much of this sensibility did she retain in her later years, this drive to simply paint her clients as she saw them, regardless of their demands for valorization? We know that she tried to paint Roosevelt admirably, and largely succeeded, even though she had no faith in the politics he represented. In other words, she clearly was not an unequivocal and persistent believer in the virtue of all her clients, even though she had no problem with the bourgeoisie, as a class, in the abstract. Rand was trained as a serious artist at the height of aesthetic realism, and yet, like so many others, she could not afford to be outside the marketplace.

There is also a dissonance in the archive that should be taken into account when parsing out the relationship of the portrait artist and her wealth clients. That is, why did she hold onto their letters of complaint? She was not a meticulous archiver of her business transactions—this portion of her papers is actually rather sparse. Letters of dissatisfaction from the likes of Corson and Reddy are some of the few professional correspondences she retained. Was she unsettled by their disapproval, and felt the need to hold onto their critiques in order to better gauge such clients' demands in the future? Or, was keeping the letters a form of resistance, a kind of satisfaction she took from getting them to see their esteemed visages through her own eyes? Or was it confirmation that she did in fact retain her realist credentials as an artist, as one who can find a kind of delight in the ugly as well as the beautiful? After all, political alliances are just that—expedient coalitions that ask only that the partners come together in a limited sphere of everyday life—at the ballot box, or against a common

foe in a particular fight, for instance. They do not require that all the partners love, or even like, one another. We will never know for certain why she retained the letters. Whatever the case, while she was clearly impatient with political assaults on elite rule, there was a contradiction between her explicit politics, her precarious position on the edge of the bourgeois, and her need to make a living, one that likely paved the way for the appearance of the stain in her work, even if unconscious to the artist.

It is telling that in social democratic economy of the postwar years, the painted portrait began to wane as an expression of bourgeois identity and leadership. Following the upheavals of the Depression and the war, and their consequent class realignments, the form came gradually to be seen as pretentious and archaic. For example, Karl Kusserow notes that the grandiose portrait collection of the New York Chamber of Commerce was significantly scaled back in the period from 1930 to 1980, when such collections began to appear as ostentatious and even embarrassing.[32] Following the neoliberal turn of the 1980s, wealth began freely flowing to the top echelons of society once again, but, by and large, the painted portrait did not return to enter the flow along with it. Corporations in the United States and Western Europe still display art in their offices, but this art generally takes the form of abstract and figurative work that communicates organizational identity and values, not painted images of leadership. Where images of leaders remain, they are typically photographs, and even these tend to be displayed in the office of the individual represented, not in public areas.[33] Had Rand lived for another twenty years, she might have needed to find a new way to make a living.

The letters between the artist and her clients reveal the last days of a very long era, when the centuries-old practice of honoring wealth through portraiture was no longer working its ideological magic, even among those who paid for it. Once others had stopped seeing the sparkle in their eyes, the affluent classes apparently began to wonder if had even been there in the first place, and the uncertainty was enough to make them stop seeking out the Rands of the world to paint it. With their power restored in the neoliberal age, they would have to find new ways of ennobling their capital gains, but without the help of the portrait artist and her sometimes unreliable brush.

Notes

1 I would like to acknowledge the gracious collegiality of Emily Mazzola in sharing with me archival materials from Hyde Park, New York.
2 Letter from William C. Corson to Ellen Emmett Rand, March 13, 1939, Ellen Emmet Rand Papers, Archives & Special Collections, University of Connecticut Library (EER Papers, ASC, UConn), Box 1, Folder 53.
3 Letter from Mrs. James L. Thomson to Ellen Emmett Rand, September 17, 1938, EER Papers, ASC, UConn, Box 1, Folder 52.
4 Ellen E. Rand, *Dear Females* (New York: Ellen E. Rand, 2009), 86.
5 Emily Mazzola, *Enabling Authority: Ellen Emmet Rand, President Franklin D. Roosevelt, and the Power of Portraiture*, Master's Thesis, University of Connecticut, 1–3; On Rand's correspondence with the Roosevelts, see EER Papers, ASC, UConn Box 1, Folders 45, 48, 54.

6 EER Papers, ASC, UConn, Box 1, Folders 40–56.

7 U.S. Bureau of Labor Statistics, *100 Years of Consumer Spending: Data for the Nation, New York City, and Boston* (2006), 15.

8 Mazzola, *Enabling Authority*, 11.

9 Letter from Richard Whitney, July 17, 1928, Box 1, Folder 44; Letter from Dixon Ryan Fox, October 29, 1929, Box 1, Folder 44; Letter from Anna Roosevelt Cowles, July 14, 1930, Box 1, Folder 45, EER Papers, ASC, UConn.

10 Karl Kusserow, "Portraiture's Use, and Disuse, at the Chamber of Commerce and Beyond," in *Picturing Power: Portraiture and Its Uses in the New York Chamber of Commerce*, ed. Karl Kusserow (New York: Columbia University Press, 2013), 36. See also Barbara Dayer Gallati, *Beauty's Legacy: Gilded Age Portraits in America* (London: Giles, 2013).

11 Kusserow, *Picturing Power*, 55.

12 See also Margaretta M. Lovell, *Art Is a Season of Revolution: Painters, Artisans, and Patrons in Early America* (Philadelphia: University of Pennsylvania Press, 2007).

13 Kusserow, *Picturing Power*, 37.

14 Letter to Rand from unknown author (Hotchkiss School letterhead), October 26, 1928, EER Papers, ASC, UConn, Box 1, Folder 43.

15 Kusserow, *Picturing Power*, 4.

16 Letter to Rand from Eskil Berg, July 8, 1929, EER Papers, ASC, UConn, Box 1, Folder 44.

17 Letter to Rand from "Florence," September 7, 1928, EER Papers, ASC, UConn, Box 1, Folder 43.

18 Slavoj Žižek, *The Sublime Object of Ideology* (London: Verso, 2008), 45.

19 The first critique from a client to appear in the Ellen Emmet Rand Papers is a very mild rebuke of the background color. Letter from Darragh DeLancey, October 22, 1927, EER Papers, ASC, UConn, Box 1, Folder 42. Other critiques, not referenced in other notes, include Letter from Mildred Bliss, March 30, 1938, Box 1, Folder 52; Letter from Letter from Mrs. James L. Thompson, September 24, 1938, Box 1, Folder 52; Letter from Mrs. Henry H. Gilman, June 13, 1940, Box 1, Folder 54.

20 Letter from "Anne," April 7, 1929, EER Papers, ASC, UConn Box 1, Folder 44

21 Slavoj Zizek, *Looking Awry: An Introduction to Jacques Lacan through Popular Culture* (Cambridge, MA: MIT Press, 1995), 93.

22 Michael Denning, *The Cultural Front: The Laboring of American Culture in the Twentieth Century* (London: Verso, 1997), 4.

23 Robert McElvaine, *The Great Depression: America, 1929–1941* (New York: Times Books, 1993), 224–5, 262.

24 Nelson Lichtenstein, "Class Politics and the State during World War II," *International Labor and Working-Class History* (Fall, 2000): 264.

25 Qtd. in Chris Vials, *Realism for the Masses: Aesthetics, Popular Front Pluralism, and U.S. Culture, 1935–1947* (Jackson: University Press of Mississippi, 2009), 166.

26 McElvaine, Chapter 10; Henry Wallace, "The Dangers of American Fascism," *Democracy Reborn*, ed. Russell Lord (New York: Reynal and Hitchcock, 1944); Harry Truman, "Address in the Chicago Stadium," Harry S. Truman Library and Museum. *The Public Papers of the President*. Online, http://www.trumanlibrary.org/publicpapers/index.php?pid=2007, accessed March 23, 2010.

27 Denning, *The Cultural Front*, xvi.

28 Mazzola, *Enabling Authority*, 11.

29 Letter from Rand to the Fine Arts Committee, September 21, 1939, EER Papers, ASC, UConn, Box 1, Folder 53.

30 Rand, *Dear Females,* 89.

31 William Dean Howells, "Criticism and Fiction," in *Criticism and Fiction, and Other Essays*, ed. Clara Marburg Kirk and Rudolf Kirk (New York: New York University Press, 1959), 194.

32 Kusserow, *Picturing Power,* 80–2.

33 Hans Hoeken and Lenneke Ruikes, "Art for Art's Sake? An Exploratory Study of the Possibility to Align Works of Art with an Organization's Identity," *Journal of Business Communication* 42, no. 3 (2005): 233–46; Claudia Schnugg and Johannes Lehner, "Communicating Identity or Status? A Media Analysis of Art Works Visible in Photographic Portraits of Business Executives," *International Journal of Arts Management* 18, no. 2 (2016): 63–74. On the placement of executive portraits, see Schnugg and Lehner, "Communicating Identity or Status," 66.

Painting the President: The Body Politics of Ellen Emmet Rand's Franklin D. Roosevelt Portraits

Emily M. Mazzola

In August 1933, newly elected President Franklin D. Roosevelt commissioned Ellen Emmet Rand to paint the most important portrait of his career and hers—an official White House portrait (Plate 15).[1] His request made Rand the first female painter to receive the honor of an official presidential commission and the portrait was intended for permanent display in the White House, assuring a place in history for both of them. Today, despite Rand's efforts and FDR's wishes, there is no trace of Rand in the White House. Rand's FDR portrait is now lost—most likely destroyed. The portrait's disappearance from cultural memory began, however, long before it was crated and accidentally discarded in 2001.[2]

President Harry S. Truman precipitated the erasure of Rand's portrait by removing it from the executive mansion in 1947, replacing it with a somber portrait by Frank Salisbury (Figure 9.1). Upon its removal, Truman gifted Rand's canvas to the Roosevelt family, an exchange that occurred within a larger negotiation between Truman and Anna Eleanor Roosevelt over the fate of the Franklin D. Roosevelt Library (FDRL).[3] The portrait remained with the Roosevelt family until they donated it to the FDRL in 1962. In 2001, the portrait was crated during renovations and never seen again. When the Library realized the canvas was missing in 2004, the FDRL notified the Rand family of the loss, suggesting a possible theft occurred or that it was accidentally thrown out.[4] Despite the loss of Rand's artistic and gendered contribution to presidential portraiture, the true travesty of the painting's destruction was the cultural erasure of a likeness capable of complicating contemporary imaginings of FDR's paralysis.

This chapter is not only an object history, tracing the production, display, and destruction of Rand's canvas. It is also a story about the pleasures and frustrations of representation and the limits of portraiture's agency in constructing historical legacies.

For Rand, the commission was her chance for lasting national recognition, an opportunity she seized by setting a new course for White House presidential portraiture, one defined by warmth and accessibility rather than rigid stoicism. For FDR, his White House portrait was an opportunity to concretize the historical portrayal of his body, preserving for posterity how he understood himself—as a healthy, active, vigorous man capable of occupying the presidency. Rand's portraits capture FDR immersed

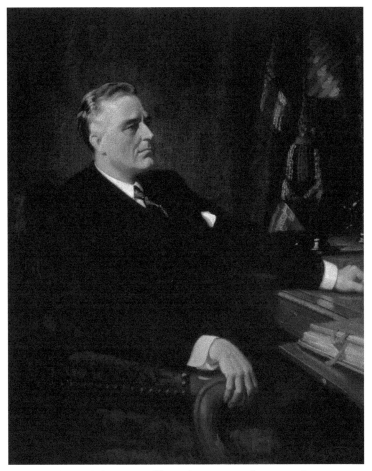

Figure 9.1 Frank O. Salisbury, *Franklin Delano Roosevelt*, 1947, oil on canvas, 50 ¼ x 40 ⅜″, White House Historical Association (White House Collection).

in the work of governance, a state when his paralysis was immaterial to his status as a world leader. Reading Rand's portrait as a visualization of disability unmarked by bodily variance, it is possible to see a nuanced and sympathetic rendering of the president's complex physicality.

Truman's remarkable actions in removing the portrait from the White House required careful planning and delicate execution—a significant undertaking revealing of Truman's deep discomfort with Rand's embodied portrait. By inserting Salisbury's stoic figuration in the White House, Truman, in effect, erased the primary element of FDR's official historical representation. American visual culture and historical memory have yet to overcome the ramifications of Truman's exchange.

Today FDR is remembered as an exceptional leader despite his paralysis, a characterization that culminated in a bronze statue along the National Mall

depicting FDR in a wheelchair.[5] The essential cultural work this figuration does for disability advocacy, however, has also shifted collective understandings of FDR's physicality. FDR understood and experienced his disability, as situational and fluid, but current categorizations of his historical representation are unable to account for this complexity.[6] Classifications of FDR imagery often operate along the binary of disability/ability. Representations absent of his mobility aids are labeled denials of disability or passing, and images that foreground his wheelchair or braces are noted for more honestly revealing the thirty-second president's physical condition.[7] Rand's portraits, in their insistent presentation of FDR's paralyzed lower limbs, but without picturing his medical apparatus, offer an alternative formulation, one that reflects the ways FDR lived and imagined his physicality.

The Commission

When Rand sought out Eleanor Roosevelt's aid in procuring the White House commission, she was approaching a former friend and confidant.[8] Yet, by the time FDR emerged on the national political stage, Rand and Roosevelt had been out of touch for decades.[9] Following FDR's election, Roosevelt and Rand's only remaining connections were Grenville T. Emmet and his wife, Paulina. Grenville was Rand's first cousin and one of FDR's closest friends from Harvard University.[10]

Shortly after FDR's inauguration word arrived through the Emmet's that Rand would likely be asked to paint FDR's official White House portrait. When an invitation did not immediately appear, Rand, eager to capitalize on this opportunity, wrote to Roosevelt on April 24, 1933: "I want now to say, that I should like very much to paint a portrait of the President at a time when he can manage it."[11] Rand's first letter went unanswered, but she was undeterred. Months later, on July 25, 1933, Rand wrote, "If there is a chance that I might try my luck with a portrait of the President, would he have time on this next trip to Hyde Park to give me a sitting so that I could get a start."[12] On August 8, 1933, Roosevelt finally replied: "Franklin says that he is most anxious for you to do his portrait to be left in the White House." Rand got to work the next day.

For Rand, painting the president was an honor, but not a pleasure. FDR often welcomed artists into his office to work alongside him, but he refused to pose.[13] Rand found FDR's unwillingness to pose and the constant interruptions of his staff arduous. During her first trip to the White House, Rand exasperatedly wrote in her diary, "I could really get a lot of fun out of this life, it is comfortable & very independent, it is O.K. as long as one is not trying to paint the President."[14] Rand painted FDR for approximately nine months, from the summer of 1933 to the spring of 1934, and her diaries detail her progress, anxieties, and frustrations at length.[15]

During the first six months Rand painted FDR (August to December 1933) she referred to her portrait in her diary as the "President's portrait." In January of 1934, Rand began making a distinction between a first presidential portrait (Plate 16) and a second (Plate 15) in her letters and diary, indicating that she painted the White House portrait twice during this period. It appears Rand worked the first canvas to a point where she was no longer satisfied and began again of her own volition.[16]

In November 1933, Rand journeyed to Washington, DC for sittings with FDR with a blank canvas to begin a new portrait. On the train down from New York she wrote, "going to the White House to spend the week end, what will come of it heaven alone knows but I have a canvas to paint a ready F.D.R. and that I am going to do, so that I can get the thing just right and I will sit around until I get enough sittings."[17] On her first day at the White House, she had poor sittings, but "mostly got him drawn in—he looks well I think."[18] The following day went more smoothly for her, "The President said he would sit until a conference at 3, so up I flew & got started, I was surrounded by Cabinet officers & secretaries, but I pushed right ahead and got some paint on & got I think a proper start."[19] As Rand progressed, she grew increasingly confident in her efforts. On January 23, 1934, Rand wrote, "I did do a lot I worked on the 2nd Presidential portrait. It really is a lot better than the first & may turn out all right. Several people have seen it & all like it very much. I worked darned hard, how glad I will be when it is finished."[20] She had the second portrait photographed in preparation for her last sittings with FDR, enabling her to show the Roosevelts her progress.[21] Rand wrote of the first family's approval to her husband from Washington, DC on January 26, 1934:

> They all like the photograph very much, a lot better than the first portrait. My sketch down here is going alright and I had a good sitting though he was going over papers all the time. Such telephone messages he was getting all the time, about bills being passed, and appropriations of hundreds of millions, but he did not turn a hair.[22]

That FDR, famous for refusing to pose, acquiesced to Rand and conducted the business of the nation sitting perfectly still, speaks not only to Rand's powers of persuasion, but FDR's investment in the portrait and his desires to be memorialized by Rand exerting the full range of her considerable creative faculties.

Visualizing Disability

Portraying FDR, Rand took the task of representing his body upon herself. Rand's portraits presenting nearly all of FDR's figure were the first to do so since his contraction of poliomyelitis in 1921, marking a significant development in FDR's visual history. FDR was an avid collector of his own image, but in the years between falling ill and entering the White House, he sat for just four formal portraits, each offering only partial views of his physique, avoiding, it would seem, the representation of his lower limbs.[23] The absence of FDR's legs from the portraits of this period can be attributed, in part, to the differences between three-quarter and half-length portraits. Rand's articulations of FDR's bodily form, however, far exceed the detail typically found in White House presidential portraits, indicating intentionality beyond art historical convention.

Presidential portraits are an image type characterized by finely rendered faces, well-modeled hands, and unremarkable bodies. In the White House portrait collection presidential bodies are often concealed in shadow, obscured by dark clothing, or placed partly beyond the compositional frame. It is an American pictorial convention

that renders presidential bodies—physiques burdened with symbolic and political meaning—difficult to read and thus less problematic for both artists and their sitters. By presenting FDR directly and more completely, highlighting his legs, rather than denying or diminishing the site of his paralysis, Rand made the American presidential portrait type her own while honoring the physicality of the newly elected thirty-second president.

In 1933 (Plate 16), Rand pictured FDR as the robust and physically vigorous candidate that traveled endlessly across the country in 1932 to win the election through pictorial and formal elements that communicate movement and agility. In 1934 (Plate 15) Rand depicted FDR gazing off lost in thought, capturing him physically and mentally subsumed in the work of the presidency in an image defined by compositional balance and tonal harmony. These embodied portraits move beyond the binary of disability/ability that has defined FDR's visual representation since the late twentieth century.[24] Drawing on the foundations of disabilities studies, it is helpful to interpret Rand's portraits as representations of bodily variance that capture—through compositional structures, formal qualities, and representational elements—the complexities of FDR's lived physicality.

Rand's portraits present FDR as the modern statesman seated at work in his Hyde Park study, showing him as straightforward, authoritative, and dignified. FDR sits alongside a nondescript circular table, as opposed to a desk.[25] The use of tables in place of desks is a tradition of American presidential portraiture that in Rand's interpretation underscores FDR's accessibility to the viewer. Employing a circular furnishing rather than the traditional rectangular form, Rand implements the table's curvature as a guiding sight line that leads the viewer into her images and directs the eye to the president's adjacent body rendered in remarkable detail.

Despite their similarities of pose, setting, and shared signifiers of authority, the portraits diverge in critical ways. In 1933 (Plate 16) Rand imparts the commanding presence of her subject through composition, tonal contrast, and lively brushwork. FDR sits alert, positioned toward the viewer, and returns our gaze. FDR's ascendant, frontal figure is at the end of a table and the edge of the compositional frame, making him appear confined in the space while emphasizing his presence within it. The result is an unyielding presentation of FDR's figure—one that demands the viewer's attention through his compositional dominance. The foreshortened depth of field is further compacted by the crowded furniture, implying FDR's physical agility and his ability to navigate the condensed space.

Rand's brushwork enlivens the image, creating a sense of energy and action, replicating the equivalencies FDR drew between his body and his rigorous campaign travel.[26] His lapels fall open and the dramatic creases of FDR's business attire imply a day actively spent. FDR's morning jacket and trousers are loosely rendered with bold brushstrokes; Rand's painterly wrinkles convey action and mobility while revealing the form of the body underneath them. Rand suggests the musculature beneath the suit through careful delineations of fabric, capturing the subtle pull of wool around his shoulders, elbows, upper thigh, and top knee. Fabric contours also highlight the angular forms of FDR's thin legs and kneecaps, revealing that the president sits without his braces.

The 1934 image (Plate 15), alternatively, illustrates FDR comfortably immersed in the work of governance, epitomizing his political fitness and friendly countenance. Through strategic changes in compositional structure, color palette, and pose, Rand captures FDR's embodied intellect and charisma. Relaxed and accessible, Rand replicates the sense of intimacy the American people felt with the first president they welcomed into their homes for "Fire Side Chats," depicting FDR looking off contemplatively. By adjusting the scale for FDR's figure in relation to his environment, and expanding its pictorial depth, Rand balances the compositional weight between his body and his surroundings. This restructuring draws attention to FDR's study, where his paralysis was irrelevant to conducting the business of the nation.

Rand's rich sepia-toned color palette accentuates her compositional harmony; in which FDR's plain umber suit and lightly sun-kissed skin complement the mahogany furnishings and sienna hued drapes of his surroundings.[27] This pictorial cohesion of the 1934 version sets the image's emotional tenor, creating an equivalency between the tonal warmth of the image and the amiability of its subject. Streams of light fall upon FDR's gently uplifted face, drawing the eye to his serene expression allowing for a more intimate relationship between the president and viewer. By softening FDR's expression, redirecting his gaze, and shifting his pose, Rand invites us to freely observe the president's body, working at ease, just as she did.

Rand replicates her previous efforts to provide a sense of FDR's physicality, but to far greater effect, acutely rendering the fabric of his suit to reveal what lies beneath it. Sunlight accentuates the crests and furrows of material that trace the curvatures of FDR's rounded shoulders and relaxed arms, as well as the straight lines of the president's slender legs, their angularity attesting to the absence of his braces. Rand's highlights also make visible the slope of FDR's upper back and the delicate wrinkles of his mature skin. Even the fall of FDR's lapel against his chest adds to Rand's portrayal of his bodily structure.

This embodied portrait hung in the White House for eleven years, memorializing FDR with the body he understood himself to have, one that reflected his physical vigor and political fitness. Recovering the corporeal complexity of Rand's presidential portraits, however, also requires recuperating how FDR understood and experienced his paralysis and examining how his figure has been historicized.

Disability studies' conceptualization of the distinction between impairment and disability is essential to reconsidering FDR's lived experiences and Rand's portrayals of them.[28] After contracting poliomyelitis in 1921 FDR's strength and agility fluctuated, a physical reality he used to frame his paralysis as perseverance over poliomyelitis, but it was not mere political posturing.[29] Through seven years of rigorous rehabilitation, FDR had regained his strength, enabling limited mobility. FDR reentered political life able to walk, drive, and stand behind a podium; he did these things with aid and effort, but he did them nonetheless.[30] The social model of disability stipulates that physical difference only becomes disability when confronted by a society shaped by and for normative bodies.[31] As a man of extraordinary power and privilege, FDR exerted significant control over his environments, creating circumstances exceeding the polarity of disability/ability. During his convalescence, FDR also came to understand his paralysis as negligible to his overall well-being; viewing himself as improved

because rehabilitation had strengthened his body beyond its state prior to falling ill.[32] The conditional nature of FDR's experience of paralysis is best exemplified by the full mobility he regained in water. After discovering hydrotherapy, FDR wrote to his physician with excitement, "For the past month I have been swimming three times a week, and the legs work perfectly in the water. In every other way I am perfectly normal."[33] To see the fluidity of FDR's corporeal condition as delusional or political machinations undermines the agency of an individual to conceive and live their physicality and only reifies normative or "original" versions of corporeality.[34]

During the 1932 presidential election, Republicans asserted that his paralysis made FDR unfit to hold public office, which he refuted with strategies historians frequently categorize as passing.[35] After his inauguration, FDR's condition continued to be an issue for his critics, but deploying it against him became increasingly complicated when FDR's body no longer represented a singular identity but functioned as a symbol of the nation.[36] FDR, however, took nothing to chance, asserting his political fitness by maintaining absolute control over his photographic image through the White House Press Office. Photographs depicting FDR in his wheelchair, climbing ramps, or being lifted into his car were prohibited; journalists who disregarded this dictum risked having their equipment destroyed and losing their White House access.[37]

If there was ambiguity to the nature of FDR's physicality during his life, in subsequent decades, due to the emergence of the disabilities rights movement, FDR's paralysis has become a stable and visible element of his historical representation. New consciousness regarding the discourses that define and sustain disability prompted the reimagining of FDR's legacies.[38] This shift culminated in 2001 when the Franklin Delano Roosevelt Memorial in Washington, DC was reopened with a figuration of FDR seated in the wheelchair the American people never saw during his lifetime.[39]

The FDR this memorial commemorates is clearly not the figure Rand depicts. Rand's sympathetic portraits reflect a shared understanding of what it means to imagine one's body a certain way and for the world to see it another. As an aging female artist Rand knew the confines of physicality well. Her diaries detail at length her abhorrence of press photographs of herself and the emotional toll their circulation elicited, especially when a likeness failed to resemble her self-image.[40] Disability is the state of becoming we all inhabit—a fact that Rand's profession as portraitist and her more personal experiences of her aging body made her acutely aware. (Consider as well Pfeiffer's chapter in this collection concerning Rand and athleticism.) Her portraits of middle-aged patrons reflect a keen sensitivity to the human conditions of enfleshment—none more so than her portrayals of FDR's.[41]

By articulating FDR's corporeal complexity, Rand's portraits provide a model for addressing disability in relation to images that suppress or render invisible signifiers of bodily difference. Such a model is necessary because art historical scholarship, drawing upon the conceptual frameworks of disability studies, continues to overlook conventional historical portraiture.[42] Rosemarie Garland-Thomas's essay "Picturing People with Disabilities: Classical Portraiture as Reconstructive Narrative" is a notable exception; however, her inquiry focuses on contemporary portraits that explicitly present disabled persons. Garland-Thomas argues that portraits such as Chris Rush's *Swim II*, a regal portrayal of a young woman with Down's syndrome, "make newly

intelligible devalued forms of human embodiment and promote new forms of cultural literacy by rendering subjects into esteemed public figures and teaching us how to value them."[43] Inverting and expanding Garland-Thomas's method by identifying disability in historical political portraiture can achieve the same ethical imperative.[44] By reading the variety of human difference into images of political power, national reverence, and cultural authority, such as Rand's, we can further destabilize the narrow ways disability has been historically marginalized and culturally construed.[45]

Discovering bodily nuance in a classical portrait requires relentlessly seeking it out, interrogating a likeness's formal qualities, questioning its pictorial narrative, and looking beyond its iconographic symbols for secondary interpretations. In the case of FDR's portraits, Rand articulates the fluidity between paralysis and disability that characterized FDR's embodied experiences, through formal elements and bodily details. Her portraits communicate the same scene of the newly inaugurated president at work, a state in which his paralysis is inconsequential to his political prowess. While attending to national affairs, FDR could directly and unabashedly present himself to the American public, because seated at work, impairment was not a disability.

Similarly, the prominence of FDR's beloved model of the USS *Constitution* in both canvases operates on two symbolic registers. FDR acquired the model while serving as Assistant Secretary of the Navy; it was the centerpiece of his vast collection of over 400 miniature ships.[46] The frigate, constructed in 1797, was commissioned after George Washington signed the Naval Act of 1794, making it one of the six original vessels of the US Navy.[47] In Rand's portraits, it exemplifies FDR's adoration for the sea, reverence for military history, and pride in becoming Commander-in-Chief. While the primary symbolism of the USS *Constitution* is overt, there is a secondary register worth considering; boats provided a parallel to FDR's corporality. FDR—like the warships he took pleasure in surrounding himself with—enjoyed aquatic mobility and maintained the capacity for authority and force, even in motionless tranquility.

In Rand's canvases, the president and his boat enjoy the respite of portraiture's eternal stillness, where there is no end to FDR's time in the study.[48] Portraiture offered FDR the permanent physical state that the material conditions of his body denied him. It also provided FDR the satisfaction of being seen and authority over his representation that photography (and indeed even his daily reality) could not. FDR found genuine enjoyment in having his portrait taken and surrounding himself with them, amassing an extensive collection of portraits of himself throughout his lifetime. These images and FDR's pleasure in them demand an acknowledgment of the situational and complex nature of disability, and pleasures possible from its visualization.

Beyond the Boiler Room

The 1934 portrait was Rand's opportunity to shift perceptions of her creative abilities and change the economic conditions of her life. The portrait alone, however, was not enough to build the legacy she desired—it needed a place of prominence in the White House, and she knew exactly where it should go. She envisioned her charismatic portrait hanging at the heart of the White House, which she unabashedly expressed to FDR in a letter from June 14, 1934:

If I was consulted where to hang it I would say that it would look very well where President Harding's portrait hangs, to the left of the front door and opposite President Coolidge but I don't at all expect a voice in the matter, so probably all this opinion will amount to nothing.[49]

Once the portrait arrived FDR took the time to express his pleasure with it:

This morning the portrait was unpacked and I am really thrilled by it. It is far and away the best thing that has ever been done of me and I don't need to tell you how happy I am that you should be the author of it. As to 'hanging myself,' it is quite contrary to custom to have any portrait of the incumbent in the White House where anyone can see it! Therefore, we are going to hang it in the upstairs hall. What my successor will do with it, I don't care to guess. He may put it in the boiler room, but that will not be because of the portrait but rather because of the subject.[50]

Despite FDR's ardent wishes and his wife's efforts, Rand's portrait would suffer a fate far worse than being marooned in the boiler room of the White House.[51]

Mere hours after FDR's death, on April 12, 1945, Eleanor Roosevelt set to work acting as the guardian of her husband's presidential legacy and protector of his memory. During the politically critical weeks that followed, Roosevelt devoted herself to the legacy FDR had imaged for himself—which included ensuring his favorite portrait remained in the White House.

On April 24, nine days after FDR was laid to rest, Roosevelt informed the Commission of Fine Arts chairman, Gilmore Clarke, that she wished to "present the portrait of the late President to the Government of the United States for display in the White House."[52] Clark readily agreed as the Commission had recently viewed the portrait in the family residence of White House, and the sentiment of the group was that "everyone present thought that the portrait was an excellent one by a well known and competent artist."[53] On May 4, 1945, Rand's place in the White House and the history of American portraiture was finally solidified, at least momentarily, when the Commission gathered to approve the portrait, designating it the "official portrait of President Roosevelt in the White House."[54] During their congress, the Commission also discussed where the portraits of Warren G. Harding, Calvin Coolidge, and J. Edgar Hoover were to be relocated, as Rand's would occupy "the place of honor at the right of the main entrance."[55] Its placement there, the spot Rand had deemed worthy of her portrait eleven years earlier, was per White House precedent dictating that the latest presidential portrait acquisition be displayed prominently at the entrance of the executive mansion.

Rand's time "in the place of honor" was short-lived. In February of 1947, President Truman began planning to remove Rand's portrait, intent on replacing it with a copy of English painter Frank Salisbury's portrait of FDR originally from 1935 (Figure 9.1). Truman clearly understood the gravity of the exchange because he enlisted Myron Charles Taylor, a wealthy industrialist, and diplomat, to act on his behalf. Taylor, who served as FDR's personal envoy to Pope Pius XII during World War II, was uniquely situated to procure the copy Truman wanted because Taylor had commissioned the original for the New York Genealogical and Biographical Society.[56]

Under these circumstances, to the public and the press, Taylor's donation of the Salisbury copy to the White House would appear as a gesture of gratitude and remembrance from the late president's trusted advisor—and in part it was. It was also political gamesmanship. If public outcry erupted over the exchange of an American portrait for an English one, or the removal of the first female artist in the collection for another male, it could be mitigated through the guise of diplomatic courtesy. Taylor wrote to Salisbury on February 2, 1947:

> Last Friday when I was with President Truman, and we were discussing portraits, he suggested that the original portrait of President Roosevelt which is in the New York Genealogical and Biographical Society was the one he liked best … The thought has occurred to me that perhaps I could arrange with you to provide such a portrait, if the cost were to be not too great, and have it donated through President Truman to the White House. I know you are busy, but this seems to be an opportunity that is without precedent, and perhaps you and I can conspire together to accomplish the desired result.[57]

Only three days after Taylor wrote to Salisbury (and before Salisbury responded) Truman's secretary William D. Hassett produced a memorandum regarding the Salisbury portrait. The memorandum asserts that because FDR paid Rand for the commission privately, the substitution of Rand's portrait for the Salisbury copy, "to be presented by Mr. Myron C. Taylor," would be greatly simplified.[58] Perhaps more revealing than how Truman was able to make the replacement is that Truman, according to this document, prearranged with Taylor prior to contacting the artist, a plan for acquiring the portrait he wanted in the White House. Upon the arrival of Salisbury's portrait to the White House, Truman penned a thank-you note to Taylor: "The Salisbury portrait of the late President arrived today and I am more appreciative than I can say of the generous impulse which prompted you to do so grand a thing in honor of a great and good man—your friend and mine."[59] The generous impulse was, of course, Truman's plan.

Truman's exchange remains the only instance of a president removing the portrait of another executive from 1600 Pennsylvania Avenue. As the archival record reveals, removing Rand's portrait was a remarkable action requiring significant effort and delicate political maneuvering. What remains elusive, however, are Truman's motivations for violating FDR and Roosevelt's expressed wishes. The Salisbury portrait may have been the FDR image Truman "liked best," but the exchange was a notable undertaking for a preference concerning portraits. Instead, I speculate that the replacement was not a matter of taste but a political necessity.

By the spring of 1947 Truman's re-election bid was facing significant obstacles, particularly from within his party.[60] Liberal Democrats criticized Truman for abandoning the ideals of the New Deal and sought a replacement for the "spiritual anchor" FDR had been to the party.[61] In comparison with his predecessor, Truman fell short, incapable of the "warm, human, smiling, face-to-face dealings Roosevelt made famous and effective."[62] Truman was competing against both FDR's memory and his primary opponent Senator Alben W. Barkley for the approval of the Democratic Party.

To make matters worse, FDR, resplendent in his charismatic warmth, haunted Truman from the walls of his own home. Truman wanted what Rand's portrait could not offer, a memorial.

Salisbury's half-length profile portrait (Figure 9.1) is in many ways a pensive and somber effigy. Despite having originating from live sittings with FDR, the work hovers in FDR's symbolic qualities. Salisbury depicts FDR looking out beyond the frame, but here his penetrating gaze is pensive and resolute, distancing him from the viewer. Magnifying this separation are the polished wood surfaces of FDR's desk and chair, angled toward one another creating a physical barrier between the president and the viewer. Casting FDR in an eerie, ethereal light, his psychological space is impenetrable, despite his proximity to the pictorial plane. Compared to Rand's emphasis on movement, physicality, and the embodied intellect at work, Salisbury's portrait is characterized by stillness. In place of Rand's carefully articulated fabric folds and sheets of creased paper, Salisbury alludes to action through a single gesture, signaling FDR's authority and decisiveness through his outstretched arm and closed fist. Precisely modeled flesh juxtaposes the generalized treatment of FDR's torso. And where Rand highlighted FDR's musculature, Salisbury's loose brushwork merges FDR with his surroundings at the president's left shoulder, collapsing his physical form with the portrait's tonal background.

Additionally, FDR's lower extremities are largely eliminated from view, obscuring any impression of his full corporeality, a stark contrast to Rand's more replete visualization of FDR's physique. It is a difference that can be attributed to the conventions of half-length portraiture and its capacity to obscure representationally problematic bodies. The half-length portrait allowed Salisbury to easily transform FDR's complex form into another unremarkable presidential body, removing the president's personally and politically charged lower limbs from view.

By replacing the vitality, physicality, and charisma of Rand's portrait with the disembodied stoicism of Salisbury's, Truman redefined FDR's White House legacy. In place of Rand's *memento vivere*, the image FDR loved best of himself—one portraying an active mind and body engrossed in the work of the presidency—Truman transformed FDR into a timeless symbol.

Despite Truman's efforts to distance himself from the removal of Rand's portrait, he did consult Roosevelt regarding his plans.[63] She graciously acquiesced, asking that it be sent to her youngest son, John A Roosevelt.[64] It appears a small negotiation occurred between Roosevelt and Truman regarding the conditions for the replacement, her acceptance belying her ambivalence regarding the situation, which Roosevelt revealed years later in her syndicated column, "My Day."

Mr. Salisbury has done a number of copies himself of his own portrait of my husband, and one of these copies was chosen by President Truman to be the portrait of my husband to remain in the White House. My husband had had a friend and a great American artist, Bay Emmet Rand, paint the portrait that he left in the White House, but President Truman preferred Mr. Salisbury's portrait, as do many other people, and with my consent the change was made.[65]

Roosevelt's column hints toward her dismay with Truman's defiance of FDR's wishes, but by that point the Salisbury portrait was in place, safe and sound where it remains today, in the White House presidential collection.

Conclusion

In 2004 Rand's grandson Peter Rand visited the FDRL and asked to see his grandmother's portrait of the president. He was informed that it was not available for viewing, and left without suspecting anything was amiss.[66] Six months later, the FDRL informed Peter Rand that the portrait was missing.[67] On February 23, 2011, the Archives' Inspector General, Paul Brachfeld, implied to the *Washington Post* that the portrait was stolen; by suggesting he knew who took Rand's painting.[68] The Rand family questions the feasibility of the massive crated painting being stolen in a heist that included no other objects. They have long believed the portrait was accidentally destroyed.[69]

Extraordinary actions and remarkable circumstances characterize the story of Rand's White House portrait. Expelled from the White House only to be accidentally destroyed, the series of unfortunate events that befell Rand's portrait also erased it from cultural memory. FDR's White House figuration remains stoic and disembodied, a portrait that contradicts the historical representation FDR desired for himself. A lasting national legacy eluded Rand because her depictions of FDR diverged from how Truman and American history needed to reimagine his body. Rand's intimate portraits depicting FDR as he understood himself ceased to resemble the author of the New Deal when collective memory assigned him permanently to his wheelchair. Rand captured the fluidity of FDR's corporeality, giving representational form to material conditions that exceeded the binary of ability/disability. Her sensitive portrait could, however, not transcend what the twenty-first century needed from FDR's representation. Historical memory demanded the figuration of FDR be an extraordinary leader despite his paralysis. When Rand painted FDR contentedly consumed in the work of governance, she painted his bodily variance as immaterial to his capacity for inhabiting the presidency.

Notes

1 I refer to Franklin Delano Roosevelt as FDR throughout.
2 Jim Rutledge, "Missing FDR Painting from New York Library a Mystery," AntiqueWeek.com, http://www.antiqueweek.com/ArchiveArticle.asp?newsid=2334, accessed November 1, 2014.
3 I refer to Anna Eleanor Roosevelt as Roosevelt throughout.
4 Rutledge, "Missing FDR Painting."
5 Sally Stein, "The President's Two Bodies: Staging and Restaging of FDR and the New Deal Body Politic," *American Art* 18, no. 1 (Spring 2004): 47.

6 Davis W. Houck and Amos Kiewe, *FDR's Body Politics: The Rhetoric of Disability* (College Station: Texas A&M University Press, 2003), 27. See also Hough Gregory Gallagher, *FDR's Splendid Deception* (New York: Dodd, Mead & Company, 1985), 65.

7 Gallagher, *FDR's Splendid Deception*, 211.

8 Blanche Wiesen Cook, *Eleanor Roosevelt Vol. I 1884–1933* (New York: Penguin Books, 1992), 129.

9 There are no letters archived attesting to Roosevelt and Rand being in direct contact or close friends after 1905.

10 Grenville T. Emmet served as the United States Ambassador to the Netherlands and Austria under FDR. "In Office Ten Days, U.S. Minister Dies: Grenville T. Emmet Victim of Pneumonia in Vienna," *The New York Times*, September 27, 1937.

11 Letter, Ellen "Bay" Emmet Rand to Eleanor Roosevelt, April 24, 1933, Container 9: General Correspondence, R-Miscellaneous, FDRL. All Rand quotations are faithful to her original word choices, grammar, and punctuation.

12 Letter, Ellen "Bay" Emmet Rand to Eleanor Roosevelt, July 25, 1934. Container 9: General Correspondence, R-Miscellaneous, FDRL.

13 David Meschutt, "Portraits of Franklin Delano Roosevelt," *The American Art Journal* 18, no. 4 (Autumn 1986): 6.

14 Diary, November 11, 1933, Ellen Emmet Rand Papers, Archives & Special Collections, University of Connecticut Library (EER Papers, ASC, UConn).

15 There is significant archival evidence indicating that the dated signature of 1932 on Rand's first FDR portrait is incorrect and that the portrait was created in 1933; I refer to the 1933 date throughout. Rand sold the portrait to Sara Delano Roosevelt in 1939, at which time she signed the six-year-old canvas with the wrong date. Diary, November 25, 1939, EER Papers, ASC, UConn. For a full discussion of the incorrect date see Emily Mazzola, "Enabling Authority: Ellen Emmet Rand, President Franklin D. Roosevelt, and the Power of Portraiture," MA Thesis, University of Connecticut, Storrs, 2015.

16 Diary, August 28, 1933, EER Papers, ASC, UConn.

17 Diary, November 10, 1933, EER Papers, ASC, UConn.

18 Diary, November 11, 1933, EER Papers, ASC, UConn.

19 Diary, November 12, 1933, EER Papers, ASC, UConn.

20 Diary, January 23, 1934, EER Papers, ASC, UConn.

21 Diary, January 26, 1934, EER Papers, ASC, UConn.

22 Letter, Ellen Emmet Rand to Blanchard Rand, Ellen Emmet Rand Papers, Private Collection, Brooklyn, New York, viewed 2015. Currently the Emmet-Rand Family Personal Papers, courtesy of Felicia Garcia-Rivera.

23 Meschutt, "Portraits of Franklin Delano Roosevelt," 4–9. Pierre Troubetzkoy's 1927 portrait represents FDR seated with only the top of his knee visible. DeWitt M. Lockman painted a half-length portrait of FDR in 1930. Jacob H. Perskie's 1932 three-quarter-length portrait of FDR angles his legs away from the viewer and out of the compositional frame. Lastly, Edward P. Buyck's 1933 portrait positioned FDR behind a table, obscuring FDR's lower body.

24 Stein, "The President's Two Bodies," 46–51.

25 Rand began the portrait at Springwood, the Roosevelt family's estate in Hyde Park, New York. It is unclear if the circular table FDR sits alongside is a furnishing from Springwood, a studio prop, or Rand's creative invention.

26 FDR won the 1932 election in part because he used his body as a means of refuting his opponents' claims that his physical disability made him unsuitable for the presidency.

Roosevelt presented the country with the one thing that could end to the speculation: his physical presence. In the year leading up to the election, FDR traveled the nation at a grueling pace, inviting the electorate to see that his body, though hindered by the effects of polio, was capable of withstanding the pressures of office. Photographed driving cars and riding trains, FDR created an equivalency between his constant travel and his mobility. (Houck and Kiewe, *FDR's Body Politics*, 95.)

27 Visual analysis of the 1934 portrait is necessarily speculative due to the loss of the canvas. My analysis is based on the only known color photograph of the image.

28 Disability studies scholar Anne Waldschmidt describes the difference as, "Impairment and disability need to be distinguished and do not have a causal relation; it is not impairments per se which disables, but social practices of 'disablement' which result in disability." Anne Waldschmidt, "Disability Goes Cultural: The Cultural Model of Disability as an Analytical Tool," in *Culture—Theory—Disability: Encounters Between Disability Studies and Cultural Studies*, eds. Anne Waldschmidt, Hanjo Berressem, and Moritz Ingwersen (Bielefeld: transcript Verlag, 2017), 19.

29 Houck and Kiewe, *FDR's Body Politics,* 27. See also Matthew Pressman, "Ambivalent Accomplices: How the Press Handled FDR's Disability and How FDR Handled the Press," *The Journal of the Historical Society* XIII, 3 (2013): 332.

30 For a full description of FDR's walking strategy, see Gallagher, *FDR's Splendid Deception*, 65.

31 Gareth William, "Theorizing Disability," in *Handbook of Disability Studies*, eds. Gary L. Albrecht, Katherine Seelman, and Michael Bury (Thousand Oaks: Sage Publications, 2001), 129.

32 Houck and Kiewe, *FDR's Body Politics*, 50.

33 Ibid., 27.

34 Tobin Siebers, "Disability as Masquerade," *Literature and Medicine* 23, no. 1 (2004): 5.

35 Daniel J. Wilson, "Passing in the Shadow of FDR," in *Disability and Passing*, eds. Jeffery A. Brune and Daniel J. Wilson (Philadelphia: Temple University Press, 2013), 15.

36 Pressman, "Ambivalent Accomplices," 350–1.

37 Ibid., 339–40.

38 Rosemarie Garland-Thomas, "The FDR Memorial: Who Speaks from the Wheelchair?" *The Chronicle of Higher Education* 47, no. 20 (January 2001): B11.

39 Stein, "The President's Two Bodies," 46–51.

40 For example, Rand wrote of seeing herself on the front pages of the *New York Times*: "The first shock I got today was my picture in both the Herald Tribune & Times both pictures was so ugly that, I could not shake it off but just felt hideous all day … I suppose my looks are getting so offensive to me that I can no longer laugh it off." Dairy, April 10, 1940, EER Papers, ASC, UConn.

41 Waldschmidt, "Disability Goes Cultural," 19.

42 For a discussion of disability in photographic portraiture, see Kristin Lindgren, "Looking at Difference: Laura Swanson's Anti-Self-Portraits, Diana Arbus's Portraits, and the Viewer's Gaze," *Journal of Literary & Cultural Disability Studies* 9, no. 3 (2015), 277–94. For an analysis of disability in contemporary sculptural portraiture, see Ann Millett, "Sculpting Body Ideals: Alison Lapper Pregnant and the Public Display of Disability," *Disability Studies Quarterly* 28, no. 3 (Summer 2008), http://www.dsq-sds.org/article/view/122/122, accessed July 26, 2020.

43 Rosemarie Garland-Thomas, "Picturing People with Disabilities: Classical Portraiture as Reconstructive Narrative," in *Re-Presenting Disability: Activism and Agency in the Museum*, eds. Richard Sandell, Jocelyn Dodd, and Rosemarie Garland-Thomas (New York: Routledge, 2010), 39.

44 Lindgren rightfully points out, "Variant bodies have always been present in portraiture: think of canonical works such as Velazquez's *Las Meninas* and Frida Kahlo's self-portraits" (Kristin Lindgren, "Looking at Difference: Laura Swanson's," *Anti-Self-Portraits*, 280). See also Shearer West, *Portraiture* (New York: Oxford University Press, 2004), 97.

45 Garland-Thomas argues, "Understanding how images create or dispel disability as a system of exclusions and prejudices is a move toward the process of dismantling the institutional, attitudinal, legislative, economic, and architectural barriers that keep people with disabilities from full participation in society." Rosemarie Garland-Thomas, "The Politics of Staring: Visual Rhetorics of Disability in Popular Photography," in *Disability Studies: Enabling the Humanities*, eds. Sharon L. Snyder, Brenda Jo Brueggemann, and Rosemarie Garland-Thomas (New York: Modern Language Association, 2002), 75.

46 "Ship Model Collection," Franklin D. Roosevelt Library and Museum, http://www.fdrlibraryvirtualtour.org/index.asp, accessed September 22, 2018.

47 "Chronology," USS Constitution Museum, http://www.fdrlibraryvirtualtour.org/index.asp, accessed September 22, 2018.

48 Robert E. Gilbert, "Disability, Illness and the Presidency: The Case of Franklin D. Roosevelt," *Politics and the Life Sciences* 7 no. 1 (August 1988): 35.

49 Letter, Ellen "Bay" Emmet Rand to Franklin D. Roosevelt, June 14, 1934, Presidential Papers, Personal Correspondence, Container 5, Box 1690, FDRL.

50 Letter, Franklin D. Roosevelt to Ellen Emmet Rand, June 19, 1934, Ellen Emmet Rand Papers, Private Collection, Brooklyn, New York, viewed 2015. Currently the Emmet-Rand Family Personal Papers, courtesy of Felicia Garcia-Rivera.

51 Memorandum to Gilmore D. Clark, Chairman of the Commission of Fine Arts, Washington, DC, May 2, 1945; Roosevelt Portraits and Busts, Box 157, Project Files 1910–12, General Files, General Records of the Commission of Fine Arts, Record Group 66, National Archives Building, Washington, DC.

52 Gilmore D. Clark, Chairman of the Commission of Fine Arts, Washington, DC to H. G. Crim, White House Usher, Washington, DC, April 30, 1945; Roosevelt Portraits and Busts, Box 157, Project Files 1910–12, General Files, General Records of the Commission of Fine Arts, Record Group 66, National Archives Building, Washington, DC.

53 Ibid.

54 Minutes of Meeting of the Commission of Fine Arts, Held in Washington, DC, May 4, 1945, U.S. Commission of the Fine Arts, July 1, 1943 to June 30, 1945, https://archive.org/details/cfaminutes4may1945, accessed April 12, 2017.

55 Memorandum to Gilmore D. Clark, Chairman of the Commission of Fine Arts, Washington, DC, May 2, 1945; Roosevelt Portraits and Busts, Box 157, Project Files 1910–12, General Files, General Records of the Commission of Fine Arts, Record Group 66, National Archives Building, Washington, DC.

56 Meschutt, "Portraits of Franklin. Delano Roosevelt," 27.

57 Letter, Myron C. Taylor to Frank O. Salisbury, February 2, 1947, White House Curatorial Files, Washington, DC.

58 William D. Hassett, Memorandum Re Salisbury Portrait of the Late President, February 5, 1947, White House Curatorial Files, Washington, DC.

59 As quoted in Meschutt, "Portraits of Franklin Delano Roosevelt," 27.

60 Alonzo L. Hamby, "Liberals, Truman, and FDR as Symbol and Myth," *Journal of American History* 56, no. 4 (1970): 859–62.

61 Ibid., 862.

62 Ibid., 864.

63 Truman contacted Roosevelt regarding the exchange of Rand's portrait for Salisbury's in March 1947, the same month Salisbury's portrait arrived at the White House. The archival record is not clear concerning when Truman first revealed his plans for the portrait exchange to Roosevelt. See Eleanor Roosevelt, "Correspondence: 1947," Eleanor and Harry: The Correspondence of Eleanor Roosevelt and Harry S. Truman, Harry S. Truman Library and Franklin D. Roosevelt Library, https://www.trumanlibrary.org/eleanor/1947.html, accessed February 18, 2014.

64 Ibid. John A. Roosevelt donated Rand's portrait to the FDRL in 1964, where it resided until 2001.

65 Eleanor Roosevelt, *My Day Project*, November 21, 1959, George Washington University, http://www.gwu.edu/~erpapers/myday/displaydoc.cfm?_y=1959&_f=md004595, accessed March 13, 2015.

66 Rutledge, "Missing FDR Painting from New York Library a Mystery."

67 Ibid.

68 Lisa Rein, "Reclaiming America's Stolen Property," *The Washington Post*, February 23, 2011.

69 Ellen Emmet Rand, Private Conversation, November 2013.

Contributors

Alexis L. Boylan is Director of Academic Affairs of the University of Connecticut Humanities Institute and Associate Professor with a joint appointment in the Art and Art History Department and the Africana Studies Institute. She is the author of *Visual Culture* (MIT Press, 2020), *Ashcan Art, Whiteness, and the Unspectacular Man* (Bloomsbury Academic, 2017), co-author of *Furious Feminisms: Alternate Routes on Mad Max: Fury Road* (University of Minnesota, 2020), and editor of *Thomas Kinkade: The Artist in the Mall* (Duke University Press, 2011).

Emily C. Burns is Associate Professor of Art History at Auburn University. Her research focuses on Franco-American artistic exchange in the late nineteenth and early twentieth centuries. Her book *Transnational Frontiers: the American West in France* was published from University of Oklahoma Press in 2018. Her research has been supported by the Terra Foundation for American Art, the Metropolitan Museum of Art, the Amon Carter Museum of American Art, and the Smithsonian American Art Museum.

Betsy Fahlman is a Professor of Art History at Arizona State University. Her specialties include American modernism, the New Deal, industrial archeology, and women artists. Her books include *Kraushaar Galleries: Celebrating 125 Years* (2010), *New Deal Art in Arizona* (2009), *James Graham & Sons: A Century and a Half in the Art Business* (2007), *Chimneys and Towers: Charles Demuth's Late Paintings of Lancaster* (2007), and *Guy Pène du Bois: Painter of Modern Life* (2004).

William Ashley Harris has spent twenty-five years in the archival profession at the state and national level. The majority of his career has been spent with the Presidential Library System operated by the National Archives. He served as a founding archivist of the George H. W. Bush Presidential Library, as a senior director in the Office of Presidential Libraries, and currently as the deputy director of the Franklin D. Roosevelt Presidential Library.

Elizabeth L. Lee is an Associate Professor of art history at Dickinson College in Carlisle, Pennsylvania. She specializes in late nineteenth- and early twentieth-century American art and its intersections with the history of the body, disease, medicine and health. Her research has appeared in *American Art, The Journal of American Culture, Nineteenth Century* and *Hektoen International: A Journal of Medical Humanities*. Lee's book, *Therapeutic Culture: Health and Illness in Late Nineteenth-Century American Art* is forthcoming from Bloomsbury Academic Press.

Emily M. Mazzola is currently a PhD student at the University of Pittsburgh in the History of Art and Architecture. She received her MA in Art History from the University of Connecticut in 2014. Her interest in the life and work of Rand began with her master's thesis, "Enabling Authority: Ellen Emmet Rand, President Franklin D. Roosevelt and the Power of Portraiture."

Claudia P. Pfeiffer has been the George L. Ohrstrom, Jr. Curator of Art at the National Sporting Library & Museum in Middleburg, VA, since 2012. Pfeiffer has studied and written about eighteenth- to twenty-first-century sporting art and history for twenty years. She has curated over twenty exhibitions including *Munnings: Out in the Open*, The Chronicle of the Horse *in Art, Clarice Smith: Power & Grace,* and *Foxcroft School: The Art of Women & the Sporting Life.*

Susan Spiggle has recently retired as Professor of Marketing at the University of Connecticut's Business School where she served as Department Head and Interim Department Head for the Department of Management. Spiggle has written dozens of articles for journals and books in her career and is currently working on a book about the secondary art market and the impact of technology on sale of art.

Thayer Tolles is Marica F. Vilcek Curator of American Paintings and Sculpture at The Metropolitan Museum of Art. A sculpture specialist, she was editor and co-author of a two-volume catalogue of the Metropolitan's historic American sculpture collection (1999, 2001). Among her exhibitions are *Augustus Saint-Gaudens in The Metropolitan Museum of Art* (2009) and *The American West in Bronze, 1850–1925* (2013–2015), both accompanied by publications. She also serves as President of the Saint-Gaudens Memorial.

Christopher Vials is Director of American Studies and Professor of English at the University of Connecticut-Storrs. He is the author of *Haunted by Hitler: Liberals, the Left, and the Fight against Fascism in the United States* (2014) and *Realism for the Masses: Aesthetics, Popular Front Pluralism, and U.S. Culture, 1935–1947* (2009). He is also a co-editor of *The U.S. Antifascism Reader* (2020).

Bibliography

Selected Archives

Augustus Saint-Gaudens Papers, Rauner Special Collections Library, Dartmouth College, Hanover, N.H. (Saint-Gaudens Papers).

Charles Follen McKim Papers, Library of Congress (McKim Papers).

Ellen Emmet Rand Papers, Archives & Special Collections, University of Connecticut Library (EER Papers, ASC, UConn).

Emmet family papers, 1792–1989, bulk, 1851–1989. Archives of American Art, Smithsonian Institution (Emmet Family, AAA).

Emmet-Rand Family Personal Papers, courtesy of Felicia Garcia-Rivera.

Franklin D. Roosevelt Library. Hyde Park, New York (FDRL).

Frederick William MacMonnies Papers, 1874–1997, Archives of American Art, Smithsonian Institution.

Mary Foote Papers, Beinecke Rare Book and Manuscript Library, Yale University.

The Metropolitan Museum of Art Archives (MMA Archives).

National Academy of Design, New York, NY (NAD).

Stanford White Papers, New-York Historical Society.

Stanford White Papers, Avery Architectural and Fine Arts Library, Columbia University, NY (White Papers, Avery Library).

Selected Sources

Adler, Kathleen, Erica E. Hirshler, and H. Barbara Weinberg. *Americans in Paris, 1860–1900.* London: National Gallery, 2006.

American Art Galleries. *Loan Exhibition of Portraits for the Benefit of the Orthopaedic Dispensary and Hospital.* New York, 1903.

American Women Artists: Gender, Culture and Politics. Edited by Helen Langa and Paula Wisotzki. London and New York: Routledge, 2016.

Anesko, Michael. *Henry James and Queer Filiation.* London: Palgrave Pivot, 2018.

"Of Art and Artists." *Los Angeles Times.* November 16, 1924, 75.

"Art Exhibitions," *New-York Tribune,* November 6, 1907, 7.

"Art at Home and Abroad. Some Recent Pictures Acquired by the Metropolitan Museum of Rare Interest," *The New York Times,* July 12, 1902, X6.

"Attractions in the Galleries." *The New York Sun.* Art section. April 18, 1936, 12.

Bassanese, Lynn. "The Franklin D. Roosevelt Library: Looking to the Future." *Government Information Quarterly* 12 (1995): 103–12.

Baxter, Kent. *The Modern Age: Turn-of-the-Century American Culture and the Invention of Adolescence.* Tuscaloosa: The University of Alabama Press, 2008.

Beatrice Cuming, 1903–1974. New London, CT: Lyman Allyn Art Museum, 1990.

Beaux, Cecilia. *Background with Figures*. Boston: Houghton Mifflin Company, 1930.

Binet, Alfred, "La Psychologie Artistique de Tade Styka." *L'annee Psychologique* 15 (1908): 316–57.

Black, Conrad. *Franklin Delano Roosevelt: Champion of Freedom*. New York: PublicAffairs, 2003.

Blauvelt, Maria Taylor. "The Artistic Temperament." *Book Buyer* 21 (January 1901): 542–8.

Borzello, Frances. *Seeing Ourselves: Women's Self-Portraits*. New York: Harry N. Abrams, 2016 [1998].

Bourguignon, Katherine, ed. *Impressionist Giverny: A Colony of Artists, 1885–1915*. Giverny: Musée d'Art Américain, 2007.

The Brooklyn Eagle. April 27, 1936, 9.

Brown, Marilyn R. *Picturing Children: Constructions of Childhood between Rousseau and Freud*. Aldershot: Ashgate, 2002.

The Bryn Mawr Hound Show One-Hundredth Anniversary. Bryn Mawr, PA: The Bryn Mawr Hound Show Association, 2014.

Buick, Kirsten Pai. *Child of Fire*. Durham and London: Duke University Press, 2010.

Burgin, Martha and Maureen Holtz. *Robert Allerton: The Private Man and the Public Gifts*. Champaign, IL: News Gazette, 2009.

Burns, Emily C. "Innocence Abroad: The Construction and Marketing of an American Artistic Identity in Paris, 1880–1910." PhD diss., Washington University in St. Louis, 2012.

Burns, Emily C. "Nationality, Modern Art, and the Child in Late-Nineteenth Century Painting." In *Children and Childhood: Practices and Perspectives*, edited by Chandni Basu and Vicky Anderson-Patton, 45–59. Oxford: Inter-Disciplinary Press, 2013.

Burns, Emily C. "Puritan Parisians: American Art Students in Late Nineteenth-Century Paris." In *A Seamless Web: Transatlantic Art in the Nineteenth Century*, edited by Cheryll May and Marian Wardle, 123–46. Newcastle upon Tyne: Cambridge Press Scholars, 2014.

Burns, Sarah. *Inventing the Modern Artist: Art and Culture in the Gilded Age*. New Haven and London: Yale University Press, 1996.

"Chaplin Blighted Artist's Romance." *New York Daily News*. February 4, 1923, 3.

Cheney, Liana De Girolami and Alicia Craig Faxon, and Kathleen Russo. *Self-Portraits by Women Painters*. Brookfield, VT: Ashgate, 2000.

The Connecticut Paintings of Ellen Emmet Rand. Salisbury, CT: The Salisbury Association, 2008.

Cook, Blanche Wiesen. *Eleanor Roosevelt Vol. I 1884–1933*. New York: Penguin Books, 1992.

Corn, Wanda M. *Georgia O'Keeffe: Living Modern*. New York: Brooklyn Museum of Art and Delmonico Books, Prestel, 2017.

Corn, Wanda and Tirza True Latimer. *Seeing Gertrude Stein*. Berkeley and LA: University of California Press and the Contemporary Jewish Museum and Smithsonian Institution, 2011.

"Costume Carnival in Artist's Studio: Gay Frolic in Bohemia." *The New York Times* (January 19, 1908): 11.

Cox, Kenyon. "In Memory of Saint-Gaudens." *Architectural Record* 22 (October 1907), 249–51.

Cummings, Hildegard. *Good Company: Portraits by Ellen Emmet Rand*. Storrs, CT: William Benton Museum of Art, 1984.

Curran, Grace Wickham. "Ellen Emmet Rand, Portrait Painter." *American Magazine of Art* 9 (September 1928): 471–9.

Czaplin, Czeslaw. *The Styka Family Saga*. Clark, NJ: Bicentennial Publishing Company, 1988.

Dearinger, David, ed. *Paintings and Sculpture in the Collection of the National Academy of Design*, vol. 1, 1826–1925. New York and Manchester, 2004.

Dearinger, David and Isabelle Derveaux. *Challenging Tradition: Women of the Academy, 1826–2003*. New York: National Academy of Design, 2003.

deButts, Mary Custis Lee and Rosalie Noland Woodland. *Charlotte Haxell Noland, 1883–1969*. Middleberg, VA: Foxcroft School, 1971.

Denning, Michael. *The Cultural Front: The Laboring of American Culture in the Twentieth Century*. London: Verso, 1997.

"Discontinues St. Gaudens Suit," *New York Tribune*, January 30, 1910, 9.

Dolfman, M. L. and D. M., McSweeney. *100 Years of U.S. Consumer Spending: Data for the Nation*. New York City, and Boston. Washington, DC: U.S. Department of Labor and U.S. Bureau of Labor Statistics, 2006. http://digitalcommons.ilr.cornell.edu/key_workplace/280/.

Dryden, John. *The Poetical Works of John Dryden, Esq. Containing Original Poems ...*, vol. II: The Secular Masque. Edited by John Warton. London: New England Press, 1811.

Dryfhout, John H. *The Work of Augustus Saint-Gaudens*, rev. ed. Hanover, N.H., 2008; first published, 1982.

Duffy, Henry and John H. Dryfhout, *Augustus Saint-Gaudens: American Sculptor of the Gilded Age*. Washington, DC: Trust for Museum Exhibitions in cooperation with the Saint-Gaudens National Historic Site, Cornish, N.H., 2003.

Edel, Leon. *Henry James: A Life*. New York: Harper & Row, 1985.

Edel, Leon. *Henry James, the Master, 1901–1916*. Philadelphia: Lippincott, 1972.

Fahlman, Betsy. "The Art Spirit in the Classroom: The 'New Women' Art Students of Robert Henri." In *American Women Modernists: The Legacy of Robert Henri, 1910–1945*, edited by Marian Wardle, 93–115. Provo, UT: Brigham Young University Museum of Art and New Brunswick, NJ: Rutgers University Press, 2005.

Fahlman, Betsy. "Women Art Students at Yale, 1869–1913: Never True Sons of the University," *Woman's Art Journal* 12, no. 1 (Spring/Summer 1991): 15–23.

Fine, Norman. *The Norfolk Hunt: One-Hundred Years of Sport*. Boyce, VA: Millwood House, 1995.

Fineberg, Jonathan, ed. *Discovering Child Art: Essays on Childhood, Primitivism, and Modernism*. Princeton, NJ: Princeton University Press, 1998.

Fineberg, Jonathan. *The Innocent Eye: Children's Art and the Modern Artist*. Princeton: Princeton University Press, 1997.

Fineberg, Jonathan. *When We Were Young: New Perspectives on the Art of the Child*. Berkeley: University of California Press, 2006.

Fink, Lois Marie. *American Art at the Nineteenth-Century Paris Salons*. Washington, DC: National Museum of American Art, Smithsonian Institution, 1990.

Fitzpatrick, Tracey. "Ellen Day Hale: Painting the Self, Fashioning Identity," *Woman's Art Journal* 31 (Spring/Summer 2010): 28–34.

Freedman, Russell. *Eleanor Roosevelt: A Life of Discovery*. New York: Houghton Mifflin Harcourt, 1993.

Galbraith, John Kenneth. *The Great Crash 1929*. New York: Houghton Mifflin Harcourt, 1955 [1990].

Gallagher, Hough Gregory. *FDR's Splendid Deception*. New York: Dodd, Mead & Company, 1985.

Garb, Tamar. *Sisters of the Brush: Women's Artistic Culture in late nineteenth-century Paris*. New Haven: Yale University Press, 1994.

Garland-Thomas, Rosemarie. "The FDR Memorial: Who Speaks from the Wheelchair." *The Chronicle of Higher Education*. January 26, 2001. https://www-chronicle-com.pitt.idm.oclc.org/article/The-FDR-Memorial-Who-Speaks/22439. Accessed September 5, 2018.

Garland-Thomas, Rosemarie. "Picturing People with Disabilities: Classical Portraiture as Reconstructive Narrative." In *Re-Presenting Disability: Activism and Agency in the Museum*, edited by Richard Sandell, Jocelyn Dodd, and Rosemarie Garland-Thomas, 23–40. New York: Routledge, 2010.

Garland-Thomas, Rosemarie. "The Politics of Staring: Visual Rhetorics of Disability in Popular Photography." In *Disability Studies: Enabling the Humanities*, edited by Sharon L. Snyder, Brenda Jo Brueggemann, and Rosemarie Garland-Thomas, 56–75. New York: Modern Language Association, 2002.

Gerdts, William H. *Art Across America: Two Centuries of Regional Painting in America*, vol. 1. New York: Abbeville Press, 1990.

Gerdts, William H. *Monet's Giverny: An Impressionist Colony*. New York: Abbeville Press Publishers, 1993.

Gilbert, Robert E. "Disability, Illness and the Presidency: The Case of Franklin D. Roosevelt." *Politics and the Life Sciences* 7 (1988): 33–49.

Gordon, E. Adina. "The Expansion of a Career: Frederick MacMonnies as a Teacher and a Painter." In *An Interlude in Giverny*, edited by Joyce Henri Robinson and Derrick R. Cartwright, 59–86. University Park, PA: The Pennsylvania State University and Palmer Museum of Art; Musée d'Art Américain Giverny and Terra Foundation for the Arts, Giverny, France, 2000.

Gordon, E. Adina. "The Lure of Paris." In *Augustus Saint-Gaudens, 1848–1907: A Master of American Sculpture*, edited by Alain Daguerre Hureaux, 91–8. Paris: Somogy Editions D'Art, 1999).

Gordon, Meryl. *The Phantom of Fifth Avenue*. New York: Grand Central Publishing, 2014.

Green, Anna. *French Paintings of Childhood and Adolescence, 1848–1886*. Aldershot: Ashgate, 2007.

Grogan, Kevin, Cary Wilkins, Amy Kurtz Lansing, and Erick Montgomery. *First Lady Ellen Axson Wilson and Her Circle*. Augusta, GA: Morris Museum of Art, 2013.

Hall, G. Stanley. *The Contents of Children's Minds*. New York: E.L. Kellogg, 1893.

Hall, James. *The Self-Portrait: A Cultural History*. London: Thames and Hudson, 2014.

Hamby, Alonzo L. "Liberals, Truman, and FDR as Symbol and Myth." *Journal of American History* 56, no. 4 (1970): 859–67.

Henri Robinson, Joyce, Derrick R. Cartwright, and E. Adina Gordon. *An Interlude in Giverny*. University Park: The Pennsylvania State University, 2001.

Heywood, Colin, ed. *A Cultural History of Childhood and Family in the Age of Empire*. Oxford: Berg, 2010.

Higginson, A. Henry. *The Hunts of the United States and Canada, Their Masters, Hounds and Stories*. Boston: Frank W. Giles, 1908.

Hill, May Brawley. *Fidelia Bridges, American Pre-Raphaelite*. New York: Berry Hill Galleries, 1981.

Hirshler, Erica E. *A Studio of Her Own: Women Artists in Boston, 1870–1940*. Boston: MFA Publications, 2001.

Hoeken, Hans and Lenneke Ruikes. "Art for Art's Sake? An Exploratory Study of the Possibility to Align Works of Art with an Organization's Identity." *Journal of Business Communication* 42 no. 3 (2005): 233–46.

Hoppin, Martha. *The Emmets: A Family of Women Painters*. Pittsfield, MA: The Berkshire Museum, 1982.

Houck, Davis W. and Amos Kiewe. *FDR's Body Politics: The Rhetoric of Disability*. College Station: Texas A&M University Press, 2003.

Isaacson, Joel. "Constable, Duranty, Mallarmé, Impressionism, Plein Air, and Forgetting." *Art Bulletin* 76, no. 3 (1994): 427–50.

James, Henry. *What Maisie Knew*. London: Penguin Books, 1985.

Jewell, Edward. "Art of Tade Styka of Boldini Flavor." *The New York Times*. February 9, 1934, 17.

Jewell, Edward Alden. "Parnassian Suppers." *The New York Times*, January 13, 1929, 120.

Kahn, Eve. "Rediscovering Mary Rogers Williams," *Fine Art Connoisseur* 11, no. 5 (September/October 2014): 76–81.

Kusserow, Karl, ed. *Picturing Power: Portraiture and Its Uses in the New York Chamber of Commerce*. New York: Columbia University Press, 2013.

Lansing, Amy Kurtz. "Art Colonies of the Connecticut Coast." In *Call of the Coast: Art Colonies of New England*, edited by Thomas Denenberg, Amy Kurtz Lansing, and Susan Danly. Portland, ME: Portland Museum of Art and Old Lyme, CT: Florence Griswold Museum, distributed by New Haven: Yale University Press, 2009.

Larkin, Susan G. *The Cos Cob Art Colony: Impressionists on the Connecticut Coast*. New York: National Academy of Design and New Haven: Yale University Press, 2001.

Larkin, Susan G. *The Ochtmans of Cos Cob: Leonard Ochtman (1854–1934), Mina Fonda Ochtman (1862–1924), Dorothy Ochtman (1892–1971), Leonard Ochtman, Jr. (1894–1976)*. Greenwich, CT: Bruce Museum, 1989.

Larkin, Susan G. and Amy Kurtz Lansing. *Matilda Browne*. Old Lyme, CT: Florence Griswold Museum, 2017.

Letts, Elizabeth. *The Eighty-dollar Champion: Snowman, The Horse That Inspired a Nation*. New York: Ballantine Books, 2012.

Levander, Caroline F. *Cradle of Liberty: Race, the Child, and National Belonging from Thomas Jefferson to W.E.B. DuBois*. Durham: Duke University Press, 2006.

Levy, Deborah. *Things I Don't Want to Know*. New York and London: Bloomsbury, 2013.

Lichtenstein, Nelson. "Class Politics and the State during World War II." *International Labor and Working-Class History* 58 (Fall, 2000): 261–74.

Lindgren, Kristin. "Looking at Difference: Laura Swanson's Anti-Self-Portraits, Diana Arbus's Portraits, and the Viewer's Gaze." *Journal of Literary & Cultural Disability Studies* 9, no. 3 (2015): 277–94.

Lübbren, Nina. *Rural Artists' Colonies in Europe, 1870–1910*. Manchester: Manchester University Press, 2001.

Macbeth Gallery. *Exhibition of Portraits by Ellen Emmet from March eleventh to twenty-third 1907*. New York, 1907.

Macleod, David. *The Age of the Child: Children in America, 1890–1920*. New York: Twain, 1988.

Madeline, Laurence. *Women Artists in Paris, 1850–1900*. New York: American Federation of Arts, 2017.

McElvaine, Robert. *The Great Depression: America, 1929–1941*. New York: Times Books, 1993.

McLean, Lydia Sherwood. *The Emmets: A Family of Women Painters*. Pittsfield, MA: The Berkshire Museum, 1982.

Mathews, Nancy Mowll. "'The Greatest Woman Painter': Cecilia Beaux and Mary Cassatt, and Issues of Female Fame." *The Pennsylvania Magazine of History and Biography* 124 (July 2000): 293–316.

Mazzola, Emily M. "Enabling Authority: Ellen Emmet Rand, President Franklin D. Roosevelt, and the Power of Portraiture." M.A. thesis, University of Connecticut, 2015.

Meixner, Laura. *An International Episode: Millet, Monet and Their North American Counterparts*. Memphis, TN: Dixon Gallery and Gardens, 1982.

Melanson, Philip H. *The Secret Service: The Hidden History of an Enigmatic Agency*. New York: Carol and Graph Publishers, 2005.

Merrill, Todd. *James Mont: The King Cole Penthouse*. New York: Todd Merrill and Associates, 2007.

Meschutt, David. "Portraits of Franklin Delano Roosevelt." *American Art Journal* 18 (1986): 2–50.

Metropolitan Museum of Art. *Catalogue of a Memorial Exhibition of the Works of Augustus Saint-Gaudens*. New York, 1908.

Millett, Ann. "Sculpting Body Ideals: Alison Lapper Pregnant and the Public Display of Disability." *Disability Studies Quarterly* 28, no. 3 (Summer 2008). http://www.dsq-sds. org/article/view/122/122. Accessed September 18, 2018.

Mintz, Steven. *Huck's Raft: A Cultural History of Childhood in America*. Cambridge: Belknap Press of Harvard University Press, 2004.

"Miss Ellen Emmet A Bride. Portrait Artist Married to William B. Rand. In Salisbury, Conn," *The New York Times*. May 7, 1911, 11.

Monbiot, George. *Feral: Rewilding the Land, the Sea, and Human Life*. Chicago: University of Chicago Press, 2014.

Moore, Lucy. *Anything Goes: A Biography of the Roaring Twenties*. New York: The Overlook Press, 2010.

Morris, Harrison S. "American Portraiture of Children." *Scribner's Magazine* 30 (December 1901): 641–56.

"Mrs. Saint-Gaudens Loses. Ellen Emmet's Portrait of the Sculptor Found to be the Painter's Property." *The New York Times* June 23, 1911, 11.

Nochlin, Linda. "Why Have There Been No Great Women Artists?" In *Art and Sexual Politics*, edited by Thomas B. Hess and Elizabeth C. Baker, 194–205. New York: Macmillan, 1973.

"Noted Painter Here." *Milwaukee Sentinel*. February 28, 1930, 8.

Peck, Amelia and Carol Irish. *Candace Wheeler: The Art and Enterprise of American Design, 1875–1900*. New York: The Metropolitan Museum of Art with Yale University Press, 2001.

Pierpont, Claudia Roth. "The Canvas Ceiling: How New York's Postwar Female Painters Battled for Recognition." *The New Yorker*, October 8, 2018. https://www.newyorker. com/magazine/2018/10/08/how-new-yorks-postwar-female-painters-battled-for-recognition. Accessed January 26, 2019.

"President Gets Picture of Mother." *Washington Post*. May 8, 1934, 10.

Pressman, Matthew. "Ambivalent Accomplices: How the Press Handled FDR's Disability and How FDR Handled the Press." *Journal of the Historical Society* 3 (2013): 325–59.

Prieto, Laura R. *At Home in the Studio: The Professionalization of Women Artists in America*. Cambridge: Harvard University Press, 2001.

"Portrait Painters." *Life Magazine*. February 3, 1941, 46–8.

Powers, Lyall H. *The Portrait of a Lady: Maiden, Woman, and Heroine*. Boston: G.K. Hall & Co., 1991.

Rand Ellen E. *Dear Females*. New York: Ellen E. Rand, 2009.

Rein, Lisa. "Reclaiming America's Stolen Property." *Washington Post*. February 23, 2011.

Rideal, Liz. *Mirror, Mirror: Self-Portraits by Women Artists*. New York: Watson-Guptill Publications, 2002.

Ringelberg, Kirstin. *Redefining Gender in American Impressionist Studio Paintings*. Surry and Burlington, VT: Ashgate Press, 2010.

Schnugg, Claudia and Johannes Lehner, "Communicating Identity or Status? A Media Analysis of Art Works Visible in Photographic Portraits of Business Executives." *International Journal of Arts Management* 18, no. 2 (2016): 63–74.

Scudder, Horace E. "Childhood in Modern Literature and Art." *Atlantic Monthly* 56, no. 338 (December 1885): 751–67.

Scudder, Janet. *Modeling My Life*. New York: Harcourt, Brace and Co., 1925.

Seaman, Donna. *Identity Unknown: Rediscovering Seven American Women Artists*. New York and London: Bloomsbury Press, 2017.

Siebers, Tobin. "Disability As Masquerade." *Literature and Medicine* 23 (2004): 1–22.

Smart, Mary. *A Flight with Fame: The Life and Art of Frederick William MacMonnies (1863–1937)*. Catalogue Raisonné of sculpture and checklist of paintings by E. Adina Gordon. Madison, CT, 1996.

Smith, Todd D. *Lillian Mathilde Genth: A Retrospective*. Hickory, NC: Hickory Museum of Art, 1990.

"Solon's Wife Illustrious Painter." *Hartford Courant*. January 30, 1927, D5.

Sporting Portraits by Ellen Emmet Rand, N.A. New York: Sporting Gallery & Bookshop, 1936.

Stein, Sally. "The President's Two Bodies: Staging and Restaging of FDR and the New Deal Body Politic." *American Art* 18, no. 1 (2004): 32–57.

"Styka Gives His Impressions of Poincare and Ideal Woman." *Baltimore Sun*. March 28, 1934, 11.

Swinth, Kirsten. *Painting Professionals: Women Artists and the Development of Modern American Art, 1871–1930*. Chapel Hill: University of North Carolina Press, 2001.

Tappert, Tara Leigh. *The Emmets: A Generation of Gifted Women*. New York: Borghi & Co., and Roanoke, VA: Olin Gallery, Roanoke College, 1993.

"Tade Styka Thinks Wet France Dryer than Arid United States." *Baltimore Sun*. March 26, 1923, 18.

"Tade Styka, Famous Prodigy Artist of Poland, Will Exhibit with His Famous Father at St. Louis." *San Francisco Call*. June 26, 1904, 17.

Theresa Bernstein: A Century in Art. Edited by Gail Levin. Lincoln and London: University of Nebraska Press, 2013.

Thomas, Greg M. *Impressionist Children: Childhood, Family, and Modern Identity in French Art*. New Haven: Yale University Press, 2011.

Tolles, Thayer. *Augustus Saint-Gaudens in The Metropolitan Museum of Art*. New York: Metropolitan Museum of Art, 2009.

Tolles, Thayer. "Kenyon Cox." In *Augustus Saint-Gaudens, 1848–1907: A Master of American Sculpture*, edited by Alain Daguerre Hureaux, 100–1. Paris: Somogy Editions D'Art, 1999).

Van Hook, Bailey, *Violet Oakley: An Artist's Life*. Newark: University of Delaware Press, 2016.

Vaughan, Henry. *Master of Foxhounds Association of America: 1935*. Boston, MA: Master of Foxhounds Association of America, 1936.

Vials, Chris. *Realism for the Masses: Aesthetics, Popular Front Pluralism, and U.S. Culture, 1935–1947*. Jackson: University Press of Mississippi, 2009.

Waldschmidt, Anne. "Disability Goes Cultural: The Cultural Model of Disability as an Analytical Tool." In *Culture—Theory—Disability: Encounters Between Disability Studies and Cultural Studies*, edited by Anne Waldschmidt, Hanjo Berressem, Moritz Ingwersen, 19–27. Bielefeld: transcript Verlag, 2017.

Wallace, Henry. "The Dangers of American Fascism." In *Democracy Reborn*, edited by Russell Lord, 259–63. New York: Reynal and Hitchcock, 1944.

Walz, Jonathan Frederick, "Past and Present in the 1920s: Ellen Emmet Rand." In *For America: Paintings from the National Academy of Design*, edited by Jeremiah William McCarthy and Diana Thompson, 150–5. New Haven and London: Yale University Press, 2019.

Weinberg, H. Barbara. *The Lure of Paris: Nineteenth-Century American Painters and Their French Teachers*. New York: Abbeville Press Publishers, 1991.

West, Shearer. *Portraiture*. New York: Oxford University Press, 2004.

William, Gareth. "Theorizing Disability." In *Handbook of Disability Studies*, edited by Gary L. Albrecht, Katherine Seelman, and Michael Bury, 123–41. Thousand Oaks: Sage Publications, 2001.

Wilson, Daniel J. "Passing in the Shadow of FDR." In *Disability and Passing*, edited by Jeffery A. Brune and Daniel J. Wilson, 13–35. Philadelphia: Temple University Press, 2013.

Winants, Peter. *Foxhunting with Melvin Poe*. Lanham, MD: Derrydale Press, 2002.

Wolfe, Martha. *The Great Hound Match of 1905*. Lanham, MD: Rowman & Littlefield, 2015.

Yount, Sylvia et al. *Cecilia Beaux: American Figure Painter*. Atlanta: High Museum of Art and Berkeley: University of California Press, 2007.

Žižek, Slavoj. *Looking Awry: An Introduction to Jacques Lacan through Popular Culture*. Cambridge, MA: MIT Press, 1995.

Žižek, Slavoj. *The Sublime Object of Ideology. London: Verso, 2008*.

Index